The Best American
Travel Writing 2018

The Best American Travel Writing™ 2018

Edited and with an Introduction
by **Cheryl Strayed**

Jason Wilson, Series Editor

A Mariner Original

HOUGHTON MIFFLIN HARCOURT

BOSTON • NEW YORK 2018

hmhco.com

ISSN 1530–1516 (print) ISSN 2537–4830 (e-book)
ISBN 978–1–328–49769–7 (print) ISBN 978–1–328–50165–3 (e-book)

Printed in the United States of America
DOC 10 9 8 7 6 5 4 3 2 1

"Goodbye My Brother" by Elliot Ackerman. First published in *Esquire*, April 2017. Copyright © 2017 by Elliot Ackerman. Reprinted by permission of Elliot Ackerman.

"Hope and Home" by Rabih Alameddine. First published in *Freeman's: Home Issue 2017*. Copyright © 2017 by Rabih Alameddine. Reprinted by permission of Rabih Alameddine and Aragi Inc.

"Peak America" by Sam Anderson. First published in the *New York Times Magazine*, March 26, 2017. Copyright © 2017 by the *New York Times*. Reprinted by permission of the *New York Times*.

"Why Should a Melon Cost as Much as a Car?" by Bianca Bosker. First published in *Roads & Kingdoms,* March 27, 2017. Copyright © 2017 by Bianca Bosker. Reprinted by permission of Bianca Bosker.

"The Ghost of Capablanca" by Brin-Jonathan Butler. First published in *Southwest,* June 2017. Copyright © 2017 by Brin-Jonathan Butler. Reprinted by permission of Brin-Jonathan Butler.

"My Mother and I Went Halfway Around the World to Find Each Other" by Jennifer Hope Choi. First published in *BuzzFeed*, February 3, 2017. Copyright © 2017 by BuzzFeed, Inc. Reprinted by permission of BuzzFeed, Inc.

"Signs and Wonders" by J. D. Daniels. First published in *Esquire*, May 2017. Copyright © 2017 by J. D. Daniels. Reprinted by permission of J. D. Daniels.

"Traveling While Black" by Camille Dungy. First published in Catapult, June 30,

Contents

Foreword

IN MY TRAVELS, I am always fascinated by the palaces, estates, châteaus, manors, and towers left behind by the dysfunctional rulers of past epochs—particularly the ones erected by the crazier, more ruthless dukes, lords, doges, and strongmen. One of the most memorable and striking examples I've ever visited is in Ferrara, Italy.

In 1385, Marquis Niccolò II d'Este—Ferrara's ruler, known as Niccolò the Lame because of his crippling gout—raised taxes on the citizens of his city-state to pay off his debts from lavish overspending on festooned luxuries and elaborate feasts. Higher taxes did not go over so well with the Ferrarese people, who had already suffered flooding and famine and all the other indignities of life as fourteenth-century peasants. And so an angry, armed mob marched on the House of Este. Unable to calm the revolt, Niccolò the Lame eventually presented his finance minister, a guy named Tommaso da Tortona, and offered him to the mob—who promptly tore poor Tommaso to shreds, limb from limb, and roasted his body parts over a bonfire of burning books looted from the palace. Some of the crowd, it is reported, dined on the taxman's flesh.

After wiggling out of that close call, and after beheading the leaders of the revolt, Niccolò the Lame concluded that he'd better build a bigger, better castle. So he borrowed 25,000 ducats from his neighbor, the Duke of Mantua, and built Castello Estense, perhaps Italy's finest Renaissance castle, with four massive towers, a deep moat, drawbridges, and an imposing redbrick facade. Through the fifteenth and sixteenth centuries, the Castello

Estense became the focal point of Ferrara's urban sophistication, and in its heyday the city-state was larger than even Rome. The House of Este attracted some of the Renaissance's greatest artists and intellectuals, including Petrarch and Titian. In the castle's vast kitchens, the famed cook Cristoforo da Messisbugo—the celebrity chef of his day—concocted grand banquets and wrote a cookbook that would help establish Italy's world-famous cuisine.

At the same time, since the Este family were still basically thugs, the violence and dysfunction continued with each successive ruler. In 1425, Niccolò III (Niccolò the Lame's illegitimate nephew) had his young second wife and her lover—his own illegitimate son Ugo—tossed into the dungeon and eventually beheaded. Then, even as he boasted of sleeping with hundreds of women and fathering more than a dozen children, Niccolò III decreed that any woman found guilty of adultery would be executed. This was soon reversed when it was made clear that the decree's enforcement would essentially depopulate Ferrara. Niccolò III's son, Ercole I, was rumored to have poisoned his wife. Ercole's son, Alfonso I, threw his illegitimate half-brother into the dungeon. Alfonso also took as his second wife the notorious beauty Lucrezia Borgia, she of the treacherous Borgia clan, who may or may not have had her two previous husbands murdered (though some insist this is fake news). By 1598, weary of the House of Este's rule, the pope stepped in to annex Ferrara by force—which was pretty simple since the Estes had no legitimate heirs remaining.

Over the next four centuries, Ferrara drifted into a sleepy, mostly forgotten backwater, a place where bicycles outnumber cars. Whatever contributions the House of Este had made to Western civilization, its art or literature or cuisine, is now largely overlooked.

Yet the Castello Estense still stands, smack in the modern city center, still surrounded by its water-filled moat and connected by a drawbridge. Ferrara is now a day-trip stopover on the tourist trail from Florence to Venice. I return occasionally to Ferrara, and I always visit the castle. I wander the alabaster hallways, the gilded chambers, the Hall of Games, the Coats of Arms Room, the orange garden, the terraces. I'm fascinated by the kitchens, where the placards on the wall describe Messisbugo's feasts as "magnificent festivity, all shadow, dream, chimera, fiction, metaphor, and allegory." From high in the tower, I look down and imagine what

it would take to transform the workaday pedestrians and bicyclists below into an angry mob. And, of course, I visit the dungeons.

I found myself thinking a lot about the Castello Estense during the late months of 2017. During that fall, I'd been traveling to Trump vacation properties around the world for a long, rather depressing travel feature I wrote for the *Washington Post Magazine*, published just as we were making the final selections for this anthology.

I traveled to the Trump golf resort in Aberdeen, Scotland, to the Trump Winery in Virginia, to the Trump Towers in Panama City and Vancouver, as well as the abandoned former Trump casinos in Atlantic City. I didn't go as an investigative journalist or political commentator, simply as a travel writer. By then, Trump had been written about in nearly every other genre: political, entertainment, financial, fashion, sports. Why not look at Trump through the prism of travel writing? So I slept in the various Trump hotels, experienced the Trump amenities, wore the Trump-branded robe and shower cap, ate and drank in the Trump restaurants and bars. I believed it would be no different than when I anonymously visit and review any other establishment in the course of an article. This, of course, was totally naive. As a jaded travel writer, someone who's stayed in many soulless hotels and eaten in many overpriced restaurants in many disappointing places, I'm completely at ease with a certain exquisite idleness and ennui. But there was something profoundly unsettling about the sort of boredom and in-your-face mediocrity that I felt in the Trump properties.

As an example of the insistent overhyping and under-delivering, consider the gold-lettered plaque that stands near the clubhouse of the Trump golf course in Aberdeen. This plaque memorializes the opening of this course "conceived and built by Donald J. Trump" (in 2012) as if it were an official historic site. It reads:

> Encompassing the world's largest dunes, The Great Dunes of Scotland, Mr. Trump and his architect, Dr. Martin Hawtree, delicately wove these magnificent golf holes through this unparalleled 600 acre site running along the majestic North Sea. The unprecedented end result is, according to many, the greatest golf course anywhere in the world!

So many mistruths to unpack on one small plaque. First of all, the so-called "Great Dunes" are in reality part of an environmen-

tally sensitive area called the Sands of Forvie (which Trump bull-
dozed) and these dunes are nowhere close to the "world's largest."
Dunes in countries like Peru and Namibia are five or more times
taller. The Sands of Forvie is actually the fifth-largest dune system
in Britain. Next, the golf course itself is nowhere near the "great-
est." The most recent ranking of *Golf Digest* lists it as the fifty-fourth
best course in the world.

In Atlantic City I sat on the boardwalk in front of the ruins
of the bankrupted former Trump Plaza Casino, which was soon
to be demolished. The other former Trump casino, the gaudy
Trump Taj Mahal, would soon be revamped and replaced with a
Hard Rock Casino. Similarly, in Panama, I sat by the ocean and
looked at Trump Tower, extremely worn for a six-year-old build-
ing, with cracks, black smudges, and what looked like rust and
mold. Within a few months of my visit, after an ugly dispute and
Panamanian police storming the tower, the Trump name would
be removed—just as it would be removed from several other of
his properties around the world.

Unlike the Castello Estense, this tower might not be around in a
half decade, let alone centuries. No travelers will visit these places
and wonder what life was like in the early twenty-first century. The
buildings that Trump has erected will stand only as monuments to
relentless mediocrity. Yet just like the Castello Estense, they still of-
fer us a parable, alarming and disturbing as it is. And the country
he leads may ultimately come to resemble his vacation properties.

Mediocrity, of course, has become a sad default of our era. It is
my sincere hope that, year after year, *The Best American Travel Writ-
ing* offers something of an antidote. Or at least, like the Castello
Estense, something worth revisiting as time rolls on.

The stories included here are, as always, selected from among doz-
ens of pieces in dozens of diverse publications—from mainstream
glossies to cutting-edge websites to Sunday newspaper travel sec-
tions to literary journals to niche magazines. I've done my best to
be fair and representative, and in my opinion the best travel sto-
ries from 2017 were forwarded to guest editor Cheryl Strayed, who
made our final selections. I was thrilled to finally have a chance
to work with Cheryl, whose book *Wild* is one of my favorites and a
modern travel classic. I'm grateful to Melissa Fisch, at Houghton
Mifflin Harcourt, for her help in producing this year's wonderful

collection, our nineteenth. I'd also like to thank Tim Mudie for his many years of working with me on this anthology.

I now begin anew by reading the travel stories published in 2018. As I have for years, I am asking editors and writers to submit the best of whatever it is they define as travel writing—the wider the better. These submissions must be nonfiction, and published in the United States during the 2018 calendar year. They must not be reprints or excerpts from published books. They must include the author's name, date of publication, and publication name, and must be tear sheets, the complete publication, or a clear photocopy of the piece as it originally appeared. I must receive all submissions by January 1, 2019, in order to ensure full consideration for the next collection.

Further, publications that want to make certain their contributions will be considered for the next edition should make sure to include this anthology on their subscription list. Submissions or subscriptions should be sent to: Jason Wilson, Best American Travel Writing, 230 Kings Highway East, Suite 192, Haddonfield, NJ 08033.

JASON WILSON

Introduction

THERE ARE ONLY two things in my life that I've experienced as a calling: to write and to travel. Those twin yearnings are like two tiny fires that have been burning in my gut since my earliest memory of myself. As a child, I spent hours gazing at the laminated maps that hung on the walls of my elementary school classrooms. Studying them was my way of occupying myself when I became bored by the teacher's lecture, which might explain my rocky relationship with math. I memorized every capital city in the nation, then the continent, then the world. I made a list of the places I'd go if I had the chance and I said them out loud to myself in my mind, as if reciting a prayer. Sri Lanka and Australia. California and New York. Kenya and Brazil.

What on earth were they? Why did I ache for them? Someday, I'd go.

I was living in a small town in Minnesota at the time, the daughter of a single mother who barely had enough money to cover rent. Our travels were limited to roughly annual drive-straight-through road trips to visit my grandparents in Alabama in cars that invariably broke down or almost killed us from heat stroke even though we had the windows wide open, the hot air roaring our hair into knots.

Still, those trips sparked my soul. There was the long monotonous haul of Wisconsin. The thrill and terror of passing through Chicago. The lush wonder of Kentucky. Everything I saw and experienced felt enormous and unforgettable, imprinted in my psyche the way regular life couldn't be. I tried to remember it all and did.

The roadside restaurants thick with cigarette smoke. The glances exchanged with strangers in passing cars. The way the land would hold on to itself and also give way, shifting from one thing to the next imperceptibly, and then all at once. From country to city. From trees to prairie. From here to there to God knows where.

Every state has at least one beautiful thing about it, my mother would say, always an optimist. And I'd sit and watch Indiana blaze by for hours and search for it. The one beautiful thing.

When I was nineteen I decided to get married, but really, I decided to travel. The crazy plan to marry was so connected to the not-so-crazy plan of temporarily dropping out of college so I could go to Ireland and England that one act can't be separated from the other. Looking back on it now, I can see what I wanted to do was study abroad my junior year. But I was paying my own way through college, so that wasn't possible. Instead, my new husband and I obtained student work visas and flew to Ireland three days after our wedding. I got a job in a vegetarian café in Dublin and he found one down the street in a pizza parlor. We rented a flat where the landlord refused to turn on the heat while repeatedly promising that he would. My coworkers at the vegetarian café were gay men who were out only to each other and, after some reluctance, me. They taught me how to deep-fry hot dogs and take a hard line with the drunk men who tried to use the toilet without purchasing food. Each night after work, if I wasn't out dancing in a secret basement gay nightclub with my coworkers, I'd go to the pizza parlor and wait for my husband to finish his shift. He got a free pizza as part of his pay and we'd take it home and eat it in our freezing flat at 3:00 a.m. while listening to the two cassette tapes we owned. Van Morrison and Toots and the Maytals.

It was hard and weird and gloriously fun. I was constantly aching for home and desperately missing my mother while simultaneously feeling like my dreams had finally come true. I walked the streets of Dublin and later London in a state of rapture thinking, *I'm here.*

I was on the map. I was no longer gazing at it.

By the time my mom died abruptly a couple of years later, I was back in college, a senior at the University of Minnesota in Minneapolis. There was a place on campus called the travel center, where students could go to research their studies abroad. It was a small room with a vast library of Lonely Planets and Frommer's and

Moon and Rough Guides that would tell you in great detail about almost any inhabited place on the planet. I spent hours at the table in the travel center poring over these books in the weeks following my mom's death, meticulously planning the three-month trip I was going to take solo around Europe using the $3,500 my grandparents had told me they intended to give me. It was a portion of the small life insurance policy they'd taken out on my mother years before, my only inheritance besides her rusted-out Toyota Tercel, which I sold to a guy named Guy for $500 a couple of months after she died.

I was so sad and shocked that I'd have to live the rest of my life without my mother that I woke most days sobbing, my sorrow surfacing before I did, as if it were drowning me in my sleep. I skipped classes and went to the travel center instead, absorbed for hours in the guidebooks. The concentration with which I dedicated myself to trip planning felt like a short-term cure for my suffering. I devoutly mapped out my European tour in fanatic detail. I agonized over whether or not I should spend any time in Geneva. Which train I would take from Lyon to Paris. How far north to venture in Finland. Where I should eat in Rome and sleep in Barcelona and swim in Portugal. What places I couldn't miss and should. I memorized tips and facts and insider points of information. Never in my life have I imagined anything with the intensity that I imagined that trip. Nearly thirty years have passed, and it's still there in me, a map carved into my bones.

I didn't go. I didn't get my $3,500. In their grief, my two siblings had gone slightly off the rails and our grandparents decided they couldn't be trusted to spend their $3,500 appropriately, and so they didn't think it'd be fair to give me mine. I went canoeing and camping in the Boundary Waters for a couple of weeks instead. I moved to New York City and worked as a waitress and realized I didn't want to live in New York City if I was going to work as a waitress. I did some going off the rails myself. I bought a 1979 Chevy LUV pickup truck and put a futon in the back and ventured into places I'd never been, traveling the only way I could—on the cheap, sleeping free on national lands and eating peanut butter on rice cakes for dinner. I traveled through every state west of the Mississippi River, sleeping almost always under the stars.

Everywhere I went, I thought of my mother. I looked for the one beautiful thing and found it every time.

I broke up with my husband and by chance heard about the Pacific Crest Trail. I decided to hike it for three months because I thought it might heal my shattered heart and because walking was less expensive than driving or flying or taking a train. I would be a pilgrim, traveling the ancient way.

When I stood on the bridge that spans the Columbia River and marked the end of my ninety-four-day trek at the border of Oregon and Washington, I was profoundly happy to be done, but I was also thinking *more, more, more.* Traveling at footspeed taught me a lot of things and one of them was about the meaning of travel itself, especially the meaning of it in my own life. It was powerful and transformative and necessary. I wanted to know the endless misery and beauty of it. That fact was a fire in me that wouldn't go out. It was one I decided to feed forevermore.

Since then, I've traveled the world. From New Zealand to Nepal to Tanzania to Sweden to Qatar to Costa Rica and dozens of places in between. Travel is the thing I do when I get to do something. So of course, I said yes when Jason Wilson asked me to take on the task of being the guest editor for the 2018 edition of this fine series. The essays in this book, and the many others I considered for it, were written by people who have those same tiny twin fires of traveling and writing burning in them too.

If I had to come up with an alternate title to this anthology composed of the twenty-four essays that I chose to include, it would be this: *There Will Be a Reckoning.* In the Fallujah Elliot Ackerman revisits a dozen years after he fought in the Iraq War. In the Flint, Michigan, Richard Manning returns to in order to contemplate the poisoned water of his hometown. In the Duluth, Minnesota, Camille Dungy visits and finds a monument to black victims of a white supremacist lynching. In Beirut, Lebanon, where Rabih Alameddine visits the Syrian refugees who are housed in unfinished buildings. In the remote reaches of the Philippines, where Albert Samaha returns to a family farm with his mother, after having left long ago. In the small towns and highways along the Appalachian Trail, where Rahawa Haile confronts a nation still reckoning with its racist past and present. In the modern Russia Ian Frazier contemplates a century after the revolution that changed the course of the nation and the world.

These are the reckonings of war, ecological disaster, political turmoil, and economic, social, racial, and gender inequities that

have persisted around the globe for all time. But this collection is also full of other, more personal but no less powerful reckonings too. Allegra Hyde descends into a cave in Bulgaria with her husband, whom she loves, though their marriage "feels like a sham." Matthew Ferrence tries to make sense of the meaning of the foxes of Prince Edward Island as he emerges from treatment for a brain tumor. Eileen Pollack travels to Poland with her "Righteous Gentile" lover and grapples with whether he would've been "one of the very few Poles who disobeyed the Nazis to save the Jews." Ryan Knighton, who is blind, struggles to comprehend "unseen sights in an unseen place" while on safari in Zimbabwe. And in the funniest essay in the book, John von Sothen reckons with the cultural mismatch between Americans and the French when it comes to the notion of what a vacation should be.

These essays and others I've not mentioned—which span the globe from South Korea to Fort Lauderdale to Estonia to Los Angeles—are as diverse in tone as they are in subject and setting. The thread that connects them in all of their variation is that each essay does what we expect great travel writing to do: Reveal truths about what it means to be human through the lens of our relationship to place, culture, and era. Dig deeply into the meaning of belonging and otherness, of home and away, of community and kinship among all species. Seek and find, as my mother would say, the beautiful things in the ugliest states. This mission seems ever more important in 2018, as we come to grips with the grave ecological consequences of human-caused climate change and the devastating results of religious and ideological extremism, cultural imperialism, and xenophobia.

I made my final selections for this book while on a fourteen-hour flight from Dubai to Seattle. I'd been in Dubai to take part in a literary festival, and while I was there Barbara Leaf, then United States ambassador to the United Arab Emirates, had hosted a private party in my honor at the American consul general's residence. It was a late breakfast affair, attended by a few dozen women, three quarters of whom were Emirati and clad in the traditional black *abayas* that cover their bodies and *shelas* that cover their hair. I'd unintentionally dressed the precise opposite of them, uncharacteristically clad entirely in white from head to toe; my blond hair in contrast to their black. Our oppositeness increased my anxiety about whether what I had to say would be relevant to them. Who

was I to think they'd want to hear about my life? It's an anxiety I've learned time and time again I need not have. I've never gone any place in the world where people didn't look at me with deep understanding as I shared my story with them. And yet, in Dubai, with these women who looked and seemed so very different from me, I felt apprehensive.

Until I began speaking, of course. And they started nodding and smiling and letting tears come into their eyes and telling me about their own lives.

It isn't true that I made the final selections for this book on the plane flying home from Dubai. By the time I was on that flight, I knew I wanted to include them. It was that I wanted to read them again and take them in together, one after the other, as a reader would in the form of a book. As I made my way through the pile of essays stacked in alphabetical order on my lap, the man across the aisle to my left murmured aloud for hours passages from the Koran he held in his hands; the man to my right in the seat beside me watched a series of movies that seemed to be composed entirely of long scenes of men shooting each other with assault rifles, punctuated by lingering shots of scantily clad women. It struck me as just right to be literally couched between two men whom I perceived to be entirely different from each other, and from me, while reading stories about all the many near and far places in the world we can go and find connection.

"Oh yes," one of the women had said to me after my talk at the American consul general's house, after we'd hugged and posed for selfies, and I'd confessed to her that I'd been afraid I'd have nothing in common with her and her friends. "Yes, yes, yes," she said. "This is what we always think: we look different, so we are different. But you see, about that, we are always wrong. Always wrong."

Always.

<div align="right">CHERYL STRAYED</div>

The Best American
Travel Writing 2018

ELLIOT ACKERMAN

Goodbye, My Brother

FROM *Esquire*

THREE DAYS I'VE been here running from one ministry to another, making phone calls, emailing the US embassy, asking favors of friends and then favors of friends of friends. Nothing has worked. I want to be in Fallujah. But I can't get out of Baghdad. It's two in the afternoon on a Thursday in late October. I'm in a nearly empty shopping mall, at a Toll House cookie kiosk across the street from the Iraqi Ministry of the Interior. It's Fityan, Hawre, and me. We're waiting for a call from Fityan's cousin Tahrir, a captain in the police. He is inside the ministry negotiating my letter of permission into Fallujah.

In Fallujah there is a doorway I want to stand in. My friend Dan Malcom was shot and killed trying to cross its threshold twelve years ago. A sniper's bullet found its mark beneath his arm, just under the ribs.

In Fallujah there is a building I want to stand on top of. It was a candy store. The day after Dan was killed, my platoon fought a twelve-hour firefight from its rooftop. That was the worst day of the battle, the largest and bloodiest of the Iraq War. We began the morning with forty-six guys. By nightfall, twenty-five of us were on our feet.

That doorway in Fallujah, that rooftop—I remember exactly where they are.

Fityan's phone rings, startling him so much that a worm of ash tumbles from his cigarette. He brushes at the black T-shirt that is snug over his round belly. As he answers Tahrir's call, I try to de-

code the slushy tonality of Fityan's Arabic. His expression sags as
he hears his cousin's report.

"They are asking for a $500 bribe," Fityan says. He tosses his
phone onto the coffee table between us. Fityan and Tahrir are
Sunni, with deep ties in Iraq's restive al-Anbar Province. I met
Fityan through a friend of mine, an American who used to teach
at a university in northern Iraq. He knew Fityan through one of
his students, which is to say he hardly knew Fityan at all. Weeks
ago, over long-distance Skype calls and emails, Fityan introduced
me to Tahrir. The two of them promised that they could get me
into Fallujah, and I've come a long way because of their promises.
"If you were Iranian, it'd be easier," Fityan mutters. "The minis-
tries are all Shia. They're giving you a hard time because you're
an American."

Our server brings our drinks. Hawre, the photographer as-
signed to this story, sets down his camera and examines the enor-
mous cup of coffee in front of him. "Fityan, tell him I ordered a
medium." Hawre is an Iraqi Kurd from Kirkuk, north of Baghdad.
His teeth are crooked and overlapping, like cards fanned out by
an unskilled dealer. Whenever he parts his lips, he appears to be
smiling. He is immensely proud that he barely speaks Arabic.

Fityan confirms that Hawre's coffee is the size he ordered.

"Toll House is an American chain," I say to Hawre, attempting
to explain his enormous "medium." Everyone lights a cigarette.

It's been twelve years since I fought in Fallujah as a Marine. If a
bribe is all that's preventing my return to the city—a place that's
been in my thoughts every day since 2004—it seems I have no
choice. "I could just pay the five hundred."

"They always do this bullshit," Fityan says.

They is Iraq's Shia-majority government, which has marginalized
the country's Sunni minority since the United States officially with-
drew in 2011. Shia flags emblazoned with the deific portrait of Ali
—the Prophet Muhammad's martyred cousin and son-in-law—line
nearly every government building, lamppost, and shopfront in
Baghdad. Ali has an impenetrable beard, a confrontational stare,
and a forest-green shroud covering his head. For the Shia, who
believe that he was Muhammad's legitimate successor, he has be-
come the personification of resistance to the Islamic State.

The Sunnis, meanwhile, who dominated Iraq under Saddam
Hussein, claim that the rightful heir to Muhammad was Abu Bakr

al-Siddiq, a companion of the Prophet's who was made caliph in
AD 632. When the Islamic State established its modern caliphate
in Mosul in June 2014, the group's leader, a slightly obscure reli-
gious scholar named Ibrahim Awwad Ibrahim al-Badri, asserted a
grandiose nom de guerre. Claiming his place in the succession, he
declared himself to be Abu Bakr al-Baghdadi.

I slump in my chair and wait for Tahrir for another hour. I
fought in Iraq for two years. I know that this country's dysfunction
is millennia deep. Why did I expect that Tahrir and Fityan, two
Sunnis from al-Anbar, would be able to navigate the bureaucracy
of an Iranian-backed Shia government?

Then Tahrir appears, strutting past the cashier, who, like every-
one else, is nearly a head shorter than him. "Elliot, bro, you look
sad. Why the long faces?"

I'm about to ask if I should pay the bribe when he whips from
behind his back a brown envelope closed with an official seal.
Handwritten Arabic script is lashed along its front. I go to tear
it open as if it were one of Willy Wonka's Golden Tickets. "Slow
down," he says. He takes the envelope and places it on the table.

"What about the bribe?" I ask.

"I was fucking with you, *habibi*. You Americans think we Iraqis
can't do anything right," he says. "I told you, the guy at the minis-
try is my friend."

We carefully remove the letter, a single page covered with seals,
serial numbers, and many signatures. "What does it say?" I ask.

Fityan reads the text, his mouth silently forming the words in
Arabic while the tip of his cigarette bounces over the syllables with
metronomic precision. He glances up at me. "It says you're going
back to Fallujah."

Early on Friday morning, the first day of the Muslim weekend,
Baghdad is asleep as we drive out through the city's deserted
streets. Fityan and Tahrir are up front, and Hawre's next to me
in back, hungover with a pair of knockoff Gucci sunglasses pulled
over his eyes. His head is against the window when his phone rings.
The voice on the other end is frantic, and soon Hawre is frantic as
well. He tucks his phone away. "That was my brother. At 4:00 a.m.
the Daesh attacked Kirkuk."

Four days ago, the Iraqis began an offensive to retake Mosul
from the Daesh, also known as the Islamic State. Thus far, an alli-

ance of Iraqi security forces, Kurdish peshmerga, and Shia militias known as Hashd al-Shaabi, or Popular Mobilization Forces, has made steady advances toward Mosul, Iraq's second-most-populous city and the Islamic State's capital in the country. These gains come on the heels of more than a year's worth of successful offensives by Iraqi security forces in Tikrit, Hit, Ramadi, and Fallujah. Prime Minister Haider al-Abadi has staked the credibility of his government on the Mosul operation's success, appearing on television to announce the offensive in the black uniform of his elite counterterrorism forces.

The attack on Kirkuk was part of an Islamic State counteroffensive. We search for news about it on Facebook and Twitter. "The Daesh are fucking smart," Tahrir says, as we pull up to a checkpoint outside Baghdad. A sentry examines my passport and the Interior Ministry letter at length. Tahrir has worn his police uniform for good measure, an ad hoc mixture of camouflage pants and an olive-green safari shirt. His pistol is tucked into his waistband. Opposite us, the queue of vehicles entering Baghdad extends nearly half a mile. There is virtually no traffic departing for al-Anbar. We are waved through.

The highway stretches out with palm groves on either side. More than a decade ago, on daylong foot patrols, our platoon would rest in the trees' shade with our backs to their scaled trunks and our rifle barrels facing outward. Soon Abu Ghraib, the infamous Iraqi prison, appears. The cupolas of its guard towers menace the prisoners inside and the travelers on the road: *Watch where you're going and what you do.* Villages with low-slung dwellings and names as forgettable as passwords race by—Nasr Wa Salam, Zaidan, Amiriyat. There are also the places we named ourselves, because we knew no better, like the bulging peninsula cut by the Euphrates that separates al-Anbar and Babylon. We called it the Ball Sack.

After twelve years, everything is unchanged. And looming over it now, as it did then, is Fallujah. Fityan points up the road, where four- and five-story buildings form a barricade on the horizon. "There it is," he says. A picket of minarets stab heavenward, their sides paneled with crumbling mosaics. Everything anyone has ever built in this city is pocked with bullet holes. "Is it like you remembered it?" Fityan wants to know.

At a barbed-wire checkpoint decorated with flowers to welcome returning residents, we meet Colonel Mahmoud Jamal, the city's

chief of police, who escorts us to his headquarters. He is a member of the Albu Issa tribe, which supported the Anbar Awakening, a Sunni movement that rebelled against al-Qaeda in Iraq, the Islamic State's precursor. We are served bread, fried eggs, and tea with a finger's worth of sugar lurking at the bottom. We sit in his office, with his unmade bed in the corner and a pair of his socks airing out on the windowsill. A clicking table fan circulates the inside air.

For nearly an hour, Colonel Jamal tells us how the city is being rebuilt, but what he says doesn't correspond with what we see. Though Iraqi security forces retook Fallujah from the Islamic State four months ago, in June, three-quarters of the city's population has yet to return. There is still no electricity, no water, no sanitation. Colonel Jamal grew up here and has worked in and around the city as a police officer since 2005—longer than anyone, he tells us. "I will never give up on my home," he says. One can't begrudge him his persistence. In his job only an optimist—even a foolish one—could hold out any hope for success.

"The Daesh are vampires," Colonel Jamal says. "I insist on this description. They suck the life from everything." He suggests that we visit an Islamic State prison the Iraqi security forces discovered after liberating the city. I agree but also ask to visit a couple of other buildings, obscure ones. Before he has a chance to ask why, there is a commotion at the front of the police station. A tall officer in a well-starched uniform with deliriously embroidered epaulettes and a retinue in tow steps into Colonel Jamal's office. It is Brigadier General Mahmoud al-Filahi, commander of the Iraqi army's Tenth Division, which is responsible for all of al-Anbar Province, here for an impromptu visit.

Colonel Jamal assigns us an escort of two soldiers and ushers us hastily out of his office so that he can speak with the general alone. As I pack up my things, Colonel Jamal explains our plans to General al-Filahi. The general's questions are pointed. "And what is it that you're looking for?" I hesitate, not certain that I want to offer up this detail. Before I can respond, the general adds, "Perhaps you are looking for your WMDs?"

I smile and laugh lightly at his joke. He does not.

Dan was a great chess player. We played our last game sitting across from each other, with his magnetic set spread across an upturned

crate of Meals Ready to Eat. "Life is like chess," Dan would some-
times say, usually when he was winning.

The door he was trying to get through when he died was on
the rooftop of a five-story building in the Fallujah mayor's com-
plex. We called it the High Rise. My platoon was spread on top of
two identical buildings next door, which we'd dubbed Mary-Kate
and Ashley, after the Olsen twins. It was November 10, 2004, dur-
ing the opening days of the battle. Dan had run up to the roof
after friendly artillery nearly fell on my platoon. The shells were
so close I could hear the steel fragments slapping against the side
of Mary-Kate, where I was lying prone on the roof. All of us had
our mouths open to keep the blast overpressure from rupturing
our eardrums. Dan crawled across the top of the High Rise and
managed to call back to our headquarters. He got the artillery
shifted away from us, and I picked up the radio to thank him.
That's when I heard my company commander call for a corpsman.
Dan's body had collapsed across the threshold when he was shot,
and he'd died almost instantly. He's buried at Arlington now. I
heard that his magnetic chessboard was in his cargo pocket when
he was killed.

After we leave the police headquarters in Fallujah, Hawre wants
to walk. So do I. But our two escorts shepherd us into the bed of
a pickup truck instead. The mayor's complex is a few hundred
meters away, on the north side of Highway 10, whose four lanes
bisect the city. Across the street is the timeworn candy store, the
other place I want to see. Tahrir begins to argue with our escorts
in Arabic, insisting that they take us there. Fityan pulls me aside
and says, "We're not telling them that you fought here, so they're a
bit confused." I can't disagree with his judgment. Visiting this city
as a former Marine feels like walking through New Orleans if your
name is Hurricane Katrina.

The escorts drive us to what is left of the mayor's complex. The
Islamic State leveled most government buildings during its occu-
pation. Our escorts warn us to be careful as we step through the
rubble. The city has yet to be demined, and booby traps are un-
covered daily. Among fragments of cement, I stumble across a hu-
man hip bone. I also find the skeletal remains of Mary-Kate, from
whose rooftop I had called Dan. Searching the horizon, I see only
blue sky where the High Rise once loomed. Mysteriously, not even
the wreckage remains.

Tahrir glances at the rubble and asks, "Is this where it was?"
I point at the empty patch of ground. "No, it was over there."
"The door, *habibi?*"
"I guess it's gone."

I find the candy store, where insurgents surrounded my platoon the day after Dan was killed. Earlier that morning, at three o'clock, we had crossed Highway 10 in advance of a larger assault of nearly one thousand Marines that was scheduled for a few hours later. I had never seen the outside of the candy store in daylight. "This is the place," I tell Hawre. He begins to shoot photos, which only increases the suspicions of our Iraqi escorts. They glance in my direction and whisper among themselves. A sign on the side of the structure is in English. It reads, MOONLIGHT SUPERMARKET.

A rusted mesh fence, padlocked shut, encircles the building. I climb up the side. By the time I am on the rooftop, I am covered in a familiar dust. I recognize not so much the building as the vantages it offers. The view from where we set in our medium machine guns so they could rake a long street. The approach where we waited desperately for an armored ambulance as one of the Marines, who'd been shot through the femoral artery, was bleeding to death. The southeastern corner where I crouched alongside my platoon sergeant, who in his early thirties seemed infinitely old and wise, seconds before he was shot in the head, only to miraculously survive.

I try to imagine this place not as a battlefield but as a community of homes and businesses. Many of our most iconic cities —Rome, Istanbul, Athens—have a layered architectural aesthetic, each population having built on what its predecessors created. Fallujah is different. It is defined not by creation but by destruction.

My eyes cast out, searching for hard-fought neighborhoods and alleyways, for unrepaired scars on the buildings. I am looking for the marks we left behind. I see them everywhere, commingled with the marks left by others. They have become the city, both battlefield and home.

Colonel Jamal is eager for us to see the torture house. We've driven into Fallujah's Jolan District, where townspeople strung up the burned bodies of four American Blackwater contractors from a bridge in 2004, beginning the first battle for the city. The prickly scent of cordite lingers on every street in Fallujah, but it is heaviest

up here. We follow Colonel Jamal into the courtyard of a mansion. In the foyer, light pours through stained-glass windows. Above us a chandelier's crystal pendants tinkle in time with a soldier's footfalls in an upper bedroom. We enter an atrium. A winding staircase ascends beneath a domed roof painted purple, yellow, and pink. A human femur rests on the tiled floor.

"These were the mass holding cells," says Colonel Jamal, "and the offices for the Daesh courts." Hastily welded steel doors enclose salon-sized rooms with bags of dates and almonds stashed in the corners. "This is all they fed the prisoners," he explains. On a single shelf rests a small library of religious texts, with two curious exceptions: a collection of letters by Nelson Mandela with a foreword by Barack Obama, and *The Short Stories of H. G. Wells.*

Colonel Jamal says it's time for us to go next door. Instead of walking outside, he crawls through a hole that Islamic State fighters sledgehammered into the wall so they could move between buildings without being detected by coalition aircraft. "This is the place they don't want you to see," Colonel Jamal says of this second house. A fire has ripped through the interior: heat has warped and melted air-conditioning units, glass, anything not made of stone or steel. An eerie silence possesses every room. Hardly anyone in our group speaks, and none of us hazards more than a whisper. There is only the rhythmic sound of our steps crunching against the charred wreckage—that and the smell, a cauterized scent sickly sweet with the undertones of death.

We climb a stairwell. A hand-cranked winch is fastened to the banister. A pulley is bolted to the ceiling. The steel wires hanging from it have loops just large enough to cuff a pair of human wrists. Car batteries are stacked in a corner, and next to them are bales of copper wire with the insulation stripped away, as well as a melted plastic chair. It seems gratuitous to ask what it's all for. On the second floor, the windows are covered. It is pitch-black. I turn on my iPhone's flashlight. Six steel cages are arrayed in two rows. Each cell has a thin mat and a pillow, and a padlock is notched jauntily onto every door. "Step inside," Colonel Jamal insists. I hesitate. He asks again, challenging me. I duck my head and walk into the solitary-confinement cell. "Turn off your light," he says. I do, for maybe three seconds, possibly for as long as five—long enough, in any event, for him to tell me through the

impenetrable darkness, "What you see are the accomplishments of the US government."

Spray-painted in white on an interior courtyard wall is the first part of the Shahada: *lā 'ilāha 'illā-llāh,* "There is no god but God." A handful of hair dryers and curling irons are heaped beneath the Islamic State graffiti. Colonel Jamal dips his wrist effeminately and laughs. "The Daesh," he says, "are very vain, especially about their hair." He is still amused by this when we amble into the street and squint against the sunlight.

As we walk, the city's energy refreshes Colonel Jamal. He is eager for us to speak with the locals. Sitting in front of a boarded-up shop is a stout man in a gray ankle-length dishdasha and Nike sandals. He is passing a tangle of wire to his nephews to coil around a scrap of wood. "Wire is expensive, so we're digging up what's left in the city and using it in our homes," he explains.

The man's name is Ahmed Abas al-Jabor. He is a mukhtar, a community leader. When I ask if he was here during the Islamic State's occupation, he insists he was not. His nephews shift restlessly and insist that they, too, left the city. Fityan, who has been translating, leans toward me and whispers, "No one is going to admit that they stayed." Al-Jabor continues, "Many are waiting to see if the insurgents will retake the city."

Colonel Jamal cuts him off. "Don't call them insurgents."

Al-Jabor stares back blankly.

"You must call them Daesh."

Every tenth house or so, someone is trying to rebuild, clearing out a courtyard, sweeping up debris, tampering with a generator. True to Fityan's word, citizens across the board tell me they left Fallujah during the Islamic State occupation. We see a smattering of Iraqi police and army checkpoints. Many fly the Shia flags emblazoned with the image of Ali that were so ubiquitous around Baghdad. The evidence of this summer's battle—and those that preceded it—is apparent everywhere.

We spend the afternoon outside Fallujah, at Habbaniyah air base. Unbeknownst to us, Colonel Jamal has arranged a VIP visit to the Iraqi police's Special Tactical Regiment. The regiment's commander, Lieutenant Colonel Adel Hamed, tells us hair-raising stories about the recent battles for Ramadi and Fallujah, replete with slick promo videos made by his in-house media team. His

men, trained by Navy SEALs, served as shock troops in both bat-
tles. When I ask the colonel how his background landed him a
job as the leader of an elite commando unit—he once worked
as an administrative officer—he shrugs and says that nobody else
wanted the position. He tells us that he raised the Iraqi flag over
Ramadi's city hall himself and then shows us a video to prove it.
(At his urging, we watch it several times.) He is also eager to show
off a picture of himself with a bandage over his left eye, sunglasses
down. The photo shows him in Ramadi, strutting along a highway
flanked by the skeletal wreckage of buildings, his men trailing be-
hind him. Gesturing upward, presumably at the enemy, his hand is
formed into a karate chop. "I took a grenade fragment in my eye,"
he says. "It's still there. And on that day, I realized my purpose in
life: I love fighting more than anything else."

After a tour of his barracks, armory, and motor pool—the last
of which is filled with bullet-riddled Humvees and the occasional
ballistic windshield shattered by rifle fire—I find myself chatting
with one of his troopers, a slim but debonair man with a sunken
chest and tobacco-stained teeth. He speaks perfect English and
is the regiment's joint tactical air controller, meaning he is quali-
fied to call in airstrikes from Western warplanes. He calls himself
Maximus, a nod to Russell Crowe's character in *Gladiator*. It seems
the SEALs' talent for self-promotion has rubbed off on their Iraqi
counterparts. Maximus, one of the most well-trained troopers in
this unit, is also his regiment's press liaison. He follows us around
wearing a khaki safari vest with MEDIA OFFICER embroidered on
the chest.

"I used to work with the Marines," he says. "Three-seven, one-
nine, two-eight—those are my boys." I tell him I was with one-eight,
otherwise known as the First Battalion of the Eighth Marine Regi-
ment. "Right on, man," he says, his head nodding in a rhythmic
groove. We chat about Fallujah, Ramadi, and our respective battles
in these cities. When I offer my hand, he shakes it before rotating
his palm and pulling me in for an American bro hug.

Soon we are back on the road, driving toward Fallujah. "What
did you think?" Tahrir asks. Before I can answer, he continues,
"They're as good as most Americans."

I can't disagree, but the conclusion is unsettling. With select
units like the Special Tactical Regiment, the United States has
managed to create a security apparatus built in its own image.

These elite groups are well trained and well equipped and have won decisive battles against the Islamic State in Fallujah and Ramadi. They will likely do the same in Mosul. But winning battles was never the US military's problem. The problem was always what came after, the rebuilding.

As the sun descends, the rubbled outskirts of Fallujah come into view. We pull over by Moonlight Supermarket so that Hawre can take a few more photographs before we return to Baghdad. Hawre wanders across the street, followed by Tahrir, who is soon surrounded by residents. His uniform seems to confuse them. I imagine they have mistaken him for a member of the local police and are accosting him with questions about when, if ever, basic services will return to their city.

While Fityan speaks to our Iraqi escort, I notice a broken cinder-block wall on the back side of the supermarket. It forms a corner, maybe three feet on one side and five on the other, and rises a little higher than my knees. I crouch behind it, into a familiar position. When our platoon escaped from the candy store twelve years ago, I found myself pinned behind this tiny wall for about twenty minutes as we struggled to advance deeper into Fallujah. A flood of memories returns. The clattering of tank treads. The panicked squelch of radio traffic. The terrified, uncomprehending looks of the Marines around me. How by that afternoon I had shouted myself hoarse and was reduced to issuing orders under fire in a depleted whisper. I glance over the wall, toward the mayor's complex, to the void in the sky where the High Rise once stood, the place where Dan was killed. I reach over to the wall's far side. Under my hand, I can feel tiny gouges. My fingertips read them like braille. I wonder if they were made that day in 2004.

I occasionally still play chess. During a game with a Turkish friend at a café in Istanbul, I once reiterated Dan's words, explaining as I took a piece that life was like chess. My friend laughed at me. "No, it's not." He gestured toward another table where players rolled dice from a cup across a board. "Life is backgammon. The game takes skill, but it also takes luck." As he said this, I thought about the bullet that found Dan. I often think about the bullet that never found me.

When I return to Fityan and our Iraqi escort by the car, they are silent for a moment until the soldier asks what I was looking at.

I tell him that I've been here before. Then I explain about the

candy store and the mayor's complex. He wants to know why I came back.

"To see what it was like now, I guess."

He looks at me, perplexed. "It is just as you left it."

Two days later, Hawre and I are driving again. Fixed along the horizon is Bartella, on the outskirts of Mosul. The town is burning. Noxious columns of smoke lift upward, like stitches fastening earth to sky. Yesterday Hawre and I left Baghdad and headed north to join the offensive. Now, around 2:00 p.m., our Toyota HiLux is stopped on the shoulder of the road, alongside a mélange of tanks, armored bulldozers, and black Humvees from the Iraqi Counter Terrorism Service's First Brigade, also known as the Golden Division. Bartella is a Christian town and the Golden Division, with its Shia flags fluttering from the back of every other vehicle, will soon liberate it from more than two years of Islamic State occupation.

Soldiers in black uniforms and black ski masks escort a pair of priests into a white Suburban, and I find myself trying to remember when, in the history of war, the good guys wore black. The priests plan to hold Mass that afternoon in the Mart Shmoni Church, in the center of Bartella. As their Suburban pulls into the street, Hawre and I pull up behind them. A soldier with the Golden Division cuts us off. I offer my press credentials—a dog-eared letter from the magazine—and my passport. Hawre argues with him in Kurdish. He hands the soldier his Iraqi identification card. "He wants to keep your passport until we come out of Bartella," Hawre says.

"I'm not giving him my passport."

"Then we can't go," Hawre says. A beat passes. "Don't worry," he pleads. "I've got his cellphone number."

The soldier grins. He's missing one of his incisors and another tooth is made of gold. "I be here when you back," he tells me in choppy English. I hand him my passport and our HiLux slides behind the priests.

A day after the Golden Division launched its assault on Bartella, we hear early estimates that eighty Islamic State fighters lie dead in the town. On either side of the road, scorched swaths of dry grass spot the ground. Nearly every building is a mass of twisted rebar and collapsed cinder blocks. Snaps of rifle fire and the low

percussive thuds of artillery and airstrikes can be heard in the distance, causing confused flocks of birds to leap from their perches and juke across the skyline. A sedan passes us going the opposite direction. Hunched behind its steering wheel with his eyes barely above the dashboard is a boy not much more than ten years old. Two little girls even younger than him are in the backseat. They are wearing school uniforms. We pass a road sign: MOSUL, 27KM.

Unlike Fallujah, which is sixteen square kilometers, Mosul and its environs are sprawling. The battles for Fallujah in 2004 involved little maneuver. We cleared house-to-house through dense urban blocks. This battle, by contrast, has seen movement along multiple axes of advance. We are to the east of Mosul, with the Iraqi security forces. To the north and south is the Kurdish peshmerga, as well as other units of the Iraqi security forces. Waiting in reserve is the Iranian-backed Hashd al-Shaabi, whose presence is controversial. Prime Minister Abadi has promised that only Iraq's nominally secular security forces, including the Golden Division, will participate in the final fight for Mosul itself. But if the Islamic State proves too much for the Iraqi security forces, the peshmerga and Hashd al-Shaabi may find themselves immersed in the battle, further inflaming sectarian tensions. What will happen inside Mosul is the question on everyone's mind.

A sergeant flags us down, instructing us to park. Hawre and I will have to travel the rest of the way on foot. Humvees and dismounted soldiers rush past us, setting up their positions in the newly liberated town. The soldiers' voices are jubilant. Several who fought this morning now strip to the waist and wash with bottled water. Others clean weapons. I meet a soldier who is working on the grenade launcher in his Humvee's turret with a rag and oil, and ask him for directions to the church. He isn't certain, but he is eager to talk. He says that the Daesh "are good with ambushes and IEDs, but not as good in conventional battle." He explains that his family is proud of him: "I have been fighting nonstop for a year, but they don't worry. If I die, I will be a martyr." He insists that I take down his name: "Maher Rashid from Baghdad." I ask him again if he knows where the church is. Before he can answer, the bells toll, for the first time in two years. "That way," he says.

Affixed to the dome on the Mart Shmoni Church are two tree limbs hastily lashed together into a cross. An Iraqi flag flies from its top. There is an enormous gouge in the side of the church in

the shape of a crucifix, no doubt the work of the Islamic State. Inside, upturned pews litter the nave. The altar in the sanctuary is covered in rubble but still intact. The priests continue to toll the bells. Soldiers file in and out of the ravaged church. They take selfies next to destroyed artifacts. Not even the priests think to stop them.

Between here and Mosul, there are a dozen more Bartellas to clear. The noose is tightening on the Islamic State, but gradually. Four months from now, in February, Iraqi security forces will control only the eastern half of the city. But today, the Golden Division's work is done. The discipline it maintained for the battle ebbs away, devolving into horseplay. The soldiers take off their boots and body armor and walk around in flip-flops and T-shirts. A grinning artillery gunner wears a T-shirt with a skull that reads: KILL 'EM ALL LET GOD SORT 'EM OUT! Another soldier has chosen a tank top with an airbrushed portrait of a lion staring into the sunset. A burly sergeant is attempting to throw his bayonet as close as possible to his opponent's foot, in a makeshift game of mumblety-peg.

I feel a tap on my shoulder. A soldier stands behind me, cradling a ceramic statue of the Virgin Mary. I take his picture, which seems to satisfy him. Then a lanky, baby-faced private wanders up and pantomimes slashing the blade of his bayonet across his own neck. His eyes go wide, and with a broad, homicidal grin he says, "Daaaeeeeesh." His buddies laugh. The sergeant wanders over. He explains that tomorrow they'll continue their advance at first light. They plan to liberate three more villages, he says, before muttering under his breath, "Inshallah."

I am anxious to retrieve my passport, so I find Hawre. We walk back toward our HiLux. Ahead of us is a consistent rumble of artillery and airstrikes. Behind us we can hear the chatter of the Golden Division as it beds down for the night. The soldiers' voices are cheerful, certain of victory. And they probably will take Mosul. But even if the Islamic State loses all of the cities it occupies across Iraq, the group will likely plague the country with a Sunni insurgency that will cause further sectarian violence, a repeat of the past decade. I think of all the cities we took in our war: Fallujah, Ramadi, Najaf, Nasiriyah. Winning those battles did little to end the fighting. What difference will Mosul make?

Someone calls out from behind a flatbed ammunition truck

parked in a field. When I turn, a hulking figure in an old American-style desert uniform with a brown T-shirt jogs toward me with a broad smile, his enormous gut swaying in rhythm with his steps. "Cigarette, *habibi?*" I offer him a Marlboro Light. "Oh, no, I don't like Lights. You American?" he asks, taking out one of his own cigarettes, a brand called Pine. "My sister, she lives in America, in Texas."

"Oh, yeah, where in Texas?" My mother is from Texas.

He looks confused. "In Texas!"

"No, what part—Dallas, Houston?"

"Like I say, in Texas."

His name, he says, is Firaz Saleh Mohammad. I take it down at first just to be polite. He is a sergeant. Then he explains how he helped his sister immigrate because "I've been a soldier longer than anyone. I was ICDC, *habibi*," he says, referring to the Iraqi Civil Defense Corps, the precursor to the Iraqi army. It was founded in 2003 and summarily dissolved a year later. "I have been here since the very beginning, starting with the ICDC and Marines in Fallujah in 2004. No one has seen as much as I have seen."

I tell him that I was in Fallujah in 2004.

"I was with one-five. You know one-five?"

"Yes, I know one-five." A few friends come to mind. "I was with one-eight."

He puts his arm around me and laughs. "What are you doing here?" he asks. "Did you get lost?" I don't say anything, and he doesn't push it. He just smiles, jabs his finger in my face, and says, "My sister, she is very happy in Texas." As he finishes his cigarette, he's looking to the west, toward Mosul.

"What do you think's going to happen?" I ask him.

He shakes his head. "This? The future of all this, it cannot be predicted."

Hope and Home

FROM *Freeman's*

WHEN I WAS IN GRAD SCHOOL, I went to a classmate's apartment for lunch one afternoon, nothing elaborate, just sandwiches and sodas. As I sat at her particleboard dinette table, unfolded for the occasion, I realized that she was the first in our cohort to begin nesting. She had invited me to lunch—the rest of us just dropped in on each other when we didn't want to get drunk or high publicly. More telling, on the coffee table she had placed a glass vase resplendent with poppies and wildflowers she'd picked herself. She was creating home.

I tried the flower trick to make my place feel homier, but it didn't seem to work. In those days, where I lived always felt transitory, like a cheap hotel room. The fact that I had rented a furnished apartment didn't help. I upgraded a couple of times, but the units I lived in still didn't feel homey. They all felt beige.

I was a late bloomer. It took me years and years, till my early forties, before I was finally able to admit that I wasn't leaving my rent-controlled apartment in San Francisco. I wasn't going to live in Paris, Rome, or Kuala Lumpur; I wasn't going to write verse in the Canary Islands, dance flamenco in Seville, or ride a gaucho in Patagonia. My nesting was gradual. I replaced the avocado carpeting with hardwood floors, painted the walls all kinds of bright colors, organized my books alphabetically in more than a dozen bookshelves. I put up paintings. I threw fabulous dinner parties.

One day I bought a small glass vase that could barely hold a single flower. I thought it exquisite. It reminded me of the delightful things I'd seen in Murano on my first trip to Europe, with my

mother and sister when I was thirteen. I placed the vase next to where I sit in the den. No one notices it but me.

A few years ago I was in Beirut visiting family—to be more precise, family visiting me. I stay at my mother's apartment, my second home in a manner of speaking, and I rarely leave it. I become a teenager again: I don't have to cook, clean, or do dishes, which I don't do in San Francisco either, but there's something more comforting about my mother taking care of me.

I was lounging about doing nothing when my friend Anissa Helou, author of many excellent cookbooks, mentioned that she was writing an article on the changes in diet and cooking among the Syrian refugees now that they were in Lebanon, away from home. I thought this was a chance to do something useful. Since I was going to write about the World Cup for a magazine blog, I could tag along, take pictures of some of the children, ask them who they were rooting for and how they were going to watch the games, and publish their responses.

I was unprepared.

That first day, we went to the office of the United Nations High Commissioner for Refugees (UNHCR) in the Jnah neighborhood of Beirut. It was raining, atypical for Beirut in May. Some two hundred refugees sat on molded plastic chairs waiting to officially register with the organization. Anissa, more socially adept than I could ever hope to be, chatted with a few women, asking where they came from and why they had left. I listened, dumbfounded, as they related tales of woe, cities destroyed, relatives killed or tortured, losing everything, losing history.

And I had thought that asking about soccer might be a good idea. I returned to my mother's lovely apartment and hid under the duvet.

Lebanon is home to the largest number of Syrian refugees, and to the largest refugee population per capita in the world. In a country of four million, there are more than a million registered refugees, though the actual number is closer to a million and a half. The operative word here is "registered," meaning with UNHCR. The official count doesn't include those who choose not to register or who have slipped through the many cracks. Jordan and Turkey have set up camps that allow them to monitor the refu-

gee population as well as control it. Lebanon has no such thing; the country doesn't do control very well. Since their inception, Lebanon and Syria have always had a porous border. Syrians have been living and working here, both legally and not, for as long as anyone can remember. Today the refugees live everywhere, in unofficial tent settlements where they rent a patch of land, in abandoned buildings, storefronts, and warehouses, and in apartments or rooms that only a small percentage of them can afford. Every part of Lebanon has had to deal with the issues arising from the influx. Some Lebanese have been welcoming, others not.

A number of villages and municipalities have put up signs that say, WE ASK OUR SYRIAN BROTHERS TO REFRAIN FROM ANY MOVEMENT IN PUBLIC SPACES.

In other words, stay in the homes you don't have.

Americans are up in arms because the United States has promised to admit ten thousand Syrian refugees in 2016.

Terrorists, you know.

After I crawled out from under the duvet, I felt guilty, and guilt is my primary motivator. Not doing anything seemed selfish, maybe even solipsistic. I decided I would talk to refugees, listen to their stories, maybe write something. If nothing else, I could be a witness.

I went south of Beirut first, to a never-finished university building in Sidon where 177 families lived, more than nine hundred people. They had taken over the place, made homes out of classrooms. The building was bald concrete on a mild hill overlooking the Mediterranean. To get to it, I had exited the relatively new seaside highway that connected Beirut to Sidon and South Lebanon, and driven up an unmarked dirt road until I arrived at the end of the line. Laundry and satellite dishes adorned the front of the structure, and children, lots of children, were running around everywhere. The very air smelled of human spoor and a kind of resigned permanency.

Every nook of the five floors was being used, every space peopled. All the families invited me into their homes for tea and a chat—kettles always boiling, always on the ready, doors always open. Noticeable was the higher number of women; it seemed to me that they outnumbered men about four to one. Some husbands and adult sons, afraid of being arrested at the border, had stayed

behind in Syria to fend for themselves. Some were out working or looking for work. Most of this compound's refugees were from the rural areas surrounding Hama, from farming and riparian villages.

The rooms I visited were impeccably clean. Colorful mats of woven palm leaves carpeted the floor, intricately patterned textiles covered the walls, both as decoration and to hide the graffiti. For furniture there were one or two cushions and a television, the most important possession—every home had one and it was always turned on. No beds, no chairs, no tables. Rooms with barely enough space for a single person were occupied by families of eight or ten or twelve, sleeping on the ground. Stacks of blankets everywhere.

The Syrian families told their stories, with a cup of tea, of course. All talked about how they left Syria, the routes they took, the journeys lasting days. All told their tales of why they fled, from bombing campaigns and sniper fire to marauding gangs and arbitrary arrests. A common admonishment to misbehaving children was, "Bashar will come take you."

I had the chance to kick around a soccer ball with some kids on the balcony corridor of the third floor. Below us, on the ground floor, the main soccer game was on. More than forty kids moved as one giant amoeba upon the concrete terrace.

I visited a group of women and sat on the floor next to a tall makeshift closet: plywood stacks holding thin mattresses, blankets, and clothes, all covered in fake pink shantung below a red tasseled tablecloth that reached only two-thirds of the way down—a closet and Murphy bed in one. The women told me how they hid when fighting was nearby, leaving their villages, running for cover, ducking into any nearby copse or wooded area.

I said that during the Lebanese civil war we used to rush down to the underground garage for safety. For the seventeen years of the civil war, these garages became more than shelter; they became the hearth of the building, where families congregated for comfort, for entertainment, and, most important, for solace.

One woman said that they had no garages. They'd lived in a poor village with few if any cars. Another said that it would have made no difference even if they did have garages, since the MiGs dropped barrel bombs. "We hid from RPGs," they said, "not from MiGs, which were nothing if not quick death, no hiding, no hope."

Two of the women were pregnant.

"We have to replenish what they took from us," one said.

"Let me bring out my sister's boy," another said.

She returned with the parents and a boy of no more than seven months, wide blue eyes and a scrunched brow that made him look like a young philosopher puzzled by our intellectual infirmities—why oh why did we not understand him? His birth name was Ahmad, but that was not what everyone called him. His mother had experienced complications while pregnant and had given birth prematurely. A Lebanese charity was able to pay for the operation but not for the postnatal care in an incubator. The mother was flown to Turkey, where a second charity was able to keep the baby in an incubator for a month. Upon his return to the compound, everyone, and I mean everyone, called him Erdogan.

The second compound I visited was also in Sidon, in an abandoned underground Pepsi-Cola storage facility that had fallen into disrepair before the Syrians moved in. A long tunnel with rooms on either side and exits at each end reminded me of the hackneyed expression "moving toward the light." Three women were sweeping the cement outside their rooms, and the usual gaggle of kids was playing all over the place, but what differentiated these children from others I'd seen was that a number of them sported kohl around their eyes. I had heard of the long-ago practice of putting kohl around a newborn's eyes to keep away the evil eye, to keep Satan and his jinn at bay, but when I asked the mothers, they said that what kohl kept away was conjunctivitis.

Big sheets of plywood divided each storage space into three or four rooms, and each room, decorated to the hilt, had a minimum of ten people living and sleeping in it. Every room had at least two vases overfilled with fake flowers. Some group, probably UNHCR, had helped clean the place up and drain the sewage when the refugees moved in. The owner of the building now collected $100 monthly rent per room, a new source of income.

"At the beginning of the month," a woman said, "he arrives in his Range Rover, collects the rent from each family, and leaves. He accepts no excuses. You don't pay, you're out."

A young girl wanted me to meet the new bride.

The new bride?

"You must," the girl said. "You must."

She led us along to a dark drawn-back curtain that functioned as a door. The new bride looked a bit startled to see all of us: a stranger, a group of fifteen children and some of their mothers. She refused to be photographed; her right hand, like a stalking cat, lay upon the savanna above her bosom ready to pounce and cover her face if the camera lens so much as tilted in her direction. A bit tentative, somewhat shy, she stood beneath a large sheet of translucent plastic with metal shutters. She seemed more concerned than afraid. She simply did not wish to risk having her picture taken. Her parents were still in Syria.

The modesty of her dress served to highlight her beauty. Many people from that part of Syria had striking light eyes, yet hers were a remarkable griseous blue that grabbed your attention by its lapel. She was seventeen, she said; when she was fourteen, her parents had sent her to Lebanon with her uncles because the army and the shabiha were raping girls as they went through villages. Two days before my visit, she had married her first cousin. There would be no honeymoon.

She called her aunt to come talk to me. A firebrand, the aunt stormed out of her room. I could hear her approach, stomping on the cement, even though she wore soft slippers.

"Why should I talk to him?" she yelled. "Why? I've talked to journalists, to do-gooders, to everyone. Over and over. Told our stories many times. Does anyone do anything? No." With a dismissive wave of her hand and a flick of her left eyebrow, she glared at me. "If I talk to you will anything change?"

"No," I said, "I'm sorry. Nothing will change."

She regarded me askance for a brief moment and told her story.

I have set up my life in such a way that I rarely have to leave my home. It's where I feel most comfortable. I don't handle being around people too well these days, and I avoid them until I get lonely, at which time I either go out on some excursion or invite friends over for dinner. Did I mention that I have fabulous dinner parties?

Home is where I can be most myself.

Talking to refugees drains me, and then I berate myself for being so fearful and weak. What is my discomfort compared to their suffering? I have what I call tennis match conversations in my head. I keep telling myself that someone with my tempera-

ment is not meant for this. I'm meant for sitting at my computer and cuddling with my cats, I'm meant for bubble baths and mud baths—oh, and massages, don't forget massages. I'm a spoiled princess by nature. My traumas involve nothing more than a bad pedicure. I end up interviewing refugees because even though I'm useless, even though there's nothing I can do, doing nothing is a crime.

After spending a week with refugees in Lebanon, I needed time off. I took a trip to Botswana all by myself and happened to join a group of Americans for dinner, thinking that some company might be healthy. They were East Coasters, and they wanted to know whether I liked San Francisco. Of course, I said, I'd been living in the city for over thirty years. I should have stopped there, but I'd had a couple of glasses of lovely wine, the night sky was gloriously decked in stars, the fire ablaze in its pit. I didn't think. I was having an outdoor meal in the vast expanse of the Kalahari, for crying out loud. How could I be guarded? I told my interrogators that I was surprised I'd lasted so long because it never felt like home to me—not the city, not America.

One of the men, dressed in high-end Hemingway, dropped his knife. What did I mean? I should have noted his tone, definitely his flushing face, but neither starlight nor firelight is good for color discernment. Okay, okay, I might have had three glasses of wine. I rambled on. I quoted from one of my books, auto-plagiarized so to speak: "In America, I fit but I do not belong. In Lebanon, I belong but I do not fit." Nothing controversial or confrontational.

I was triple-barreled. Three men began to explain to me that America was a great home, the best home ever in the history of humankind. Their wives nodded in concert. Americans were the kindest, warmest people, the most convivial, the most welcoming people. I would have backtracked if I'd been allowed a word. I did not wish to argue, and, most important, I didn't want to lose my most welcome buzz.

Luckily, the only other non-American at the table was a local woman. In a high Brit accent, she asked the men where home was. One of them said he lived in New York and Florida but had to declare New York his home. If he lived in his Upper East Side apartment for less than six months of the year, he would lose his rent control, so he was unable to take advantage of Florida's lack

of income tax. He made sure to insist that the unfairness of his situation caused him no little anguish.

In the Bekaa Valley of Lebanon, near Zahlé, I visited a medium-size Syrian settlement. About eighty back-to-back tents ran in a straight line between two agricultural fields—onions, I believe. Almost everyone who lived in that settlement is from the same village near Aleppo or is related to someone in that village. Ahmad M., the man who began the settlement, told me that three-quarters of them are interrelated. A concrete mason, he used to come from Aleppo to Zahlé for a few months each year to work construction jobs in the area. When the bombing of Aleppo began, he brought his family to his small tent in the fields, soon to be followed by his and his wife's relatives. The UNHCR helped make the tents bigger, sturdier, and—though not always successfully—rainproof.

Living on the land was not free. The women had to work the fields for the owner. The deal was this: they worked six hours a day, got paid for five, and the extra hours went toward rent. They were paid 5,000 Lebanese pounds per day, which translates into $3.33, or 55 cents an hour.

The men were paid better if they were lucky enough to find work. One young man had a job as a delivery-truck driver; he left his tent at 4:00 a.m. to deliver yogurt to Beirut, returning at 6:00 p.m. For fourteen hours a day, he earned $300 a month.

Ahmad M. probably earned a bit more since he had contacts already established, but because of the extra competition, he had less work and his hourly wage had been drastically reduced. He had five children, and one in "the house of fire," a term I had never heard before, meaning a gun chamber—his wife was pregnant with the sixth. Three were in private schools ($600 per child for the year) because he and his wife considered the UN schools not up to par. His wife made sure to mention that her eldest daughter was second in her class, as good as if not better than the local Lebanese.

We sat in their tent drinking sweet tea—unreasonably sweet. Their dwelling consisted of white plastic sheets imprinted with the UNHCR logo, sheets of plywood on the roof, cement floors, one window that was no more than a glassless opening, yet the care and effort that went into making it feel homey was impressive. Knickknacks and tchotchkes all about, violet textiles draped

from the ceiling, matching the ones surrounding the television on
a hand-built stand, matching the throw blankets covering cushions
and futon mattresses. Violet was the main theme in the mother's
headscarf as well as the young daughter's dress.

I mentioned that it was wonderful to see such effort going into
decorating. I had visited a tent where a young woman had painted
the plastic sheeting bright crimson. Another woman had covered
a wall with textile embroidered with mirrors (another ward against
the evil eye), only to be outdone by a woman who studded her en-
tire pantry with sequins, with results Liberace would have envied.

"We live here," Ahmad M. said.

I last saw the woman with the besequined pantry in 2014, but I
think of her often. What would make someone spend so much
time gluing sparkles onto sheets of wood that would become a
pantry to store nonperishables? Intricate and delicate, no space
left uncovered, so over-the-top that many a drag queen would kill
for it.

She looked to be in her midtwenties, if that, and seemed slightly
embarrassed, admitting that it took her a long time to finish it,
longer than she'd anticipated, what with caring for her four chil-
dren, cooking, cleaning, and tending to her husband and in-laws.

"It's good to have something beautiful to come home to," she
said. "The children love it."

"I do too," I said. "It's magnificent."

She beamed. "I had so many sequins."

To whoever thought it was a good idea to donate thousands of
sequins to Syrian refugees who had nothing left, whose entire lives
had been extirpated: Bless your heart.

The tents the Syrians live in are nothing like the flimsy ones used
by the homeless in San Francisco. UNHCR donates the wood, the
sheets of plastic, everything imprinted with the UN logo, and the
refugees build the structure. Some organization donates tents to
the homeless of San Francisco, but they are meant for camping. A
good gust of wind might send them kite-flying. Tent stakes don't
go into concrete.

A few days ago, I walked by a serried group of thirty tents on
Folsom Street around Eighteenth Street. None of the homeless

talked to me or made eye contact. It seemed to me that they considered it bad form to panhandle where one sleeps.

I should have asked one of them if that was so, but I was frightened.

Years ago while riding the 24 northward, I noticed a homeless woman sitting on an old, bulging Samsonite on the corner of Haight and Divisadero, under the faded green awning of Phuket, a Thai restaurant. The sun was shining. Even though I was in a bus and she was a few feet away, the human aromas emanating from her were stupefying. She had a long blond pigtail that looked like a single dreadlock. Glasses on the tip of her nose, she was reading a hardcover of Alice Munro's *The Love of a Good Woman*.

The World Food Programme had given each registered refugee family in Lebanon a debit MasterCard that they can use to buy food at a number of supermarkets all over the country. In 2014, each account received thirty dollars per family member at the beginning of the month. The amount is quite a bit less now; money is running out. Food in Lebanon is by no means cheap. Every woman I talked to complained that she could not afford any meat or fresh fruit. One used an expression I had never heard before: one piece of coal instead of meat (it rhymes in Levantine Arabic). She explained that she would cook rice and vegetables in a pot, then place a hot coal on a small plate with a layer of olive oil, put that in the pot, and cover it. The meal would end up having a "grilled meat" flavor.

What did the refugees buy most? Not rice or bread, not lentils or olive oil. More than twice as much as anything else, they bought sugar and tea, a specific brand called Horse Head, what they drank back home. The tradition of hospitality must be maintained.

I was surprised the first time I was invited into the makeshift homes of refugees. If someone noticed me passing by, the invitation was instantaneous. In Sidon, in the onion fields, they asked me in for tea.

But there were places where I wasn't invited in.

North of Beirut, in the hills above Tripoli, refugees living in an olive grove did not invite me. Their situation seemed more desperate. Their jury-rigged tents looked like they wouldn't last the first snowstorm. The ground was nothing more than mud because of

the rains. There were no decorations, no tapestries, no tchotchkes, no televisions.

Another camp about half an hour's drive from the onion fields in the Bekaa Valley was in worse shape. Though the tents were of the same materials donated by UNHCR, they were shoddily erected. Smells of sewage everywhere. All the adults were in tatters, all had sagging features. The children looked so miserable, so grimy, that they seemed to be made of clay yet to be fired and glazed.

No one invited me into the tent, but everyone assured me that as soon as the situation was settled in Syria, they were moving back.

I have visited Ahmad M. a number of times, and will probably do so again next time I'm in Lebanon, though I have yet to convince him or his wife that if I drink one more cup of their tea I'll develop type 2 diabetes. On my last visit, there had been a major renovation of the tent. They now had two bedrooms, a kitchen (no sequins on their pantry), and a living room where the family ate all their meals. They had two flat screens.

"Hope?" Ahmad said. "I knew we couldn't return the minute the war started."

"We lost everything," his wife said.

Their latest project, which I have yet to see, is to cover the cement floors with Lebanese stone tiles.

I asked what if the impossible happened and the situation calmed down in Syria and everything went back to normal. Would they return?

"It will never happen," he said.

In January 2016, I was on a small hill in the middle of the Moria refugee camp on the island of Lesbos, Greece. The camp is a military facility and looks like nothing if not a prison, with high concrete walls and razor wire. Ironically, there isn't much space inside Moria. Refugees who are lucky sleep in the barracks, the rest in flimsy tents in the olive groves outside the prison.

I was miserable, the thousands of refugees far more so. It was drizzling. I was not yet soaked. I was supposed to be an interpreter, but I couldn't seem to move from my spot next to the NGO offices. I felt so out of place, so wrong. I wished I were smoking again. I would have been able to do something if I had a cigarette.

There was a smell of lard and dampness in the air. The view from the hill made me feel anxious, apprehensive, a much stronger feeling than I'd had in any refugee camp before. At the bottom of the hill, the large squadron of Greek riot police in high butch did not help.

So many people, so many. Families, single men, children. Syrians, Iraqis, Afghanis, Iranians, and more, more. North Africans from Algeria, from Morocco, sub-Saharan Africans from Mali, from Congo. They were running away from so much, the Syrian regime, Daesh, the Taliban, terrorist groups with even sillier monikers. Lines everywhere, for registration, for food, for clothes, for donations. And white people directing pedestrian traffic.

The sun came out. Newly arrived families trudged up the hill carrying their belongings, pulling rolling suitcases, their voices submerged in the hullabaloo of conversations among the volunteers, the *tap-tap* of hard soles on harder concrete, the bustle of movement. A Syrian family walked up the hill toward me, mother, father, three kids, including a boy of perhaps twelve, his face a picture of glacial determination. A large group of young volunteers in neon orange vests walked next to them, more boisterous, less self-conscious. One of them, a blond in her early twenties, screamed. Everyone stopped. She screamed again, pointing at the sky. "Oh my God, oh my God." She screamed once more before she was able to form an actual sentence. "Look, it's a rainbow," she yelled. She tried to engage a little girl, kept pointing at the far sky, spoke louder in English to make herself understood, but the little girl wanted nothing to do with her. The Syrian family reached me before I was able to hear what they were talking about.

"She's excited because she saw a rainbow," the father said.

The mother shook her head. The twelve-year-old boy said in a quiet voice, not realizing that I spoke his language, "She should shove that rainbow up her ass."

The father snickered. The mother smacked the back of his head, not violently, for they were both carrying heavy loads.

Peak America

FROM *The New York Times Magazine*

NOTHING ABOUT OUR TRIP to Mount Rushmore went according to plan. Our flight was delayed. We found ourselves stranded in the Minneapolis airport for four hours. "Minneapolis airport four hours," we typed into Google, and the internet responded by persuading us to take a train to the Mall of America. The entrance was shabby; the elevators were slow and small and confusing; locals walked around in the freezing weather wearing short sleeves. It was not just a mall but an elaborate fun house of malls—malls within malls within malls within malls—at the center of which was, somehow, a gigantic amusement park. My children watched in jealous awe as another family floated by on a log ride. I could see their child-minds recalibrating the relative scales and possibilities of American experience. How big could one thing be while still fitting inside another?

"It's like Disney World," my son said, "*but inside of a mall.*"

They wanted to stay forever, to be swallowed by the crowds, but we were on a different pilgrimage, in search of a different America, so we continued on.

Late that night, finally, we reached South Dakota.

It was unfathomably empty. In downtown Rapid City, we idled at empty intersections, block after snowy block, waiting for traffic lights that governed no traffic. Emptiness is, to some degree, South Dakota's natural condition: it is the seventeenth-largest state in the country but has only the forty-sixth-largest population—the square mileage of Senegal, the people of Fort Worth. The empti-

ness reaches a new extreme in winter, when all the tourists scatter and the open spaces take over. The map-boards on the sidewalks, set up to guide pedestrians from shop to shop, were covered in a crust of snow. Our hotel, a grand old lodge built concurrently with Mount Rushmore itself, bragged of hosting six presidents over the decades. But its rooms, in February, were cheap and vacant, and we met no one in the grand lobby except imitation wooden Indians and mounted bison heads.

Why were we there? Why had I dragged my family—my wife and our snapchatting twelve-year-old daughter and our longhaired, talkative nine-year-old son—away from work and school to see, of all places, Mount Rushmore?

I couldn't say, exactly. All I knew was that I seemed to be suffering a crisis of scale. America was taking up a larger part of my mind than it ever had before. It was dominating my internal landscape, crowding out other thoughts, blocking my view of regular life. I couldn't tell if it was reaching its proper size, growing the way a problem tends to grow just before a solution is found, or if it was swelling the way an organ does before it fails and bursts.

I felt drawn to Mount Rushmore, instinctively, like a spawning fish to the head of a river. I wanted to look American bigness squarely in the face.

Somewhere on the way to Mount Rushmore, we realized that none of us knew, for sure, which presidents were carved into the mountain. The image was so familiar that we had never really bothered to look closely. After some discussion, we managed to agree on George Washington, Abraham Lincoln and Teddy Roosevelt. But who was the fourth? John Adams? Benjamin Franklin? Alexander Hamilton? We were just guessing figures from money. We had to look it up. It was Thomas Jefferson. I asked my son to draw me a picture, from memory, of Rushmore, and after several minutes of earnest work, he revealed something that looked like a police sketch of a middle-aged Beatles cover band that has been caught shoplifting after a gig at a strip mall. None of the presidents had a nose, Roosevelt's glasses had fallen off, and Jefferson (who sported a jet-black mop-top) was on the wrong side of Washington. Otherwise, we all agreed, the picture was excellent.

"I think I really nailed Abraham Lincoln," my son said. "He has that long face and skinny chin."

My wife read in the local paper about a man who was in trouble for setting off an elk stampede with a drone. We drove off into the South Dakota vastness.

The Black Hills are a geological oddity—an island of rock thrusting out from an ocean of prairie. They contain some of the oldest and hardest stone in the world; over the course of seventy million years or so, erosion has sculpted them into spindly towers and ragged loaves, five-thousand-foot-high turrets protected by moats and moonscape boulders. To the Plains Indians, the area was supernaturally charged, a place of powerful spirits, sudden raging storms, magic caves, and special trees—ponderosa pine, tall and straight and strong—that they liked to use for lodgepoles. The landscape was so rugged and remote that it managed to repel white civilization deep into the nineteenth century.

This changed suddenly in the 1870s, when the notorious George Armstrong Custer arrived to make a map of the Black Hills. (In a bizarre coincidence—history ripped from today's headlines —Custer's most trusted Indian guide joined the expedition from Standing Rock and was named Maga.) In the course of their exploring, Custer's men discovered gold. Word flew across the nation ("From the grass roots down, it was 'pay dirt'"), and before long a fire hose of white Americans went spraying into the isolated land, violating an Indian treaty with impunity, setting up mining towns and trading posts, blasting roads through mountains, changing the nature of the place forever.

Before long, of course, the boom went bust. Many miners left; the region's economy sagged. In the 1920s, local boosters proposed an eccentric solution. What if some of the Black Hills' ancient rock could be carved into a monument to American history —a patriotic tribute that would also serve, in this new era of automobiles, as a roadside attraction? Spindly granite towers, it was suggested, could be carved into free-standing statues honoring heroes of the American West: Red Cloud, Sacagawea, Lewis and Clark. Instead of gold, South Dakota could harvest tourists.

Only one American sculptor seemed up to the task. He was, like the sculpture he would create, a larger-than-life weirdo: John Gutzon de la Mothe Borglum, son of a Danish immigrant, friend of Auguste Rodin, publicity hound, populist, salesman, self-styled tough guy with a white Stetson and a flowing scarf and a dark,

bushy mustache. At the time, Borglum was working on another huge sculpture chiseled into the front of a mountain: a tribute, in Georgia, to great heroes of the Confederacy—Jefferson Davis, Robert E. Lee, Stonewall Jackson. (The project was initially sponsored by the United Daughters of the Confederacy and entangled with the Ku Klux Klan.)

When Borglum was enticed to visit the Black Hills, he saw presidents: Washington, Lincoln. Anything else, he argued, would be too limited, too provincial, not sufficiently star-spangled "USA!!!" Borglum believed that America was a special artistic challenge, a place so heroically grand that the effete styles of Europe could never hope to do it justice. "Art in America should be American," he wrote, "drawn from American sources, memorializing American achievement." He accepted the challenge to transform the Black Hills.

From the beginning, the project struck many locals as absurd. Controversy raged in the newspapers. To carve statues in the mountains, one wrote, "would be as incongruous and ridiculous as keeping a cow in the rotunda of the Capitol building." "Why not just paint a mustache on everything?" another asked.

Funding for Mount Rushmore was touch-and-go, as was political and public support. But Borglum would not give up. The project took far longer, and cost far more money, than anyone could have imagined. Logistics were murderously complex. Men were lowered over the rock face on sling chairs; carving was done mainly with dynamite and jackhammers. At one point, a crack running through the stone threatened to break Thomas Jefferson's nose, so his face was blown off the mountain and started again in a different spot.

Mount Rushmore is not just big; it is *about* bigness—a monument to monumentalism. Borglum was obsessed with America's size: the heroic story of a handful of tiny East Coast settlements growing to engulf an entire continent. The four presidents were chosen largely for their roles in this expansion. Jefferson, for instance, not only wrote the Declaration of Independence but also greatly increased the country via the Louisiana Purchase. Teddy Roosevelt oversaw the creation of the Panama Canal, which increased America's global reach.

The sculpting of Mount Rushmore began in 1927, with a ceremony overseen by President Calvin Coolidge, who wore a comi-

cally large hat. Work spanned fourteen years, encompassing some of the defining spasms of American history: the Great Depression, the beginning of World War II. Separate dedication ceremonies were held for each of the four faces; Franklin Roosevelt himself came to dedicate Jefferson. The sculpture was finished one month and one week before the attack on Pearl Harbor. Work would have continued—the plan was to depict each of the presidents down to the waist—but funding began to dry up again, and Borglum died, and after a few finishing touches, the figures were abandoned as good enough. This was precisely the moment when American influence was about to explode, the dawn of fifty years of prosperity and cultural dominance. Mount Rushmore was completed, conveniently, just in time to serve as a kind of superheated mascot for the mythology of the Greatest Generation and baby boomers: that America's hugeness is bound up with its nobility, that it deservedly dominates the globe.

The granite of Mount Rushmore is so hard that the sculptures will erode at a rate of one inch every ten thousand years.

Several times, as we drove to Mount Rushmore, we worried that the road was too small for our car. We had rented a huge SUV, like a tank without the gun turret—a rolling monolith of American power—and the road to Rushmore was old, narrow and winding. It passed through forests of ponderosa pine; the trees held the snow way out on the tips of their branches, in clumps, as if they were clutching snowballs. The road, in summer, is loaded with traffic, but that morning we had it all to ourselves. The pavement was covered with a skin of snow; we chugged over it with total confidence. In this way, winding and winding, switchback after switchback, we made our way up the mountain.

Huge thrusts of rock burst out of the landscape at random intervals in the forest. My wife said they looked as though they had fallen from outer space.

"They're just rocks, Mom," said our daughter, who was listening to Chance the Rapper on one earbud. "Calm down."

We passed over quaint wooden bridges that curled like pigtails and through old stone tunnels that looked, every time, as if they were going to rip off our side mirrors. More than once, I had the feeling that we were driving in a theme park. Each tunnel had been carefully blasted to frame a perfect view of Mount Rushmore.

The presidents were watching us come to them. Our daughter screamed when she saw them and made me pull over so she could get a good angle for Snapchat.

"I hate pictures," our son said. "Your mind is your own picture-taker-thing."

At one point, we passed a roadside cliff that looked vaguely like a face, and we all spent several minutes debating whether it had been carved like that deliberately or if we were maybe going slightly crazy in the snowy, empty woods. Soon everything we saw started to look like a face: rocks, trees, snowdrifts. "They're haunting me!" our daughter shouted. "Every rock I look at! I don't understand life!"

By the time we pulled into the Mount Rushmore parking garage, after an eternity of winding, everyone was exhausted and starving. The park's restaurant was closed for renovation, so we settled into a sort of triage-unit café next door. We ate in tense silence. The food was bad. I drank a beer called Honest Abe Red Ale, the can of which featured a picture of Mount Rushmore below the slogan GET SICK-N-TWISTED. Our son complained, bitterly, that his plastic cup of applesauce was "hot." "I don't want to be here," he said—and that "here" seemed to encompass everything: the café, Mount Rushmore, South Dakota, America, the twenty-first century.

After lunch we walked outside, to the viewing deck, and there— well, there was Mount Rushmore. That was really the biggest thing you could say about it: There it was. Rushmore is a ubiquitous American image, tattooed on the inside of every citizen's eyelids, so it felt disorienting to see it in three-dimensional space, pinned to this particular spot on the earth. We had the viewing deck almost to ourselves, which meant that the presidents and our family faced off. Four of us, four of them.

There was Washington, out front, the leader of the band—noble, aristocratic, and smooth, his mouth a grim stone line. A dollop of snow stuck to the bridge of his nose. Peering over his shoulder, like a shy sidekick, was Jefferson, his big nose held high, showing his nostrils to the world. (This was not an artistic choice; the grain of the rock forced Borglum to tilt the head back.) Lincoln stood apart from them, heavy eyebrows frosted with snow, and in the middle, almost swallowed by the mountain, was Teddy Roosevelt, with his wire-rimmed spectacles and Freddie Mercury mustache.

They were all looking in slightly different directions, not at us but far over our heads, into the great American distance.

I must admit that, in person, I was not especially moved by the beauty of the sculptures. They were, essentially, traditional busts, distinguished mainly by their insane scale and placement. The novelty of it was stronger than the beauty.

What stood out most was everything around the presidents' faces: the Black Hills landscape that spreads and spreads, incorporating eons of old rock and new growth, last century's roads and yesterday's snow. This was something that was hard to appreciate in photographs, which tend to be tightly cropped—just the presidents, stony and smooth. But the mountain itself is magnificent: rough and rutted and craggy, like an ancient crocodile's back. The stone is warped and twisted, a frozen surge flowing toward and around the artificial faces; it is like a diagram of the geological energy that thrust it into being nearly two billion years ago. This speaks to forces much larger than America or nationalism of any kind. It made the giant heads look small.

I felt a rush of emotion that was not patriotism but awe: awe at human weirdness, at our capacity to create, in the actual world, such an improbable and unnecessary artifact as this. Why had humans done this? Why did Mount Rushmore exist?

"Oh, it's a nice little mountain thing," my son said appreciatively, and then he asked if we could leave.

We drove away from Mount Rushmore, down and down, through the uncarved wilderness, into the city of Custer, a windswept Old West outpost where the guidebook recommended a coffee shop and a bakery, both of which turned out to be closed. We sat for a while, instead, sheltered from the icy wind, inside a Pizza Hut. We debated whether it was snowing outside or whether the outrageous wind was just blowing all the old snow around. Our children giggled over their phones. A vending machine by the door sold Christian stickers for fifty cents: "I don't believe in luck, I believe in Jesus."

Outside Custer was the Crazy Horse Memorial—another granite mountain being carved, Rushmore-style, into the enormous likeness of a historic figure. This one depicted Crazy Horse, the enigmatic leader of the Oglala Sioux, one of the fiercest defenders of the Black Hills from the indignity of white invasion. It was a sort

of corrective to Rushmore, a reclaiming of the landscape by the people from whom it was stolen. My family was tired and refused to get out of the car, so I walked through the museum myself. I looked at a tiny model of the monument. The carving has been in progress, without federal funding, for nearly seventy years. The finished figure would be 563 feet tall, sitting on his horse, pointing toward the Black Hills.

I understood the impulse, of course, but it also struck me as strange: to honor a Native American leader in terms of Rushmore-style gigantism.

And it began to seem foreign to me, our American obsession with size. We are born a fantasy of bigness. We are tall and strapping, with big hats and big hair and loud clothes and booming voices. We drive our big cars through the epic landscapes of our giant continent. We work in tall buildings, where we give 110 percent in order to build larger-than-life careers that distinguish us from the huge teeming masses of our fellows. Our great ideas define infinite eras. Our big weapons win big wars. We are economically, geographically, culturally, and spiritually huge: the Gigantic States of America.

There is something childish about this fantasy — the way it tends to conflate virtue and size. Why does goodness have to be huge? It is a dangerous belief, and one that inevitably causes stress and confusion when — as it must — it runs up against reality. Inevitably, there will be a shift in scale; the dominant thing (nation, culture, religion, demographic) will begin to shrink. Does it lose its virtue with its dominance? If we truly believe that, then what virtue will we not be willing to sacrifice to make ourselves feel big again?

At the gift shop, I bought a length of braided sweet grass, which was said to dispel negative energy; we set it on our dashboard as we pulled away.

Later, as the sun was beginning to set, we drove through the spreading wilderness of Custer State Park. We passed through huge, shaggy herds of buffalo, which raised their heads and stared. The landscape seemed to change every five hundred feet: lakes, buttes, forests, gashes of red dirt. A small herd of pronghorns glided over a bluff, ghostly white on the snow. It was as beautiful as any land I've ever seen; driving through it inspired the kind of awe that the sculptures of Rushmore had not. But then again, we never would have seen this landscape if we hadn't come to look at Rushmore.

At one point, our car was besieged by a herd of burros. They surrounded us completely, forcing us to stop. We rolled our windows down. They stuck their heads in and worked their giant lips; we could see, deep inside their mouths, tiny sets of teeth clacking away in anticipation of food. It was like a horror movie, but hilarious. The burros were not native to the Black Hills: Their ancestors had been brought to the region as pack animals, then set loose, so these creatures were a result of many generations of acquired wildness. We had nothing to feed them, so they started licking our car, presumably for the salt from the roads. When we got out later, the entire vehicle was covered in thin white swirls.

It took some doing to find a lodge near Rushmore that was open in the off-season. Its driveway was thick with unplowed snow, but our SUV ate its way through. The place was a log cabin bed-and-breakfast, lushly decorated with antler-based furniture; it billed itself as the only lodge with a full-frontal view of the monument itself. After our day of driving, I looked forward to studying the presidents' faces in detail, at length, warm and undisturbed. The owner of the lodge was a living exponent of the story of Rushmore, the granddaughter of the man who designed the pigtail bridges. Whenever I asked her a question, history books poured out of her mouth.

She pointed me to the Rushmore view, and sure enough, there it was, unobstructed. But it was so far away that you could barely see it. Binoculars hung by the window. Even magnified, the heads were tiny. Borglum made the sculptures on Mount Rushmore eighty times as large as an average human head—each one roughly the size of a sperm whale. This window shrank those heads down to the size of a pin.

As the evening wore on, the view got stranger. Outside, somewhere in the wilds of the Black Hills, a fire was burning. As the sky darkened, the fire grew and grew, and from our perspective through the window, it was directly in front of Rushmore. It sent its smoke into the presidents' miniature faces, and the smoke glowed an eerie red. George Washington looked at us through the screen of a red cloud. It seemed like one of those weird meteorological events, an eclipse or a comet, that ancient cultures invested with meaning. Tiny giant America seemed to be burning.

BIANCA BOSKER

Why Should a Melon Cost as Much as a Car?

FROM *Roads & Kingdoms*

MY JOURNEY TO THE HEART of the muskmelon cult started with a strawberry. A few years ago, I was in a dimly lit Tokyo restaurant that served more courses than it had seats, where I dined on anatomical selections I couldn't name belonging to species I didn't know existed, prepared by a chef whose elegance with a knife resembled ballet more than cooking. Back home, an American version of this feast might have ended with a procession of desserts: a palate cleanser of grapefruit semi-freddo; a heftier dessert entrée of coffee buttercream with dark chocolate ganache; then a post-dessert dessert of truffles and sugar-coated jellies, plus a pastry to take home for later. But at my dinner in Tokyo, when the chef presented my dessert, I found a single, sliced strawberry, served alone on a plate.

Biting into one sliver of the fruit, I had the sense I was tasting in color for the first time. The strawberry was perfumed. It tasted of roses, honey, and a kiss. And it made absolutely no sense. Where did it come from? What made it special? Why only one?

I discovered my strawberry was both more special than I'd thought and less unique. In Tokyo's department stores, just a few floors down from Dior dresses, I stumbled on shrink-wrapped boxes of strawberries, presented in soft lighting and on pedestals, being sold for $5 apiece—a bargain when I realized the best command $500 each. And it wasn't just the strawberries: Japan had elevated all kinds of fruit to Birkin-bag status. In the subway, I spent $12 on fewer than a dozen grapes (again, cheap consider-

ing a bunch sold for $11,000 in 2016). I stared dumbfounded at YouTube fruit porn showing juicy hunks of yellow flesh being sliced from rare "egg of the sun" mangoes ($2,700 each for top specimens).

And then I learned about the "king of fruit": muskmelons, reticulated spheres of "melting sweetness" that could command $27,000 a pair, earned TV specials in Japan, and wore tiny "hats" while ripening to save their pale flesh from sunburn. But . . . why? Did the world need melons that cost as much as a car? "It's like asking in America, 'Why do you high-five?'" said a Japanese friend, one of many I hounded for answers, and one of many who shrugged in response. "We have never questioned why the fruit is so expensive." But, she added, "Since you asked about it, I started to realize, 'Hmm . . . why, why, why?'"

By all accounts, Japan's obsession with luxury fruits begins with Sembikiya, the country's largest and oldest high-end fruit provider. So, ahead of a trip to Japan last fall, I emailed Sembikiya to see about arranging an interview at their flagship store in Nihonbashi, a tony part of downtown Tokyo that's home to luxury hotels, lacquer bowl purveyors, and washi paper boutiques.

When I arrive in the marble lobby of the high-rise to which I'd been directed, I pass back and forth in front of what appears to be a jewelry store before finally realizing it is Sembikiya. Dark, polished wood and sheer curtains line the walls, and sparkling chandeliers shaped like exploding snowflakes twinkle overhead. Glass display cases hold meticulous rows of fruit tended by prim women in starched black uniforms and berets ready to share anecdotes about the sweetness of the pears ($19 each), or Sekai-ichi apples ($24 each). Middle-aged women with Chanel bags and teased updos inspect plump, jade-colored Seto grapes swaddled in crisp white paper, while their husbands admire the altarlike case of muskmelons at the center of the floor, each one perched on its own wooden box lined with mint-colored paper ($125 each).

Each fruit species boasts its own full-color brochure with tasting notes to rival those for first-growth Bordeaux. "The skin is thin, while the seedless pulp is moderately firm," reads the card for the Suiho grape. Eaters can savor a "delicate sweetness and aroma with a refreshing aftertaste."

One of the salespeople informs me that around 80 percent of customers buy Sembikiya's fruit to give as gifts. The store gets busi-

est around July (when tradition dictates offering a chugen gift to people to whom you feel indebted) and in December (when it's customary to give a seibo present for similar reasons). Sembikiya can sell as many as two hundred muskmelons a day, which might be offered to bosses, clients, teachers, parents, or doctors. How do you choose what fruit to give? "If the boss loves apple more than melon, it's better to give him an apple than a melon, right?" the salesman advises. "But if the boss likes higher-glamour fruits, then maybe it's better to go for the melon."

An emissary from Sembikiya's corporate office whisks me upstairs to the company's "fruit parlor," a café serving elaborate ice cream sundaes and fruitscapes made with whatever ripe produce hasn't sold in the store. As Vivaldi's *Four Seasons* plays and we sip ice water from wineglasses, Tsuyoshi Monozumi—a former fruit-parlor chef who now oversees all sixteen Sembikiya branches—walks me through the company's history. Through my translator, he explains that Sembikiya got its start in 1834, when a samurai, Benzo Ohshima, set up a stand right here in Nihonbashi peddling, ironically, discount fruit. In the latter half of the century, the savvy wife of one of Ohshima's descendants decided to invert the business model: through her tea-ceremony master, who was well-connected in Japan's upper echelons, Sembikiya scored an appointment as fruit purveyor to the Tokugawa shogunate, the country's last feudal military government. (It governed until 1868.) Subsequent generations of Ohshimas, who still run the company today, continuously refined the quality of their produce, importing exotic selections from abroad, abandoning farming in favor of culling the best fruit from across the country's top growers, creating the forerunner to the fruit parlor, and opening new stores across Japan.

This is interesting but unsatisfactory. Plenty of British merchants supply coffee or gin to the royal family without inflating their prices to stratospheric levels. What gives? Monozumi struggles for an answer, finally settling on the explanation that people in Japan are simply more concerned than foreigners with quality. "Before, a long time ago, we were like the United States or Southeast Asia: people were eating apples walking down the street, or they'd have a mountain of apples in the corner of the street selling it," he says, making me feel like a barbarian. "But people are asking for better quality, better taste . . . The reason why Sembikiya has high-end

fruits is, they are just answering the customer's expectations, the customer's needs." It may have helped, he notes, that "we, as Japanese, are good at putting the quality in a product."

Eric Rath, a professor of premodern Japanese history and author of *Japan's Cuisines,* offers a slightly different account. During the Tokugawa period, wealthy merchants competed to outbid each other to buy the first produce of the season, hashiri. Snapping up that year's inaugural tuna or bunch of grapes afforded not only bragging rights; the first harvest of the season was also thought to taste better than the food that followed, and to extend the eater's lifespan by seventy-five days. Rath notes the "centuries-old fad" continues today: the muskmelons and grapes that fetch five figures at auctions are all hashiri.

At the same time, fruit has long played a starring role in Japanese ceremonial gift-giving. Thirteenth- and fourteenth-century samurais presented tangerines or—that king of fruits—melons to the shogun, their chief, as a show of loyalty, while in the fall, farmers gifted fruit and other edibles to neighbors with the expectation they'd return the favor by helping with the harvest. "Giving fruit, in other words, represented an expectation of a return in the form of service," Rath writes in an email. The modern version—chugen—is "a similar practice that reaffirms the expectations of relationships." In a sense, bananas, like engagement rings, are symbols of a bond, which helps explain the effort to go beyond Dole. "If the price is high, the customer is excited—thrilled—about the price," says Monozumi.

But expensive for a reason—or expensive purely to show you've splurged on your boss? Monozumi leads me back downstairs to the Sembikiya store and proudly shows me the muskmelons. He gives me a moment to bask in the splendor of the store's specimens, which are their best seller. I'm not sure what I'm looking for. They look like any other melon: beige, topped by green stems splayed like TV antennae. Like Miss America contestants, each one wears a white sash around its center, emblazoned with the words MUSK MELON SPECIAL SELECTION.

Monozumi details the journey these pampered melons undertake before arriving at the store. First, the best melon seeds, new strains of which are bred every year, are planted in soil-bedding—not the ground—and kept cozy inside greenhouses outfitted with air conditioners and heaters to ensure the melons stay warm, but

not too warm, year-round. When the vines begin to bud, scrawny flowers are ruthlessly removed, and champion farmers hand-pollinate the flowers, using a tiny paintbrush to move pollen between the blooms, like overgrown humanoid bees. Yet another culling happens once the baby melons reach fist-size: farmers pluck all but the most-promising fruit, leaving only a single melon per vine to concentrate the plant's nutrients in one uber-juicy fruit. These remaining muskmelons each get an outfit: a string tied around their stems to prevent them from falling as they ripen, plus their signature "hat"—black, cone-shaped—to prevent sunburn. As the melon grows, cracks develop in its exterior—think melon stretch marks, caused by insides expanding faster than the skin—and sugary juices flow into the cracks, creating elegant reticulation that makes it look as though the fruit has been caught in a khaki-colored net. (The finer the reticulation, the sweeter and juicier the melon, experts say.) To make the melons even sweeter, farmers don white cotton gloves and give each individual fruit a vigorous "melon massage"—what Sembikiya's website refers to as a "ball wiping"—by rubbing the outside of the fruit. (Champion growers are so enthusiastic with this ball wiping, they get holes in their gloves and go through multiple pairs per crop.)

When at last the melons are picked, they will be graded on their shape (ideally perfectly spherical), sweetness (high), reticulation (preferably tiny and delicate), and scent (intoxicating). The best will be awarded the top "Fuji" designation, but only 3 percent of a crop might qualify. The fruit travels to Tokyo's Ota market, where middlemen hired by Sembikiya purchase the finest specimens for the company, which in turn selects the best of the bunch. "For example, if Sembikiya orders one case of apples, the middleman will look for three cases of apples, they will pick the best ones to make one case, and then they will give it to the Sembikiya," explains Monozumi. "And then Sembikiya will pick the best apple from that one case to their store." The apple rejects get returned to the middleman, or, if their imperfections are merely superficial, they are cooked into the sauces and jams that Sembikiya also sells.

Later, I wait in line for a seat at the Sembikiya fruit parlor, which at 4:00 p.m. on a Wednesday is packed with little old ladies in flowered cardigans and mother-daughter duos weighed down with designer shopping bags. When I'm finally shown to a table, I order Sembikiya's signature $22 fruit plate. It comes with one-third

of a banana; three slices each of persimmon, orange, pineapple, kiwi, and mango; three partially peeled grapes; and one inch-and-a-half-wide rind of muskmelon. I began with a taste of what Monozumi referred to as "more like a commoner's fruit": the banana. It has a rich, nutty flavor, with the most concentrated banana essence I've ever tasted. The mango is melt-in-your-mouth delicious. The grapes, a revelation. I save the muskmelon for last, giddy to try it after hearing about all the melons that had been sacrificed to bring me this bite. It has a vague pumpkin odor and is served properly chilled. But it is a disappointment. It tastes like melon. Sweet, yes, but not especially so. Even a little watery.

It wasn't until later, back home in New York, that I fully appreciated the fruit I'd been served. I was at the grocery store, standing in front of a pile of lumpy, gray, misshapen orbs that, according to the sign in front of me, were cantaloupe—the closest most Americans will get to a muskmelon. They were scratched and asymmetrical, and looked borderline grotesque in a way I'd never considered before. I thought back to Sembikiya's stand of muskmelons; the spheres' skin—a soft, tan mesh over a mint-green smooth surface—reminded me of needlepoint, and I could understand why the French described them as "embroidered." Like so much in Japan, something that initially seemed nonsensical, even trivial, had altered my definition of beauty. Even fruit could become art. Later, back home, I enviously watched YouTube videos of bloggers and TV hosts slicing into muskmelons, or interviewing growers on raising the monarch of melons. "I think only about melons," said one farmer, grinning. "I'm a melon fool." I can relate.

The Ghost of Capablanca

FROM *Southwest*

AFTER A SUMMER hustling speed chess in Vancouver to raise funds for my first visit to Havana, in 2000, I met an antique bookseller on the plane ride over who helped me find an apartment in a magical neighborhood just off the Plaza de la Revolución, where Fidel Castro still delivered speeches that occasionally ran for seven hours. A dignified eighty-one-year-old retired doorman stood guard of the street. After moving from his job at Hotel Nacional de Cuba to the newly opened Habana Hilton, he was on duty when Castro and Che Guevara arrived in January 1959 to commandeer the top two floors for their government headquarters. I quickly made friends with all the families on the street. They took me in with more warmth and generosity than the neighborhood where I grew up. I'd been warned about the poverty in Havana; instead, these people illuminated a poverty of spirit I didn't know I'd had back home.

I returned to Havana the first chance I could and tried to reconnect with the bookseller. He'd told me on the plane that the only thing that disappointed him about Havana was having to leave it. I found out he'd been granted his wish—cirrhosis took his life and he was laid to rest in Havana's Colón Cemetery. When I got back to the street he'd introduced me to, everyone else had left too. The doorman had died, and the others had found various means off the island. I asked one of my few remaining friends on the block what I should do. "*Resolver,*" he said. *Figure it out.*

I finally found a place in a very different neighborhood: Cayo Hueso in Centro Habana. People in the street led me to a door

up the road from a barber shop, caged bird store, and crushed
sugarcane juice stand. I knocked and a latch swung open behind
a peephole. A dark burly man with swimming-pool blue eyes un-
locked the door and held it open a crack. He had as little English
as I had Spanish, so instead of embarking on the usual frustrating
pantomime negotiations about the room for rent, he held out two
upside-down clenched fists and motioned for me to choose one.
This is a ritual he's repeated every time I've seen him for the last
fifteen years.

I pointed to his left fist, and he opened it to unveil a white
knight chess piece. He smirked. "*Bueno. Usted primera.*" I had first
move. He invited me up onto his padlocked rooftop, where his
daughter brought a small mug of coffee, two shot glasses of Ha-
vana Club rum, and a scratched-up chessboard. His loyal dog,
Venus, jumped into his lap and he stroked her fur, and over his
shoulder was the most beautiful sunset I had ever seen. I gestured
to it, and he solemnly pointed to the board before us. Chess, it
was obvious, offered him a view more haunting and lovely than
any sunset.

Today this gentleman—let's call him Fernando—and his wife
rent a room in their Centro Habana neighborhood on Airbnb. But
many years before Airbnb was legal in Cuba and renting rooms
to foreigners was subject to fines and even seizure of property, he
provided for his family by secretly leasing a room on the roof of a
four-story walk up.

Fernando has Chinese, Spanish, African, and German blood,
and it seemed to inform all the features of his face with a noble
and almost magical harmony of purpose: *getting me to play one
more game.* On the streets below us, amidst cigar smoke and die-
sel fumes, the slap of dominoes was heard well into the night,
while Fernando and I were invariably playing chess up above. His
chessboard was always waiting on his roof, freshly reset with pieces
or, more likely, frozen where a game was left off. Up there, Fer-
nando also read from one of a dozen books reliving the games of
José Raúl Capablanca, his beloved hero and Cuba's greatest chess
champion. It was Fernando who introduced me to Capablanca. I
was obsessed with Bobby Fischer, but for Fernando there was only
one *gran maestro,* not only on the chessboard, but as an artist, a
scientist, a philosopher.

Fernando has a booming voice that dipped into a panicked

hush for only two men: Castro and Capablanca. In all the years I've known him, he's never mentioned Castro by name. Instead he motions by grabbing an imaginary beard or simply refers to "Him." Capablanca receives the same treatment for entirely different reasons. His genius was mystical. "Capablanca," Fernando whispered, "was born in 1888 in Havana to a Spanish army officer. That was the only ordinary thing about him." He won the world championship every year from 1921 until 1927 and is regarded as one of the great artists of the game. "But he was bigger than the game!" Fernando assured maniacally. "The Yuma at *Time* magazine put him on the cover in 1925. Brinicito, do you know the other men who were on *Time* magazine that year? Winston Churchill! Charlie Chaplin! Leon Trotsky! John D. Rockefeller!" He lost only thirty-five games in his entire professional career, and upon dying in 1942—while watching a chess game at New York's Manhattan Chess Club—his body was sent back to Havana and honored with a state funeral.

Chess had arrived in Cuba more than four centuries earlier, aboard Columbus's Spanish ships in 1492, and while the shackles of colonialization were broken with Cuba's revolution in 1959, chess's hold on the island nation has proved considerably more durable. They joke in Cuba that what King Midas was to gold, Castro was to politics, but Fernando likes to remind me that chess is fifteen hundred years old and will be around long after communism or capitalism. "Like a great book that never finishes what it has to say, chess is no closer to being solved. It only gets more beautiful as people try in vain. Just like life off the board, we all *resolver.*"

Resolver—"to resolve" or, colloquially, "to get by"—remains one of the most vital words in the Cuban vocabulary. Considering the new and unknown challenges ahead for Cubans, perhaps it's not surprising that chess has never flourished more.

The last time I'd seen Fernando was during Barack Obama's March 2016 visit to the island, the first time a sitting American president had done so in eighty-eight years. In November, I watched from back home in New York as the island experienced an even bigger political disruption: the death of Fidel Castro, who had inhabited the island like Moby Dick in a goldfish bowl. In January, I wrote Fernando to see if he would help me dig deeper into Cuba's chess history. I wanted to understand its relevance

to today's culture, and how it might illuminate the tidal waves of change on the island. He wrote back and suggested we begin at the Capablanca Chess Club, the first place he went after his own father could no longer give him a decent game.

Before leaving for Cuba, I met with Bruce Pandolfini at a diner near his Manhattan home. Pandolfini is one of the most sought after—and probably the most famous—chess instructors in history. He served as the Manhattan Chess Club's executive director from 1984 until 1987. "Capablanca was called invincible," Pandolfini told me, wiping coffee from his mustache. "Capablanca always claimed his brilliance lay in intuition rather than calculation. It was almost supernatural."

Stories about the genesis of Capablanca's genius all have the same basic coordinates regardless of the storyteller, but every version blossoms with unique awe. Pandolfini told of how, at four years old, Capablanca was watching his father and uncle play one afternoon. His uncle went to the bathroom, and Capablanca notified his father that his uncle had cheated with his knight. (Capablanca maintained an obsession with knights all his life, and no other player has ever been more of a magician with them.) His father didn't believe his son knew how to play and challenged him to a game. According to some, Capablanca played his father to a draw. "There are so many myths," Pandolfini said, laughing. "They all take on a life of their own."

Pandolfini brought along private artifacts given to him by Capablanca's late widow, Olga: unpublished photos, a letter, Capablanca's personal Cuban National Bank book with a lone deposit for $6,000 from his winnings on December 23, 1941. Pandolfini also showed me a prized book of Russian chess openings that a teen-aged Bobby Fischer had once carried all over New York for a year. Midway through the book was Fischer's clunky and strangely printed signature: *BOBBY* in all caps and *fischer* lowercased. In 1965, when Bobby Fischer was denied entry to Cuba for the José Raúl Capablanca Memorial (the Bay of Pigs invasion had increased tensions between Cuba and the United States), Fischer competed in the tournament by telex from inside the Marshall Chess Club in New York. Pandolfini relayed Fischer's moves while José Raúl Capablanca Jr., Capablanca's only son, did the same for Fischer's opponent in Havana. Fischer lost, and the following year he was

granted entry to Cuba and competed in several exhibitions on the island, including one against Fidel Castro. (Castro won.)

"Olga always believed in reincarnation," Pandolfini told me while repacking the artifacts in his leather bag. Paul Morphy, the greatest player of his era, died in 1884, and Capablanca was born four years later. Olga believed Morphy's spirit entered her husband's body. Capablanca died in 1942, and a year and a day later, on March 9, 1943, Fischer was born. "She was certain Capablanca's spirit went into Bobby's genius," Pandolfini said. "For her it was all a continuation. Fischer always adored Capablanca's games. When he played the match on telex during the Capablanca Memorial in Havana, he played on a table Capablanca had donated to New York."

After landing in Havana in March, a '57 Chevy taxi takes me from the airport past the Plaza de la Revolución, where murals of Che Guevara and Camilo Cienfuegos climb several stories across a pair of buildings. All the driver can talk about is the local taxi strike. Queues of stranded commuters are gathered all along the highway, and their ranks increase as we edge closer to the heart of the city.

We swing past the gates of Colón Cemetery, where Capablanca is buried, his grave marked with a white queen chess piece. Fernando brought me to the grave after our first handful of games. Vendors sold paper funnels of peanuts outside, and Fernando bought a half-dozen for our tour. "Peanuts everywhere," he said, tossing a handful into his mouth. "Yet peanut butter has yet to be discovered on the island." It was one of a thousand paradoxes he navigated every day. He worked at a hospital full-time but had struggled to support his family until he began renting out the spare room in his apartment. He hated the risks, but what choice was there? He introduced me to the chess term "zugzwang," a situation in which you're forced to move but every available move puts you in a worse position. "*Resolver*," he said, shrugging.

Driving into town, it's clear that all of Havana is dealing with change. For years, Cuba's connection to the outside world via the internet has been miserably limited and terribly expensive. Now the government sells one-hour internet cards for two Cuban pesos, which are snatched up by entrepreneurial locals and scalped with a 50 percent markup. Cellphones were once rare; now they are as ubiquitous in Havana as any other major city. (When the Roll-

ing Stones played the largest concert in Cuban history just after
Obama left last year, what amazed me more than the estimated
five hundred thousand people in attendance was how the audi-
ence experienced the event: behind a phalanx of iPhones. Just
like everywhere else.) Wi-Fi locations all over the city are filled
with clusters of young Cubans nodding off into the glow of their
phones. Of the thirty friends I made who were around my age dur-
ing my first trip to the island in 2000, only five of them remain in
Cuba. The rest started new lives in Miami, Spain, Austria, Canada,
and elsewhere. While pawns are the most vulnerable piece on the
chessboard, they are also the only piece capable of transforming
into something entirely new, provided they make the perilous jour-
ney across the board.

I drop off my things and catch a cab down to the Malecón, Ha-
vana's famous boardwalk, where Fernando is waiting to join me
at the Capablanca Chess Club (just down the hill from the Ho-
tel Tryp Habana Libre, where the first Capablanca Memorial was
played in 1962). When I climb out of the cab, a wave crashes over
the seawall and splashes a bicycle taxi carrying two tourists in the
backseat. I greet Fernando, who's carrying a chessboard under his
arm, and he tells me he's arranged a meeting with José Antonio
Hedman, one of the professional players who works with children
at the club. "Do you know where the money came from for the
first Capablanca Memorial tournament?" Fernando asks.
 I shrug.
 "Che Guevara raised the money. Later on, he regularly played
against visiting grandmasters. Even Bobby Fischer. Che's father
took him to a tournament when he was a boy growing up in Bue-
nos Aires, and he saw Capablanca playing. That's where he first got
addicted to chess and also where he first learned about the coun-
try where Capablanca came from. Che and the Cuban government
invested huge amounts of money to support the game."
 Standing before the entrance of the club, it's clear that those
investments weren't aimed at ostentatiousness. There's a large row
of pink-framed windows nestled into a cream-colored cement exte-
rior, the paint chipped and peeling from the salty sea breeze. Next
to the front door, CLUB CAPABLANCA rests above a plaque com-
memorating the centennial of Capablanca's birth. The club itself
has been in operation for almost a century.

Inside, the mint-green walls are mostly bare, save for a schedule of lessons and events and a green-and-white magnetic chessboard hung behind an office desk. Aside from the two club managers' desks pushed up against one wall and a row of tables emblazoned with eight chessboards on the other side of the room, the club is filled only with sunlight. Somehow the place feels a bit like an abandoned church. Inspecting the green-and-white squares on the wooden boards, I slide my index finger inside the grooves worn from excessive use.

Fernando and I sit opposite Hedman, a painted board between us. "Life in Cuba," he explains, "is about solving challenging problems. The skills chess offers help us a great deal on and off the board."

Chess is taught in nearly all Cuban elementary and high schools, and in 2003, universities began offering chess degrees. A year later, with thirteen thousand players taking on five hundred chess masters, Cuba broke the world record for the largest simultaneous chess exhibition in history. In 2008, Cuban grandmaster Leinier Domínguez won the World Blitz Championship. While Domínguez is a long way from rivaling Capablanca's accomplishments, he's hovered around the top 20 of the world's best chess players for some time.

This didn't happen by accident. After Castro banned professional sports in 1962, huge resources were devoted to making Cuba a global powerhouse in baseball, boxing, and chess. The symbolic value of triumph in these fields during the Cold War paid huge dividends. Cuba went on to dominate Olympic boxing and international baseball, and, for an island of only eleven million people, Cuba has so far produced an astounding forty-three chess grandmasters.

Hedman invites Fernando and me to an upcoming exhibition at the Meliá Cohiba Hotel. Some of the children Hedman has worked with at the club, he tells us, are eager to glimpse their chess heroes. Domínguez might even be in attendance.

When I spot Fernando's taxi approaching the Meliá Cohiba the morning of the exhibition, the driver is frantically trying to dodge a patchwork of sea puddles. Fernando hops out and sniffs around the hotel for the exhibition, but nothing advertises it, so he asks the security guards inside for help. They suggest we ask the front

desk. No luck there either. A different security guard approaches and advises us to try the Hotel Riviera next door. Nobody at the Riviera has any clue what we're talking about, so we're back to square one in the lobby of the Meliá Cohiba. "Cuba *neo*," Fernando moans. *Only in Cuba.* Just then Hedman taps me on the shoulder.

"You made it," he says, smiling. "There is good news and bad news I have for you. Domínguez will not be here this morning. However, one of our best *gran maestros* will be here, Lázaro Bruzón."

A crowd of equal parts children and adults gathers around the restaurant next to the hotel entrance, and at 8:30 a.m., we're let inside a surreal room furnished with jukeboxes, 1950s American convertibles, and aging Cessna planes. Dozens of tables surround a stage with a screen hanging over a main chess table—the center-piece on display.

Hedman approaches with Bruzón, still boyish at thirty-four, at his side. After shaking hands, Bruzón explains he learned chess from a neighbor when he was seven. By nine, he'd devoted his life to the game, and the Cuban government recognized a prodigy in its midst. At eighteen, he won the World Junior Chess Champion-ship, but now, sixteen years later, he explains that he is cutting back on international tournaments. He's receding from a life per-petually in the orbit of chess, a confession that is accompanied by a mix of mournfulness and relief. "I am immensely proud to have represented my country around the world," he tells me.

There's an ease about Bruzón's demeanor that leaves an im-pression on me. It's a stark contrast to the lingering tension and friction felt by elite Cuban athletes in other sports. "Have any of the top Cuban chess players left the island?" I ask Fernando after Bruzón excuses himself.

"None that I know of," he says. "Chess players who devote their lives to chess probably live much more comfortably here than they would in a different system."

Which makes sense. I've interviewed some of Cuba's finest box-ers and baseball players. In many cases, they've rejected the vast fortunes that come with leaving the island and crossing ninety miles to compete in the US. While none openly regret their deci-sion, they lead lives much like double-exposed photographs, al-ways wondering how they would have fared if they had left. Over the last ten years, Cuban baseball and boxing have been gutted by international poaching. But not chess. On top of having their

needs looked after, chess players in Cuba are seen as something between an athlete and an artist. They might be more appreciated and respected here than anywhere else.

After turning the matter over, Fernando puts his hand on my shoulder. "We admire *la lucha* ["the struggle"] as much on the chessboard as we do in the boxing ring. Our lives here have always been a struggle, and approaching that struggle with the courage of a boxer or the cunning and intelligence of a chess player is something that commands our respect. The same rules apply in a boxing ring or on the chessboard or growing up in our crazy system: *resolver.* Many places around the world are confronted with the same thing. They just don't have our sense of style."

After the exhibition concludes, kids still hunched over chess tables, Fernando tucks his chessboard under his arm and suggests we go to Cojímar, ten miles east of Havana, where he grew up and first learned to play. We catch a taxi on the Malecón and head toward the lighthouse. Just before we plunge into the shadowy-yellow glow inside the eastbound tunnel out of Havana, I watch as fishermen cast their lines toward Miami and a gigantic cruise ship enters the harbor.

When we emerge on the other side, very little civilization remains. We close in on a spooky unguarded tollbooth, beyond it only palm trees and giant streetlights outstretched like a diver's arms before takeoff. We pass a stagnant-looking stadium built for the Pan American Games twenty-five years ago, a paint-chipped mural of Che staring out from inside of what looks like the upside-down ribcage of Jonah's whale. Soon after, Fernando taps the driver's shoulder from the backseat and we walk the rest of the way into his village.

As we wind through the outskirts of Cojímar, the sea comes into view and we spot the long wooden pier that was once home to Ernest Hemingway's boat, *Pilar.* Near the pier is the Torreón de Cojímar, a battered fort built in 1649 to protect Havana.

A bus of tourists pulls in to visit La Terraza, Hemingway's favorite local restaurant, but Fernando's spot is a laid-back rooftop restaurant on a nearby backstreet, perched above a Dalí-like set of stairs. When we arrive, a local boy is posted in front of the stairs, holding a varnished wooden object the size of a sunglasses case. He holds out the box and asks in English if I've ever seen a "ro-

mance box" before. I shake my head, and he smirks and seamlessly pulls it apart, holding out both halves of the box with his arms spread wide. He brings the pieces back together and effortlessly repeats the gesture once more. "I'll give you thirty seconds with it," he tells me. "If you can open the box, it's yours to give to the one you love. If you cannot open it, then you must pay me ten pesos to keep it." He quickly opens and shuts the box again with a blurring sleight of hand. "See how easy it is?"

I glance over at Fernando, but he's too busy staring at the boy to offer any counsel. So, gullibly yet determinedly, I play the sucker. "*¡Vamos!*" he says, staring at his watch. I feverishly work the thing over like a Rubik's Cube until the boy hollers, "*¡Tiempo! Diez pesos por favor.*" I absentmindedly hand the box to Fernando and fish my pockets for the boy's fee. When I fork it over, the boy is no longer paying attention to me. He's staring at Fernando, who is calmly repeating the boy's opening and closing demonstration.

"How?" I gasp.

"I had the same job here when I was his age," Fernando says. "But"—and he suddenly switches over to Spanish—"when I saw a girl I loved at first sight, I asked her for something more if she couldn't solve the romance box in thirty seconds."

"What?" I ask.

"I asked her to go on a date with me. But first I wrote a secret message and put it inside the box. When she couldn't open the box, we went on our first date and I gave her the box as a gift."

"What did you write in the note?" the boy asks. His swagger has left him.

"I asked her to marry me." He laughs and passes me the box, freeing up his hands to dig through his pockets for a black and a white chess piece. He holds them in his clenched fists and motions for me to tap one, but the boy interrupts.

"What happened to the girl?" he implores.

Fernando ignores the question and grunts for me to choose a fist. I do, and Fernando holds out a white queen in his palm.

"Did you ever see the girl again?" the boy asks deliriously.

"Of course I did. I saw her this morning, when I cooked breakfast for her and our daughter." Fernando turns and winks at me. "*Resolver.*"

JENNIFER HOPE CHOI

My Mother and I Went Halfway Around the World to Find Each Other

FROM *BuzzFeed*

A YEAR AFTER MY PARENTS DIVORCED, my mother's post-cards began to arrive in the mail.

She had only ever taken two big international trips before then: when she moved to America from South Korea in 1976, and when she and I visited Madrid in 1998. For the latter, my sister Laurie was studying abroad and we stayed with her over Christmas — a miserable two weeks consisting mostly of our mother's endless grousing, due to the absence of kimchi in Spain. Nearly a decade had passed since then when, to my surprise, my mother started traveling the world alone. I discovered her whereabouts solely through the notes she sent, from Buenos Aires, Amsterdam, Beijing, Paris. After visiting the enormous soapstone statue of Cristo Redentor in Rio, she proclaimed via email: "You can spread my ash on the Corcovado."

Meanwhile, I lived on the smelliest block in Manhattan. No hyperbole here; *New York* magazine officially crowned my old block the stinkiest stretch in the city. But back when I was twenty-one, roosting on the border of Chinatown and the Lower East Side, my neighbors and I did not need outside confirmation. We were all too familiar with "the Stench": a rancid mélange that smelled like cat urine and raw sewage mixed with expired poultry. The source of the Stench could be traced a few doors down from my apartment building, to a trading company whose generic warehouse appearance obscured what existed, putridly, out of view.

When you're young and broke in New York, making certain concessions for a steal seems appropriate, if not savvy. I'd scored

a rent-stabilized lease in a tenement building downtown, so I accepted the apartment's rank location, and in my mind, rebranded the many other glaring shortcomings as "quirks." Like the fact that management stored open trash bins in the dank lobby, where posted signs read in English and Cantonese: NO SPITTING (bilingual friendly!). My elderly neighbor Agnes, who spent her days in a wheelchair, kept her door propped open with a long metal charley bar. This allowed the sharp scent of urine, overlaid with bleach, to waft down our shared hallway (wacky New York character!). My bedroom window faced a brick wall (privacy!). The foot-long gap between the wall and my window also functioned as an attractive thoroughfare for chatty stray cats, pigeons, and rats.

I unearthed the first postcard one rainy afternoon. To get to my mailbox, I'd dodged empty milk cartons and Table Talk miniature fruit pie boxes Agnes had chucked down the hall. A picture of the Fontana di Trevi practically glowed between Con Ed bills and junk mail, its fluorescent green water dappled with spotlights. On the back, my mother had written from the Vatican: "Walked everywhere, got lost many times & all . . . had capuccino on street."

A few weeks later, I found a new postcard, depicting a lush coastal town bordered with cheery red flowers. "Mt. Etna was visible with smoke coming up," she'd scribbled in Sicily. "After a day at sea, next stop is French Riviera."

She dispatched the most curious message from Santorini, Greece: "I came down on a donkey. It was tough. By the time I got to the bottom of the steps, I was able to enjoy & had to get off the donkey. I sang & called you & your sister's name over & over. Can you imagine?"

I couldn't. What would possess a woman to scream our names across the Mediterranean while riding sidesaddle on a donkey? In my sunless apartment, I examined the postcard's photo: the elegant masonry of a whitewashed plaster church, its crosses emboldened against a cobalt sea. Then I stashed my wine key in my pocket and headed for work at a nearby German biergarten, where I poured comically oversized steins of lager to petulant day traders well into the wee hours of the night before returning home—to the Stench, and the trash, and Agnes, and my scenic view of a brick wall, still wondering if what my mother wrote was true.

My mother hadn't always been an adventurer. When I was

growing up, she presented herself to the world as a woman of un-
flagging practicality: our breadwinner, taskmaster, and domestic
dictator; the open-heart surgery nurse who wore beige sweater
sets from a store called Petite Sophisticate, who donned a sensi-
ble, chin-length perm she blow-dried straight, who rarely, if ever,
smiled.

I suspected a steely sadness to her resolve though, which I'd
glimpse whenever she cleaned our shower. The stall was very small,
as slim as an airplane lavatory. Every week she locked herself be-
hind the mottled glass door, naked, clutching a squeeze bottle
filled with noxious disinfectant. I was about ten when I stood by
the sink one Saturday afternoon to observe her routine. Steam bil-
lowed as she sprayed the tiles and scrubbed the grout with manic
flourish. I watched the acrid mist swell, pinching my nose shut,
horrified and amazed by her compulsion. Now this act strikes me
as some private exercise in pain: how much she could take and
tolerate, how much she believed she deserved.

The closest I remember being to my mother happened around
the same age, during our preening rituals. My small hands would
part her hair this way and that. By her request, when I'd find a
white patch, I'd pluck out all the offending strands, which looked
like woven silver beneath the lamplight. Or I'd lie down and she'd
gingerly clean my ears with a tiny wooden scoop. We groomed
each other as monkeys do, building a quiet closeness. In these mo-
ments, she dropped her impenetrable veneer and let me in.

Rarely did she allow her inner anguish to roil to the surface.
But I do recall several nighttime car rides together, when Patsy
Cline's "Crazy" played on the radio. She'd crank the volume and
sing along, bawling: "Crazy, I'm crazy for feeling so lonely. I'm
crazy for feeling so blue . . ." Each time I wanted to ask what was
wrong. But her gaze remained fixed on some unknown distance,
and I knew not to disturb her. Once the song ended, she'd zip up
her misery, and we drove on.

Patsy's song was about heartbreak. And yet, not once had I wit-
nessed my parents kiss or hold hands. I'd wondered if this was
a Korean thing. Both my mother and father had been born and
raised in Seoul, a place as familiar to me as Mars. Laurie and I
grew up in a sleepy, Southern California suburb. Half an hour
east from us, in Hollywood, studios cranked out rom-coms by the

dozen. My parents' affectionless marriage, in comparison, seemed at best a lesson in mergers and acquisitions. It appeared as if for them, there hadn't been any love to lose.

Ten years after those car rides, my father had an affair with a secretary at church, my mother's single social space outside of work. To be betrayed in public is a particular kind of humiliation. But what I hadn't realized as a child was this: when she sobbed to "Crazy," my mother wasn't mourning a loss of love, anyway—what she so achingly longed for hadn't transpired in the first place.

Once my parents officially split, my mother stopped eating and dropped to a skeletal ninety pounds. She subsisted solely on boxed Franzia merlot for months. Whatever chilly fortitude she'd clung to sloughed away, leaving her shivering and raw, her whole being an open wound. I called her from New York. She wept feverishly for weeks, and I listened.

In 2005, shortly after the divorce, my mother relocated to a gated city called Canyon Lake, two hours southeast of Los Angeles. Unlike gated communities, gated cities (of which five exist in California) boast their own city halls, chambers of commerce, country clubs, and grocery stores, which are all locked behind town boom barriers, monitored by twenty-four-hour community patrol.

My mother chose Canyon Lake because she said she wanted to see beauty every day. She enjoyed the idea of passing picturesque shoreline views on her commute to work, like some morning meditation. Never mind that pumpkin-colored men blasted Limp Bizkit on their boats while skittering by the mini lighthouse on the man-made lake. Or that residents preferred cruising the streets in flame-painted golf carts instead of their regular cars. Or that beyond the guarded gates a grim and parched expanse, speckled with dead grass and half-built model homes, extended beneath a scorching sun in every direction.

When I visited my mother in Canyon Lake for the first time, she'd finally stopped crying. She'd also dyed her black hair orange, teased and pinned it aloft with glitter-spangled butterflies. She'd swapped her sweater sets for sequined baby-tees that proclaimed CUTIE PIE, and wore a pair of flared blue jeans adorned with appliquéd houses, purchased from the children's age ten–eleven sale rack. "They only $7.99!" she bragged. "How can you beat that?"

She smiled deliriously, as if to distract me from something. And then I saw it, in her eyes: the same look I'd seen from Agnes, my old neighbor across the hall. Besides the army of young roaches that streamed out of her home, Agnes lived alone. Whenever I stopped by, which was far less often than she requested, Agnes held my hand and pulled me close with an urgent grip. Cataracts may have eclipsed her pupils with a gray fog, but the way her eyes quivered resembled my mother's then—they shared the same barely tamped, quaking desperation.

My mother needed me in Canyon Lake, but rather than rest by her side as I'd done as a child, I turned away. Perhaps cruel, but I couldn't parse which version of her she might summon next: the starved and drunk mother, electric with grief, or the inscrutable one hiding behind our shower's mottled glass door. I'd suffered a loss too, anyway—one I'd yet to fully comprehend. In comforting my mother, whatever threadbare relation I'd maintained with my father over the years disintegrated for good. He did not reach out to me on my visit, or for that matter ever again. I felt hollow in Canyon Lake, like a conch gutted clean. So I flew back to New York, leaving my mother behind the walls of her desert mirage.

I don't know how I procured her vacation photos, or why they appeared in my apartment one day. Whatever the case, they document a particularly mysterious period of my mother's life: the year after I left her in Canyon Lake, when she decided to up and ditch her gated town in favor of jet-setting around the world. My mother has moved many times since then, so it's possible I'd gained the pictures for safekeeping.

At twenty-eight, I no longer lived on the smelliest block in Manhattan. I'd relocated to a sunny second-floor walk-up in Brooklyn, though saddled with a new gloom. I was still bartending, now in a speakeasy whose gypsy jazz soundtracks snapped my own life's anachronisms into focus; the rift with my father, the stagnant writing career I'd claimed to pursue for years, both frozen in time.

It is a strange thing to stumble upon someone else's private memories. Dozens of unflattering, low-angle shots my mother had taken of herself (in a pre-selfie era) filled the rolls, with landmarks or her face accidentally cropped out of the frame. The leaning lower half of Pisa, for example. My mother's chin aboard a London double-decker bus. Her orange hair wind-socking into a Roy

Orbison–esque pompadour off Copacabana Beach. In most of these pictures, she's showing teeth but failing to forge a candid smile. It looks as if she doesn't know how.

Then there was Costa Rica. Another slew of unrecognizable photos: brown fuzz (a monkey?) tightroping a phone line, a hazy zigzag (boa constrictor?) nestled in a pile of leaves. But also a set of clear, earnest self-portraits. She's left her hair undone in them, her perm curly and wild. Wide jungle fronds splay at her shoulders. You can see her giving in to the moment, the soft corners of her mouth upturned. Finally, inside her bungalow, where the peach-painted walls warm her skin and the room, she beams a sincere, toothy smile.

I have nearly identical, unremarkable photos from Costa Rica. Monkeys (hairy blurs) carousing in sky-high vines, an eyelash viper (a cloudy coil) hidden on a tree trunk. I'd flown to Costa Rica on my twenty-ninth birthday. A week prior, a patron at work drunkenly spilled a craft beer all over my butt. I caught myself glaring at her, looking positively homicidal. At home, I came unhinged, and howl-wept, pausing between gasps for sips of wine. What was I doing with my life?

On a whim, I decided to escape the States for as long as I could afford (four days). I remember arriving to Costa Rica's Caribbean coastline at midnight, driving through velvet darkness to my beachside bungalow. I fell asleep to the trill of a million little living things secreted by shadows. I hoped I'd wake up an improved person, bequeathed overnight with instant, magic clarity.

I don't have pictures of the dismal moments, like when my jungle guide's feral dog chased me and I fell face-first onto his gravel driveway. Or when the cocoa farmer's apprentice insulted me in Spanish while toasting my beans. I did relish a few moments of peace, while lying in a hammock outside my bungalow where I took many of my own unsuccessful self-portraits. I returned to New York sun-kissed but, to my dismay, otherwise unaltered.

Real change is neither instant nor magic, but a long process, a kind of honest work. Then one day you reach a point of stillness, when you can look, maybe only briefly, with clear eyes, and simply let go. My mother knows this. She has yelled my name in many far-flung places, at the top of peaks and cliffs, over frozen lakes, or while riding Greek donkeys. I asked her once why she called out our names, and she answered: "Just to say something."

I understood when I began yelling her name too, first while standing on a towering peak in the Icelandic highlands, then again while perched on the white cliffs near Cochiti Pueblo in New Mexico. It soothed me to see how the terracotta mesas pleated into an opulent skyline, or how miles of slick deltas wove through black sand and vanished into the horizon. I sang and called her name over and over. Can you imagine? Each time I shouted, she echoed back.

J. D. DANIELS

Signs and Wonders

FROM *Esquire*

"YOU DO UNDERSTAND that the center of the earth is extremely hot," a friend said when he saw me packing Jules Verne's *Journey to the Center of the Earth*. "The center of the earth is uninhabitable."

The geographic center of the forty-eight contiguous states is Lebanon, Kansas. For years, I had wanted to see it. Not to scc it. To stand at the center.

All of my friends knew I wanted to go. I had this routine I did after dinner where I balanced a plate on my finger and said the plate was the USA and the point of balance was Lebanon.

"That's you, all right," my friends said. "Mister Point of Balance."

Lebanon, population 218, is 108 miles east of US Route 83: nineteen hundred miles of yellow center line running straight down the middle of the United States. It passes through North and South Dakota, Nebraska, Kansas, Oklahoma, and Texas, all the way from Manitoba to Matamoros.

I wanted to follow US-83, to drive to the core, to the *heart of the matter*, as we say. I have lived in Massachusetts for a decade, but I was born in Kentucky and I lived there for thirty years. I know something about what the pundits will go on calling our divided country.

But the country is not divided. The human heart is divided.

I wrote book proposals, I read maps. I did everything humanly possible except take the trip. And then, a few weeks before Elec-

tion Day, I went up into the attic. *Take me to the eye of the storm,* I said to my suitcase, and my suitcase said, *Okay.*

North Dakota, October 2016. Twenty-nine degrees Fahrenheit. My car died thirty minutes from the Bismarck Municipal Airport.

"What brings you to Bismarck?" said a guy I'll call Jim. What had brought him to Bismarck? "Married the wrong woman."

"These new cars are nothing but giant computers now," Dan said. He took a small computer out of his pocket and called Bob down at the dealership, who used a medium-sized computer to search for the solution to our problem.

"You're going to drive 83 down the middle of the country from here to Abilene?" Dan said. "I wouldn't do that if I were you. It's nothing but two-lane. You shouldn't do that. Why are you doing that? I would never do that. Don't do that. It's just farmland," he said, starting the Lincoln. This guardian demon of the first threshold was a tall man with wire-rimmed glasses and a gray mustache. "If your rental dies again, you're on your own. But I guess it's your choice." There is no need to guess.

"This is a nice gas station," Dan said. "You and your fancy East Coast friends might not eat dinner in a gas station, and I can't say I blame you."

I told him I was from Kentucky.

"That's all right, then," he said. "You see these tables here? Every Thursday, they sell a great steak sandwich at this gas station. They must sell a thousand of them."

I drove east, away from Bismarck and Mandan on Interstate 94 through Menoken and McKenzie to Sterling, where I stopped to eat a half-order of biscuits and gravy and read *Outdoor Forum* before turning at exit 182 for US-83 south.

North Dakota in pheasant season is ashy silver, yellow, rusty orange and white, cinnamon brown and gray, green and gold, with masses of crows—the word for a religious gathering of crows is not a *mass* but a *murder*—crows lifting off from, or settling into, the corn stubble.

"We keep it simple out here," Jim had told me, and it's easy to see how the environment enforces that. North Dakota is simple. For long stretches, nothing is visible but the earth and the sky, and

their unadorned hugeness is on a mythological scale: the sexual congress of Gaea and Uranus, the primal scene of creation.

In this simplicity, a man is revealed as what he is.

"Away with everything," writes Valéry, "so that I may see."

A cloudy day. The mirror of Long Lake at Moffit, slashed open by the two lanes of US-83.

Martha Argerich was on the radio, ripping through the bourrées from Bach's English Suite no. 2 in A Minor as I ripped through Hazelton, North Dakota, at eighty miles an hour in my big red rented Lincoln with its California plates.

I thought: Maybe this trip is not the best idea I ever had. What is the best idea I ever had? How good was the best idea I ever had? Have I already had the best idea I'm ever going to have?

Temvik Butte, Linton Municipal Airport—OUR CONCERNS: RE-SPECT FOR GOD AND LIFE, VOCATIONS, PATRIOTISM—Lawrence Welk Highway, ONE MILE TURN RIGHT FOR THE WELK HOME-STEAD HISTORICAL SITE. WELCOME TO STRASBURG, BIRTH-PLACE OF ACCORDIONIST LAWRENCE WELK.

The sun came out as I passed Rice Lake and entered South Dakota, 120 miles to Pierre, where in the brown-and-yellow seem-ing unpeopledness I was seized by a fierce and bizarre desire for a Hostess King Don, a so-called treat I had never enjoyed as a child. Why did I want one now? As I considered this, I was caught in a speed trap by a nice deputy young enough to be my son, if I had knocked up my high school sweetheart.

WELCOME TO HERREID, YOUR FIRST STOP IN SOUTH DAKOTA.

"Sir, I pulled you over today because I clocked you doing forty-five miles an hour in a thirty. Can you tell me why you did that?"

"Because I am a fool. That is why."

"License and registration, please."

"My license is in my pocket, officer. I'll get it for you now."

"Hey, sir. Look at me. You don't have to tell me where you're going to put your hands."

"My father was a military policeman in Vietnam," I said.

"And I appreciate the respect you show the uniform. You're far from home. I'm going to run this license, and if it comes back clean, I'll give you a verbal warning. Listen, sir. Shake my hand. I have a television, you know. I can see these terrible cops murder-

ing decent, innocent people. It makes me sick. It makes me cry."
He let me go.

MOUND CITY, POPULATION 71. Three miles east of Akaska, it can
no longer be ignored: North Dakota is beautiful, but South Da-
kota, *l'Amérique profonde,* is more beautiful still, with its far vistas of
yellow and brown and gold.

Three small silos, seven larger silos. To the left, a field of sun-
flowers with their heads bowed, as far as the eye can see. To the
right, corn, as far as the eye can see. And the eye can see very far.

Outer space becomes inner space. All the visible distance, geog-
raphy as prophecy: it does something to you inside.

What happens in South Dakota is a man sees so far ahead of
himself that he can see with his own eyes how things are going to
be, what's going to happen next, if he keeps moving in the same
direction.

Was that sign defaced, or did it mean to indicate "Agar, pop. 3"?
AGAR, HOME OF THE 1977 STATE B TRACK CHAMPIONS.

Past Onida and on into Hughes County and the state's capital,
Pierre, South Dakota, population 13,646. Back in Bismarck, Dan
had warned me that Pierre was rinky-dink, but it looked all right
to me.

When I went to get dinner, the sign outside my motel said,
THE EARTH HAS ITS MUSIC FOR THOSE WHO LISTEN. I ate the
chicken taquito plate with red sauce at La Guadalajara and walked
around beautiful La Framboise Island, called by Lewis and Clark
"Good humered [*sic*] Island." I saw the sun set over the quiet Mis-
souri River and watched dope deals happen in a nearby park be-
fore walking back toward the grunts and coughs of the trucks on
the main drag. Now my motel's sign said, ARISE PETER KILL AND
EAT ACTS 10:13.

Bearing in mind what Dan had told me about the importance
of gas stations to civic life in small towns in the Dakotas, I took
a chance the next morning on a superb quad shot from a joint
marked COFFEE ESPRESSO LATTE, DRIVE THRU IN ALLEY, LIVE
BAIT. You guys think I can make Omaha in seven hours?

"If you drink that, sir, you'll make it in five."

*

Don't die until you've seen the sun come up over the Fort Pierre
National Grassland. But I'd had enough of US-83. I'd been driving
dead south all day, keeping the sun on my left, burning my face. I
turned east on Interstate 90, running parallel to old US-16 at Viv-
ian, 187 miles to Sioux Falls.

I had coffee, two eggs, toast, bacon, hash browns, and more cof-
fee at Hutch's Café & Lounge on Highway 16. Near my booth, the
regulars grumbled about work and women.

Can you poach those eggs for me?

"No."

I know some men who will fight in a cage for money, and I know
a couple who will do it just for fun. But I didn't know anyone who
would drive with me through Nebraska.

In 2014, I had a disturbing personal experience, the kind that
half the time you call a *hallucination* and the other half an *insight*
—half *breakdown*, half *breakthrough*. The vision came to me as I
burned a copy of Michael Eigen's *The Psychotic Core* in my grill.

My girlfriend was horrified. "As good almost kill a man as kill a
book," she said.

"No," I said. "As good almost kill a man as kill a *good* book. Who
kills a man kills a reasonable creature, God's image; but he who de-
stroys a good book kills reason itself, kills God. It's from *Areopagitica*."

"Sometimes I hate you," my girlfriend said.

We watched *The Psychotic Core* curl and smoke. It's a good book.
Eigen is an unusually interesting psychoanalyst. William S. Bur-
roughs once claimed that "a psychotic is a guy who's just found
out what's going on," but Eigen does more than make wisecracks:
he wonders what it means to *find out what's going on.* "The psy-
chotic person dissolves his mind in order to rebuild himself from
its elements. Or he may seem to need to search grimly through its
debris, leaving nothing out, as if he were looking for something es-
sential, but still unknown. He cannot rest until he sees everything."

"Where they burn books," my girlfriend said, "they will, in the
end, burn people."

"They burn people everywhere, all the time."

"Sometimes I hate you so much," she said.

The number of places in this country that call themselves the core,
THE CROSSROADS OF AMERICA, will astonish you—from Indian-

apolis, Indiana, to Vinita, Oklahoma. In a game with no rules, in a circle without circumference, every point has equal claim to be the center.

Kearney, Nebraska, contends that it is the Midway City, 1,733 miles from San Francisco to the west and from Boston to the east. My beef with Kearney isn't Nebraska's problem; it's mine. My first professional assignment, which I botched, was to review *The Echo Maker*, a novel by Richard Powers set in Kearney. Richard Powers is not my kind of novelist, but *Dick Powers* is a good name for a man.

A blond girl in my hotel in Omaha had flown from Baltimore for her company's annual meeting. "We could have Skyped it," she said, her hair still wet, as she pushed the elevator button. "Are you going to one?"

"No, I'm going to eleven. Eleven is like one, but it's twice as good." She stared into my eyes. "Take me with you," she said.

One rainy morning in Nebraska, you wake up and look out the hotel-room window at a red thread-leaf maple and you say: *Remind me what we're doing here.*

You say: *We are driving to the center of America.* It's a metaphor, bright boy. A journey to the central issue, a reconciliation with the Founding Fathers, the mythic lawgivers, the Dick Powers.

A teenage boy dressed all in black except for the white soles of his low-top Chuck Taylors and his white socks—black hair, black glasses—he's staring out across four lanes of State Highway 2 into a cornfield, at the Sapp Bros. gas station in Percival, Iowa. He's still there, staring. The movie posters for *Easy Rider* said, A MAN WENT LOOKING FOR AMERICA. AND COULDN'T FIND IT ANYWHERE. In Iowa, you can *not find* it everywhere you turn. It's right there, staring you in the face. If you don't see America, is that America's fault?

On the fifth day of my trip, I headed west out of Kansas City. One telephone pole, like a crucifix. A vulture wheeling over the divided highway.

I took I-29 south looking for the exit to Topeka. I passed massive car dealerships, and the Worth Harley-Davidson clearance tent sale, and Dick's and Dillard's at the Congress Avenue overpass three-quarters of a mile from Amity Avenue.

The sky was pale blue with thumbprints of cloud over I-435 to Topeka into Wyandotte County. I drove past exit 13 to the National

Agricultural Center and Hall of Fame and the Kansas Speedway, and took I-70 west, listening to the poison drip of AM talk radio.

At the Leavenworth County line, I saw yellow wildflowers and orange-and-white traffic cones and parked construction equipment. I passed exit 212 to Tonganoxie and Eudora on 222nd Street.

ELLSWORTH PRISON IS HIRING, said a billboard decorated with a giant sunflower.

I entered Douglas County and headed for 1927 Learnard Avenue, the little red house where William S. Burroughs lived in Lawrence, Kansas, from 1981 until 1997, when he died. Burroughs's house in Lawrence, with its white balustrade, is the geopsychic core of my American earthquake.

It is difficult to understand, rereading it twenty years later, how Burroughs's little book *Exterminator!* could have motivated me to become an exterminator. I wanted to be a writer, Burroughs was a writer. Burroughs had been an exterminator, I would be an exterminator. What a foolish reason to be an exterminator.

The Japanese beetle, or *Popillia japonica,* is a scarab beetle. *Animalia, Arthropoda, Hexapoda, Insecta, Coleoptera* ("beetles"), *Polyphaga, Scarabaeoidea, Scarabaeidae, Rutelinae* ("shining leaf chafers"). Its colors are coppery and metallic green. It is a lovely little creature.

I don't think I ever knew the name of the poison we used: acetamiprid, or chlorantraniliprole, or what, exactly. In June 1995 alone I must have killed at least three thousand Japanese beetles, maybe twice that many. I am sorry for what I did.

I drove straight to the Burroughs house, past a clockless tower bricked in, I imagined, so as not to provide a rifleman a wide field of vantage. I parked the rental and stood there, staring at the place where Burroughs had written *The Western Lands.* It was a house.

A man opened the screen door and stepped out onto his front porch. He wore a white T-shirt and red gym shorts. He was bald on top, with a wild tuft of blond hair over each ear.

He said, "Can I help you with something?"

"No, sir. I'm here because—"

"Burroughs!" he said. "I will warn you. It's illegal to park there. And they will ticket you." He closed the door.

I tried to gather my impressions. All I responded to was the lamb's ear and daylilies planted by the roadside mailbox. The temple was empty. I stood there, not finding anything like the deep, pervasive meaning I had wished for, and I mourned.

Mourning is creativity, writes Alice Miller in *Prisoners of Childhood*. It's a good name for a book—it would be a good name for our planet.

I drove down to the freight-train station and sat in my car and watched the rail containers pass. Maersk SeaLand, CSX Intermodal, Schneider National, Hyundai, Matson, China Shipping, Triton.

The redheaded girl at the hotel's front desk said, "We have you in our haunted room. I hope that's all right." A gateway to another dimension!

"Maybe I can use it to go home," I said.

People from all over the country visit that hotel to stay in its haunted room. It has been filmed more than once, and it is mentioned in several books about haunted US sites.

In no time I was snorting pills off the top of the haunted dresser. There is no point pretending this wasn't my plan for my life. On the contrary, it has cost me years of precise, unremitting effort to arrive here.

I tell myself I'm clean and sober, but it's the same every time I go out of town: snort some pills, eat some lasagna. I walked down Kentucky Street to the Kaw River and smoked a Fuente Long Story. I looked at the light on the water. I fell asleep in a restaurant. The bartender looked at me over her arty eyeglasses and brought me a cup of coffee with six Coffeemates.

"Do you think six will be enough?" I said.

"I like my coffee like I like my men," she said. "White and sweet. You want something to eat?"

"It says here that even the most jaded palate will be ravished. Ravish my palate. Relish my pivot. Polish my rabbit. Pilot my radish."

"I'll bring you a menu," she said.

Why stop in Concordia, Kansas? Because of a Union soldier named Boston Corbett. In 1865, Corbett killed the killer of President Abraham Lincoln, who had presided over a deeply divided country. Lincoln's assassin, John Wilkes Booth, had been trapped in a burning barn and Corbett had been commanded to capture Booth alive. But he could not resist the echo of shooting Booth from the same angle from which Booth had shot Lincoln.

It seems Corbett's personality was not well structured. He had, for example, been so concerned as a young man about the man-

agement of his sexual urges that he'd cut off his testicles with a pair of silver sewing scissors. And the national attention focused on him in the wake of killing Booth drove him madder still. Corbett moved to Concordia and dug a hole, and he lived in that hole until he died.

These, at least, were the facts as I then understood them. I planned to visit Corbett's Hole. I figured I could find it with a little help. The local Boy Scout troop had raised a monument nearby in 1958.

"And then what will you do?" said my friends.

"I'll stand there and see how I feel."

"Have you never heard the expression *Be careful what you wish for*?"

"Yes, of course. I have heard that expression many, many times."

In the vision that came to me as Eigen's *Psychotic Core* burned on my grill, I saw that the ancient Egyptians were correct: There is another world beneath this one, a spirit world called the Duat, where Amon-Ra's sun chariot rides unseen while we face the dark of night. The truth of that world is this: When Booth killed Lincoln, Booth became shadow president of the United States. When Corbett killed Booth, the man who had killed the man who had been the president, Corbett became the president.

President Booth kills the Lincoln-father, Corbett kills the Booth-father, and then Corbett crawls into a dirt hole in Concordia. Until 1894, the year it is assumed Corbett died, the president of the United States lived like a rabbit in a hole in the center of the country.

The president of the United States! It is an open question as to which is more pernicious: the wish to command or the wish to obey. Where there is no vision, the people perish. But the people will perish anyway.

We know what we want. First we want to make a president or a king-in-the-woods, a godfather or a father-god. Then we want to kill our god.

We want to kill the great white god under the sea, as in *Moby-Dick*, as in *Jaws*, and we want him to rise from the dead so we can kill him again, as in *Jaws 2*, *Jaws 3-D*, and *Jaws: The Revenge*.

Most of all, we don't want to know that the *him* we kill is really *her*: a white whale disguising a black hole.

And why shouldn't we kill our god? It's not as if Jesus was such a sweetheart. When's the last time you read the Parable of the Talents? "For unto every one that hath shall be given, and he shall have abundance: but from him that hath not shall be taken away even that which he hath. And cast ye the unprofitable servant into outer darkness . . . Depart from me, ye cursed, into everlasting fire."

Or, as Billie Holiday sang, "Them that's got shall get, them that's not shall lose."

On my way to Concordia, I drove past McCray Lumber and Millwork, Nail Arts, Lawrence Feed & Farm Supply, Title and Payday Loans, Jayhawk Pawn & Jewelry ("money to loan"), and CarQuest. I took I-70 west. At the Topeka city limits, I saw a billboard: THE HOLY BIBLE. INSPIRED. ABSOLUTE. FINAL. 855-FOR-TRUTH. PSALM 119:89—which is to say: *For ever, O LORD, thy word is settled in heaven.*

I passed Hickory Knob, and Buffalo Mound, and Paxico. I passed exit 301 to Fort Riley, home of the Big Red One and the US Cavalry Museum. I drove past the 2ND FRIENDLIEST YARN STORE IN THE UNIVERSE. At exit 250B, I took US-81 north.

I was doing ninety-five miles per hour in a car I didn't own, listening to Mötley Crüe's "Girls, Girls, Girls" in the middle of Kansas. Happiness. The sky was everywhere. I passed Snell Excavating and Demolition at the Concordia city limits.

The girls I met when I stopped to ask directions, Raylene and Miranda, were sweet and helpful. They said there'd been a big rain and I'd never make it up the muddy hill to Corbett's Hole. They sketched an alternate route.

"I can't believe you said my name right the first try," Miranda said. "My mother invented it. She couldn't decide whether to name me Mary or Amanda. But that didn't cause you any problem at all."

When the road turns to dirt, you're onto something. Same goes for a bridge two cars can't pass side by side. Soon I was throwing up mud in a rooster tail. In the rearview mirror, I saw my tire tracks zigzagging out of the Walk-in Hunting Area.

Alfred, bring me my Dante: *Let all those whose dull minds are still vexed / by failure to understand what point it was / I had passed through, judge if I was perplexed.*

A hawk came in low. The car fishtailed in the mud. I was stuck in a wet, brown hole in the center of our country.

South of Belleville, I turned west on US-36. A man wearing a flower-print dress got out of a minivan at Panther Pause near Scandia, a convenience store on the Republican River. If it wasn't a dress, I'd like to know what he thought it was.

I drove through Montrose. *Except ye see signs and wonders, ye shall not believe,* says the Gospel of John. I saw a sign that said, WELCOME TO MANKATO. I saw a raccoon crossing the road in broad daylight. I saw a sign for MAC'S KWIK STOP GAS=GRUB. I saw a sign for the annual Jewell County Threshing Bee.

"You're far from home," a man at the next gas pump said.

I looked at his van's plates. Utah.

"I could say the same about you. That's pretty country, that Utah. I was stranded in Zion once."

"You were *stranded* in Zion?" he said. "That's funny."

"It wasn't funny at the time."

"That's not what I mean. It's like saying you were *held prisoner in heaven.* You know what I mean? The castle of Zion is the city of David. Out of Zion, the perfection of beauty, God hath shined. You know? Let them all be confounded and turned back that hate Zion."

"Got it."

"Yet have I set my king upon my holy hill of Zion. The LORD loveth the gates of Zion. The Redeemer shall come to Zion."

"Right on."

"Thus saith the LORD, I am returned unto Zion."

"Yes, man," I said. "I understand you."

Lebanon, Kansas. The center of the country. A cairn of stones, a plaque, an American flag, a green picnic table, a spring-loaded toy horsey for children to ride on. And a little chapel.

A man took a selfie while in his other hand he held—what? "I told my friend I was going to the belly button of America," he said, "and what I've got here is the biggest fistful of navel lint I figure anybody has ever seen. Can you imagine how many weeks I cleaned my dryer filter to collect all this?"

I strolled past the children at play and went into the little white

chapel. On the pulpit in the dead center of our country, a Bible was open to Ezekiel 36:36–38:7, the valley of dry bones and Gog in the land of Magog.

Marion, don't look at it, I heard Indy say. *Shut your eyes, Marion, don't look at it, no matter what happens.*

Instead, I knelt to pray. But what to pray.

Despeñéme en la sima y saqué a luz lo escondido de su abismo, says the Knight of the Wood to Don Quixote: I threw myself into the chasm and brought to light what lay hidden there in darkness.

I said: *Our Father, who art in heaven.*

Outside, in the park, a little girl shouted, "Daddy, look!"

I drove away from the center. I passed a pale yellow cinder-block garage.

I took 181 south to Downs and turned east on 24 and passed Cawker City, home of the world's largest ball of twine. I passed Waconda Lake and Beloit and Asherville and Glasco and Miltonvale and Clay Center, and just before Leonardville I turned south on 82 and then east again at Bala on 24–77.

I was north of Maple Hill, fifty-four miles out of Topeka, when the radio warned me that *circulatory* activity had been detected, *circulatory* being a polite way to say *tornadic.* It's difficult to maintain the feeling you aren't in Kansas anymore when you're still in Kansas.

I changed the radio until I found Led Zeppelin playing "Trampled Under Foot" and turned it up as loud as it would go. Pretty loud.

I drove into the biggest storm I ever hope to see. All I saw was sky, and the storm filled the sky. It began to hail whomping big rocks. I saw a double rainbow touching on both ends while lightning struck unceasingly all round it.

Oh my God, you can't be serious, I thought. What is the point of driving ten hours out here past where Judas threw his boots if no one is going to believe me when I get home, unless you people see signs and wonders you will never believe, but I'm looking right at it and I still don't believe it.

Before long, I was hydroplaning across an overpass at exit 355 to Forbes Field Airport via 75 south. As I spun in circles, I thought about my own death. It has to happen sometime.

*

To Oklahoma then I came, where the hotel bar had five trompe-
l'oeil bookshelves painted on its walls and not a single real book
to be seen. There was something faintly untoward, not to say *treif*,
about my fried-chicken sandwich served with an over-easy egg on
top. I ate it. I can eat fifty eggs.

There were weddings in Oklahoma, weddings everywhere I
turned. The brides' mothers appealed to me much more than the
brides, a sign of a new era in a man's life.

In those huge Oklahoma skies, each evening was momentous. I
listened to the Schweriner Blechbläser-Collegium play Handel for
brass as the sun went down over Oklahoma City.

In the morning, in Oklahoma, a retired dairy farmer told me
and my new friend Gloria about the old S&H green stamps over
country-fried steak with gravy, biscuits, breakfast potatoes, and two
poached eggs.

"Long day?" Cody asked when I pulled over for a sandwich at
his lunch counter. He could tell just by looking. I had to admit
it, the drives were wearing me down. "You be careful. Drive safe,
now."

I took I-40 west through Oklahoma to Texola at the state line
and on to Shamrock, to resume driving south on US-83.

Everywhere I turned in Oklahoma, I saw signs instructing me
to stop here or there and buy this or that. But in South Dakota,
the road signs had said, IT IS FORBIDDEN TO STOP YOUR CAR IN
THE PROTECTED NATIONAL GRASSLANDS.

Do you think I can make Abilene in four hours?

"I've never heard of that town, sir."

In Texas, Route 83 passes through Perryton, Canadian, Wheeler,
Shamrock—another Crossroads of America, with a Happy State
Bank and a Dollar General, Tendall's Rexall Drugs, Sears Rob-
ertson Refrigeration, Geana's Chop Shop, Accurate Remodeling,
Bartlett's Lumber & Hardware, Budget Fuels, James Reneau Seed
Company, and the El Sombrero Restaurante—through Lutie and
Wellington—home of the Wellington Skyrockets 2013 state foot-
ball champions, home of the Salt Fork Cafe and Cherokee Inn,
Roberson Family Restaurant ("truck parking at rear"), the Get-
tin Spot Drive Thru and the Taco Shack—through Childress, Pa-
ducah, Guthrie (pop. 160), Aspermont (pop. 919), Hamlin, An-

son, and Abilene. It's like a song, or a poem. It's the country itself
that writes the poem.

Every man at the gas station in Childress was wearing a cow-
boy hat.

Three dead wild boars lay by the side of the road in Radium,
Texas.

WELCOME TO ANSON. Waylon's Tire Service, the *Western Ob-
server* newspaper (est. 1883), ANSON CHAMBER OF COMMERCE
WELCOMES HUNTERS, Haechten Crop Insurance, and Butter-
beans Busted Knuckle Garage.

And then there was Sam. I handed over my rental car and got in
Sam's shuttle for a ride to the Eleganté hotel.

He said, in his bewildering English, "Tell me something, sir. You
for Trump or Hillary? It don't matter much to you? Listen, sir.
When Hillary Clinton crooked. When she crooked. And she lie."

"To a certain extent, that is true," I said. "But Donald Trump is
also crooked. And almost every word he says is a lie."

Sam seemed never to have considered this. "Yes," he said, and
he frowned. "But I tell you, sir, when they taking IN GOD WE
TRUST off the money. When this country built on God and trust. I
trust him. In my gut."

Sam trusted his gut. I'm not saying I blame him. My instinct
had taken me in search of my country's psychotic core, or my own.

My gut said, *Drive,* and I answered, *O gut, I hear and obey.*

When's the last time you had a long look at what emerges from
your gut?

Sam dropped me off at the Eleganté hotel across from the Mall
of Abilene. I ordered the Monterrey plate at Ta Molly's (two sour-
cream chicken enchiladas, one soft cheese burrito, refried beans,
rice, and guacamole) and cut the end off a cigar with a steak knife
at the table.

I ate my dinner and walked out into the dark and sat on a
rock and lit my cigar. A truck slowed and a man leaned out its
passenger-side window.

"You're an asshole!" he shouted.

Traveling While Black

FROM *Catapult*

In Good Company

AT THE LEFT EDGE of a field of ombré blue flies a rough-legged hawk, talons extended, the dark brown tips of its tail and wings unfurled, mouth open mid-key. This is the cover of my book *Smith Blue*. I loved the image from the first moment I saw it. I love the hawk's unapologetic hunger and vigor. That hunger, those talons, were nothing for which the hawk needed permission. For the cover of a book about surviving—thriving, even—in a time of global and domestic strife, Dudley Edmondson's photo of a hawk in the midst of graceful predation is perfect. Dudley lives in Duluth. The summer my daughter turned four, my family spent a few days in northern Minnesota, aiming to take a break from the routine patterns of our lives. On our final day in the state, the three of us, plus our friend Sean Hill, drove to meet Dudley at a restaurant on the shore of Lake Superior.

As much as I liked Dudley's art, it was clear that day that Ray, my husband, and Sean loved Dudley even more. The three men grew loud and large over our lunch together. They all sounded blacker to me in each other's company than they usually tended to sound. Which means that they sounded comfortable and happy in their bodies, that they cracked jokes in a particular kind of way about particular kinds of things, that they laughed upon receiving these jokes as well as on delivering them, that they danced a little when they walked. This is not to say all black people are good and constant dancers. It is to say that these three men were happy and

light, that there was—as I have often heard said about others, but I have not often been able to say about my husband or these two friends—a spring in their steps.

There is a joke I have heard more than once that there are only five black birders in the country. Two of them are Sean and Dudley. Another, Drew Lanham, is also my friend. Which is to say that I am, according to lore, personally acquainted with 60 percent of the nation's black birders. This would be shocking if my life weren't filled with statistics that put me in company with others who are also virtually alone.

The three men spent lunch comparing notes about living in America in black bodies that were regularly confused with the bodies of other black men. Funny at first, the stories of being mistaken for a birder half a foot taller with completely different hair. But they soon became less funny. What a menace, to live in bodies that might be anybody's, that are so frequently assumed to be corrupt. To be followed through stores by security. To be stopped and frisked as they walked to their offices. To be both erased and singled out. Their storytelling was a performance of one-upmanship. This story was worse than that story, was worse than the story one of them had just told, and always—this was the crux of the celebration, that it had not yet come to this—there was another story, much worse, that at any given moment the survivors might be left behind to tell.

After lunch, Dudley took us to one of the bluffs surrounding Lake Superior. "It was there and gone before I even saw it," he said, crouching in the spot where he'd captured our rough-legged hawk. He'd snapped the picture, but hadn't taken aim. Dudley is a masterful photographer. I am not writing this to underplay his skills. That is one of the things that keep me up at night: worrying that I'll make difficult work sound easy.

His camera, Dudley said, just happened to be pointing the right way at the right time.

The Monument

"You wrote about a lynching that happened in your hometown," Dudley told Sean as we left the poetry reading we'd all attended after our shared lunch. "I want to take you up the street to show

you the memorial to a lynching that happened here." We are all telling the same story. When writing about race, there can perhaps be precious little wholly fresh revelation. As with writing about motherhood. It has been the same story for as long as anyone can remember. As with writing about the corruption of the body. As with writing about the landscapes of our world.

We walked up a hill and looked toward the corner of First Street and Second Avenue. Ninety-four years and fourteen days earlier, the mutilated bodies of Elias Clayton, Elmer Jackson, and Isaac McGhie hung from a streetlight. For the sculptures erected there to memorialize the three, artist Carla Stetson used young local men as models.

This is where I am supposed to tell you the story behind the lynching of Clayton, Jackson, and McGhie, though there really isn't any reason for it. Clayton, Jackson, and McGhie were black bodies in the wrong place at the wrong time—which could be any place in this country, at any time.

"Roustabout" is one of the words used to describe Clayton, Jackson, and McGhie, which meant they worked for the John Robinson Circus as cooks and physical laborers. Consider "outlandish": people—originally black people—who come from other places and bring with them "outlandish" ways of moving through the world. Consider "hippie": in the Senegambian language known as Wolof, "hippi"—from which we get the terms "hip," "hippie," and "hipster"—means to open one's eyes. And also to be sold down-river: a phrase that originally referred to the sale of enslaved human beings to more treacherous destinations along the Mississippi River basin. Words with derogatory shading—like "roustabout"—are often words that were associated with black bodies as they moved through America.

These particular roustabouts happened to be working in a circus that visited Duluth. On June 15, 1920, a mob of white men—some say more than a thousand, while others say as many as ten thousand—wanted them dead. The three men were being held in jail, supposedly for their protection. "The people who were outside were saying, 'Just give us somebody,' and that first somebody was a young man named Isaac McGhie," says Michael Fedo, author of the book *The Lynchings in Duluth*.

Our little party spent a good deal of time walking around the monument. It fills a whole corner of the block and features quota-

tions by people like James Baldwin, Martin Luther King Jr., and Euripides. "The truth is rarely pure, and never simple." Oscar Wilde. "The world is a dangerous place, not because of those who do evil, but because of those who look on and do nothing." Albert Einstein. Siddhartha Gautama: "Holding onto anger is like grasping a hot coal with the intent of throwing it at someone else. You are the one getting burned." Over the top of the monument scrolls a quote from Edmund Burke: "An event has happened upon which it is difficult to speak and impossible to remain silent." The quotations are familiar. If not in their particulars, at least in their ilk. Written against the damage we do to others and ourselves. The only new language on the monument is the description of the final hours of the lives of Clayton, Jackson, and McGhie.

I pointed my camera catty-corner across the street to the site where McGhie, Jackson, and Clayton were killed. (I keep using their names because I don't want to let myself be part of the men's erasure.) Duluth has maintained its brick streets in this section of town, but in places, as in the intersection of First Street and Second Avenue, there are tarred spots to patch potholes. My photo also reveals a crack in the sidewalk leading toward Second Avenue. The harsh climate in Duluth takes its toll.

In the image, the streetlight on that particular corner was attached to an arm from which hung a number of signs. The first sign read FIRST ST. The second was gray with a white P in a blue circle. PUBLIC PARKING, it read. A white arrow indicated which direction to proceed. The final sign, closest to the traffic light—which was red in my photo—was black-and-white. It read ONE WAY. An arrow pointed in the direction of the Clayton Jackson McGhie Memorial. Sometimes it is easy to draw meaning from the arbitrary order of things.

Ray's arms are long, and so it was he who captured a photograph of all of us in front of the monument. My four-year-old daughter, three of my favorite black men, Nancy, and me.

Routine Traffic Stop

That night in Duluth, dinner turned into a lingering dessert. The restaurant closed around us. Callie fell asleep with her head in my lap.

Our family had to fly back to Colorado early the next day. We finally said goodbye to Dudley. In the front seat of the car, Sean and Ray kept up their conversation. The two-lane highway was dark. Callie and I tried to doze in the backseat's blackness. Ray passed two sedans. Lights and a siren filled our car.

When the Minnesota State Patrol officer approached the passenger-side window, he found two black men prepared for the worst. Sean's hands were open and positioned on the dashboard. Ray's arms were in the air, the wallet in his hand already open to his ID. Long before he met me, Ray attended police academy in California. There are over a thousand code violations you can come up with, he told me. If you want to pull someone over, he told me, you can always come up with a reason. He told me this three years ago, when we were driving in our new town in Colorado and, for no apparent reason, he was pulled over. I asked, What were you doing wrong? This, he reminded me, is an irrelevant question.

"Uh, sir," said the officer, clearly startled by the two black men in their positions of surrender, "you can put your hands down."

Ray did so, but very slowly, handing his ID to the officer as part of the arc. The cop, after trying to strike a balance between reassuring him and scolding him for speeding, walked to the squad car and ran the license numbers to see if there were warrants in Ray's name. Mosquitoes swarmed through the open window as the officer handed Ray his citation. I slowly covered my daughter's exposed skin with a light sweater, trying not to alarm anyone with a sudden slap.

I'd been in Minnesota the year before to teach at the same writers' conference that had brought my family to the state that summer. The day I flew in the first time, self-appointed neighborhood watchman George Zimmerman was acquitted of the murder of Trayvon Martin, a seventeen-year-old black kid walking home from buying snacks. Our routine traffic stop happened just a week after Texas police shot and killed thirty-eight-year-old Jason Harrison, a black man. And one month earlier, Eric Garner, a black forty-three-year-old father of six, had been choked to death by New York Police Department officers. It was six weeks before Ferguson police shot Michael Brown, and five months before Cleveland police shot and killed twelve-year-old Tamir Rice while he played in

a community recreation center. I made it clear to Callie that she should not open her mouth to ask what was going on.

Nine months before we were pulled over, unarmed twenty-four-year-old Jonathan Ferrell endured and died from ten gunshot wounds when he approached police officers while seeking help after a car accident. Moses Wilson, one of the jurors who sought a murder conviction for the police officer who shot Ferrell, said after the trial, "It became not what he did, or what they did to him, but more, what he didn't do, what he should have known what to do, so that the police would not either beat him silly or shoot him." These are some of the reasons that Sean's hands remained on the dashboard when we were pulled over.

Sandra Bland had not yet been killed after a routine traffic stop in Waller County, Texas, but in June 2012, the unarmed twenty-three-year-old Shantel Davis had been shot by police just after shouting, "I don't want to be killed, don't kill me!" In a month, Renisha McBride would be shot in the head when she knocked on a door seeking help after a car accident in Dearborn Heights, Michigan. I wish I could say that the night my family sat on the side of the road in Minnesota I couldn't have imagined that two years later, just thirty minutes from the airport we would use to fly out of the state the next day, four-year-old Dee'Anna Reynolds would find herself trying to console her mother from the backseat of a car whose driver, Philando Castile, had just been shot and killed by a panicked police officer. But I worry about such horrors all the time. These incidents, those that happened before and those that would happen later—like the monument we'd visited earlier that afternoon—were not irrelevant to our behavior that evening.

The four of us had no voices as we pulled back onto the highway and drove north through the pitch-black night.

After a few miles, Ray laughed, breaking our silence. "One thing we can say for sure," he said into the darkness, remembering the officer's shocked expression when we rolled down the window and he took us all in. "That was not a case of driving while black."

These are the jokes you make when you are always, at some level, afraid for your life.

MATTHEW FERRENCE

The Foxes of Prince Edward Island

FROM *The Gettysburg Review*

NINE MONTHS BEFORE I knew anything at all about the brain tumor, I drove through the slowly arriving spring of Prince Edward Island National Park. Winter had been rough that year in Atlantic Canada, socked hard by late heavy snows. Even in early May, the shady banks of the coast road still held massive snowbanks, cold and deep with surfaces crusted over and pocked with dirt and twigs. To my right, the Gulf of Saint Lawrence spread across the horizon, gray-blue, nearly as cold as the snowbanks. Lobster buoys dotted the surface, the fleet having finally been able to set traps after several delays to the season, the harbor ice melted and hacked out enough to get going. The ferry had just resumed running from Nova Scotia across the warmer Strait of Northumberland, it also beset by ice. Coastal shrubs still waited to bloom, their limbs dulled and winterized. Everything about the landscape seemed to be in suspension, everything on pause. New growth came slowly, and though spring carried its usual insinuation of relief and hope, this too seemed measured, cautious.

I steered around a bend, and there in the middle of the road was a fox, one of the many that call the island home. He was a typical red, but even from a distance, I could tell his pelt was mottled and frayed. This could have been a sign of spring, the molting of a heavy winter coat in anticipation of summer, probably was. But I also knew enough about the foxes of my childhood farm in Pennsylvania to think about disease, about the slow death of mange, relentless mites causing an animal to turn its teeth upon

itself. Invisible pain drives afflicted animals mad, the tearing of fur and opening of flesh the result, false relief that leads often to infection and demise.

The mottled fox waited, curious. I slowed my car, then stopped, and we watched each other. I noticed his eye, the glaucous, blind, all-seeing whitened magical dead eye, his right. Eventually, he moved out of the road, and I crawled forward. He watched from his good eye as I drove past along the coast road, and I watched in the rearview mirror until he disappeared from my view.

My wife, two sons, and I came to the island that spring for a half-year respite. I had taken a sabbatical from my teaching job, and it seemed the escape could not have come at a better moment. I was off kilter that spring, had been for a long time, feeling displaced by turmoil in the place I worked. The previous year, a colleague had been arrested by the FBI, and I'd had to negotiate both the burdens of his teaching load and the psychological crises his betrayal ignited in our students. His crimes had been against children, and the shortness of his eventual prison sentence seemed to me an outrage, as did the apparently blind support some of my other colleagues offered him. Maybe this was because I knew him less well, or because I had young children. Perhaps I carry less capacity for forgiveness, or maybe forgiveness is undeserved when a person collects and shares half a million images of children on a well-cataloged external hard drive.

Elsewhere in town, the opioid crisis of the United States churned, a new meth bust it seemed every week. Addicts had taken to new methods of manufacture, a "shake and bake" system that involves throwing cold medicine and shaved match tips and lithium batteries in a pop bottle, shaking it up, then regulating the gas pressure by twisting the cap. From time to time, when the reaction goes out of control, the bottles are tossed in someone's yard. One Sunday afternoon, someone chucked a smoking bottle into a four-year-old's birthday party just a few blocks from our house.

I'd been suffering strange physical symptoms as well, something I chalked up to stress. My face would flush, and my eyes would get hot, as though I were allergic to life itself. I'd be so tired after teaching that I'd just sit, exhausted, unable to move, think, or do anything at all. I had also started to notice that my glasses never

seemed right for my left eye, but three optometrists over the past few years had checked and assured me that everything was fine, that the eye was healthy and there was nothing to worry about.

Eventually, my wife convinced me to see my doctor about the flushing symptoms, which set off a long sequence of testing. I gave up vials and vials of blood, collected my piss for twenty-four hours in a giant bottle, gave more vials of blood, lay awake at night thinking about my boys, then two and six, and sobbed into my pillow. I endured therapeutic blood lettings, and I scraped my own shit into plastic jars, wondering how to gracefully drop off my urine and feces at the local lab, particularly after everyone there got to know me on a first-name basis.

We found nothing, only curious results indicating, well, *something*. By the time we reached the island that spring, I was beginning to think of my health concerns as a matter of history. I doubted any future diagnosis and figured only that I'd be checking in with my new hematologist from time to time as a formality. I didn't know yet about the tumor. I didn't realize that I was living in the temporary stillness between "you're fine" and "you're not."

So, when we arrived at Prince Edward Island, I had some unarticulated goal of renewal. We were a thousand miles away from the troubles of home, and that seemed like an important separation. We moved into a cottage overlooking the Hunter River, tucked into a quiet dead end behind the New Glasgow cemetery. There was a rusting bus in the front yard, something our landlady apologized for but that I found appealing enough to post on Facebook as a sign of rugged northern beauty. Foxes had covered an old spare tire chucked in the bus's interior with an impressive pile of scat, marking territory with a heavy musk. I imagined this as a war to claim the bus as a winter den.

Evenings, I drove through the national park and looked for foxes, mostly for *that* fox. I thought about landscapes and recovery, about being drawn to this place that is not so different from the place I am from, western Pennsylvania coal country an analogue to the Maritimes even in the ways that the people are stereotyped as backward, and less, and hick. But I thought also about being always in exile, never belonging to either place. My parents were not from Appalachia, meaning it was not theirs by birthright. And living on PEI wasn't exactly being a "summer person," but I'd never be an islander. Still, the island is the upper tip of the Appalachian

Mountains and is thereby geologically related to my hometown. In its rockiness, it felt completely like home and completely not.

Some nights, I felt as physically worn as I did at home, experiencing no sense of relief at all. I'd lean against the walls of the shower and let hot water flow over me. When I read to my older son, I squinted harder and harder. I closed my right eye, left eye, right, left, and watched the images change, bright through the right, veiled through the left. Words were clear if I read with my right eye, hazy and gray through the left, an emptiness emerging in the center of my field of view. We were reading *Calvin and Hobbes* that summer, and I could make Hobbes disappear just by closing one eye.

On the night that I first saw the mottled and half-blind fox in the national park, I saw a second one, hardly more than a shadow, moving across the twilight road. This one wore a dark black mask, almost as if part raccoon, and the same ragged molting pelt as the first. The sum of these two foxes equated to a haunting, or so I felt. I wanted these foxes to be a symbol of some sort, a portent of something I couldn't quite voice but desired.

I sought a way to bring order to the disorder of the past few years. I needed a method to weigh, assess, figure out, to read the signs of my life and determine a path. More than anything, I wanted these foxes to mean something in a life that seemed to have just accumulated, and not fully in the way I'd hoped.

The truth is, the half-blind fox and the masked fox and the unseen foxes that set up camp in the rusting bus all live on Prince Edward Island as relics of a failed industry. Beginning around the turn of the twentieth century, a pioneering captive-breeding program had turned fox farming into a major boon to PEI. At its peak, nearly one hundred thousand captive foxes lived on the thousands of farms that dotted the landscape, each one valued as a pelt to be sold for significant cash or, even better, as a viable breeding animal that could be sold to speculators in or beyond the province.

Much of the success of this fur enterprise lay in the breeding of a stable strain of the silver fox, the dark, melanistic phase of the red fox. These animals wear black fur flecked with silver strands, a normal variation within natural populations. Through careful crossbreeding, farmers established a predictable and viable source

of silver fox pelts, which carried a much higher price than the standard red.

Markets crash when growth outstrips demand. So it was with the Prince Edward Island foxes. Prices eroded as consumers turned away, fashion having soured on natural fur. Farmers were left with nearly worthless animals, liabilities that had to be fed or destroyed or simply let free. Silver fox genes still circulate on the island, and foxes themselves are plentiful enough to be both thrill and nuisance. They are the remnants of collapse, their success possible only because of a different failure. Foxes thrive on Prince Edward Island as a sort of accidental mercy.

That summer, I began tallying the foxes I saw on a piece of paper magneted to the cottage refrigerator. I saw the phantom silver fox twice, early in the morning, racing across the lawn. I passed the scratching, mosquito-mad red on the Confederation Trail, way out near O'Leary. The national park was home to foxes galore, anonymous reds and golden reds who lingered on the road. My tally sheet quickly filled up.

One afternoon, while playing outside the cottage with our two-year-old, I turned to see a fox sitting on its haunches in the tall grasses beside the yard. Likely, it had been watching us for some time, curious and silent. As soon as I made eye contact, it darted into the overgrowth and then reappeared a little farther away.

I couldn't help the surge of quick fear, not for me but for my son. I felt embarrassed, a farm boy afraid of a tiny dog-like animal that had always thrilled me, an animal I wanted to think of as my totem. Yet I couldn't help but wonder about the toddler wobbles of my son, how easily he could be knocked down, how a good-sized fox like this was as big as my boy.

I grabbed my son and whisked him inside. I offered the pretense of getting my camera, but the truth was better described as fear. The fox bolted again when I moved but returned a little farther out, as fearful and curious as I was but not willing to give up.

In the photos I took, the fox is a dark shadow, a silver fox, one of the rare and formerly valuable. One patch of light illuminates the right side of its face, the eyes visible only if I lean in very close to the picture. Both are clear.

Of that day, I remember most when the fox disappeared, the longing I felt to see it again though it would never return. I wish

I'd never taken its photo, had stayed in the yard with my son and watched it watch us.

By Canada Day, tourists began to arrive on the island in numbers sufficient to push the foxes into deeper hiding. Though I still drove often through the park, I rarely saw foxes, there or at the cottage. I no longer bothered to stop at the beaches or overlooks to spend time at the water. There were simply too many people, the parking lots crammed with cars and the beaches filled. My preferred overlook was the worst, swarmed by tourists stupidly climbing down the edge of the red dirt cliffs or taking pictures of themselves with expandable selfie sticks. The overlook thronged with bus tourists who clogged the trail as they trudged to the water's edge for a brief glimpse or quick photo, checking off a to-do list filled with things they imagined as having appeared in *Anne of Green Gables,* the only reason they bothered coming to PEI.

Through the spring, I had seen the blind-eyed fox regularly. Always he had waited and watched me as long as I watched him. But the increased traffic had driven him away, as it had the other foxes. Or at least I imagine that's what happened. Maybe I stopped looking as hard. Still, I slowed at the curve where the blind-eyed fox lived, hoping. When I rode my bike past that spot, I could smell the heavy musk of wet dog at the bend where he usually appeared, a sign of his invisible presence. But I never saw him again. And I doubt I ever will.

What I didn't know that summer was how February would shape up, four months later when we returned to Pennsylvania because I had to go back to work. The things I might have worried about turned out fine. My hematologist was satisfied with my red blood count, high but not worrisome. My other symptoms seemed to improve while on the island, leading me to believe that stress was indeed the problem. But the nagging concern of my vision lingered. Reading in the dim light of my older son's bedroom at night became much more difficult; entire frames of *Calvin and Hobbes* would disappear when I closed my right eye.

By then, we had spent enough money on all of my other tests that we were close to the family deductible on our newly mediocre health insurance, so I decided to see an ophthalmologist. He confirmed the blind spot in my left eye by handing me a piece of graph paper and having me circle the emptiness. "Retinopathy,"

he said, a minor kind of fluid bubble on the retina that a laser would seal. "Caused by stress," he told me, and that made sense. But the retina specialist he sent me to looked at the results of his battery of expensive tests and was convinced there was no retinopathy. He peppered me with a series of questions.

"Take any drugs?"

"No."

He persisted. "Cocaine?"

"No."

"Meth?"

"No."

"A little Viagra for fun?"

"No."

He was breezy, unconcerned, suggested that maybe an MRI was in order. In all his years of practice, he'd only once seen an issue like this wind up being neurological, but it would be worth checking out.

That was a Wednesday. By Friday I lay in the vibrating thumps of an MRI tube. Monday morning, I spoke with my ophthalmologist about the tumor that had sprung to life on the lining of my brain, a pea-sized meningioma lodged tight against the optic foramen of my sphenoid bone, the tiny hole through which the optic nerve passes into the brain. The pressure was slowly killing my optic nerve. He said he'd call the Pittsburgh neurosurgeons to set up an appointment, who a week and a half later would explain their suspicion and make their recommendation: I needed brain surgery, and very soon.

A few weeks before I learned of the trouble with my brain, the novelist Cathy Chung came to campus as part of our visiting writer series. I taught her novel, *Forgotten Country*, which follows a sister facing her father's cancer-driven death and the ghosts of the family's Korean past. At the reading, she charmed my students with new writing, what she called a ghost story, really her own version of a *kumiho* story, a Korean legend about a shape-shifting sort of fox spirit that seduces young men by appearing as a beautiful woman who holds them in magical thrall while eating their hearts and livers.

After the reading, we headed to dinner, where we talked of France, of swimming in dangerous seas, of Cathy's near-drowning

while trying to exit the water on sharp rocks. My poet colleague told a story of his own perils at sea, once when he nearly succumbed to a whirlpool in Greece, and another time when heavy California seas forced him to crash into shoals in order to free himself from a dangerous current. In his latter story and in Cathy's, the tellers focused on the people on shore, blithely unaware of the danger and simply waving.

When I think of that night, however, the cold darkness of February, snow coating our vehicles when we left the restaurant, I think most of all about the kumiho. I am spooked by it, and I wonder at the capacity to be deceived, to be consumed from within. Yet isn't this what foxes are supposed to be? Always cunning? Always shape-shifting? The fox is a lesser trickster, not quite coyote, usually driven by ill intent. The fox is deceitful, slippery, deadly to know. The kumiho devours the young man. The Japanese *yako kitsune* possesses a human body, revealed only by the sudden onset of illness. The cock Chanticleer dreams of death arriving in the form of a fox but is assured by one of his wives that it is just a dream, only to be later captured by the fox Don Russel. Aesop's fox can't reach the grapes, then whines that they must be sour. Volpone pretends to be sick so people will bring him gifts.

What, then, are my foxes? Are they apparitions, threats, warnings? Only foxes? I want to think of them as guardians, and though I neither belong to the system of belief nor yet fully understand it, I am comforted by the *zenko* or *Inari kitsune.*

These are good foxes, symbols of benevolence and prosperity. Maybe foxes can be all of these things, as we all can be built of competing parts, frictioned for sure but made whole by the ways that joy and despair swirl within. Maybe this is why I cannot stop thinking about foxes. Maybe this is why I think the trickster can never be just evil, shapeshifting too, a sort of way of life.

A confession: Some nights on Prince Edward Island, driving the coast road, I thought about steering into the gulf. Sometimes, I stood on the rocks at the overlook and thought about wading into the cold water, or leaping from the eroding cliffs, about the shock of coldness when I entered the sea, how heavy it would be as it soaked into my clothes. Even now, I don't know what this means, whether such impulses are the signs of depression, or that sirens do exist, and I heard them on those rocks. Probably, I was

tired of feeling tired, of being worn out, tired of hopelessness and absences of happiness and satisfaction that—well, I don't know. Maybe it was the tumor, my body instinctively reacting to the mad growth of cells that had flipped the wrong switch.

I do know that driving home one night, navigating the curve just beyond North Rustico, where the bridge abutments creep in to tighten the road, and where the bay would later in the summer be filled with mussel farm buoys and, for one week, a dank blue-green algae bloom, I held the wheel an extra second. I never intended to hold the line long enough to fail, to hurtle off the pavement and into the water. But I held it. A second too long. Then veered back on course and headed home to my wife and children.

I carried then a deep stupor, something I'd prefer to think of as melancholy but that might be less artful than I imagine. Why I hesitate to call it depression, I don't know, but that's probably as good an explanation as any. And this is a cliché of terrible commonality: we too often ignore our hurt psyches because they are invisible and because we count this as weakness. But we are captive to them, even when we remain steadfast in our commitment to denial.

Blindness can be cultivated. It blossoms into a state of being, a fullness of misguided attention, nurtured and abetted by a desire not to see. Moving to PEI for half a year may not have been, in itself, an act of blindness, but my readiness to see it as some kind of pure escape certainly was. I carried deep wounds, and some kind of still unknown, flawed, frantic cell division that was itself both a propagating blindness and something easy to ignore, until I couldn't.

They wheeled me into surgery a month and a half after I learned of the tumor. A team of nurses and residents chatted with me, all of us joking somehow in the whitened terror of a pristine operating room. I had seen my neurosurgeon an hour before, when he had written on my forehead with a magic marker an X that signaled the focal point of surgery. I told him it was the other eye, and he crossed out the first X and made another. It didn't really matter where he went in, he said, but it did make sense to cut around the bad eye instead of the good one.

I slept for eight hours, if that was something I can call sleep. The neuro-ophthalmologist drew a neat incision at the top of my

left eyelid, in the natural crease. He stretched the skin open, sawed out a two-inch rectangle from the front of my skull. This was laid aside, and the neurosurgeon retracted my frontal lobe and worked to remove tissue and bone. They called this a "decompression," removing the matter around my optic nerve to make a void. Later, I would undergo radiation, and the tumor would swell, and this void was meant to protect my eye from further damage.

What they could not do in the OR was remove the tumor. They found it on the inside of the optic sheath, too close to the nerve to allow even a biopsy. So they left it intact, replaced the hatch of my skull, wound in titanium screws, and sealed the cut with bone putty. The neuro-ophthalmologist sewed the incision tight, and I woke up later in the intensive care unit, still alive.

When radiation finally ended in midsummer, my wife and I decided to return to Prince Edward Island. Even a brief trip between treatments and the start of the school year seemed like an important act of recovery. Radiation had taken more out of me than I'd expected, leaving me exhausted and in bed for nearly as much of the day as I had been when still recovering from brain surgery. Two large patches of hair had fallen out, one the size of a half-dollar behind my left ear, and another on top of my head. My vision seemed worse, cloudier. We decided to go anyway. We needed to, and I needed to, even if we'd spend as many days in the car getting there and back as we would being on the island, six for each.

I wish I could wax about the splendid magic of crossing the threshold of New Brunswick, driving off that land and onto the Confederation Bridge, the rolling hills of PEI laid out in front of us, beauty and grace and healing. There's some truth in that, I suppose, or at least it is a story I imagine I might tell someday. Reality proved to be rainier, misty gray, and somewhat disappointing. So it is when you've been waiting months, lying in bed staring at ceilings, or lying in a Versa proton accelerator while ionized particles blast through your head and kill a tumor that will never shrink, never disappear, just, best-case scenario, stop growing. The damage done to the nerve—reduced vision and a blind spot and a veil and eye weariness when reading—serve as a permanent reminder of the dead seed that will remain tucked in my skull forever. I wanted the island to heal that, right away. Instead, the landscape felt dimmed, as everything had felt for some time, whether

seen through my damaged left eye or the scarred lens of my own imagination.

Of course, I also hoped for foxes, that great false symbol on which I have hung so much. For the first several days, I saw none. Tourist season had struck, and visitation was up over the summer, good for the island, bad for fox sightings.

Worst of all, the first fox I saw was a dead one, recent roadkill. I was driving alone, and the fox appeared on the side of the road, a shock of fresh blood streaming from its mouth onto the pavement.

"Did you see the fox," I asked my wife a few days later.

"Yes," she said, understanding always what I really meant.

I saw only one other fox before we left the island, a golden with a clear upper pelt and ragged molt on its lower third. It appeared while I strolled to the tee box of the golf course one afternoon. It seemed healthy, whole or nearly so, poised next to the tall grasses at the golf course margin with one foot in the air, its snout pointed into the thicket. It pounced, a foxy move, flashing its head into the grass and fishing out a large field mouse it soon dispatched, dropped, and ate. A metaphor, maybe, but if so, meaning what? Am I fox, and if so which one, or a mouse, or a man watching, or all of these?

I want this to mean something. I want it all to mean something, even if I don't yet know how to interpret the symbols I create.

My very first Prince Edward Island fox ambled out of the coastal shrub, long wisps of molting hair clung to his hindquarters like dandelion fluff, or a sheep sheared halfway and inattentively, as if someone heard the phone ring and just stopped and listened to a doctor explain something unreachable, impossible, dire. Or maybe the fur had been torn and rent because, how could that fox bear the pain of being etherized for eight hours, knowing that its mate would sit in a polyester and vinyl waiting room, her phone ringing and a nurse intoning, "everything is going well" and "they're closing now" and "you can see him in the ICU." Maybe its day had begun before dawn in a converted convent now a hotel in a seedy neighborhood of Pittsburgh, and he walked out with her in the cool air of a March morning, first hints of spring in the blooming cherry trees, just a distant hum of traffic, gleaming neon lights atop the US Steel building and the Highmark health insurance building, then on to the washed-out lights of the anxious reg-

istration room. He would lie all morning in pre-op watching other patients roll out, waiting six hours there pretending to be hale and healthy and joking and somehow apparently happy, dressed in a worn hospital gown, socks with rubber grippers on the soles, watching *Top Gear* on an iPad, eventually with an IV jabbed in each paw. How could that fox bear to hear over and over again the great cheerfulness of the OR nurse and the anesthesiology intern who came to roll him away, understating also how leaving meant opening a gaping emptiness for her, marked only by the clunking sound of hospital bed rails being locked into place and the oomph of two women pushing the bed away and the bed rolling away, gone, she left not knowing what or who would return. If ever there were a moment to shape-shift, this would have been it. But there were no foxes at the hospital, only a wounded man and woman, not ready for this.

On the last day of our July return to Prince Edward Island, we decided on a whim to look at a farmhouse up for sale. With a speed and surety that I fear indicates desperation, we offered on that house, eventually agreeing to buy it even though the foundation was shot and would need total replacement. Maybe I'm a sucker for reclamation projects, want to see the hope that comes with repair. Maybe we just knew we needed a place of refuge, and the island offered that to us.

Regardless, I returned alone to PEI in October for a final walk-through before purchase. Hurricane Matthew came with me, heavy rains soaking the province on Thanksgiving, coupled with winds blowing as high as 90 kmh. When I drove the coast that day, the air was heavy and claustrophobic; tall seas rumbling in, pounding the shore with irregular fury. I looked for the glimpses of beauty, trees in the middle of their autumn blaze, the pastoral landscape, and I couldn't help but wonder if we'd been hasty. Everything was dim and murky and, dare I say, ugly. As with the July visit, I felt cut off.

The storm passed that night, and Tuesday arrived as the kind of brilliant, crisp, high-pressure autumn day that inspires much clichéd poetry. I drove from Summerside to the house, running so early that I steered down a side road for a quick exploration. There, I passed an old farmhouse tucked in among linden trees, New London Bay stretching across the background, small waves shimmering in the morning sun.

"This is me," I said as a dopey smile arrived, meaning something self-deprecating and foolish, mocking myself for the grin: "Ha ha, 'this is me.' Look at the fool driven to joy, agape at the view." But then my emotions welled, and I heard myself a different way, understood this statement not as mockery but as a declaration: "This is me" meaning "Here I am." It was a declaration of joy, a recognition of my absence. *This* is me. This is *me*. Hello old friend, thanks for returning here to the island and to your life, from which you've been absent so long. Thanks for coming back, for revealing yourself as being *here.*

Later, I drove to the national park, walked to the edge of the gulf, and watched the waves roll in. I touched my cap in a hokey gesture of honor, then turned back toward the lot and saw, right there, a fox. His pelt was full, ready grown for winter, and he looked healthy and powerful. I drove down the coast road, finding a second fox in the morning sun, near the spot where I'd often seen the blind one. It too was strong and whole. Do I need to mention that the blind fox was nowhere to be seen, that his absence might as well have been the absence of a ghost, the residue of a departed kumiho, the greatest gift I've ever known?

IAN FRAZIER

What Ever Happened to the Russian Revolution?

FROM *Smithsonian*

I

RUSSIA IS BOTH a great, glorious country and an ongoing disaster. Just when you decide it is the one, it turns around and discloses the other. For a hundred years before 1917, it experienced wild disorders and political violence interspersed with periods of unquiet calm, meanwhile producing some of the world's greatest literature and booming in population and helping to feed Europe. Then it leapt into a revolution unlike any the world had ever seen. Today, a hundred years afterward, we still don't know quite what to make of that huge event. The Russians themselves aren't too sure about its significance.

I used to tell people that I loved Russia, because I do. I think everybody has a country not their own that they're powerfully drawn to; Russia is mine. I can't explain the attraction, only observe its symptoms going back to childhood, such as listening over and over to Prokofiev's *Peter and the Wolf,* narrated by Peter Ustinov, when I was six, or standing in the front yard at night as my father pointed out *Sputnik* crossing the sky. Now I've traveled enough in Russia that my affections are more complicated. I know that almost no conclusion I ever draw about it is likely to be right. The way to think about Russia is without thinking about it. I just try to love it and yield to it and go with it, while also paying vigilant attention—if that makes sense.

I first began traveling to Russia more than twenty-four years

ago, and in 2010 I published *Travels in Siberia,* a book about trips I'd made to that far-flung region. With the fall of the Soviet Union, areas previously closed to travelers had opened up. During the 1990s and after, the pace of change in Russia cascaded. A harsh kind of capitalism grew; democracy came and mostly went. Then, two years ago, my son moved to the city of Yekaterinburg, in the Ural Mountains, on the edge of Siberia, and he lives there now. I see I will never stop thinking about this country.

As the 1917 centennial approached, I wondered about the revolution and tangled with its force field of complexity. For example, a question as straightforward as what to call certain Russian cities reveals, on examination, various options, asterisks, clarifications. Take St. Petersburg, whose name was changed in 1914 to Petrograd so as not to sound too German (at the time, Russia was fighting the Kaiser in the First World War). In 1924 Petrograd became Leningrad, which then went back to being St. Petersburg again in 1991. Today many of the city's inhabitants simply call it "Peter." Or consider the name of the revolution itself. Though it's called the Great October Revolution, from our point of view it happened in November. In 1917, Russia still followed the Julian calendar, which lagged thirteen days behind the Gregorian calendar used elsewhere in the world. The Bolshevik government changed the country to the Gregorian calendar in early 1918, soon after taking control. (All this information will be useful later on.)

In February and March I went to Russia to see what it was like in the centennial year. My way to travel is to go to a specific place and try to absorb what it is now and look closer, for what it was. Things that happen in a place change it and never leave it. I visited my son in Yekaterinburg, I rambled around Moscow, and I gave the most attention to St. Petersburg, where traces of the revolution are everywhere. The weather stayed cold. In each of the cities, ice topped with perfectly white snow locked the rivers. Here and there, rogue footprints crossed the ice expanses with their brave or heedless dotted lines. In St. Petersburg, I often passed Senate Square, in the middle of the city, with Étienne Falconet's black statue of Peter the Great on his rearing horse atop a massive rock. Sometimes I saw newlyweds by the statue popping corks as an icy wind blew in across the Neva River and made the champagne foam fly. They were standing at a former pivot point of empire.

*

I'll begin my meditation in 1825, at the Decembrist uprising. The Decembrists were young officers in the czar's army who fought in the Napoleonic wars and found out about the Enlightenment and came home wanting to reform Russia. They started a secret society, wrote a constitution based on the US Constitution and, on December 14, at the crucial moment of their coup attempt, lost their nerve. They had assembled troops loyal to them on Senate Square, but after a daylong standoff Czar Nicholas I dispersed these forces with cannon fire. Some of the troops ran across the Neva trying to escape; the cannons shot at the ice and shattered it and drowned them. The authorities arrested one-hundred-some Decembrists and tried and convicted almost all. The czar sent most to Siberia; he ordered five of the leaders hanged. For us, the Decembrists' example can be painful to contemplate—as if King George III had hanged George Washington and sent the other signers of the Declaration of Independence to hard labor in Australia.

One good decision the Decembrists made was to not include Alexander Pushkin in their plot, although he was friends with more than a few of them. This spared him to survive and to become Russia's greatest poet.

Tolstoy, of a younger generation than theirs, admired the Decembrists and wanted to write a book about their uprising. But the essential documents, such as the depositions they gave after their arrests, were hidden away under czarist censorship, so instead he wrote *War and Peace*. In Tolstoy's lifetime the country's revolutionary spirit veered into terrorism. Russia invented terrorism, that feature of modern life, in the 1870s. Young middle-class lawyers and university teachers and students joined terror groups of which the best known was Naródnaya Volia, or People's Will. They went around shooting and blowing up czarist officials, and killed thousands. Alexander II, son of Nicholas I, succeeded his father in 1855, and in 1861 he emancipated the serfs. People's Will blew him up anyway.

When Tolstoy met in 1886 with George Kennan, the American explorer of Siberia (and a cousin twice removed of the diplomat of the same name, who, more than a half-century later, devised Truman's Cold War policy of "containment" of the Soviet Union), Kennan pleaded for support for some of the Siberian exiles he had met. But the great man refused even to listen. He said these revolutionaries had chosen violence and must live with the consequences.

Meanwhile Marxism was colonizing the brains of Russian intellectuals like an invasive plant. The *intelligentsia* (a word of Russian origin) sat at tables in Moscow and St. Petersburg and other cities in the empire or abroad arguing Marxist doctrine and drinking endless cups of tea, night after night, decade after decade. (If vodka has damaged the sanity of Russia, tea has been possibly worse.) Points of theory nearly impossible to follow today caused Socialist parties of different types to incubate and proliferate and split apart. The essential writer of that later-nineteenth-century moment was Chekhov. The wistful, searching characters in his plays always make me afraid for them. I keep wondering why they can't do anything about what's coming, as if I'm at a scary movie and the teenage couple making out in the car don't see the guy with the hockey mask and chain saw who is sneaking up on them.

The guy in the hockey mask was Vladimir I. Lenin. In 1887, his older brother, Aleksandr Ulyanov, a sweet young man by all accounts, joined a plot to assassinate Czar Alexander III. Betrayed by an informer (a common fate), Ulyanov was tried and found guilty, and he died on the gallows, unrepentant. Lenin, seventeen at the time, hated his family's liberal friends who dropped the Ulyanovs as a consequence. From then on, the czar and the bourgeoisie were on borrowed time.

The Romanov dynasty stood for more than three hundred years. Nicholas II, the last czar, a Romanov out of his depth, looked handsome in his white naval officer's uniform. He believed in God, disliked Jews, loved his wife and five children, and worried especially about his youngest child, the hemophiliac only son, Alexei. If you want a sense of the last Romanovs, check out the Fabergé eggs they often gave as presents to each other. One afternoon I happened on a sponsored show of Fabergé eggs in a St. Petersburg museum. Such a minute concentration of intense, bejeweled splendor you've never seen. The diamond-encrusted tchotchkes often opened to reveal even littler gem-studded gifts inside. The eggs can stand for the czar's unhelpful myopia during the perilous days of 1917. Viewers of the exhibit moved from display case to display case in reverent awe.

One can pass over some of the disasters of Nicholas's reign. He was born unlucky on the name day of Job, the sufferer. On the day of his coronation, in 1896, a crowd of half a million, expecting a

special giveaway in Moscow, panicked, trampling to death and suf-
focating fourteen hundred people. Nicholas often acted when he
should have done nothing and did nothing when he should have
acted. He seemed mild and benign, but after his troops killed hun-
dreds of workers marching on the Winter Palace with a petition
for an eight-hour workday and other reforms—the massacre was
on January 9, 1905, later known as Bloody Sunday—fewer of his
subjects thought of him as "the good czar."

The 1905 protests intensified until they became the 1905 Revo-
lution. The czar's soldiers killed perhaps fourteen thousand more
before it was under control. As a result, Nicholas allowed the con-
vening of a representative assembly called the State Duma, Russia's
first Parliament, along with wider freedom of the press and other
liberalizations. But the Duma had almost no power and Nicholas
kept trying to erode the little it had. He did not enjoy being czar
but believed in the autocracy with all his soul and wanted to be-
queath it undiminished to his son.

It's July 1914, just before the beginning of the First World War:
The czar stands on a balcony of the Winter Palace, reviewing his
army. The whole vast expanse of Palace Square is packed with
people. He swears on the Bible and the holy icons that he will not
sign for peace so long as one enemy soldier is standing on Russian
soil. Love of the fatherland has its effect. The entire crowd, tens
of thousands strong, falls to its knees to receive his blessing. The
armies march. Russia's attacks on the Eastern Front help to save
Paris in 1914. Like the other warring powers, Russia goes into the
trenches. But each spring, in 1915 and 1916, the army renews its
advance. By 1917 it has lost more than three million men.

In America we may think of disillusionment with that war as a
quasi-literary phenomenon, something felt by the writers of the
Lost Generation in Paris. Long before America entered the war,
Russian soldiers felt worse—disgusted with the weak czar and the
German-born czarina, filled with anger at their officers, and en-
raged at the corruption that kept them poorly supplied. In the
winter of 1916–17, they begin to appear in Petrograd as deserters
and in deputations for peace, hoping to make their case before
the Duma. The czar and the upper strata of Russian society insist
that the country stay in the war, for the sake of national honor, and
for their allies, some of whom have lent Russia money. Russia also
hopes to receive as a war prize the Straits of Bosporus and the Dar-

danelles, which it has long desired. But the soldiers and common people see the idiocy of the endless, static struggle, and the unfair share they bear in it, and they want peace.

The absence of enough men to bring in the harvests, plus a shortage of railroad cars, plus an unusually cold winter, lead to a lack of bread in Petrograd. In February many city residents are starving. Women take to the streets and march on stores and bakeries crying the one word: *"Khleb!"* Bread! Striking workers from Petrograd's huge factories, like the Putilov Works, which employs forty thousand men, join the disturbances. The czar's government does not know what to do. Day after day in February the marches go on. Finally the czar orders the military to suppress the demonstrations. People are killed. But now, unlike in 1905, the soldiers have little to lose. They do not want to shoot; many of the marchers are young peasants like themselves, who have recently come to the city to work in the factories. And nothing awaits the soldiers except being sent to the front.

So, one after another, Petrograd regiments mutiny and join the throngs on the streets. Suddenly the czar's government can find no loyal troops willing to move against the demonstrators. Taking stock, Nicholas's ministers and generals inform him that he has no choice but to abdicate for the good of the country. On March 2 he complies, with brief complications involving his son and brother, neither of whom succeeds him.

Near-chaos ensues. In the vacuum, power is split between two new institutions: the Provisional Government, a cabinet of Duma ministers who attempt to manage the country's affairs while waiting for the first meeting of the Constituent Assembly, a nationwide representative body scheduled to convene in the fall; and the Petrograd Soviet of Workers' and Soldiers' Deputies, a somewhat amorphous collection of groups with fluid memberships and multi-Socialist-party affiliations. (In Russian, one meaning of the word "soviet" is "council"—here, an essentially political entity.) The Petrograd Soviet is the working people's organization, while the Provisional Government mostly represents the upper bourgeoisie. This attempt at dual governance is a fiction, because the Petrograd Soviet has the support of the factory workers, ordinary people, and soldiers. In other words, it has the actual power; it has the guns.

The February Revolution, as it's called, is the real and original

Russian revolution. February supplied the raw energy for the rest of 1917—energy that Lenin and the Bolsheviks would co-opt as justification for their coup in October. Many classic images of the people's struggle in Russia derive from February. In that month red became the color of revolution: sympathetic onlookers wore red lapel ribbons, and marchers tore the white and blue stripes from the Russian flag and used the red stripe for their long, narrow banner. Even jaded Petrograd artistic types wept when they heard the self-led multitudes break into "The Marseillaise," France's revolutionary anthem, recast with fierce Russian lyrics. Comparatively little blood was shed in the February Revolution, and its immediate achievement—bringing down the Romanov dynasty—made a permanent difference. Unlike the coup of October, the February uprising had a spontaneous, popular, tectonic quality. Of the many uprisings and coups and revolutions Russia has experienced, only the events of February 1917 seemed to partake of joy.

2

The city of St. Petersburg endlessly explains itself, in plaques and monuments everywhere you turn. It still possesses the majesty of an imperial capital, with its plazas, rows of eighteenth- and nineteenth-century government buildings receding to a vanishing point, glassy canals, and towering cloudscapes just arrived from the Baltic Sea. The layout makes a grand backdrop, and the revolution was the climactic event it served as a backdrop for.

A taxi dropped me beside the Fontanka Canal at Nevskii Prospekt, where my friend Luda has an apartment in a building on the corner. Luda and I met eighteen years ago, when Russian friends who had known her in school introduced us. I rented one of several apartments she owns in the city for a few months in 2000 and 2001. We became friends despite lack of a common language; with my primitive but slowly improving Russian and her kind tolerance of it, we made do. Now I often stay with her when I'm in the city.

When we first knew each other Luda worked for the local government and was paid so little that, she said, she would be able to visit the States only if she went a year without eating or drinking. Then she met a rich Russian American, married him, and moved to his house in Livingston, New Jersey, about ten miles from us.

After her husband died she stayed in the house by herself. I saw her often, and she came to visit us for dinner. The house eventually went to her husband's children, and now she divides her time between St. Petersburg and Miami. I have more phone numbers for her than for anyone else in my address book.

Her Nevskii apartment's mid-city location is good for my purposes because when I'm in St. Petersburg I walk all over, sometimes fifteen miles or more in a day. One morning, I set out for the Finland Station, on the north side of the Neva, across the Liteynyi Bridge from the city's central district. The stroll takes about twenty minutes. As you approach the station, you see, on the square in front, a large statue of Lenin, speaking from atop a stylized armored car. One hand holds the lapel of his greatcoat, the other arm extends full length, gesturing rhetorically. This is your basic and seminal Lenin statue. The Finlandskii Voksal enters the story in April of 1917. It's where the world-shaking, cataclysmic part of the Russian Revolution begins.

Most of the hard-core professional revolutionaries did not participate in the February Revolution, having been earlier locked up, exiled, or chased abroad by the czar's police. (That may be why the vain and flighty Alexander Kerensky rose to power so easily after February: the major-leaguers had not yet taken the field.) Lenin was living in Zurich, where he and his wife, Nadezhda Krupskaya, had rented a small, disagreeable room. Awaiting developments, Lenin kept company with other expatriate Socialists, directed the Petrograd Bolsheviks by mail and telegram, and spent time in the public library. He did not hear of the czar's abdication until some time after the fact. A Polish Socialist stopped by and brought news of revolution in Russia in the middle of the day, just after Krupskaya had finished washing the lunch dishes. Immediately Lenin grew almost frantic with desire to get back to Petrograd. His wife laughed at his schemes of crossing the intervening borders disguised as a speech- and hearing-impaired Swede, or of somehow obtaining an airplane.

Leon Trotsky, who would become the other major Bolshevik of the revolution, was then living in (of all places) the Bronx. With his wife and two young sons he had recently moved into a building that offered an elevator, garbage chute, telephone, and other up-to-date conveniences the family enjoyed. Trotsky hailed the Feb-

ruary Revolution as a historic development and began to make arrangements for a trans-Atlantic voyage.

Both Trotsky and Lenin had won fame by 1917. Lenin's Bolshevik Party, which emerged from the Russian Social-Democratic Labor Party in 1903, after splitting with the more moderate Mensheviks, kept its membership to a small group of dedicated followers. Lenin believed that the Bolsheviks must compromise with nobody. Since 1900, he had lived all over Europe, spending more time outside Russia than in it, and emphasized the international aspect of the proletariat revolution. Lenin wrote articles for Socialist journals and he published books; many devotees knew of him from his writings. Trotsky also wrote, but he was a flashier type and kept a higher public profile. Born Lev Davidovich Bronstein in the Ukraine, he had starred in the 1905 Revolution: at only twenty-six he organized a Soviet of Workers' Deputies that lasted for fifty days before the government crushed it.

Lenin's return to Russia required weeks of arrangements. Through German contacts he and a party of other exiled revolutionaries received permission to go by train via Germany, whose government encouraged the idea in the hope that Lenin and his colleagues would make a mess of Russia and thereby help Germany win the war. In pursuit of their political ends Lenin and the Bolsheviks acted as German agents and their policy of "revolutionary defeatism" strengthened the enemy. They went on to receive tens of millions of German marks in aid before the Kaiser's government collapsed with the German defeat, although that collusion would not be confirmed until later.

The last leg of Lenin's homeward journey led through Finland. Finally, at just after eleven on the night of April 16, he arrived in Petrograd at the Finland Station. In all the iconography of Soviet Communism few events glow as brightly as this transfiguring arrival. Lenin and his fellows assumed they would be arrested upon stepping off the train. Instead, they were met by a band playing "The Marseillaise," sailors standing in ranks at attention, floral garlands, a crowd of thousands, and a searchlight sweeping its beam through the night. The president of the Petrograd Soviet, a Menshevik, welcomed Lenin with a condescending speech and reminded him that all Socialists now had to work together. Lenin listened abstractedly, looking around and toying with a bouquet of red roses someone had given him. When he responded, his words

"cracked like a whip in the face of the 'revolutionary democracy,'"
according to one observer. Turning to the crowd, Lenin said,

> Dear Comrades, soldiers, sailors, and workers! I am happy to greet in
> your persons the victorious Russian revolution, and to greet you as the
> vanguard of the worldwide proletarian army . . . the hour is not far dis-
> tant when at the call of our comrade Karl Liebknecht, the people of
> Germany will turn their arms against their own capitalist exploiters . . .
> The worldwide Socialist revolution has already dawned . . . the Russian
> revolution accomplished by you has prepared the way and opened a
> new epoch. Long live the worldwide Socialist revolution!

A member of the Petrograd Soviet named Nikolai Sukhanov,
who later wrote a seven-volume memoir of the revolution, heard
Lenin's speech and was staggered. Sukhanov compared it to a
bright beacon that obliterated everything he and the other Petro-
grad Socialists had been doing. "It was very interesting!" he wrote,
though he hardly agreed with it. I believe it affected him—and all
of Russia, and the revolution, and a hundred years of subsequent
history—because not since Peter the Great had anyone opened
dark, remote, closed-in Russia so forcefully to the rest of the world.
The country had long thought of itself as set apart, the "Third
Rome," where the Orthodox Faith retained its original and unsul-
lied purity (the Second Rome having been Constantinople). But
Russia had never spread that faith widely abroad.

Now Lenin informed his listeners that they had pioneered the
international Socialist revolution, and would go forth into the
world and proselytize the masses. It was an amazing vision, Marx-
ist and deeply Russian simultaneously, and it helped sustain the
despotic Bolsheviks, just as building St. Petersburg, no matter how
brutal the cost, drove Peter the Great two hundred years before.
After Lenin, Russia would involve itself aggressively in the affairs
of countries all over the world. That sense of global mission, soon
corrupted to strategic meddling and plain troublemaking, is why
America still worries about Russia today.

Making his ascension to the pantheon complete, Lenin then
went out in front of the station and gave a speech from atop an
armored car. It is this moment that the statue in the plaza refers
to. Presumably, the searchlight illuminated him, film-noirishly. As
the armored car slowly drove him to Bolshevik headquarters he

made more speeches standing on the vehicle's hood. Items associated with this holy night have been preserved as relics. The steam engine that pulled the train that Lenin arrived in resides in a glass enclosure next to the Finland Station's Platform Number 9. And an armored car said to be the same one that he rode in and made the speeches from can be found in an unfrequented wing of the immense Artillery Museum, not far away.

Guards are seldom in evidence in the part of the museum where the historic *bronevik* sits permanently parked. Up close the armored car resembles a cartoon of a scary machine. It has two turrets, lots of rivets and hinges, flanges for the machine guns, solid rubber tires, and a long, porcine hood, completely flat and perfect for standing on. The vehicle is olive-drab, made of sheet iron or steel, and it weighs about six tons. With no guard to stop me I rubbed its cold metal flanks. On its side, large, hand-painted red letters read: *Vrag Kapitala,* or "Enemy of Capital."

When Lenin mounted this metal beast, the symbolic connection to Peter the Great pulled tight. Falconet's equestrian Peter that rears its front hooves over Senate Square—as it reared over the dead and wounded troops of the Decembrists in 1825—haunts the city forever. It's the dread "Bronze Horseman" of the Pushkin poem. Gesturing dramatically from atop his armored beast-car, Lenin can be construed as re-enacting that statue, making it modernist, and configuring in his own image the recently deposed Russian autocracy.

Alone with the beast in the all-but-deserted Artillery Museum, I went over it again. At its back, on the lower corners on each side, two corkscrew-shaped iron appendages stuck out. I could not imagine what they were for. Maybe for attaching to something? But then why not use a simple metal hitch or loop? I still don't know. And of course the appendages looked exactly like the tails of pigs. Russia is an animist country. In Russia all kinds of objects have spirits. Nonanimal things are seen as animals, and often the works of men and women are seen as being identical with the men and women themselves. This native animism will take on special importance in the case of Lenin.

Bolshevik headquarters occupied one of the city's fanciest mansions, which the revolutionaries had expropriated from its owner, a ballerina named Matilda Kshesinskaya. Malice aforethought may

be assumed, because Kshesinskaya had a thing for Romanovs. After a performance when she was seventeen, she met Nicholas, the future czar, and they soon began an affair that lasted for a few years, until Alexander III died. Nicholas then ascended the throne and married the German princess Alix of Hesse (thenceforth to be known as Empress Alexandra Feodorovna). After Nicholas, the ballerina moved on to his father's first cousin, Grand Duke Sergei Mikhailovich. During her affair with that grand duke, she met another one—Grand Duke Andrei Vladimirovich, Nicholas's first cousin. They also began an affair. Such connections helped her to get good roles in the Imperial Ballet, although, in fairness, critics also regarded her as an outstanding dancer.

Whom she knew came in handy during the hard days of the war. In the previous winter the British ambassador, Sir George Buchanan, had been unable to find coal to heat his embassy. He even asked the head of the Russian Navy, who said there was none. While out on a walk with the French ambassador, Buchanan happened to see four military lorries at Kshesinskaya's house and a squad of soldiers unloading sacks of coal. "Well, if that isn't a bit too thick!" Buchanan remarked. Good contacts kept her a step ahead of events in 1917. Warned, Kshesinskaya fled with her more portable valuables before the Bolsheviks arrived. Later she and her son and Grand Duke Andrei emigrated to Paris, where she ran a ballet school and lived to be almost one hundred years old. A movie, *Matilda*, based on her affair with Nicholas, is due to be released in Russia on October 25, 2017. Admirers of Nicholas have sought to ban it, arguing that it violates his privacy.

The mansion, an example of the school known as Style Moderne, won a prize for the best building facade in St. Petersburg from the City Duma in 1910, the year after its construction. It sits on a corner near Trinity Square, and from a second-story French window a balcony with decorative wrought-iron grillwork extends above the street. In Soviet times the mansion became the Museum of the October Revolution, said to be confusing for its many omissions, such as not showing any pictures of Trotsky. Today the building houses the Museum of Russian Political History, which tells the story of the revolution in clear and splendid detail, using text, photos, film, sounds, and objects.

I have spent hours going through its displays, but my favorite part of the museum is the balcony. I stand and stare at it from the

sidewalk. Upon his arrival from the Finland Station, Lenin made a
speech from this balcony. By then he had grown hoarse. Sukhanov,
who had followed the armored car's procession, could not tear
himself away. The crowd did not necessarily like what it heard,
and a soldier near Sukhanov, interpreting Lenin's internationalist
sentiments as pro-German, said that he should be bayoneted—a
reminder that although "Bolshevik" meant, roughly, "one of the
majority," not many ordinary Russians, or a majority of Socialists,
or even all Bolsheviks, shared Lenin's extreme views.

Lenin gave other speeches from the balcony during the three
months more that the Bolsheviks used the mansion. Photographs
show him speaking from it, and it appears in Socialist Realist paint-
ings. A plaque notes the balcony's revolutionary role, but both
plaque and subject are above eye level, and no passersby stop to
look. In fact, aside from the pope's balcony in Rome, this may
be the most consequential balcony in history. Today the ground
where the listeners stood holds trolley-bus tracks, and cables sup-
porting the overhead electric wires attach to bolts in the wall next
to the balcony.

I can picture Lenin: hoarse, gesticulating, smashing the uni-
verse with his incisive, unstoppable words; below him, the sea of
upturned faces. Today an audience would not have much room to
gather here, with the trolley buses, and the fence enclosing a park
just across the street. Like a formerly famous celebrity, this small
piece of architecture has receded into daily life, and speeches
made from balconies no longer rattle history's windowpanes.

In the enormous three-ring shouting match and smoke-filled de-
bating society that constituted revolutionary Petrograd during the
months after the czar's removal, nobody picked the Bolsheviks to
win. You had parties of every political ilk, from far left to far right,
and schismatic groups within them, such as the Social-Democratic
Labor Party's less radical wing (the Mensheviks); another power-
ful party, the Socialist-Revolutionaries, had split contentiously into
Left SRs and Right SRs. Added to these were many other parties,
groups, and factions—conservatives, populists, moderates, peasant
delegations, workers' committees, soldiers' committees, Freema-
sons, radicalized sailors, Cossacks, constitutional monarchists, wa-
vering Duma members. Who knew what would come out of all that?
Under Lenin's direction the Bolsheviks advanced through the

confusion by stealth, lies, coercion, subterfuge, and finally violence. All they had was hard-fixed conviction and a leader who had never been elected or appointed to any public office. Officially, Lenin was just the chairman of the "Central Committee of the Russian Social-Democratic Labor Party (Bolsheviks)," as their banner read.

The dominant figure of Alexander Kerensky, a popular young lawyer, bestrode these days like a man with one foot on a dock and the other on a leaky skiff. He came from the city of Simbirsk, where his family knew the Ulyanovs. His father had taught Lenin in high school. Kerensky had defended revolutionaries in court and sometimes moved crowds to frenzy with his speeches. As the vice chairman of the Petrograd Soviet and, simultaneously, the minister of war (among other offices) in the Provisional Government, he held unique importance. Dual government, that practical implausibility, embodied itself in him.

Some participants in the Russian Revolution could not get the fate of the French Revolution out of their heads, and Kerensky was among them. When spring moved toward summer, he ordered a new, make-or-break offensive in the war, and soon mass demonstrations for peace boiled over again in Petrograd. The Bolsheviks, seeing advantage, tried to seize power by force in April and again in early July, but Kerensky had enough troops to shut these tentative coup attempts down. Also, Lenin's traitorous connection to the Germans had begun to receive public attention. Concerned about being arrested or lynched, he hurried back to Finland. But Kerensky felt only contempt for the Bolsheviks. Thinking of Napoleon's rise, he mainly dreaded a counterrevolution from the right.

This predisposition caused him to panic in August while trying to keep the war going and supply himself with loyal troops in the capital. After giving ill-considered and contradictory orders that caused one general, fearing arrest, to shoot himself, Kerensky then accused the commanding general, Lavr Kornilov, of mutiny. Kornilov, who had not, in fact, mutinied, became enraged by the charge and decided to mutiny for real. He marched on Petrograd, where a new military force, the Red Guards, awaited him. This ad hoc people's militia of young workers and former Russian Army soldiers carried weapons liberated in the February mutinies. Rallied by the Bolsheviks, the Red Guards stopped Kornilov before he reached the capital. The Kornilov episode strengthened the

Bolsheviks' credibility and destroyed Kerensky's support among the regular military. Now he would not have an army when he needed one.

With Lenin in hiding, Trotsky kept the Bolsheviks on message with their promise of "Bread, Peace, and Land." The first two watchwords were self-explanatory, and the third went back to a hope the peasants had nourished since before emancipation in the nineteenth century. Their wish that all privately held lands would be distributed to the smaller farmers ran deep. The slogan's simplicity had an appeal; none of the promises would be fulfilled, but at least the party knew what people wanted to hear. In September, for the first time, the Bolsheviks won a majority of seats in the Petrograd Soviet. Responding to perceived threats from "Kornilovites" and other enemies of the revolution, the Petrograd Soviet also established its Military Revolutionary Committee, or MRC. For the Bolsheviks, this put an armed body of men officially at their command.

Lenin sneaked back from Finland but remained out of sight. Kerensky now held the titles of both prime minister and commander in chief, but had lost most of his power. The country drifted, waiting for the Second All-Russian Congress of Soviets that was set to meet in October, and beyond that, for the promised first gathering of the Constituent Assembly. Both these bodies would consider the question of how Russia was to be governed. Lenin knew that no better time for a takeover would ever present itself. He wanted to act quickly so as to hand the upcoming assemblies a fait accompli. Through the night of October 10, in the apartment of a supporter, Lenin argued with the other eleven members of the party's Central Committee who were there. Relentlessly, he urged an immediate armed takeover. Several of the dissenters thought he was moving too fast.

By morning the committee voted in his favor, 10 to 2.

3

One can read about these events in Sukhanov's *The Russian Revolution 1917: A Personal Record* (a good abridgment came out in 1984); or in Richard Pipes's classic, *The Russian Revolution;* or in

on's fascinating intellectual history, *To the Finland Sta-*
otsky's extensive writings on the subject; or in many
s. For the coup itself I rely on my hero, John Reed.
ecame swept up in the story of the Russian Revolution
ead Reed's landmark eyewitness account, *Ten Days That
Shook the World.* Reed went to Harvard, class of 1910, and joined
the humor magazine, the *Lampoon.* He had the college-boy hair of
that era, the kind that went up and back, in waves—Mickey Rooney
hair. None of the fancier clubs asked him to join, and I wouldn't
wonder if the pain of that, for a young man whose family had
some standing in far-off Portland, Oregon, didn't help make him
a revolutionary. When I joined the *Lampoon,* fifty-nine years later, a
member pointed out to me the building's stained-glass window in
memory of Reed. It shows a silver hammer and sickle above Reed's
name and year, on a Communist-red background. Supposedly the
window had been a gift from the Soviet Union. The strangeness of
it gave me shivers. At that stage of the Cold War, Russian missiles
were shooting down American jets in Vietnam. How had this man
come to be revered by the other side?

Reed dwelt in romance. Everything he did had style. In college
he cut a wide swath, leading the cheers at football games, writing
plays, publishing poetry, and tossing off grand gestures, like hop-
ping a ship for Bermuda during spring break and returning to
campus late and getting in trouble with the dean. Three years after
graduation he was riding with Pancho Villa's rebels in Mexico. *In-
surgent Mexico,* the book he wrote about the experience, made him
famous at twenty-seven. When the First World War started he de-
camped to Europe. On a tour of the front lines he somehow man-
aged to cross over to the entrenchments of the Germans, where,
at the invitation of a German officer, he fired a couple of shots in
the direction of the French. When he returned to New York, news
of this exploit got out, and afterward the French quite understand-
ably refused to let him back into France.

So he made his next trip to the Eastern Front instead. The jour-
ney brought him to Russia, and to a passion for the country that
would determine the rest of his life. In his 1916 book *The War in
Eastern Europe,* Reed wrote:

> [Russia is] an original civilization that spreads by its own power . . . And
> it takes hold of the minds of men because it is the most comfortable,

the most liberal way of life. Russian ideas are the most exhilarating, Russian thought the freest, Russian art the most exuberant; Russian food and drink are to me the best, and Russians themselves are, perhaps, the most interesting human beings that exist.

Yikes! As an intermittent sufferer of this happy delusion myself, I only note that it may lead a person astray. In 1917, paying close attention to events, Reed knew he had to return to Russia. He arrived in Petrograd in September, not long after the Kornilov mutiny. (With him was his wife, the writer Louise Bryant.) What he saw around him thrilled him. He had participated in strikes and protests in the United States, gone to jail, and shared in the hope of an international socialist revolution. "In the struggle my sympathies were not neutral," he wrote in the preface to *Ten Days*. With the unsleeping strength of youth he went everywhere in Petrograd and saw all he could. By limiting a vast historical movement to what he experienced over just a short period (in fact, a span somewhat longer than ten days), he allowed his focus to get up-close and granular.

St. Petersburg has not changed much from when it was revolutionary Petrograd. The Bolsheviks' move of the government to Moscow in 1918 exempted the former capital from a lot of tearing-down and rebuilding; becoming a backwater had its advantages. In places where Reed stood you can still picture how it looked to him. He wrote:

> What a marvelous sight to see Putilovsky Zavod [the Putilov Factory] pour out its forty thousand to listen to Social Democrats, Socialist Revolutionaries, anarchists, anybody, whatever they had to say, as long as they would talk!

Today that factory is called Kirovsky Zavod and it has its own metro station of that name, on the red line, southeast of the city center. Photographs from 1917 show the factory with a high wall along it and big crowds of people on the street in front. Now the wall and the factory's main gate are almost the same as then. Next to the gate a big display highlights some of what is built here— earthmovers, military vehicles, atomic reactor parts. The factory wall, perhaps fifteen feet high, runs for half a mile or more next to the avenue that adjoins it. Traffic speeds close by; no large

crowds of workers could listen to speakers here. Like many of the public spaces important in the revolution this one now belongs to vehicles.

At a key moment in the Bolsheviks' takeover, Reed watched the army's armored-car drivers vote on whether to support them. The meeting took place in the Mikhailovsky Riding School, also called the Manège, a huge indoor space where "some two thousand dun-colored soldiers" listened as speakers took turns arguing from atop an armored car and the soldiers' sympathies swung back and forth. Reed observes the listeners:

> Never have I seen men trying so hard to understand, to decide. They never moved, stood staring with a sort of terrible intentness at the speaker, their brows wrinkled with the effort of thought, sweat standing out on their foreheads; great giants of men with the innocent clear eyes of children and the faces of epic warriors.

Finally the Bolshevik military leader, N. V. Krylenko, his voice cracking with fatigue, gives a speech of such passion that he collapses into waiting arms at the end. A vote is called: those in favor to one side; those opposed, to the other. In a rush almost all the soldiers surge to the Bolshevik side.

The building where this happened is on Manège Square; Luda's apartment is just around the corner. Today the former riding academy has become the Zimnoi Stadion, the Winter Stadium, home to hockey matches, skating competitions, and non-ice events like track meets. The last time I saw it the nearby streets were filled with parents and little kids carrying balloon animals and other circus souvenirs.

I think of the scene from Reed's book whenever I pass by. He caught the details, large and small—the dreary, rainy November weather, with darkness coming at three in the afternoon; the posters and notices and manifestos covering the city's walls; the soldier who was putting up some of the notices; and the little boy who followed behind him, with a bucket of paste. And the mud. Reed observed it on greatcoats, boots, floors, stairways. I have often marveled at the big patches of mud that suddenly appear in the middle of completely paved St. Petersburg avenues. Then I remember the swamp the city was built on. The February Revolution

happened in the snow, but in swampy Russia, the glorious October Revolution happened in the mud.

Ten Days That Shook the World is a rare example of a book that is better for being more complicated. Reed could have spared his readers the effort of figuring out who was who among (as he put it) "the multiplicity of Russian organizations—political groups, Committees and Central Committees, Soviets, Dumas, and Unions." Instead he begins the book with a detailed list, including the subdistinctions among them. It's like a speed bump to slow the reader down, but it's also respectful. The care he took kept his book alive even after Soviet censors banned it during the Stalin era. (Stalin has basically no role in *Ten Days* and his name appears only twice.)

The book returned to publication during the Khrushchev period, after Stalin's death, though even then it was not much read. Boris Kolonitsky, a leading historian of the revolution, found his vocation when he happened on a copy of the book at the age of fourteen. Today Kolonitsky is first vice-rector and professor of history at the European University at St. Petersburg, and has been a visiting professor at Yale, Princeton, and the University of Illinois. I met him at his university office in a building near the Kutuzov Embankment of the Neva.

Kolonitsky looks like a professor, with a beard and round glasses and quick, dark-blue eyes, and his jacket and tie reinforce a courteous, formal manner. I asked how he had first discovered Reed's book.

"I was born in Leningrad, my early schooling was here, and I graduated from the history department of the Hertzen State Pedagogical University in Leningrad," he said. "So I am a Leningrad animal from a long way back, you might say. The fact that Reed's book takes place mostly in this city made a connection for me. I first read it when I was in middle school, and of course at that time it was impossible not to know the Soviet story of the glorious October—the volley from the cruiser *Aurora,* the storming of the Winter Palace, and so forth. For me reading Reed was very much a cultural shock. Suddenly here before me was a complicated and contradictory story. Reed was greatly in sympathy with the Bolsheviks but also a very good journalist, and his picture is multidimensional, not just black and white—or Red and White. Trotsky, for

example, who had become a nonperson, is vivid in the book. Also the opponents of the Bolsheviks were much more complicated than in Soviet iconography. Later, when I became a teacher (still in Soviet times), I assigned this book to my students and they came back to me with their eyes wide and said, 'Boris Ivanovich, this is an anti-Soviet book!'"

I mentioned Reed's courage. "Yes, at one point in the book they are going to shoot him on the spot!" Kolonitsky said. "He is near the front at Tsarskoe Selo"—a village about fifteen miles south of Petrograd—"where the Whites are making an attack, and he becomes separated from the soldiers who brought him; and then other Red Guards, who are illiterate, cannot read the journalist's pass he has from the Bolshevik leadership, and they tell him to stand by a wall, and suddenly he realizes they are about to shoot him. He persuades them to find someone who can read."

"And afterward he does not make any big production about it," I said. "He just goes on reporting."

"It was not a rational time, not a conscious time," Kolonitsky said. "Reed did not speak much Russian and what surrounded him often was simply chaos."

I had noticed, at the Museum of Russian Political History, that Kolonitsky was scheduled to lecture on "Rumor in Revolutionary Petrograd in October of 1917." I asked about his work on rumor and the popular culture of the revolution.

"Well, this subject had not been too much written on before. Rumor and street culture—jokes, postcards, sayings, bawdy plays performed in saloons—changed the image of the czar and the czarina, desacralized them, before and during the war. Empress Alexandra's dependence on Rasputin, the so-called crazed monk, had catastrophic consequences. Tales of the czarina's debauchery with Rasputin (completely untrue), and rumors of the czar's impotence, and her supposed sabotage of the war effort because she was born in Germany, all undermined the Romanovs, until finally nobody could be too sad when the monarchy went away. People sent each other erotic postcards of the czarina with Rasputin, audiences howled laughing at plays about his supposed sexual power. It resembled modern defamation by social media, and it did great damage. I call it the 'tragic erotics' of Nicholas's reign. If you loved Russia you were obliged to love your czar. People were saying, 'I know I must love my czar, but I cannot.'"

He went on, "Rumor also had a very big role in October of
1917, of course. Kerensky, whom many people almost worshipped,
was damaged by rumors about his affair with his wife's cousin, or
about his fantasies of his own greatness, or his supposed plan to
abandon Petrograd to the Germans. Many such rumors spread
through the crowds on the streets. It caused a highly unstable at-
mosphere."

Everybody knew that the Bolsheviks were planning an overthrow.
In the Duma, Kerensky reassured its members that the state had
sufficient force to counter any Bolshevik action. Reed obtained
an interview with Trotsky, who told him that the government had
become helpless. "Only by the concerted action of the popular
mass," Trotsky said, "only by the victory of proletarian dictatorship,
can the Revolution be achieved and the people saved"—that is, a
putsch would come soon. The Bolshevik-run Military Revolution-
ary Committee began making demands for greater control of the
army, and the Petrograd garrison promised to support the MRC.
In response, Kerensky ordered loyal army units to occupy key
points in the city.

 Lenin, who had not appeared in public since July, narrowly es-
caped arrest as he made his way in disguise to Bolshevik headquar-
ters, now at the Smolny Institute, a vast building that had formerly
housed a school for noble-born girls. In meetings of the Petrograd
Soviet and of the long-awaited Second All-Russian Congress of So-
viets (both also housed in Smolny), and in the State Duma, thun-
derous arguments raged about the course the Bolsheviks were
taking. Defending his party before the Petrograd Soviet, Trotsky
stepped forward, "[h]is thin, pointed face," Reed wrote, "positively
Mephistophelian in its expression of malicious irony." On a stair-
way at Smolny in the early morning of October 24, Reed ran into
Bill Shatov, an American acquaintance and fellow Communist,
who slapped him on the shoulder exultantly and said, "Well, we're
off!" Kerensky had ordered the suppression of the Bolsheviks'
newspapers and the MRC was moving "to defend the revolution."

 On that day and the next, Reed ranged widely. He had tick-
ets to the ballet at the Mariinsky Theater—regular life went on in
Petrograd, revolution or no—but he decided against using them
because "it was too exciting out of doors." On the night of the
twenty-fifth he made his way to Smolny and found the building

humming, with bonfires burning at the gates out front, vehicles coming and going, and machine guns on either side of the main entryway, their ammunition belts hanging "snake-like from their breeches." Feet were pounding up and down Smolny's hallways. In the crowded, stuffy, smoke-filled assemblies, as the arguments raged on and on, a deeper sound interrupted—the "dull shock" of cannon fire. Civil war had begun. With a reporter's instinct Reed ventured out again into the city.

One morning I decided to trace part of the route he took that night. Leaving Luda's apartment I walked the couple of miles to Smolny, a multi-block-long building that now houses St. Petersburg's city government. The front of the pale yellow imperial structure looms high, and its tall, narrow windows give passersby a view of the interior ceilings and chandeliers. "The massive facade of Smolny blazed with light," Reed wrote; and indeed from every window the chandeliers were shining down on the gloomy sidewalk I stood on. Arriving office workers passed by. Black limousines pulled up at the inner gate, drivers opened the back doors, and dark-suited men with briefcases strode through the security station, past the Lenin statue and into the building.

The immense park in front of Smolny is a quiet place, with asphalt pathways and drastically pruned trees whose stubby branches jut like coral. People walk their dogs. I saw a bulldog wearing a jumpsuit that had a buttoned pocket on one side, and a white Labrador in four-legged pants with the cuffs rolled up.

When Reed came out of Smolny the night was chilly. "A great motor truck stood there, shaking to the roar of its engine. Men were tossing bundles into it, and others receiving them, with guns beside them." Reed asked where they were going. A little workman answered, "Down-town—all over—everywhere!" Reed, with his wife, Bryant, and several fellow correspondents, jumped in. "The clutch slid home with a raking jar, the great car jerked forward." They sped down Suvorovsky Prospekt tearing open the bundles and flinging printed announcements that read: "TO THE CITIZENS OF RUSSIA! The State Power has passed into the hands of the organ of the Petrograd Soviet of Workers' and Soldiers' Deputies, the Military Revolutionary Committee, which stands at the head of the Petrograd proletariat and garrison," and so on. The vehicle soon had "a tail of white papers floating and eddying out behind."

Today Suvorovsky Prospekt presents the usual upscale urban Russian avenue. Reed saw bonfires, and patrols gathered on the corners. Bus shelters featuring ads for concerts, cruises, taxi companies, and Burger King have taken their place. His fellow passengers looked out for snipers; men at checkpoints stepped toward them from the darkness with upraised weapons. Now a Ralph Lauren Home store with window mannequins in pastels came as no surprise on one of the tonier blocks.

Suvorovsky runs into Nevskii Prospekt near a hub with six major streets radiating from it. Reed wrote, "We turned into Zamensky Square, dark and almost deserted, careened around Trubetskoy's brutal statue and swung down the wide Nevsky." Today this hub is called Ploshchad Vosstaniya, Uprising Square. The "brutal statue" was of Alexander III on horseback. Horse and rider together evoked a hippo, with their breadth and squatness. Revolutionaries often used the statue's plinth for an orator's platform, and crowds gathered here; photographs of that time show the square teeming with people. The statue has been moved to a museum courtyard and an obelisk stands at the center of the square now. I wanted to see the obelisk close up but walking into the square is almost impossible. Endless cars and buses swirl around its rotary, and waist-high metal barriers keep pedestrians out.

A loudspeaker somewhere on the square was playing "It's Beginning to Look a Lot Like Christmas." Russian public spaces sometimes emit American Christmas music at odd times of year, such as early March. This was my first St. Petersburg neighborhood, back when I used to stay at the nearby Oktyabrskaya Hotel. There's a florist across the street from it, and I stopped to buy Luda some flowers, considering some roses for 2,500 rubles but settling instead on a bouquet of yellow chrysanthemums for 2,000 rubles (about $30).

Reed's conveyance swayed and bounced along Nevskii Prospekt toward the city center, then slowed at a crowded bottleneck before the bridge over the Ekaterina Canal (now the Gribodeyeva Canal). He and his companions climbed out. A barrier of armed sailors was blocking the passage of a group of three or four hundred well-dressed people lined up in columns of four, among whom Reed recognized Duma members, prominent non-Bolshevik Socialists, the mayor of Petrograd, and a Russian reporter of Reed's acquaintance. "Going to die in the Winter Palace!" the reporter shouted to

him. The ministers of the Provisional Government were meeting in emergency session in the Winter Palace, and these unarmed citizens intended to defend the building with their bodies. The mayor and other eminences demanded that the sailors let them through. The sailors refused. After some further arguing the eminences about-faced and, still in columns of four, marched off in the opposite direction. Meanwhile Reed and his companions slipped by.

At Luda's apartment, where I took a break on my hike, she admired the flowers and put them in water. I explained that I was retracing Reed's route during the night of Glorious October and asked her if she wanted to come along to the Winter Palace. She said yes, and after some kielbasa and tea we left. Because she had been sick she preferred not to walk. We decided to take a trolley bus.

The Number 1 Nevskii Prospekt trolley bus pulled up. As we boarded, several dark-haired guys, all similarly dressed in jackets and sweats, crowded around and pushed and shoved through the door. Once inside they stood close to me. I couldn't even see Luda. The fare lady came and I took out my wallet and paid my forty rubles. The fare lady looked at me for a too-long moment, with a weird smile. The door opened at the next stop and the guys suddenly all crowded out, bumping and pushing even more. After they left I sat down next to Luda, wondering what that had been all about. Then I felt in the back pocket of my jeans.

Losing my wallet to these thieves temporarily derailed my purpose. I completed it the next day. I had been robbed of credit cards and rubles, but not my passport, which I kept in a separate pocket. I wished I had spent more of the now-vanished rubles on the flowers. Luda, for her part, berated me up and down for being a naive, trusting, stupid American and moved on to criticisms of my worldview in general. I kept silent. Some years ago she took care of me when I had dysentery and since then she can do no wrong.

Beyond the sailors' checkpoint, Reed and company got in with a throng that flowed to Palace Square, ran halfway across it and sheltered behind the Alexander Column in its center. Then the attackers rushed the rest of the distance to the firewood barricades around the Winter Palace, jumped over them and whooped when they found the guns the defenders had left behind. From there

the miscellaneous assault, mostly composed of young Red Guards, walked into the building unopposed. There was no "storming" of the Winter Palace, then or earlier, Sergei Eisenstein's celebratory 1928 film notwithstanding. The building's defenders had mostly disappeared. As Reed went in, he saw the ministers of the Provisional Government being led out under arrest. Kerensky was not among them; he had left the city the day before in search of loyal troops at the front.

Reed and his companions wandered up into the huge building, through rooms whose liveried attendants were saying helplessly, "You can't go in there, *barin!* It is forbidden . . ." Finally he came to the palace's Malachite Room, a chamber of royal splendor, with walls of gold and deep-green malachite. The Provisional Government ministers had been meeting there. Reed examined the long, baize-topped table, which was as they had just left it:

> Before each empty seat was pen, ink, and paper; the papers were scribbled over with beginnings of plans of action, rough drafts of proclamations and manifestos. Most of these were scratched out, as their futility became evident, and the rest of the sheet covered with absent-minded geometrical designs, as the writers sat despondently listening while Minister after Minister proposed chimerical schemes.

An ambient crowd of soldiers grew suspicious and gathered around Reed's small group, asking what they were doing there. Reed produced his pass, but again, no luck: the soldiers could not read. This time a savior appeared in the form of an MRC officer whom Reed knew and who vouched for him and his companions. Gratefully back on the street, in the "cold, nervous night," they stepped on broken pieces of stucco—the result of a brief bombardment of the palace by mutinous cannoneers. By now it was after three in the morning. Along the Neva, the city was quiet, but elsewhere frenzied meetings were going on. Reed, sleepless, hurried to them.

As for my own storming of the Winter Palace, I took the conventional route of paying the entrance fee to the Hermitage Museum, of which the palace is now a part. (I had the funds thanks to a loan from Luda. *"Ne bespokoisya,"* she said. "Do not disquiet yourself. I am not a poor woman.") Following a stochastic path through the multitude of galleries I soon hit upon the Malachite Room, which

is room 189. Like many of the Hermitage's interiors, it brims with light reflected from the Neva. The river's ice was solid except in the middle, where a procession of jumbled-up blue-white chunks moved slowly across the windows' view. An informational sign announced that in this hall revolutionary workers and soldiers "arrested members of the counterrevolutionary Provisional Government." Evidently the sign's angle of interpretation has not been recently revised.

The handles of the Malachite Room's four sets of tall double doors are in the shape of bird feet, with each foot clutching a faceted sphere of red translucent stone. The doors were open. Holding the handles felt strange—like grabbing the scaly foot of a large bird that's clutching a rock. The museum guard told me not to touch. She said the door handles were the originals. Tourists came through in a constant stream. Nearly all were holding up their phones and taking videos or photographs. Sometimes a tourist would stop in the middle of the room, hold the phone up with both hands in the air, and slowly turn in a circle so the video could pan the entire room. This slow, unself-conscious video-making rotation in the room's center with arms upstretched happened over and over, a new century's new dance.

When daylight arrived on the morning after the takeover, Reed took note of the dueling posters all over the city. An order from Kerensky denounced "this insane attempt of the Bolsheviki [to] place the country on the verge of a precipice" and called on all army personnel and other officials to remain at their posts. A placard of Bolshevik origin ordered the army to arrest Kerensky. A group called the Committee for the Salvation of the Fatherland, recently created, rallied citizens to resist the Bolsheviks' "indescribable crime against the fatherland." At a session of the Duma, the mayor of Petrograd decried the coup's imposition of "Government by the bayonet," an accurate description that offended the Bolshevik delegates and caused them to walk out.

The Congress of Soviets, which the party had packed with its own people, scheduled a meeting at Smolny. Beforehand many Bolsheviks said they should agree to go along with the other Socialist parties because too many people were against them. Lenin and Trotsky declared they would not give an inch. At eight forty in the evening, Lenin entered the Congress to a "thundering wave of cheers." (In *Ten Days*, this is the first time he appears in person.)

Reed noted his shabby clothes and too-long trousers but praised his shrewdness, powers of analysis, "intellectual audacity," and ability to explain complicated ideas.

Lenin took the stage, gripped the edge of the reading stand, and waited for the long ovation to die down. Then he said, "We shall now proceed to construct the Socialist order!" That evening and into the next morning, with the Congress of Soviets' enthusiastic approval, the Bolsheviks began to put in place the basic system by which they would rule unchallenged for the next seven decades.

4

In 1967, a *New York Times* editorial titled "Russia's Next Half-Century" congratulated the Soviet Union for becoming "one of the world's foremost economic, scientific, and military powers." The *Times* said it looked forward to a prosperous future for the country, but added, "Russia's leaders, surveying the changes of fifty hectic years, surely understand that the vision of a monolithic, uniform world—whether Communist or capitalist—is a fantasy."

I wonder if any readers of this editorial stopped and asked themselves: "fifty *hectic* years"? Was "hectic" really the right word for the Soviet state's first half-century?

In December 1917, little more than a month after the coup, Lenin established the department of secret police, called the Cheka. Its name, from *Chrezvychaina Kommissia*—Emergency Committee—would change through the years, to GPU, to NKVD, to KGB, to FSK, to today's FSB. When the Cheka was founded, its purpose was to persuade white-collar employees, specifically bankers, who hated the Bolsheviks, to cooperate with administrative measures of the new government. The Cheka's mission and mandate soon expanded enormously. Its first leader, Felix Dzerzhinsky, earned a reputation for implacable fierceness, along with the nickname "Iron Felix."

Some years ago, I slightly knew the art critic Leo Steinberg, who happened to be the son of I. N. Steinberg, the first People's Commissar of Justice in the Bolshevik regime. By way of Leo, I received a copy of his father's book, *In the Workshop of the Revolution*, which describes Steinberg's attempts to preserve rule of law in the Cheka's policing methods during the government's early period.

Once, when he heard that Dzerzhinsky planned to execute an imprisoned officer without trial for possessing a gun, Steinberg and a colleague rushed to find Lenin and have Dzerzhinsky stopped. Lenin was at Smolny, in a meeting of the party's Central Committee. They summoned him from it and urgently explained the situation. At first Lenin could not understand what they were upset about. When it finally sank in, his face became distorted with rage. "Is this the important matter for which you called me from serious business?" he demanded. "Dzerzhinsky wants to shoot an officer? What of it? What else would you do with these counter-revolutionaries?"

Lenin saw the world as divided between allies and enemies. The latter had to be suppressed or killed. Even before their takeover, the Bolsheviks had promised to safeguard the elections for the Constituent Assembly, which the Provisional Government had set for November. After the coup the election went forward. Forty-four million Russians voted, and the elected delegates showed up in Petrograd in early January 1918. Unfortunately for the Bolsheviks, their candidates had lost badly. Lenin's government called for new elections. Then it ordered troops to disperse a crowd of perhaps fifty thousand, who marched in support of the assembly. The soldiers opened fire on the demonstrators, killing eight or more. Russian troops had not shot unarmed demonstrators since the February Revolution. The next day the new government closed the assembly permanently. This was the Bolsheviks' third month in power.

Ex-czar Nicholas and his family, under house arrest since soon after his abdication, had been moved to Yekaterinburg, a thousand miles east of Petrograd. The Provisional Government had treated him decently, and Kerensky thought he and his family would be safer far away from the capital. But the Bolshevik coup spelled their end. After civil war broke out and White Army forces began to approach Yekaterinburg, Lenin decided that Nicholas must be killed. On the night of July 16, 1918, an execution squad of maybe a dozen men gathered the seven Romanovs, their doctor, and three servants in the basement of the house where they were being held. Early the next morning the executioners slaughtered them all.

The pattern had been set. The secret police would kill whom they chose, Bolshevik power would be absolute, and violence would

be used not just for strategic purposes but to terrify. The murder of the Romanovs upped the ante for the new government; now there could be no return. The ghastly way forward led through the grain requisitions of the next few years, and the bloody suppression of the sailors' rebellion at the Kronstadt naval base in 1921, and the war on the peasants, and the forced mass starvations, and the rise of Stalin's terror in the '30s, and the one million who died in the labor camps in 1937–38 alone. Historians estimate that before the end of the Soviet Union the Bolshevik revolution resulted in the deaths of perhaps sixty million people.

The Bolsheviks changed their name to the Russian Communist Party in 1918. Though the Communist regime remained obsessively secretive, much information about its crimes had come out by 1967, when the *Times* published the editorial. Whoever wrote it must have known that as an adjective to describe the Soviet half-century, "hectic" did not suffice. But you can also see the problem the editorial writer faced. What could be said about such horrors? The United States had never known what to make of its cruel, sly, opaque World War II ally turned Cold War enemy. America even tried to like Stalin for a while. He appeared on the cover of *Time* magazine twelve times.

Of those few individuals who can place Yekaterinburg on a map, even fewer know that it has a population of 1.4 million. When the missionary sitting next to me on the plane asked why I was going there, I told her, "To visit family." My son, Thomas, lives in that city because of his girlfriend, Olesya Elfimova, who grew up there. The two met at Vassar College when he was studying Russian and she was taking time from her studies at Moscow University to be a language instructor. After graduating he moved with her to Yekaterinburg and taught English. Now they both work for a Swiss computer company that's based there and he also writes fiction and articles.

I had stopped in Yekaterinburg during my Siberian travels in 2001; one of my goals then had been to find the house where the Romanovs were murdered. After some searching I located the address. But the house, known as the Ipatiev Mansion, had been torn down in 1977. I could not evoke much from what remained—it was just an empty half-acre lot of bulldozed dirt and gravel.

On this trip, Olesya's father, Alexei, a slim, athletic building contractor twenty years my junior who drives a Mercedes SUV, brought

me to the site. I had forgotten it's in the center of the city. Now when I got out of the car, I was stunned. An Orthodox church perhaps fifteen stories high, topped with five golden domes, occupies the same piece of ground. It's called Khram na Krovi, the Church on the Blood. The cathedral venerates Nicholas and his wife and five children, who are now saints of the Orthodox Church. Above the main entryway a giant statue of Nicholas strides into the future, with his son in his arms and his wife and their daughters behind him. Inside, depictions of other saints cover the walls all the way to the distant top, where a portrait of a dark-browed, angry Jesus stares down.

Viewed from a distance, the church provides a strong addition to the city's skyline, a radiance in white and gold. The name of the street that the church is on—Karl Liebknecht Street—has not been changed since Soviet times. Liebknecht, a leader of the German Social-Democratic Labor Party, was killed by right-wing militia after participating in a Communist uprising in Berlin in 1919. Thus history makes its juxtapositions: a church in memory of sanctified royal martyrs gilds a street named for a martyr of international Communism.

Because I wanted to see other local sites associated with the Romanov murders—the place where the bodies were doused with acid and burned, and the swampy lane where they were buried—Alexei obligingly brought me to them, overlooking the gloominess and even creepiness of my quest. The first place, known as Ganyna Yama, is now a monastery and complex of churches and pathways in a forest outside the city. The tall firs and birches stood distinct and quiet, and deep snow overhung the church roofs. A granite marker quoted a biblical verse, from Amos 2:1 —

> Thus says the Lord: "For three transgressions of Moab, and for four, I will not revoke the punishment, because he burned to lime the bones of the King of Edom."

The story is that a bookmark in Nicholas's Bible indicated these as the last verses he happened to read on the night that he was murdered.

Many people come to pay homage to Nicholas and his family, walking single file on the paths in the snow, their steaming breath visible as they cross themselves and light candles and pray

in the unheated churches. A factotum of the monastery seized on Thomas and me as Americans and introduced us to the Metropolit, the head of the Orthodox Church in the region, who was at Ganyna Yama that morning. The high priest wore a black cassock and dark-rimmed glasses and he had a mustache and a large gray-black beard. Taking my hand in both of his he focused on me for a moment his powerful, incense-scented aura of kindness and sanctity.

The Romanovs' burial site is out in the woods and next to some railroad tracks. A more nondescript location cannot be imagined. It was marked with several small obelisks; a blue-and-yellow banner that said VIDEO SURVEILLANCE IN PROGRESS hung from ropes in the birch trees. The bodies themselves are no longer there. In 1998, the family's remains were reinterred, and those of Nicholas and Alexandra are now entombed with his forebears in the Peter and Paul Fortress in St. Petersburg.

In addition to exploring Yekaterinburg with Thomas, and meeting Olesya's mother and grandmother and two sisters, and admiring how well Thomas speaks Russian, my main occupation was visiting the Boris Yeltsin Presidential Center, which includes a museum. I spent whole afternoons there.

Yeltsin came from a village near Yekaterinburg. The museum, overlooking the Iset River, is the country's first presidential museum, in honor of the Russian Federation's first freely elected president. It features a wide-screen film explaining Russian history in semi-realistic motion-capture animation that ends with Yeltsin defying the Generals' Putsch in 1991—an attempted coup by hardline Communist Party leaders who opposed the Soviet Union's accelerating reforms. The movie portrays his triumph as the beginning of a new and ongoing era of Russian freedom. Other exhibits then take you through Yeltsin's whole career and its successes and defeats up to his eventual resignation in favor of Vladimir Putin, his then mild-seeming protégé. The overall impression is of Yeltsin's bravery, love of country, and basic humanity fading to weakness after a heart attack in 1996.

In fact, most Russians regard the Yeltsin years as miserable ones. Remembering the food shortages, lack of services, plundering of public wealth, and international humiliations of the 1990s and early 2000s, more than 90 percent of Russians, according to some

opinion surveys, view Yeltsin unfavorably. Video interviews with people who feel this way round out the museum's picture of him. Some interviewees say they consider the museum itself an insult to Russians who lived through those times. Here the museum impressed me with its candor. But the Russian sense of history often shifts like sand. A Yeltsin-centered view deemphasizes the century's earlier upheavals. The museum made only brief mention of 1917, and it will have no special exhibit to celebrate the revolution.

If you could somehow go back in time and tell this to the Soviet citizens of 1967, none would believe you. They would expect that such an important new museum—as well as every museum and municipality in the country—would devote itself on a vast scale to the jubilee. In 1967, the half-centennial was a huge deal not only in Russia but around the world. On April 16, 1967, ten thousand people (according to Soviet sources) reenacted Lenin's return to the Finland Station; some even wore period costumes. In May, two thousand Soviet mountaineers climbed Mount Elbrus, in the Caucasus, and placed busts of Lenin at the top. Anticipating the half-centennial's high point, sixty-five hundred couples applied to have their marriages performed in Moscow on the eve of November 7. Babies born in that year were named Revolutsia.

The commemorative celebrations in Moscow and Leningrad rated front-page coverage in the United States. Over-the-top extravaganzas went on for days. Only a few flaws showed in the facade. Other Communist nations sent representatives—with the exception of Albania and of China, which did not approve of Brezhnev's policies of peaceful coexistence. Cuba sent only low-level officials because Castro had been wanting to overthrow some Latin American governments and Brezhnev wouldn't let him. Ho Chi Minh, worrying about offending either China or Russia, also stayed away, but he did contribute a special gift: a piece of a recently shot down American jet.

Reporters asked Alexander Kerensky to comment on the historic milestone. Having escaped the Bolsheviks via the northern port of Murmansk, the former Provisional Government prime minister now lived on the Upper East Side of Manhattan. At eighty-six he had only recently stopped taking regular walks around the Central Park Reservoir. Few of his contemporaries of '17 had been so lucky. Almost none of the original Bolsheviks whom the jubilee might have honored still survived; Stalin, or time, had done away

with the others. John Reed had died of typhus in Moscow in 1920, before he turned thirty-three. Lenin very much admired his book and gave it what today would be called a blurb. Reed received a state funeral, and was buried in the Kremlin Wall.

The *Times*'s Harrison Salisbury, reporting from Russia, noted a certain lack of enthusiasm about the half-centennial. He interviewed a lot of young Soviets who couldn't seem to get excited about anything except jazz. In 1967 observers said that you could see the number 50 all over Russia—on posters and signs and fences and product labels. There was a fiftieth anniversary beer. You could buy a kind of kielbasa that, when cut into, revealed the number 50 formed in fat in each slice. I figured that somewhere in my 2017 travels I had to run into a sign with "100" on it for the centennial. Finally, in a metro station, I spotted it—the number 100 on a poster down the platform. But when I got closer I saw that it was an advertisement for a concert celebrating the one hundredth anniversary of the birth of Ella Fitzgerald. Perhaps Salisbury had a prophetic streak.

This November, instead of glorifying the Centennial Jubilee of the Great October Revolution, Russia will observe a holiday called the Day of People's Unity, also called National Unity Day. It commemorates a popular uprising that drove Polish occupiers from Moscow in 1613, at the end of a period of strife known as the Time of Troubles. That victory led directly to the founding of the Romanov dynasty. The Day of People's Unity had existed as a holiday until the Bolsheviks got rid of it. Before Putin reinstituted it in 2005, none of the Russians I know had ever heard of it.

As the current president of the Russian Federation, Putin has good reason not to be crazy about the idea of revolution. The example of, say, the civil unrest of early February 1917 may not appeal to a leader who faced widespread protests against his own autocratic rule in 2011, as well as earlier this year. When speaking about the centennial, Putin has made gestures toward "reconciliation" and "consolidating the social and political unanimity that we have managed to reach today." The supposed unanimity he referred to, of course, reflects favorably on himself.

When I talked to Boris Kolonitsky, the professor of Russian history, I asked him what his fellow citizens thought about the centennial and what the revolution means for them today. "You have to remember that adults in Russia have their own experience of civil

disturbance, they have seen a coup and an attempted coup," he told me. "After the generals' coup against Gorbachev, when he was removed from power in '91, we saw Yeltsin defy the conspirators and overcome them. When he stood on top of the tank addressing the crowd in front of the White House"—then Russia's new Parliament building—"that image was a clear quotation of a famous romantic image from the Russian Revolution: Lenin on the armored car at Finland Station.

"Yeltsin's victory was the beginning of a period of relative democracy," he went on. "Expectations were high. But everyone also remembers the rest of the '90s, the years that followed, which were quite terrible. Therefore we became less excited about romantic images of revolution. Two years after Yeltsin stood on the tank, he ordered tanks to fire at the Parliament building, to resolve the constitutional crisis brought on by those trying to overthrow him. As Putin himself said, 'In Russia we have over-fulfilled our plans in revolutions.'

"Now an important value in Russia is peace," Kolonitsky continued. "Stability also—and therefore revolution loses its appeal. I think the country will observe the centennial with reflection and discussion, but without celebration."

5

The oldest person I know was born before the Bolsheviks changed Russia to the Gregorian calendar. Lyudmila Borisovna Chyernaya came into the world on December 13, 1917—after the Bolshevik coup, and a week before the founding of the Cheka. This December she will celebrate her one hundredth birthday. Lyudmila Borisovna (the polite form of address is to use both the first name and patronymic) is the mother of my longtime friend, the artist Alex Melamid. I first met her twenty-four years ago when Alex and his wife, Katya, and I stayed in her apartment on my first trip to Russia. Last March I made a detour to Moscow, to see her again.

For my visit to her apartment one Saturday afternoon I brought along my friend Ksenia Golubich, whom I got to know when she translated for me at a Russian book fair in 2013. Lyudmila Borisovna shows almost no disabilities of age. In 2015, she published a much-praised memoir, *Kosoi Dozhd* (or *Slanting Rain*). Now she is

working on a sequel. She talks quickly and in long, typographical paragraphs. I was glad I had Ksenia to help me keep up. On the wall of the apartment are paintings by Alex, and portraits of her late husband, Daniil Elfimovich Melamid, an author, professor, and expert on Germany. She showed us photographs of her great-grandchildren, Lucy and Leonard, who are five and two and live in Brooklyn. They come to Moscow to visit her because at almost one hundred years old she can no longer travel easily to America.

Lyudmila Borisovna was born in Moscow. Her parents had moved here, in 1914, to a pleasant, small apartment with five rooms on a classic Moscow courtyard. They were educated people; her mother was one of the first women admitted to a university in Russia and later translated all of Stalin's speeches into German for TASS, the Soviet international news agency. Lyudmila Borisovna first experienced the revolution, indirectly, at the age of three or four; she had to give up her own room, the nursery, when their apartment became communal and two Communists moved in. Later more new residents took over other rooms, but her parents did not mind, because they believed in the revolution and wanted to do their part.

Lyudmila Borisovna had a distinguished career as a journalist, author, translator, and German-language counter-propagandist on the radio during the Second World War. Her husband, Daniil Elfimovich, was head of the counterpropaganda agency; she monitored broadcasts from Germany and refuted them in broadcasts of her own. Because of these, she was called "the Witch of the Kremlin" by Goebbels himself. Her discourse to us contained not very many pauses into which Ksenia could insert translation. In one of the pauses, returning to the subject of the revolution, I asked her if she thought it had been for the good. "Yes, it was exciting for us to have people coming to Moscow from all over the world to learn about Communism," she said. "The revolution made Moscow important to the world."

She seemed eager for us to have lunch. Lena, her live-in helper, who is from Ukraine, brought out dish after dish that she had made herself—borscht, cabbage pies, mushroom pies, several different kinds of fish, salads, beef tongue; then strong Chinese tea, very large chocolates, and an immense banana torte with cream frosting. Ksenia had to concentrate to continue translating as she and I ate and Lyudmila Borisovna watched us, beaming. Afterward

I received an email from Alex: "I got a report from mama of your and your translator's gargantuan appetites and the amount of food you both consumed. She was proud of her feeding prowess." He added that shortage of food had been one of his mother's main worries throughout her life.

I asked Lyudmila Borisovna what she considered the single highest point of the last one hundred years. "March 5, 1953," she answered, immediately. "The happiest day of my life—the day Stalin died. All the Stalin years were bad, but for us the years 1945 to 1953 were very hard. After his death the country started to become better, more free. Today life in Russia is not wonderful, but it's fairly good. People may complain, but I tell you from experience that it can get much worse than this."

At the door she helped us into our coats and bid us goodbye, with special regards to Ksenia, whom she had taken to. I'm of average height but as we stood there I realized I'm at least a head taller than she is. She smiled at us, her blueish-gray eyes vivid, but neither warm nor cold. In them I got a glimpse of the character one needs in order to live through such a time, and for one hundred years.

On my first Moscow visit, the man who drove Alex and Katya and me around the city was a wry and mournful fellow named Stas. He had a serviceable, small Russian sedan, not new, that he maintained carefully. One day he couldn't drive us because the car needed repairs. When he showed up again I asked him how his car was doing now. "Is an old man ever well?" Stas replied. At Lyudmila Borisovna's, when I was having trouble dialing her phone, she corrected me. "He likes to be dialed *slowly*," she said. When people showed me examples of Moscow architecture, the buildings usually possessed a person's name indicating their particular era. Instead of saying, "That's a Khrushchev-era building," my guides said, "That's Khrushchev. That's Stalin. That's Brezhnev." When I asked what the Russian for "speed bump" is, I was told it's *lezhash-chii politseiskii,* which means "lying-down policeman." When a noise thumped in an apartment we were visiting, our hosts explained to me that it was the *domovoi,* the resident spirit of the apartment. Every house or apartment has a domovoi.

An ancient enchantment holds Russia under its spell. Here all

kinds of things and creatures are seen to be sentient and capable of odd transmigrations. In Yekaterinburg my son, while doing some babysitting for a friend, had this conversation:

SIX-YEAR-OLD BOY: What are you?
THOMAS: I'm an American.
BOY: Why are you an American?
THOMAS: I don't know. Because I come from America.
BOY: Can you speak English?
THOMAS: Yes.
BOY (*after some thought*): Can you talk to wild animals?

The question is no less than reasonable in Russia, where even the doors in the most elegant room in the Winter Palace have the feet of birds.

Russia, the country itself, inhabits a spirit as well. The visible location of this spirit's existence in the world used to be the czar. The United States is a concept; Russia is an animate being. I think Nicholas II understood this, and it's why he believed so strongly that his countrymen needed the autocracy. Nicholas not only ruled Russia, he not only signified Russia, he *was* Russia.

The month after the murders of Nicholas and his family an assassin shot Lenin twice as he came out of an event. One of the wounds almost killed him. When, after a perilous period, he recovered, many Russians started to regard him with mystical devotion. In order to stay in power Lenin had prostrated Russia before Germany with the Treaty of Brest-Litovsk, by which Russia renounced claims on vast amounts of territory including the Baltic states, Poland, and Ukraine. When Germany lost the war, and Russia got back all it had conceded, he began to look like a military-political genius, too. Before his early death, from a series of strokes, in 1924, the person of Lenin had become interchangeable with revolutionary Russia, just as the czars had been Russia before the revolution. In a way Lenin's physical death made no difference, because his body could be preserved indefinitely in a glass tomb in Red Square for all citizens to see. As the words of a Communist anthem put it, *Lenin, yeshcho zhivoi!* "Lenin, living still!"

One annual celebration the country loves is *Dien Pobeda,* Victory Day, celebrated on May 9, the day of the German surrender in 1945. The Victory Day parade used to feature the predictable

huge portraits of leaders, but for the past ten years its focus has been on the common soldiers who fought in the war. Today, on Victory Day, marchers show up in the hundreds of thousands in every major Russian city bearing portraits of their relatives who served. These portraits, typically black-and-white photographs, keep to a single size and are attached to identical wooden handles like those used for picket signs. As a group the photos are called *Bezsmertnii Polk*, the Deathless Regiment.

The portraits in their endless numbers evoke powerful emotions as they stream by, especially when you glimpse a young marcher who looks exactly like the young soldier in the faded photograph he or she is carrying. I attended the parade in Moscow in 2016, and as I watched the missiles and tanks that always have accompanied it, I wondered where the traditional giant portraits of The Leader had gone. As under the Soviets, Russia today is governed by what amounts to one-party rule, and again its leadership is more or less an autocracy. But inhabiting the role of Russia itself, as the czars used to do, is a demanding task. Lenin solved the problem by being dead for most of his tenure. Yeltsin made a brave start, standing on the tank, but as he admitted when he turned his power over to Putin in 1999, he got tired. And Putin seems to understand that huge images of the leader's mug look corny and old-fashioned today.

Which is not to say that Putin's mug is not everywhere. It's a common sight on our screens—today's public forum—as well as in such demotic venues as the tight T-shirts featuring his kick-ass caricature that the muscular, pale, crew-cut guys who multiply on Russian streets in summer all seem to wear. As an autocrat whose self coincides with Russia, Putin has grown into the job. Taking off his own shirt for photographers was a good move: here is the very torso of Russia, in all its buff physicality.

But Putin also impersonates a Russia for an ironic age, letting us know he gets the joke, playing James Bond villain and real-life villain simultaneously, having his lines down pat. After being accused of ordering the murder of Alexander Litvinenko, a former FSB agent turned whistle-blower who was poisoned by a radioactive substance in London, Putin denied involvement. Then he added, "The people who have done this are not God. And Mr. Litvinenko, unfortunately, is not Lazarus."

Barring major unforeseen changes, Putin will be reelected in

2018, and initiate Russia's transmogrified, resilient autocracy into its next one hundred years.

Problems left unsolved take their own course. The river in flood cuts an oxbow, the overfull dam gives way. The Russian Revolution started as a network of cracks that suddenly broke open in a massive rush. Drastic Russian failures had been mounting—the question of how to divide the land among the people who worked it, the inadequacy of a clumsy autocracy to deal with a fast-growing industrial society, the wretched conditions of hundreds of thousands of rural-born workers who had packed into bad housing in Petrograd and other industrial cities, to name a few. But nobody predicted the shape that the cataclysm would take.

The speed and strength of the revolution that began in February of 1917 surprised even the Bolsheviks, and they hurried to batten onto its power before it ran away from them. An early sense of unexpectedness and improvisation gave the February Revolution its joyful spirit. Russians had always acted communally, perhaps because everybody had to work together to make the most of the short Russian growing season. This cultural tendency produced little soviets in the factories and barracks, which came together in a big Soviet in Petrograd; and suddenly The People, stomped-down for centuries, emerged as a living entity.

One simple lesson of the revolution might be that if a situation looks as if it can't go on, it won't. Imbalance seeks balance. By this logic, climate change will likely continue along the path it seems headed for. And a world in which the richest eight people control as much wealth as 3.6 billion of their global co-inhabitants (half the human race) will probably see a readjustment. The populist movements now gaining momentum around the world, however localized or distinct, may signal a beginning of a bigger process.

When you have a few leaders to choose from you get sick of them eventually and want to throw them out. And when you have just one leader of ultimate importance in your whole field of vision—in Russia, the czar—the irritation becomes acute.

So, enough! Let's think about ordinary folks for a change: that was the message of Lenin's too-long pants, of the Bolsheviks' leather chauffeur coats and workers' caps, and of all Socialist Realist paintings. But it takes a certain discipline to think about People in general. The mind craves specifics, and in time you go back to

thinking about individuals. As Stalin supposedly said, "One person's death is a tragedy, but the death of a million people is a statistic." Czar Nicholas II was sainted not for being a martyr but for being an individual, suffering person you can relate to. It's remarkable that Russia cares about the Romanovs again, having once discarded them so casually. Thousands of pilgrims come to Yekaterinburg every year to pray at the sites of the royal family's murder and subsequent indignities. Dina Sorokina, the young director of the Yeltsin Museum, told me that as far as she knows they don't also visit her museum when they're in town.

The worldwide Socialist revolution that the Bolsheviks predicted within months of their takeover proved a disappointment. In fact, no other country immediately followed Russia's lead. During Stalin's time the goal changed to "Building Socialism in One Country"—that is, in Russia. Other countries eventually did go through their own revolutions, and of those, China's made by far the largest addition to the number of people under Communist rule. This remains the most significant long-term result of Lenin's dream of global proletarian uprising.

Fifty years after the Russian Revolution, one-third of the world's population lived under some version of Communism. That number has shrunk significantly, as one formerly Communist state after another converted to a market-based economy; today even Cuba welcomes capitalist enterprises from America. The supposed onward march of Communism, so frightening to America in the '60s—first Vietnam, then all of Southeast Asia, then somehow my own hometown in Ohio—scares nobody nowadays.

But if Russia no longer exports international Socialism, it has not stopped involving itself in other countries' internal affairs. Which is not to suggest that other countries, including us, don't sometimes do the same. But by turning the state's secret and coercive forces actively outward, the Bolsheviks invented something new under the sun for Russia. It has found exporting mischief to be a great relief—and, evidently, a point of strategy, and of pride. On the street in Yekaterinburg, an older woman, recognizing Thomas and me as Americans, cackled with great glee. "Americans!" she called out. "Trump won! We chose him!" In June, James Comey, the former director of the FBI, testifying before Congress, said, "We're talking about a foreign government that, using technical intrusion, lots of other methods, tried to shape the way we think,

we vote, we act. That is a big deal." The habit of Russian intrusion that Comey is talking about began at the revolution.

Individuals change history. There would be no St. Petersburg without Peter the Great and no United States of America without George Washington. There would have been no Soviet Union without Lenin. Today he might feel discouraged to see the failure of his Marxist utopia—a failure so thorough that no country is likely to try it again soon. But his political methods may be his real legacy.

Unlike Marxism-Leninism, Lenin's tactics enjoy excellent health today. In a capitalist Russia, Putin favors his friends, holds power closely, and doesn't compromise with rivals. In America, too, we've reached a point in our politics where the strictest partisanship rules. Steve Bannon, the head of the right-wing media organization Breitbart News, who went on to be an adviser to the president, told a reporter in 2013, "I'm a Leninist . . . I want to bring everything crashing down, and destroy today's establishment." Of course he didn't mean he admired Lenin's ideology—far from it—but Lenin's methods have a powerfully modern appeal. Lenin showed the world how well not compromising can work. A response to that revolutionary innovation of his has yet to be figured out.

We Go It Alone

FROM *Outside*

IT'S THE SPRING OF 2016, and I'm ten miles south of Damascus, Virginia, where an annual celebration called Trail Days has just wrapped up. Last night, temperatures plummeted into the thirties. Today, long-distance Appalachian Trail hikers who'd slept in hammocks and mailed their underquilts home too soon were groaning into their morning coffee. A few small fires shot woodsmoke at the sun as thousands of tent stakes were dislodged. Over the next twenty-four hours, most of the hikers in attendance would pack up and hit the 554-mile stretch of the AT that runs north through Virginia.

I've used the Trail Days layover as an opportunity to stash most of my belongings with friends and complete a short section of the AT I'd missed, near the Tennessee-Virginia border. As I'm moving along, a day hiker heading in the opposite direction stops me for a chat. He's affable and inquisitive. He asks what many have asked before: "Where are you from?" I tell him Miami.

He laughs and says, "No, but really. Where are you *from* from?" He mentions something about my features, my thin nose, and then trails off. I tell him my family is from Eritrea, a country in the Horn of Africa, next to Ethiopia. He looks relieved.

"I knew it," he says. "You're not black."

I say that of course I am. "None more black," I weakly joke.

"Not really," he says. "You're African, not black-black. Blacks don't hike."

I'm tired of this man. His from-froms and black-blacks. He wishes me good luck and leaves. He means it, too; he isn't mali-

cious. To him there's nothing abnormal about our conversation. He has categorized me, and the world makes sense again. *Not black-black.* I hike the remaining miles back to my tent and don't emerge for hours.

Heading north from Springer Mountain in Georgia, the Appalachian Trail class of 2017 would have to walk 670 miles before reaching the first county that did not vote for Donald Trump. The average percentage of voters who did vote for Trump—a xenophobic candidate who was supported by David Duke—in those miles? Seventy-six. Approximately 30 miles farther away, they'd come to a hiker hostel that proudly flies a Confederate flag. Later they would reach the Lewis Mountain campground in Shenandoah National Park—created in Virginia in 1935, during the Jim Crow era—and read plaques acknowledging its former history as the segregated Lewis Mountain Negro Area. The campground was swarming with RVs flying Confederate flags when I hiked through. This flag would haunt the hikers all the way to Mount Katahdin, the trail's end point, in northern Maine. They would see it in every state, feeling the tendrils of hatred that rooted it to the land they walked upon.

During the early part of my through-hike, I arrive in Gatlinburg, Tennessee, one afternoon, a little later than I planned. I was one of many thirtysomethings who'd ended their relationships, quit their jobs, left their pets with best friends, and flown to Georgia. By this point, I'm two hundred miles into my arduous, rain-soaked trek. Everything aches. The bluets and wildflowers have emerged, and I've taken a break in town to resupply, midway through my biggest challenge thus far, the Smokies.

It isn't until I'm about to leave town that I see it: blackface soap, a joke item that supposedly will turn a white person black if you can trick them into using it. I'm in a general store opposite the Nantahala Outdoor Center. The soap is in a discount bin next to the cash register. I'd popped in to buy chocolate milk and was instead reminded of a line from Claudia Rankine's book *Citizen:* "The past is a life sentence, a blunt instrument aimed at tomorrow."

There's a shuttle back to the trail at Newfound Gap leaving in fifteen minutes. I fumble to take a photograph of the cartoon white woman on the packaging, standing in front of her bathroom sink. She can't believe it. How could this happen? Her face and hands are black. She scrubs to no avail.

I leave. Cars honk. I'm standing at an intersection and straining to return to the world. The shuttle arrives to take us from town to trailhead. The van leads us up, up into the mountains. It's a clear day. Hikers are laughing, rejuvenated. "Did you have fun in town?" a friend I met on the trail asks. "This visibility is unreal," says another, nose against the window. He thinks he has spotted a bear. The sun has lifted spirits. The van spills us out, but I can barely see a thing.

Two days later, a stream of texts hit my phone. Prince has died. I feel my vision blur, sit down on the first rock I see, and don't move for a while. The hikers who walk past ask if I'm hurt. "I'm sorry to tell you this," I'll hear myself say. "Prince just died." No one knows who I'm talking about. I will see variations of the same vacant expression for the rest of the day. "The Prince of Wales?" one hiker asks.

I'm losing light. I have to get to the next shelter. The afternoon has been a learning experience: the trail is no place to share black grief. Later, when Beyoncé releases *Lemonade*, an album that speaks powerfully to black women, I won't permit myself to hear it out here. I'm lonely enough as it is, without feeling additional isolation. I keep it from myself, and I follow the blazes north. I tell the trees the truth of it: some days I feel like breaking.

The National Park Service celebrated its centennial last year. In one brochure, a white man stands boldly, precariously, in Rocky Mountain National Park, gazing at a massive rock face. He wears a full pack. He is ready to tackle the impossible. The poster salutes "100 years of getting away from it all." The parenthetical is implied if not obvious: for some.

In a *Backpacker* interview from 2000, a black man named Robert Taylor was asked about the hardest things he faced during his through-hike of the Appalachian Trail. He'd recently completed both the AT and the Pacific Crest Trail. "My problems were mainly with people," he said. "In towns, people yelled racist threats at me in just about every state I went through. They'd say, 'We don't like you,' and 'You're a nigger.' Once when I stopped at a mail drop, the postmaster said, 'Boy, get out of here. We got no mail drop for you.'"

It will be several months before I realize that most AT hikers in 2016 are unaware of the clear division that exists between what

hikers of color experience on the trail (generally positive) and in town (not so much). While fellow through-hikers and trail angels are some of the kindest and most generous people I'll ever encounter, many trail towns have no idea what to make of people who look like me. They say they don't see much of "my kind" around here and leave the rest hanging in the air.

The rule is you don't talk about politics on the trail. The truth is you can't talk about diversity in the outdoors without talking about politics, since politics is a big reason why the outdoors look the way they do. From the park system's inception, Jim Crow laws and Native American removal campaigns limited access to recreation by race. From the mountains to the beaches, outdoor leisure was often accompanied by the words "whites only." The repercussions for disobedience were grave.

"For me, the fear is like a heartbeat, always present, while at the same time, intangible, elusive, and difficult to define," Evelyn C. White wrote in her 1999 essay "Black Women and the Wilderness." In it she explains why the thought of hiking in Oregon, which some writer friends invited her to do, fills her with dread. In wilderness, White does not see freedom but a portal to the past. It is a trigger. The history of suffering is too much for her to overcome. This fear has conjured a similar paralysis nationwide. It says to the minority: Be in this place and someone might seize the opportunity to end you. Nature itself is the least of White's concerns. Bear paws have harmed fewer black bodies in the wild than human hands. She does not wish to be the only one who looks like her in a place with history like this.

Perspective is everything.

There are eleven cats at Bob Peoples's Kincora Hiking Hostel in Hampton, Tennessee. When I ask Peoples how he keeps track of them, he responds, "They keep track of me." We talk about the places he's hiked and the people he's met. "Germans have the best hiking culture of any country," he says. "If there was a trail to hell, Germans would be on it." The chance of precipitation the next day is 100 percent. When it drizzles the rain plays me, producing different sounds as it strikes hat, jacket, and pack cover. Of the many reasons to pause while hiking, this remains my favorite. The smell and sound of the dampening forest is a sensory gift, a time for reflection.

*

The first bumper sticker I see in Hot Springs, North Carolina, says that April is Confederate History Month. A week later, I stay in a hostel near Roan Mountain, Tennessee, next to a house that's flying a Confederate flag. Hikers who've hitched into town tell me that the rides they got were all from drunk white men. Be careful, they warn.

I reconsider going into town at all. It's near freezing. Two days ago, I woke up on Roan Mountain itself in a field of frozen mayapples. Today I wear my Buff headband like a head scarf under my fleece hat. When I walk a third of a mile back to the trailhead alone the next morning, I look at the neighbor's flag and wonder if someone will assume I'm Muslim, whether I'm putting myself at risk. I lower the Buff to my neck and worry that I'm being paranoid. Six months later, the *San Francisco Chronicle* will report on a woman of color who was hiking in Fremont, California, while wearing a Buff like a bandana and returned to find her car's rear window smashed, along with a note. "Hijab wearing bitch," it said. "This is our nation now get the fuck out." She wasn't Muslim, but that's not the point. The point is the ease with which a person becomes a "them" in the woods.

Two weeks later, at Trail Days, there's a parade celebrating current and past hikers. A black man with the trail name Exterminator aims a water gun at a white crowd as he moves along. He shoots their white children. They laugh and shoot back with their own water guns. This goes on for thirty yards. I pause to corral my galloping anxiety. He is safe, I tell myself. This event is one of the few places in America where I don't fear for a black man with a toy gun in a public setting.

The Southern Poverty Law Center tracked more than a thousand hate crimes and bias incidents that occurred in the month after the election. On November 16, 2016, the Appalachian Trail Conservancy posted information about racist trail graffiti on its Facebook page. It showed up along the trail corridor in Pennsylvania. The group was encouraging anyone who encountered "offensive graffiti or vandalism" to report it via email.

Starting in 1936, amid the violence of Jim Crow, a publication known as the *Green Book* functioned as a guide for getting black motorists from point A to point B safely. It told you which gas stations would fill your tank, which restaurants would seat you, and where you could lay your head at night without fear. It remained

in print for thirty years. As recently as fifty years ago, black families needed a guide just to travel through America unharmed.

There is nothing approximating a *Green Book* for minorities navigating the American wilderness. How could there be? You simply step outside and hope for the best. One of the first questions asked of many women who solo-hike the Appalachian Trail is whether they brought a gun. Some find it preposterous. But one hiker of color I spoke to insisted on carrying a machete, an unnecessarily heavy piece of gear. "You can never be too sure," he told me.

As a queer black woman, I'm among the last people anyone expects to see on a through-hike. But nature is a place I've always belonged. My home in South Florida spanned the swamp, the Keys, and the dredged land in between. My father and I explored them all, waving at everything from egrets to purple gallinules and paddling by the bowed roots of mangroves. This was before Burmese pythons overran the Everglades, when the rustling of leaves in the canopy above our canoe still veered mammalian.

Throughout my youth, my grandmother and I took walks in Miami, where I'd hear her say the words *tuum nifas*. It meant a delicious wind, a nourishing wind. These experiences shaped how I viewed movement throughout the natural world. How I view it still. The elements, I thought, could end my hunger.

Little has changed since. Now the rocks gnaw at my shins. I thud against the ground, my tongue coated in dirt. I pick myself back up and start again.

Every day I eat the mountains, and the mountains, they eat me. "Less to carry," I tell the others: this skin, America, the weight of that past self. My hiking partners are concerned and unconvinced. There is a weight to you still, they tell me. They are not wrong. My footing has been off for days. There were things I had braced for at the beginning of this journey that have finally started to undo me. We were all hurtling through the unfamiliar, aching, choppy, destroyed by weather, trying not to tear apart. But some of us were looking around as well. By the time I made it through Maryland, it was hard not to think of the Appalachian Trail as a 2,190-mile trek through Trump lawn signs. In July, I read the names of more black men killed by police: Philando Castile, Alton Sterling. Never did I imagine that the constant of the woods would be my friends urging, pleading, that I never return home.

That was then. Back home in Oakland, California, now, my knees hurt. I struggle with the stairs. I wonder if it's Lyme disease from an unseen tick bite. The weight I lost has come back. My arms, the blackest I ever saw them after weeks in the summer sun, have faded to their usual dark brown. The bruises on my collarbones from my pack straps are no more. My legs aren't oozing blood. My feet haven't throbbed in four months. I am once again soft and unblemished and pleading with my anxiety every day for a few hours of peace. My timing couldn't be worse. The news is relentless. Facts mean nothing. The truth is, I don't know how to move through the world these days. Everything feels like it needs saving. I can barely keep up.

Who is wilderness for? It depends on who you ask. In 2013, Trail Life USA, a faith-based organization, was established as a direct response to the Boy Scouts of America's decision to allow openly gay kids into their program. A statement by the group made the rules clear: Trail Life USA "will not admit youth who are open or avowed about their homosexuality, and it will not admit boys who are not 'biologically male' or boys who wish to dress and act like girls."

Roughly two years later, news outlets profiled the Radical Monarchs, a group for children of color between the ages of eight and twelve, intended as a Girl Scouts for social activists. Headlines like "Radical Brownies Are Yelling 'Black Lives Matter,' Not Hawking Girl Scout Cookies" highlighted what an intersectional approach to youth activism could look like. Organizations such as Trail Life USA and Radical Monarchs show opposite ends of the outdoor spectrum. For conservative Christian men, religion is used as a means of tying exclusionary practices to outdoor participation. For people of color, the wilderness is everywhere they look. They don't need mountains. Wilderness lives outside their front doors. Orienteering skills mean navigating white anxiety about them. They are belaying to effect change. And even then, their efforts might not be enough.

"People on the trail, overwhelmingly, are good people, but it isn't advertised for us," says Bryan Winckler, a black AT throughhiker who went by the trail name Boomer. "If you see a commercial for anything outdoor related, it's always a white person on it. I think if people saw someone who looked like them they would be interested. It's not advertised, so people think, That's not for me."

Brittany Leavitt, an Outdoor Afro trip leader based in Washington, DC, echoed this sentiment. "You don't see it in the media," she told me recently. "You don't see it advertised when you go into outdoor stores. When I do a hike, I talk about what's historically in the area. Nature has always been part of black history."

She's right. Outdoor skills were a matter of survival for black people before they became a form of exclusion. Harriet Tubman is rarely celebrated as one of the most important outdoor figures in American history, despite traversing thousands of miles over the same mountains I walked this year.

"How can we make being in the outdoors a conduit for helping people realize, understand, and become comfortable with the space they occupy in the world?" says Krystal Williams, a black woman who through-hiked the AT in 2011. The change is happening slowly, in large part because of public figures bringing attention to the outdoors. Barack Obama designated more national monuments than any president before him. Oprah has called 2017 her year of adventure. "My favorite thing on earth is a tree," she told ranger Shelton Johnson, an advocate for diversity in the national parks, when she met him in Yosemite in 2010. A recent photo of Oprah at the Grand Canyon shows her carrying a full pack. "Hiking requires no particular skill, only two feet and a sturdy pair of shoes," she said. "You set the pace. You choose the trail. You lock into a certain rhythm with the road, and that rhythm becomes your clarion song."

Halfway through the descent into Daleville, Virginia, I found myself lying on the trail floor, wincing up at the canopy. I had taken a sudden tumble and was dazed. My right ankle ached badly, though my trekking poles had saved me from a truly nasty sprain. It was not a difficult stretch of trail—some packed dirt, a few small rocks, plenty of switchbacks. I felt betrayed and then ashamed. I could feel my confidence evaporating. If I couldn't walk a well-groomed trail, what in the world was I going to do with the boulder scrambles awaiting me in the north? Falls could be fatal. At worst this one was a slight embarrassment, but it marked the first time I needed to forgive myself for what I could not control.

Every inch of my being by that point had been shaped by an explicit choice. In pursuit of Katahdin—which I reached on October 1, after six months of hiking—I had wept and chopped off the long,

natural hair, so politicized in America, that my grandmother had told me to always treasure. My afro was no more. I had left my skin to ash, my lips to crack. I wore my transmission-tower-print bandana like an electric prayer. The Appalachian Trail was the longest conversation I'd ever had with my body, both where I fit in it and where it fits in the world.

One of the popular Appalachian Trail books I read while preparing for my trek asked readers to make a short list of reasons why they wanted to do it. The author suggested we understand these reasons, down to our core, before embarking, coming up with something deeper than "I like nature." I took out this document often when things felt overwhelming on the AT, when the enormity of the pursuit threatened to swallow me whole. Looking back, the list is a series of unrealized hopes. One line reads: "I have always been the token in a group; I have never chosen how I want to lead." Another says: "It will be the first time I get to discover not whether I will succeed but who I am becoming." The last line is a declaration: "I want to be a role model to black women who are interested in the outdoors, including myself."

There were days when the only thing that kept me going was knowing that each step was one toward progress, a boot to the granite face of white supremacy. I belong here, I told the trail. It rewarded me in lasting ways. The weight I carried as a black woman paled in comparison with the joy I felt daily among my peers in that wilderness. They shaped my heart into what it will be for the rest of my life.

One of the most common sentiments one hears about the Appalachian Trail is how it restores a person's faith in humanity. It is no understatement to say that the friends I made, and the experiences I had with strangers who, at times, literally gave me the shirt off their back, saved my life. I owe a great debt to the through-hiking community that welcomed me with open arms, that showed me what I could be and helped me when I faltered. There is no impossible, they taught me: only good ideas of extraordinary magnitude.

NATHAN HELLER

The Digital Republic

FROM *The New Yorker*

UP THE ESTONIAN COAST, a five-lane highway bends with the path of the sea, then breaks inland, leaving cars to follow a thin road toward the houses at the water's edge. There is a gated community here, but it is not the usual kind. The gate is low—a picket fence—as if to prevent the dunes from riding up into the street. The entrance is blocked by a railroad-crossing arm, not so much to keep out strangers as to make sure they come with intent. Beyond the gate, there is a schoolhouse, and a few homes line a narrow drive. From Tallinn, Estonia's capital, you arrive dazed: trees trace the highway, and the cars go fast, as if to get in front of something that no one can see.

Within this gated community lives a man, his family, and one vision of the future. Taavi Kotka, who spent four years as Estonia's chief information officer, is one of the leading public faces of a project known as e-Estonia: a coordinated governmental effort to transform the country from a state into a digital society.

E-Estonia is the most ambitious project in technological state-craft today, for it includes all members of the government, and alters citizens' daily lives. The normal services that government is involved with—legislation, voting, education, justice, health care, banking, taxes, policing, and so on—have been digitally linked across one platform, wiring up the nation. A lawn outside Kotka's large house was being trimmed by a small robot, wheeling itself forward and nibbling the grass.

"Everything here is robots," Kotka said. "Robots here, robots

there." He sometimes felt that the lawnmower had a soul. "At parties, it gets *close* to people," he explained.

A curious wind was sucking in a thick fog from the water, and Kotka led me inside. His study was cluttered, with a long table bearing a chessboard and a bowl of foil-wrapped wafer chocolates (a mark of hospitality at Estonian meetings). A four-masted model ship was perched near the window; in the corner was a pile of robot toys.

"We had to set a goal that resonates, large enough for the society to believe in," Kotka went on.

He is tall with thin blond hair that, kept shaggy, almost conceals its recession. He has the liberated confidence, tinged with irony, of a cardplayer who has won a lot of hands and can afford to lose some chips.

It was during Kotka's tenure that the e-Estonian goal reached its fruition. Today, citizens can vote from their laptops and challenge parking tickets from home. They do so through the "once only" policy, which dictates that no single piece of information should be entered twice. Instead of having to "prepare" a loan application, applicants have their data—income, debt, savings—pulled from elsewhere in the system. There's nothing to fill out in doctors' waiting rooms, because physicians can access their patients' medical histories. Estonia's system is keyed to a chip-ID card that reduces typically onerous, integrative processes—such as doing taxes—to quick work. "If a couple in love would like to marry, they still have to visit the government location and express their will," Andrus Kaarelson, a director at the Estonian Information Systems Authority, says. But, apart from transfers of physical property, such as buying a house, all bureaucratic processes can be done online.

Estonia is a Baltic country of 1.3 million people and four million hectares, half of which is forest. Its government presents this digitization as a cost-saving efficiency and an equalizing force. Digitizing processes reportedly saves the state 2 percent of its GDP a year in salaries and expenses. Since that's the same amount it pays to meet the threshold for protection (Estonia—which has a notably vexed relationship with Russia—has a comparatively small military), its former president Toomas Hendrik Ilves liked to joke that the country got its national security for free.

Other benefits have followed. "If everything is digital, and location-independent, you can run a borderless country," Kotka said.

In 2014, the government launched a digital "residency" program, which allows logged-in foreigners to partake of some Estonian services, such as banking, as if they were living in the country. Other measures encourage international startups to put down virtual roots; Estonia has the lowest business-tax rates in the European Union, and has become known for liberal regulations around tech research. It is legal to test Level 3 driverless cars (in which a human driver can take control) on all Estonian roads, and the country is planning ahead for Level 5 (cars that take off on their own). "We believe that innovation happens anyway," Viljar Lubi, Estonia's deputy secretary for economic development, says. "If we close ourselves off, the innovation happens somewhere else."

"It makes it so that, if one country is not performing as well as another country, people are going to the one that is performing better—competitive governance is what I'm calling it," Tim Draper, a venture capitalist at the Silicon Valley firm Draper Fisher Jurvetson and one of Estonia's leading tech boosters, says. "We're about to go into a very interesting time where a lot of governments can become virtual."

Previously, Estonia's best-known industry was logging, but Skype was built there using mostly local engineers, and countless other startups have sprung from its soil. "It's not an offshore paradise, but you can capitalize a lot of money," Thomas Padovani, a Frenchman who cofounded the digital-ad startup Adcash in Estonia, explains. "And the administration is light, all the way." A light touch does not mean a restricted one, however, and the guiding influence of government is everywhere.

As an engineer, Kotka said, he found the challenge of helping to construct a digital nation too much to resist. "Imagine that it's your task to build the Golden Gate Bridge," he said excitedly. "You have to change the whole way of thinking about society." So far, Estonia is past halfway there.

One afternoon, I met a woman named Anna Piperal at the e-Estonia Showroom. Piperal is the "e-Estonia ambassador"; the showroom is a permanent exhibit on the glories of digitized Estonia, from Skype to Timbeter, an app designed to count big piles of logs. (Its founder told me that she'd struggled to win over the wary titans of Big Log, who preferred to count the inefficient way.) Piperal has blond hair and an air of brisk, Northern European

professionalism. She pulled out her ID card; slid it into her laptop, which, like the walls of the room, was faced with blond wood; and typed in her secret code, one of two that went with her ID. The other code issues her digital signature—a seal that, Estonians point out, is much harder to forge than a scribble.

"This PIN code just starts the whole decryption process," Piperal explained. "I'll start with my personal data from the population registry." She gestured toward a box on the screen. "It has my document numbers, my phone number, my email account. Then there's real estate, the land registry." Elsewhere, a box included all of her employment information; another contained her traffic records and her car insurance. She pointed at the tax box. "I have no tax debts; otherwise, that would be there. And I'm finishing a master's at the Tallinn University of Technology, so here"—she pointed to the education box—"I have my student information. If I buy a ticket, the system can verify, automatically, that I'm a student." She clicked into the education box, and a detailed view came up, listing her previous degrees.

"My cat is in the pet registry," Piperal said proudly, pointing again. "We are done with the vaccines."

Data aren't centrally held, thus reducing the chance of Equifax-level breaches. Instead, the government's data platform, X-Road, links individual servers through end-to-end encrypted pathways, letting information live locally. Your dentist's practice holds its own data; so does your high school and your bank. When a user requests a piece of information, it is delivered like a boat crossing a canal via locks.

Although X-Road is a government platform, it has become, owing to its ubiquity, the network that many major private firms build on, too. Finland, Estonia's neighbor to the north, recently began using X-Road, which means that certain data—for instance, prescriptions that you're able to pick up at a local pharmacy—can be linked between the nations. It is easy to imagine a novel internationalism taking shape in this form. Toomas Ilves, Estonia's former president and a longtime driver of its digitization efforts, is currently a distinguished visiting fellow at Stanford, and says he was shocked at how retrograde US bureaucracy seems even in the heart of Silicon Valley. "It's like the nineteen-fifties—I had to provide an electrical bill to prove I live here!" he exclaimed. "You can get an iPhone X, but, if you have to register your car, forget it."

X-Road is appealing due to its rigorous filtering: Piperal's teachers can enter her grades, but they can't access her financial history, and even a file that's accessible to medical specialists can be sealed off from other doctors if Piperal doesn't want it seen.

"I'll show you a digital health record," she said, to explain. "A doctor from here"—a file from one clinic—"can see the research that this doctor"—she pointed to another—"does." She'd locked a third record, from a female-medicine practice, so that no other doctor would be able to see it. A tenet of the Estonian system is that an individual owns all information recorded about him or her. Every time a doctor (or a border guard, a police officer, a banker, or a minister) glances at any of Piperal's secure data online, that look is recorded and reported. Peeping at another person's secure data for no reason is a criminal offense. "In Estonia, we don't have Big Brother; we have Little Brother," a local told me. "You can tell him what to do and maybe also beat him up."

Business and land-registry information is considered public, so Piperal used the system to access the profile of an Estonian politician. "Let's see his land registry," she said, pulling up a list of properties. "You can see there are three land plots he has, and this one is located"—she clicked, and a satellite photograph of a sprawling beach house appeared—"on the sea."

The openness is startling. Finding the business interests of the rich and powerful—a hefty field of journalism in the United States—takes a moment's research, because every business connection or investment captured in any record in Estonia becomes searchable public information. (An online tool even lets citizens map webs of connection, follow-the-money style.) Traffic stops are illegal in the absence of a moving violation, because officers acquire records from a license-plate scan. Polling-place intimidation is a non-issue if people can vote—and then change their votes, up to the deadline—at home, online. And heat is taken off immigration because, in a borderless society, a resident need not even have visited Estonia in order to work and pay taxes under its dominion.

Soon after becoming the CIO, in 2013, Taavi Kotka was charged with an unlikely project: expanding Estonia's population. The motive was predominantly economic. "Countries are like enterprises," he said. "They want to increase the wealth of their own people."

Tallinn, a harbor city with a population just over four hundred thousand, does not seem to be on a path toward outsized growth. Not far from the cobbled streets of the hilly Old Town is a business center, where boxy Soviet structures have been supplanted by stylish buildings of a Scandinavian cast. Otherwise, the capital seems pleasantly preserved in time. The coastal daylight is bright and thick, and, when a breeze comes off the Baltic, silver-birch leaves shimmer like chimes. "I came home to a great autumn / to a luminous landscape," the Estonian poet Jaan Kaplinski wrote decades ago. This much has not changed.

Kotka, however, thought that it was possible to increase the population just by changing how you thought of what a population was. Consider music, he said. Twenty years ago, you bought a CD and played the album through. Now you listen track by track, on demand. "If countries are competing not only on physical talent moving to their country but also on how to get the best virtual talent *connected* to their country, it becomes a disruption like the one we have seen in the music industry," he said. "And it's basically a zero-cost project, because we already have this infrastructure for our own people."

The program that resulted is called e-residency, and it permits citizens of another country to become residents of Estonia without ever visiting the place. An e-resident has no leg up at the customs desk, but the program allows individuals to tap into Estonia's digital services from afar.

I applied for Estonian e-residency one recent morning at my apartment, and it took about ten minutes. The application cost a hundred euros, and the hardest part was finding a passport photograph to upload, for my card. After approval, I would pick up my credentials in person, like a passport, at the Estonian Consulate in New York.

This physical task proved to be the main stumbling block, Ott Vatter, the deputy director of e-residency, explained, because consulates were reluctant to expand their workload to include a new document. Mild xenophobia made some Estonians at home wary, too. "Inside Estonia, the mentality is kind of 'What is the gain, and where is the money?'" he said. The physical factor still imposes limitations—only thirty-eight consulates have agreed to issue documents, and they are distributed unevenly. (Estonia has only one embassy in all of Africa.) But the office has made special accom-

modations for several popular locations. Since there's no Estonian consulate in San Francisco, the New York consulate flies personnel to California every three months to batch-process Silicon Valley applicants.

"I had a deal that I did with Funderbeam, in Estonia," Tim Draper, who became Estonia's second e-resident, told me. "We decided to use a 'smart contract'—the first ever in a venture deal!" Smart contracts are encoded on a digital ledger and, notably, don't require an outside administrative authority. It was an appealing prospect, and Draper, with his market investor's gaze, recognized a new market for elite tech brainpower and capital. "I thought, Wow! Governments are going to have to compete with each other for us," he said.

So far, twenty-eight thousand people have applied for e-residency, mostly from neighboring countries: Finland and Russia. But Italy and Ukraine follow, and UK applications spiked during Brexit. (Many applicants are footloose entrepreneurs or solo venders who want to be based in the EU.) Because 88 percent of applicants are men, the United Nations has begun seeking applications for female entrepreneurs in India.

"There are so many companies in the world for whom working across borders is a big hassle and a source of expense," Siim Sikkut, Estonia's current CIO, says. Today, in Estonia, the weekly e-residency application rate exceeds the birth rate. "We tried to make more babies, but it's not that easy," he explained.

With so many businesses abroad, Estonia's startup-ism hardly leaves an urban trace. I went to visit one of the places it does show: a co-working space, Lift99, in a complex called the Telliskivi Creative City. The Creative City, a former industrial park, is draped with trees and framed by buildings whose peeling exteriors have turned the yellows of a worn-out sponge. There are murals, outdoor sculptures, and bills for coming shows; the space is shaped by communalism and by the spirit of creative unrule. One artwork consists of stacked logs labeled with Tallinn startups: Insly, Leap, Photry, and something called 3D Creationist.

The office manager, Elina Kaarneem, greeted me near the entrance. "Please remove your shoes," she said. Lift99, which houses thirty-two companies and five freelancers, had industrial windows, with a two-floor open-plan workspace. Both levels also included

smaller rooms named for techies who had done business with Estonia. There was a Zennström Room, after Niklas Zennström, the Swedish entrepreneur who cofounded Skype, in Tallinn. There was a Horowitz Room, for the venture capitalist Ben Horowitz, who has invested in Estonian tech. There was also a Tchaikovsky Room, because the composer had a summer house in Estonia and once said something nice about the place.

"This is not the usual co-working space, because we choose every human," Ragnar Sass, who founded Lift99, exclaimed in the Hemingway Room. Hemingway, too, once said something about Estonia; a version of his pronouncement—"No well-run yacht basin is complete without at least two Estonians"—had been spray-stenciled on the wall, along with his face.

The room was extremely small, with two cushioned benches facing each other. Sass took one; I took the other. "Many times, a miracle can happen if you put talented people in one room," he said as I tried to keep my knees inside my space. Not far from the Hemingway Room, Barack Obama's face was also on a wall. Obama Rooms are booths for making cell-phone calls, following something he once said about Estonia. ("I should have called the Estonians when we were setting up our health-care website.") That had been stenciled on the wall as well.

Some of the companies at Lift99 are local startups, but others are international firms seeking an Estonian foothold. In something called the Draper Room, for Tim Draper, I met an Estonian engineer, Margus Maantoa, who was launching the Tallinn branch of the German motion-control company Trinamic. Maantoa shares the room with other companies, and, to avoid disturbing them, we went to the Iceland Room. (Iceland was the first country to recognize Estonian independence.) The seats around the table in the Iceland Room were swings.

I took a swing, and Maantoa took another. He said, "I studied engineering and physics in Sweden, and then, seven years ago, I moved back to Estonia because so much is going on." He asked whether I wanted to talk with his boss, Michael Randt, at the Trinamic headquarters, in Hamburg, and I said that I did, so he opened his laptop and set up a conference call on Skype. Randt was sitting at a table, peering down at us as if we were a mug of coffee. Tallinn had a great talent pool, he said: "Software companies are absorbing a lot of this labor, but, when it comes to hardware,

there are only a few companies around." He was an e-resident, so opening a Tallinn office was fast.

Maantoa took me upstairs, where he had a laboratory space that looked like a janitor's closet. Between a water heater and two large air ducts, he had set up a desk with a 3-D printer and a robotic motion-control platform. I walked him back to Draper and looked up another startup, an Estonian company called Ööd, which makes one-room, two-hundred-square-foot huts that you can order prefab. The rooms have floor-to-ceiling windows of one-way glass, climate control, furniture, and lovely wood floors. They come in a truck and are dropped into the countryside.

"Sometimes you want something small, but you don't want to be in a tent," Kaspar Kägu, the head of Ööd sales, explained. "You want a shower in the morning and your coffee and a beautiful landscape. Fifty-two percent of Estonia is covered by forestland, and we're rather introverted people, so we want to be—uh, *not* near everybody else." People of a more sociable disposition could scatter these box homes on their property, he explained, and rent them out on services like Airbnb.

"We like to go to nature—but comfortably," Andreas Tiik, who founded Ööd with his carpenter brother, Jaak, told me. The company had queued preorders from people in Silicon Valley, who also liked the idea, and was tweaking the design for local markets. "We're building a sauna in it," Kägu said.

In the United States, it is generally assumed that private industry leads innovation. Many ambitious techies I met in Tallinn, though, were leaving industry to go work for the state. "If someone had asked me, three years ago, if I could imagine myself working for the government, I would have said, 'Fuck no,'" Ott Vatter, who had sold his own business, told me. "But I decided that I could go to the US at any point, and work in an average job at a private company. This is so much bigger."

The bigness is partly inherent in the government's appetite for large problems. In Tallinn's courtrooms, judges' benches are fitted with two monitors, for consulting information during the proceedings, and case files are assembled according to the once-only principle. The police make reports directly into the system; forensic specialists at the scene or in the lab do likewise. Lawyers log on —as do judges, prison wardens, plaintiffs, and defendants, each

through his or her portal. The Estonian courts used to be notori-
ously backlogged, but that is no longer the case.

"No one was able to say whether we should increase the number
of courts or increase the number of judges," Timo Mitt, a manager
at Netgroup, which the government hired to build the architec-
ture, told me. Digitizing both streamlined the process and helped
identify points of delay. Instead of setting up prisoner transport to
trial—fraught with security risks—Estonian courts can teleconfer-
ence defendants into the courtroom from prison.

For doctors, a remote model has been of even greater use. One
afternoon, I stopped at the North Estonia Medical Center, a hos-
pital in the southwest of Tallinn, and met a doctor named Arkadi
Popov in an alleyway where ambulances waited in line.

"Welcome to our world," Popov, who leads emergency medical
care, said grandly, gesturing with pride toward the chariots of the
sick and maimed. "Intensive care!"

In a garage where unused ambulances were parked, he took an
iPad Mini from the pocket of his white coat, and opened an "e-
ambulance" app, which Estonian paramedics began using in 2015.
"This system had some childhood diseases," Popov said, tapping
his screen. "But now I can say that it works well."

E-ambulance is keyed onto X-Road, and allows paramedics to
access patients' medical records, meaning that the team that ar-
rives for your chest pains will have access to your latest cardiology
report and ECG. Since 2011, the hospital has also run a telemedi-
cine system—doctoring at a distance—originally for three islands
off its coast. There were few medical experts on the islands, so
the EMS accepted volunteer paramedics. "Some of them are ho-
tel administrators, some of them are teachers," Popov said. At a
command center at the hospital in Tallinn, a doctor reads data
remotely.

"On the screen, she or he can see all the data regarding the
patient—physiological parameters, ECGs," he said. "Pulse, blood
pressure, temperature. In case of CPR, our doctor can see how
deep the compression of the chest is, and can give feedback." The
e-ambulance software also allows paramedics to preregister a pa-
tient en route to the hospital, so that tests, treatments, and surger-
ies can be prepared for the patient's arrival.

To see what that process looks like, I changed into scrubs and a
hairnet and visited the hospital's surgery ward. Rita Beljuskina, a

nurse anesthetist, led me through a wide hallway lined with steel doors leading to the eighteen operating theaters. Screens above us showed eighteen columns, each marked out with twenty-four hours. Surgeons book their patients into the queue, Beljuskina explained, along with urgency levels and any machinery or personnel they might need. An on-call anesthesiologist schedules them in order to optimize the theaters and the equipment.

"Let me show you how," Beljuskina said, and led me into a room filled with medical equipment and a computer in the corner. She logged on with her own ID. If she were to glance at any patient's data, she explained, the access would be tagged to her name, and she would get a call inquiring why it was necessary. The system also scans for drug interactions, so if your otolaryngologist prescribes something that clashes with the pills your cardiologist told you to take, the computer will put up a red flag.

The putative grandfather of Estonia's digital platform is Tarvi Martens, an enigmatic systems architect who today oversees the country's digital-voting program from a stone building in the center of Tallinn's Old Town. I went to visit him one morning, and was shown into a stateroom with a long conference table and French windows that looked out on the trees. Martens was standing at one window, with his back to me, commander style. For a few moments, he stayed that way; then he whirled around and addressed a timid greeting to the buttons of my shirt.

Martens was wearing a red flannel button-down, baggy jeans, black socks, and the sort of sandals that are sold at drugstores. He had gray stubble, and his hair was stuck down on his forehead in a manner that was somehow both rumpled and flat. This was the busiest time of the year, he said, with the fall election looming. He appeared to run largely on caffeine and nicotine; when he put down a mug of hot coffee, his fingers shook.

For decades, he pointed out, digital technology has been one of Estonia's first recourses for public ailments. A state project in 1970 used computerized data matching to help singles find soul mates, "for the good of the people's economy." In 1997, the government began looking into newer forms of digital documents as a supplement.

"They were talking about chip-equipped bar codes or something," Martens told me, breaking into a nerdy snicker-giggle.

"Totally ridiculous." He had been doing work in cybernetics and security as a private-sector contractor, and had an idea. When the cards were released, in 2002, Martens became convinced that they should be both mandatory and cheap.

"Finland started two years earlier with an ID card, but it's still a sad story," he said. "Nobody uses it, because they put a hefty price tag on the card, and it's a voluntary document. We sold it for ten euros at first, and what happened? Banks and application providers would say, 'Why should I support this card? Nobody has it.' It was a dead end." In what may have been the seminal insight of twenty-first-century Estonia, Martens realized that whoever offered the most ubiquitous and secure platform would run the country's digital future—and that it should be an elected leadership, not profit-seeking Big Tech. "The only thing was to push this card to the people, without them knowing what to do with it, and then say, 'Now people have a card. Let's start some applications,'" he said.

The first "killer application" for the ID-card-based system was the one that Martens still works on: i-voting, or casting a secure ballot from your computer. Before the first i-voting period, in 2005, only five thousand people had used their card for anything. More than nine thousand cast an i-vote in that election, however —only 2 percent of voters, but proof that online voting was attracting users—and the numbers rose from there. As of 2014, a third of all votes have been cast online.

That year, seven Western researchers published a study of the i-voting system which concluded that it had "serious architectural limitations and procedural gaps." Using an open-source edition of the voting software, the researchers approximated a version of the i-voting setup in their lab and found that it was possible to introduce malware. They were not convinced that the servers were entirely secure, either.

Martens insisted that the study was "ridiculous." The researchers, he said, gathered data with "a lot of assumptions," and misunderstood the safeguards in Estonia's system. You needed both the passwords and the hardware (the chip in your ID card or, in the newer "mobile ID" system, the SIM card in your phone) to log in, blocking most paths of sabotage. Estonian trust was its own safeguard, too, he told me. Earlier this fall, when a Czech research team found a vulnerability in the physical chips used in many ID cards, Siim Sikkut, the Estonian CIO, emailed me the finding. His

office announced the vulnerability, and the cards were locked for a time. When Sikkut held a small press conference, reporters peppered him with questions: What did the government gain from disclosing the vulnerability? How disastrous *was* it?

Sikkut looked bemused. Many upgrades to phones and computers resolve vulnerabilities that have never even been publicly acknowledged, he said — and think how much data we entrust to those devices. ("There is no government that knows more about you than Google or Facebook," Taavi Kotka says dryly.) In any case, the transparency seemed to yield a return; a poll conducted after the chip flaw was announced found that trust in the system had fallen by just 3 percent.

From time to time, Russian military jets patrolling Estonia's western border switch off their GPS transponders and drift into the country's airspace. What follows is as practiced as a pas de deux at the Bolshoi. NATO troops on the ground scramble an escort. Estonia calls up the Russian ambassador to complain; Russia cites an obscure error. The dance lets both parties show that they're alert, and have not forgotten the history of place.

Since the eleventh century, Estonian land has been conquered by Russia five times. Yet the country has always been an awkward child of empire, partly owing to its proximity to other powers (and their airwaves) and partly because the Estonian language, which belongs to the same distinct Uralic family as Hungarian and Finnish, is incomprehensible to everyone else. Plus, the greatest threat, these days, may not be physical at all. In 2007, a Russian cyberattack on Estonia sent everything from the banks to the media into chaos. Estonians today see it as the defining event of their recent history.

The chief outgrowth of the attack is the NATO Cooperative Cyber Defense Center of Excellence, a think tank and training facility. It's on a military base that once housed the Soviet Army. You enter through a gatehouse with gray walls and a pane of mirrored one-way glass.

"Document, please!" the mirror boomed at me when I arrived one morning. I slid my passport through on a tray. The mirror was silent for two full minutes, and I backed into a plastic chair.

"You have to wait here!" the mirror boomed back.

Some minutes later, a friendly staffer appeared at the inner

doorway and escorted me across a quadrangle trimmed with
NATO-member flags and birch trees just fading to gold. Inside
a gray stone building, another mirror instructed me to stow my
goods and to don a badge. Upstairs, the center's director, Merle
Maigre, formerly the national-security adviser to the Estonian pres-
ident, said that the center's goal was to guide other NATO nations
toward vigilance.

"This country is located—just where it is," she said, when I asked
about Russia. Since starting, in 2008, the center has done research
on digital forensics, cyber-defense strategy, and similar topics. (It
publishes the *Tallinn Manual 2.0 on the International Law Applicable
to Cyber Operations* and organizes a yearly research conference.)
But it is best known for its training simulations: an eight-hundred-
person cyber "live-fire" exercise called Locked Shields was run this
year alongside CYBRID, an exercise for defense ministers of the
EU. "This included aspects such as fake news and social media,"
Maigre said.

Not all of Estonia's digital leadership in the region is as openly
rehearsed. Its experts have consulted on Georgia's efforts to set up
its own digital registry. Estonia is also building data partnerships
with Finland, and trying to export its methods elsewhere across
the EU. "The vision is that I will go to Greece, to a doctor, and
be able to get everything," Toomas Ilves explains. Sandra Roosna,
a member of Estonia's e-Governance Academy and the author of
the book *e-Governance in Practice,* says, "I think we need to give the
European Union two years to do cross-border transactions and to
recognize each other digitally." Even now, though, the Estonian
platform has been adopted by nations as disparate as Moldova
and Panama. "It's very popular in countries that want—and not all
do—transparency against corruption," Ilves says.

Beyond X-Road, the backbone of Estonia's digital security is a
blockchain technology called KSI. A blockchain is like the digital
version of a scarf knitted by your grandmother. She uses one ball
of yarn, and the result is continuous. Each stitch depends on the
one just before it. It's impossible to remove part of the fabric, or to
substitute a swatch, without leaving some trace: a few telling knots,
or a change in the knit.

In a blockchain system, too, every line is contingent on what
came before it. Any breach of the weave leaves a trace, and trying
to cover your tracks leaves a trace, too. "Our number one market-

ing pitch is Mr. Snowden," Martin Ruubel, the president of Guardtime, the Estonian company that developed KSI, told me. (The company's biggest customer group is now the US military.) Popular anxiety tends to focus on data security—who can see my information?—but bits of personal information are rarely truly compromising. The larger threat is data integrity: whether what looks secure has been changed. (It doesn't really matter who knows what your blood type is, but if someone switches it in a confidential record your next trip to the emergency room could be lethal.) The average time until discovery of a data breach is 205 days, which is a huge problem if there's no stable point of reference. "In the Estonian system, you don't have paper originals," Ruubel said. "The question is: Do I know about this problem, and how quickly can I react?"

The blockchain makes every footprint immediately noticeable, regardless of the source. (Ruubel says that there is no possibility of a back door.) To guard secrets, KSI is also able to protect information without "seeing" the information itself. But, to deal with a full-scale cyberattack, other safeguards now exist. Earlier this year, the Estonian government created a server closet in Luxembourg, with a backup of its systems. A "data embassy" like this one is built on the same body of international law as a physical embassy, so that the servers and their data are Estonian "soil." If Tallinn is compromised, whether digitally or physically, Estonia's locus of control will shift to such mirror sites abroad.

"*If* Russia comes—not when—and if our systems shut down, we will have copies," Piret Hirv, a ministerial adviser, told me. In the event of a sudden invasion, Estonia's elected leaders might scatter as necessary. Then, from cars leaving the capital, from hotel rooms, from seat 3A at thirty thousand feet, they will open their laptops, log into Luxembourg, and—with digital signatures to execute orders and a suite of tamper-resistant services linking global citizens to their government—continue running their country, with no interruption, from the cloud.

The history of nationhood is a history of boundaries marked on land. When, in the fourteenth century, peace arrived after bloodshed among the peoples of Mexico's eastern altiplano, the first task of the Tlaxcaltecs was to set the borders of their territory. In 1813, Ernst Moritz Arndt, a German nationalist poet before there

was a Germany to be nationalistic about, embraced the idea of a *"Vaterland"* of shared history: "Which is the German's fatherland? / So tell me now at last the land!—/ As far's the German's accent rings / And hymns to God in heaven sings."

Today, the old fatuities of the nation-state are showing signs of crisis. Formerly imperialist powers have withered into nationalism (as in Brexit) and separatism (Scotland, Catalonia). New powers, such as the Islamic State, have redefined nationhood by ideological acculturation. It is possible to imagine a future in which nationality is determined not so much by where you live as by what you log on to.

Estonia currently holds the presidency of the European Union Council—a bureaucratic role that mostly entails chairing meetings. (The presidency rotates every six months; in January, it will go to Bulgaria.) This meant that the autumn's EU Digital Summit was held in Tallinn, a convergence of audience and expertise not lost on Estonia's leaders. One September morning, a car pulled up in front of the Tallinn Creative Hub, a former power station, and Kersti Kaljulaid, the president of Estonia, stepped out. She is the country's first female president, and its youngest. Tall and lanky, with chestnut hair in a pixie cut, she wore an asymmetrical dress of Estonian blue and machine gray. Kaljulaid took office last fall, after Estonia's presidential election yielded no majority winner; parliamentary representatives of all parties plucked her out of deep government as a consensus candidate whom they could all support. She had previously been an EU auditor.

"I am president to a digital society," she declared in her address. The leaders of Europe were arrayed in folding chairs, with Angela Merkel, in front, slumped wearily in a red leather jacket. "Simple people suffer in the hands of heavy bureaucracies," Kaljulaid told them. "We must go for inclusiveness, not high end. And we must go for reliability, not complex."

Kaljulaid urged the leaders to consider a transient population. Theresa May had told her people, after Brexit, "If you believe you're a citizen of the world, you're a citizen of nowhere." With May in the audience, Kaljulaid staked out the opposite view. "Our citizens will be global soon," she said. "We have to fly like bees from flower to flower to gather those taxes from citizens working in the morning in France, in the evening in the UK, living

half a year in Estonia and then going to Australia." Citizens had to remain connected, she said, as the French president, Emmanuel Macron, began nodding vigorously and whispering to an associate. When Kaljulaid finished, Merkel came up to the podium.

"You're so much further than we are," she said. Later, the EU member states announced an agreement to work toward digital government and, as the Estonian prime minister put it in a statement, "rethink our entire labor market."

Before leaving Tallinn, I booked a meeting with Marten Kaevats, Estonia's national digital adviser. We arranged to meet at a café near the water, but it was closed for a private event. Kaevats looked unperturbed. "Let's go somewhere beautiful!" he said. He led me to an enormous terraced concrete platform blotched with graffiti and weeds.

We climbed a staircase to the second level, as if to a Mayan plateau. Kaevats, who is in his thirties, wore black basketball sneakers, navy trousers, a pin-striped jacket from a different suit, and a white shirt, untucked. The fancy dress was for the digital summit. "I have to introduce the president of Estonia," he said merrily, crabbing a hand through his strawberry-blond hair, which stuck out in several directions. "I don't know what to say!" He fished a box of Marlboro Reds out of his pocket and tented into himself, twitching a lighter.

It was a cloudless morning. Rounded bits of gravel in the concrete caught a glare. The structure was bare and weather-beaten, and we sat on a ledge above a drop facing the harbor. The Soviets built this "Linnahall," originally as a multipurpose venue for sailing-related sports of the Moscow Summer Olympics. It has fallen into disrepair, but there are plans for renovation soon.

For the past year, Kaevats's main pursuit has been self-driving cars. "It basically embeds all the difficult questions of the digital age: privacy, data, safety—everything," he said. It's also an idea accessible to the man and woman (literally) in the street, whose involvement in regulatory standards he wants to encourage. "What's difficult is the ethical and emotional side," he said. "It's about values. What do we want? Where are the borders? Where are the red lines? These cannot be decisions made only by specialists."

To support that future, he has plumbed the past. Estonian folklore includes a creature known as the *kratt:* an assembly of random

objects that the Devil will bring to life for you, in exchange for a drop of blood offered at the conjunction of five roads. The Devil gives the *kratt* a soul, making it the slave of its creator.

"Each and every Estonian, even children, understands this character," Kaevats said. His office now speaks of *kratt* instead of robots and algorithms, and has been using the word to define a new, important nuance in Estonian law. "Basically, a *kratt* is a robot with representative rights," he explained. "The idea that an algorithm can buy and sell services *on your behalf* is a conceptual upgrade." In the US, where we lack such a distinction, it's a matter of dispute whether, for instance, Facebook is responsible for algorithmic sales to Russian forces of misinformation. #KrattLaw—Estonia's digital shorthand for a new category of legal entity comprising AI, algorithms, and robots—will make it possible to hold accountable whoever gave a drop of blood.

"In the US recently, smart toasters and Teddy bears were used to attack websites," Kaevats said. "Toasters should not be making attacks!" He squatted and emptied a pocket onto the ledge: cigarettes, lighter, a phone. "Wherever there's a smart device, around it there are other smart devices," he said, arranging the items on the concrete. "This smart streetlight"—he stood his lighter up—"asks the self-driving car"—he scooted his phone past it—"'Are you okay? Is everything okay with you?'" The Marlboro box became a building whose appliances made checks of their own, scanning one another for physical and blockchain breaches. Such checks, device to device, have a distributed effect. To commandeer a self-driving car on a street, a saboteur would, in theory, also have to hack every street lamp and smart toaster that it passed. This "mesh network" of devices, Kaevats said, will roll out starting in 2018.

Is everything okay with you? It's hard to hear about Estonians' vision for the robots without thinking of the people they're bloodsworn to serve. I stayed with Kaevats on the Linnahall for more than an hour. He lit several cigarettes, and talked excitedly of "building a digital society." It struck me then how long it had been since anyone in America had spoken of society-building of any kind. It was as if, in the 1990s, Estonia and the US had approached a fork in the road to a digital future, and the US had taken one path—personalization, anonymity, information privatization, and competitive efficiency—while Estonia had taken the other. Two

decades on, these roads have led to distinct places, not just in digital culture but in public life as well.

Kaevats admitted that he didn't start out as a techie for the state. He used to be a protester, advocating cycling rights. It had been dispiriting work. "I felt as if I was constantly beating my head against a big concrete wall," he said. After eight years, he began to resent the person he'd become: angry, distrustful, and negative, with few victories to show.

"My friends and I made a conscious decision then to say 'yes' and not 'no'—to be proactive rather than destructive," he explained. He started community organizing ("analog, not digital") and went to school for architecture, with an eye to structural change through urban planning. "I did that for ten years," Kaevats said. Then he found architecture, too, frustrating and slow. The more he learned of Estonia's digital endeavors, the more excited he became. And so he did what seemed the only thing to do: he joined his old foe, the government of Estonia.

Kaevats told me it irked him that so many Westerners saw his country as a tech haven. He thought they were missing the point. "This enthusiasm and optimism around technology is like a value of its own," he complained. "This gadgetry that I've been ranting about? This is not *important*." He threw up his hands, scattering ash. "It's about the mind-set. It's about the culture. It's about the human relations—what it enables us to *do*."

Seagulls riding the surf breeze screeched. I asked Kaevats what he saw when he looked at the US. Two things, he said. First, a technical mess. Data architecture was too centralized. Citizens didn't control their own data; it was sold, instead, by brokers. Basic security was lax. "For example, I can tell you my ID number—I don't fucking care," he said. "You have a Social Security number, which is, like, a big secret." He laughed. "This does not work!" The US had backward notions of protection, he said, and the result was a bigger problem: a systemic loss of community and trust. "Snowden things and whatnot have done a lot of damage. But they have also proved that these fears are justified.

"To regain this trust takes quite a lot of time," he went on. "There also needs to be a vision from the political side. It needs to be there always—a policy, not politics. But the politicians need to live it, because, in today's world, everything will be public at some point."

We gazed out across the blinding sea. It was nearly midday, and the morning shadows were shrinking to islands at our feet. Kaevats studied his basketball sneakers for a moment, narrowed his eyes under his crown of spiky hair, and lifted his burning cigarette with a smile. "You need to constantly be who you are," he said.

PAM HOUSTON

Some Kind of Calling

FROM *Outside*

WHEN I LOOK OUT my kitchen window, I see a horseshoe of snow-covered peaks, all of them higher than twelve thousand feet. I see my old barn—old enough to have started to lean a little—and the homesteaders' cabin, which has so much space between the logs now that the mice don't even have to duck to crawl through. I see the big stand of aspen ready to leaf out at the back of the property, ringing the small but reliable wetland, and the pasture, greening in earnest, and the bluebirds, just returned, flitting from post to post. I see Isaac and Simon, my bonded pair of young donkey jacks, pulling on opposite ends of a tricolor lead rope I got in Patagonia. I see Jordan and Natasha, my Icelandic ewes, nibbling on the grass inside the goose pen, keeping their eyes on Lance and L.C., this year's lambs. I see two elderly horses glad for the warm spring day, glad to have made it through another winter of thirty below zero, of whiteout blizzards, of sixty-mile-per-hour winds, of short days and long frozen nights and coyotes made fearless by hunger. Deseo is twenty-two and Roany must be closer to thirty, and one of the things that means is that I've been here a very long time.

It's hard for anybody to put their finger on the moment when life changes from being something that is nearly all in front of you to something that happened while your attention was elsewhere. I bought this ranch in 1993. I was thirty-one, and it seems to me now that I knew practically nothing about anything. My first book, *Cowboys Are My Weakness,* had just come out, and for the first time ever I had a little bit of money. When I say a little bit, I mean

it, and yet it was more money than I had ever imagined having: $21,000. My agent said, "Don't spend it all on hiking boots," and I took her advice as seriously as any I have ever received.

I had no job, no place to live except my North Face VE 24 tent—which was my preferred housing anyhow—and nine-tenths of a PhD. All I knew about ownership was that it was good if all your belongings fit into the back of your vehicle, which in my case they did. A lemon-yellow Toyota Corolla. Everything, including the dog.

I drove the whole American West that summer, giving readings in small mountain towns and looking for a place to call home. I started in San Francisco and headed north—Point Reyes Station, Tomales, Elk, Mendocino. I crossed into Oregon and looked at property in Ashland, Eugene, and Corvallis. All I knew about real estate was that you were supposed to put 20 percent down, which set my spending ceiling at exactly $105,000. I had no idea that people often lied to real estate agents about their circumstances, and that sometimes the agents lied back. I had $21,000, a book that had been unexpectedly successful, and not three pages of a new one. I understand now that, in a certain way, I was as free as I had ever been and would ever be again. I came absolutely clean with everybody.

I checked out Bellingham, Washington, and all the little towns on the road to Mount Rainier, and then headed over the pass into the eastern Cascades, where I put a little earnest money down on a place in Winthrop. Forty-four acres on a gentle hill with an old apple orchard and a small cabin. I worked my way over to Sandpoint, Idaho, and Bozeman, Montana, sill looking, still unsure.

Eventually, I drove through Colorado, a place where I had ski-bummed between college and grad school, and I remembered how much I'd loved it. In those days, I lived in the Fraser Valley, at a kind of commune of tar-paper shacks and converted school buses called Grandma Miller's New Horizons. I lived for three winters in a sheepherder's trailer named the African Queen. The twenty or so alternatives who lived there shared an outhouse, a composting toilet, and a bathhouse. From late December to early February, it often got down to thirty-five below. I was driving a tourist bus by day and washing dishes at Fred and Sophie's Steakhouse by night. I would put every strip of steak fat the diners left on their

plates in a giant white Tupperware container next to my station. When I got off work, I would go home and feed all that steak fat to my dog, Jackson. If I packed the little woodstove just right, it would burn for exactly two and a half hours. I would don my union suit, my snow pants, and my down coat, hat, and mittens, and get into my five-below North Face sleeping bag. I would invite Jackson up on top of the pile that had me at the bottom of it, and he would metabolize steak fat all night, emitting a not insignificant number of BTUs.

The writers Robert Boswell and Antonya Nelson told me about Creede. When you drive into town, the sign at the outskirts boasts 586 NICE FOLKS AND 17 SOREHEADS. It was—and still is—the kind of place where, if you happen to be in town for a couple of days poking around, someone will invite you to a wedding. That September, the guy who owned the hardware store was getting ready to marry his longtime sweetheart, and instead of sending out invitations they just put an ad in the weekly *Mineral County Miner,* so everybody would know to come by.

The morning after the wedding, a real estate lady named Kathleen, who I'd met in the buffet line, showed me an empty lot of approximately five acres and a couple of houses in town that had been built by silver miners using paper and string. She said, "I really ought to take you out to see the Blair Ranch," and I said, "Sure," and she said, "But it wouldn't be right. A single woman living out there all by herself," and I said, "How far?" and she said, "Twelve miles," and I said, "Maybe I should see it," and she said, "I'm afraid it's out of your price range."

For that I had no argument.

I was sitting in my car, studying the Rand McNally, contemplating the next potential future home. Lake City? Gunnison? Ridgway? I was just that close to driving out of Creede forever when a tall, rodeo-buckle-wearing cowboy named Dale Pizel knocked on the window. "I hear you want to see the Blair Ranch," he said. I got out of my car. "This is Mark Richter," he said, indicating his equally tall, handsome friend. "He's the selling agent, and he is going to take you out there right now."

If you can't fall in love with the San Juans during the third week of September, you can't fall in love. The mountainsides are covered with some of the world's largest aspen forests, and they are chang-

ing in vast, undulating swaths: yellow, golden, orange, vermilion. The sky is a headstrong, break-your-heart blue, the air is so clear you can see a hundred miles on a straight horizon, and the river is cold and crisp and possibly even clearer than the air. The coyotes sing, all night sometimes, and the elk bugle in the misty dawn along the river.

And there was the Blair Ranch, with the best view of it all I'd ever seen. One hundred and twenty acres of high-mountain meadow in the middle of the larger Antelope Park, at nine thousand feet, with the Upper Rio Grande cutting serpentine turns through the center of it, surrounded on three sides by the twelve-thousand-foot granite peaks of the Continental Divide, the lower slopes carpeted in Engelmann spruce and aspen.

The house was a simple two-bedroom log structure that seemed to apologize for itself in the middle of all that beauty. It hunkered down behind a little hill, just enough to miss the worst of the wind and the weather. At the top of the hill, Mark told me, the original homesteaders, who were called the Pinckleys, were buried in shallow graves. Their tiny cabins were still standing behind weathered fences, along with some outhouses and a pen where old man Pinckley had bred Canada geese. But the real prize was the barn —raised by Pinckley himself in 1920 and built from hand-hewn spruce logs, silhouetted against Red Mountain to the south, and leaning now, just slightly, to the west. I had no way to imagine, in that first moment of seeing it, that the view out the kitchen window—of the barn and the corral and the Divide behind it— would become the backdrop for the rest of my life. That I would take thousands of photographs of that same scene, in every kind of light, in every kind of weather. That I would write five more books (and counting) sitting at that kitchen table (never at my desk), looking, intermittently, out at that barn. That it would become the solace, for decades, for whatever ailed me, and that whenever it was threatened—and it would be threatened, by fire, flood, cellphone-tower installation, greedy house-sitters, and careless drunks—I would fight for it as though I had cut down the trees and stripped the logs myself.

The price was just shy of $400,000. I told Mark the same things I had told every real estate agent from Mendocino to Casper. My $21,000 would represent just over 5 percent down.

Mark rubbed the back of his hand against his chin for a minute

and said, "I believe that Dona Blair is going to like the *idea* of you. Dale knows her pretty well, and between the two of us . . . Why don't you give me your 5 percent down and a signed copy of *Cowboys Are My Weakness* and I will see what I can do." He snapped a picture of me sitting on the split-rail fence like a girl who already owned the place.

Dona Blair sold me the ranch for 5 percent down and a signed hardcover of *Cowboys,* and she carried the note herself because any bank would have laughed in my face. I bought the ranch for its unspeakable beauty, and if I am completely honest, for the adrenaline rush that buying it brought on. I nearly killed myself the first few years making the payments. I wrote anything for anyone who would hire me, including an insert for an ant farm, which I turned into a little communist ant manifesto that I imagined some enlightened but bored parent discovering with pleasure when they helped little Johnny open the box. I wrote a magazine article called "Why Clint Eastwood Is My Hero." (He isn't.) I wrote an article about twentysomething women who were getting plastic surgery to combat signs of aging. (Who cares?) I've been told by several locals that Dona tries to hide her surprise when she tells them how, for all these years, I never missed a payment.

The people in town, mostly miners and ranchers, didn't understand or much care what I did for a living, but they respected the fact that I had to work hard to keep the place and that I was willing to. I began to get looked out for by the locals who matter: the postmistress, the banker, the judge, the owner of the hardware store, the cops.

There was the night my first winter when Sheriff Phil Leggitt came barreling up my driveway at three in the morning and ran up to my house yelling, "Pam, Pam, are you all right?" Because, in an attempt to get my apparently dead phone to work, I had dialed 911 and then hung up fast when it began to ring. There was the time the president of the Creede bank intervened to keep one of my early housesitters from taking the ranch right out from under my nose in a kind of old-fashioned Wild West land grab. There was the time the postmistress, knowing I was snowed in, brought all my Christmas packages to her house, close enough that I could ski over there and drag them home on a utility sled.

In twenty-five years at the ranch, I have learned a few things: to

turn the outside water spigots off by mid-September, to have four
cords of wood on the porch and two hundred bales of hay in the
barn no later than October 1. I've learned not to do more than
one load of laundry per week in a drought year, and that if I set the
thermostat at 60 and bring the place up to 68 using the woodstove
in the living room, the heater doesn't do that horrible banging
thing that sounds one tick shy of an explosion. I've learned that
barn swallows carry bed bugs, and the only way to kill the bugs is
to wait until it is thirty below and drag the mattress out onto the
snow and leave it for forty-eight hours. I have learned to hire a
cowboy every spring to come walk the fence line, because much as
I would like to believe that I could learn to be handy with a fencing
tool, I have proven to myself that I cannot. I know that eventually
the power always comes back on, that "guaranteed overnight" is a
euphemism, that for a person who flies a hundred thousand miles
most years, choosing a place five hours from the Denver airport
was something I might have given a little more thought.

Right from the beginning, I've felt responsible for these 120 acres;
for years I've painted myself as both savior and protector of this
tiny parcel of the American West. And this much is true: as long as
I am in charge of it, this land will not turn into condos, it will not
be mined or forested, it will not have its water stolen. No one will
be able to put a cell tower in the middle of my pasture and pay me
$3,000 a year for the space.

One of the gifts of age, though, is the way it gently dispels all of
our heroic notions. The whole time that I thought I was busy tak-
ing care of the ranch, the ranch was busy taking care of me.

All my life I have been happiest in motion—on a plane, in a
boat, on a dogsled, in a car, on the back of a horse, in a bus, on a
pair of skis, in a cabbage wagon, hoofing it down a trail in my well-
worn hiking boots. Motion improves any day for me; the farther,
the faster, the better. Stillness, on the other hand, makes me very
nervous.

My childhood home did not have any safe places. My parents
were sophisticated, worldly, both brilliant in their own way, and
they drank to distraction every single night. The consequences
of getting underfoot in that house often involved violence, and
sometimes there was violence for no discernible reason at all. One
thing I was looking for when I bought the ranch was a place where

I might be comfortable sitting still. I also wanted something that no one could take away from me, but my upbringing left me addicted to danger. So I put 5 percent down on a property that cost four times more than I could afford, one that required so much maintenance that the tasks fell into two categories: things I didn't know how to do yet, and things I didn't even know I didn't know how to do yet.

That I survived, and that the ranch did, suggests something good about my karma. That when I thought I could go to Denver for New Year's Eve and keep the pipes from bursting by dripping the faucet, it was only the mudroom floor that got flooded. (It went down to thirty-eight below that night.) That when I thought it would be really cool to paint my propane tank to look like a watermelon, the dark green paint did not, in fact, absorb enough nine-thousand-foot solar heat to explode. That someone always came along in the nick of time to say, "When was the last time you had your chimney swept?" or "How often do you coat your logs with that UV protector?" and then I'd know what I was supposed to have been doing all along.

This is the only real home I have ever had—this log cabin with its tilted horse barn, leaking propane tank, and resident pack rat that has a weakness for raspberry soap. The house isn't piped for a clothes dryer, so in the winter I string lines in the kitchen, in the mudroom, and around the woodstove in the living room. The fifty-year-old furnace can keep up with the regular subzero temperatures only if the woodstove is burning all the time. As a result, when I go out into the world in a public way in the winter, I smell as if I have just come from a Grateful Dead concert. All the window screens are frayed because my little coydog, Sally, who came to me from some traumatic puppyhood that landed her in the Flagstaff, Arizona, pound, could predict a lightning storm at fifty miles, and at the first rumble would make a neat little X-shaped slice with her toenail and then power her body through the window to her place of choice, under the porch.

It doesn't seem like twenty-five years have gone by since that girl who lived in her North Face tent, whose belongings all fit into the back of her Toyota Corolla, first sat on the split-rail fence that stands in front of the aging barn. That girl who dared herself to buy this ranch, dared herself to keep still, to dig in and care for it,

to work hard enough to pay for it, to figure out what other people meant when they used the word "home."

Blink your eyes and that girl is a fifty-five-year-old woman who has lived here five times longer than she has lived anywhere else, in this meadow of lupine and fescue, surrounded by spruce and pine. Every penny that has gone toward the mortgage payments I have earned with my writing, and that fact matters so much to me that when my father died five years ago and what was left of his money fell to me, I bought a used Prius and a trip to Istanbul. Sometime in the past twenty-five years, the ranch changed from being the thing I always had to figure out how to pay for to the place I have spent my life.

Four years ago, during southwestern Colorado's largest wildfire ever—110,000 acres burning less than a mile from the ranch, tree-tops exploding into flaming rockets down one arm of that horse-shoe of mountains that for twenty years had kept me safe—I drove under an apocalyptic sky through lung-searing smoke past two fire-department roadblocks to take Dona Blair my final ranch pay-ment, my mind unable to decide whether this gesture would make it more or less likely that the ranch would be engulfed in flames. When I got to her driveway, I saw that all the giant spruce trees that her husband had carefully designed the house to fit among had orange flagging tied in the branches. These would be the first ones the Forest Service firefighters would cut if the blaze got too close.

We'd been on standby to evacuate for weeks, and I'd decided that the only thing I really wanted to save (other than the animals, who were enjoying a smoke-free vacation a hundred miles away in Gunnison) was the barn, which wouldn't fit in the back of my 4Runner. But our summer monsoon arrived with the tourists on the Fourth of July, just in time to save us, as it has all the years I've been here, and now it looks as if I will get to spend the rest of my life watching the charred mountainside to the west of me regermi-nate, revitalize, regrow.

Sometimes, when I'm driving back out Middle Creek Road after a week in Majorca, Spain, or Ames, Iowa, and I round the corner where Antelope Park stretches out huge and empty and magnifi-cent in front of me, I am open-mouthed with astonishment that this is the place I have lived the largest part of my life.

It's a full-time job lining up ranch sitters for the significant

chunks of time I need to be away, and even if it is someone more competent with a fencing tool than I am, it makes me nervous to leave so often. Some days I think I would like to live near the ocean, or a sushi bar, or a movie theater, or my friends, who by and large lead vibrant lives in sophisticated cities. But a low-level panic that feels downright primal always stops this kind of thinking in its tracks. A quiet certainty that if I gave up the ranch, there would be no more safe home, no place of refuge, no olly olly oxen free.

And there is one more thing. The summer before I drove all over the West looking for a home was the summer I lost my mother. I am only telling you now because I had never realized the coincidence of it, had never thought about the cause and effect relationship of it—until I began to write the story of the ranch.

I am only a little better at giving in than I used to be, at slowing down, at sitting still. But progress is progress, and any amount of it I have made I owe entirely to these 120 acres of tall grass and blue sage, with a simple log house, a sagging barn, and a couple of equine senior citizens.

And when the chores are all done, the ranch is a meditation in stillness. It says, *Here, sit in this chair. For the rest of the afternoon, let's watch the way the light lays itself across the mountain. Let's be real quiet and see if the three hundred head of elk who live up the mountain decide to come through the pasture on their way to the river to drink.*

How do we become who we are in the world? We ask the world to teach us. But we have to ask with an open heart, with no idea of what the answer will be.

It might have been fate or some kind of calling. It could have been random, but it doesn't feel random. Sometimes a few pieces of the puzzle click into place, and the world seems to spin a little more freely.

In other words, maybe I didn't choose this ranch at all. Maybe this ranch chose me.

Let the Devil Sing

FROM *The Threepenny Review*

THE ROAD TO HELL is narrow, bordered by a serpentine river and sheer mountain cliffs that swagger upwards and out of sight. Road signs warn of tumbling rocks, landslides, car crashes at the blind corners. The weather is fair and crisp. My husband drives our rented Peugeot. He does this calmly, effortlessly, while I sit in the passenger seat and stare at the road unblinking, as if I might intuit the speeding approach of a brakeless eighteen-wheeler or the meteoric plummet of falling rocks. But what would I do if I could? A car bound for hell will get there one way or another.

Dyavolsko Garlo, the locals call it. The Devil's Throat. A cavern plumbing Bulgaria's Rhodope Mountains. The site where, according to legend, Orpheus descended into the underworld to seek his beloved Eurydice, who had died of a snakebite soon after they wed.

My husband is six feet tall—just a touch taller than me—and sturdily built, with thick brown hair and facial scruff that arrives in an inexplicable rust-colored red. Driving has put him in a quiet mood. His fingers strum the steering wheel, tapping along with the pop-folk flowing from the radio: accordion strains overlaid with brassy vocals praising easy money, women.

THE DEVIL'S THROAT, reads a sign, 44 KM.

My husband and I love one another, but our marriage feels like a sham. This is one of our problems. The other is living in Bulgaria.

*

Eurydice had died too soon, so Orpheus traveled to hell to bring her back. Orpheus—that famous Thracian, the musically blessed son of Apollo and Calliope—had strummed his famous lyre at the feet of Hades and Persephone, pronouncing his heartbreak in melodies so sweet the cold-souled King of the Dead was moved. So moved, the story says, the king shed iron tears. Plunk. Plunk. Plunk. The noise echoed through the underworld.

My husband and I have lived in Bulgaria for six months, lived in this country often confused for other places. "You'll have to brush up on your French," said a friend before I left the United States, believing me bound for Algeria. "Enjoy the northern lights," said another. Bulgaria is one of the forgotten nations once tucked behind the Iron Curtain, its cities now stocked with crumbling Soviet tenements and silent factories and stray dogs too hungry to bark. In the winter, in Haskovo—the city where I teach English to three hundred hardened teenagers—the air thickens to a gray haze as residents burn brush and scraps of trash. The smoke makes me cough, makes my eyes sting, makes my thoughts turn dark.

Today, though, we have left Haskovo. We have left winter as well. The first spring blossoms are starting to show, forsythia yellowing the countryside. As the road to the Devil's Throat continues its manic winding route through the Rhodopes, we pass the occasional village of squat red-roofed dwellings, laundry lines strung with colorful underwear like prayer flags. Chickens bustle after bugs. Kids kick soccer balls on smears of new grass.

21 KM, says a sign.

Even in the presence of spring, I feel nervous. I can't help imagining the ways we might die on this mountain road, squeezed between cliffs and a squalling river. It's a bad habit of mine: envisioning worst-case scenarios. I picture our car tumbling end to end over a ledge, the windshield shattered, our bodies flecked with glass. I do this despite also worrying that if I envision such things I might make them come true.

My husband gives no sign of noticing my nervousness. He's absorbed by the purely physical task of driving. Or perhaps by thoughts of what's to come: this purported entrance to hell. A myth made real. A myth, in many ways, still in the making. Odd things are said to happen inside the Devil's Throat. Having rushed down from peaks of the Rhodopes, the Trigrad River enters the cavern

in a spectacular waterfall—the highest in the Balkans—then disappears into an underground siphon. No one knows where the river goes, what it does, as it courses through the earth. If a person were to send a log into this siphon, or a marked flotation device, it would never come out. There have been two diving expeditions, back in the 1970s. Both divers disappeared; their bodies were never recovered. Since then, no one has tried.

5 KM, says a sign. The landscape begins to change. Cliffs lean over the road, as if to engulf our car, swallow us. As we gain elevation, the air turns chilled, icicles spearing down from the rockface like a thousand sharpened teeth. The river changes too. The water becomes wilder, more tangled as it scrambles past the skinny leafless trees lining the river banks, their branches decked with pale shreds of shopping bags. They have a wraith-like quality, these shreds. They look like the torn edges of ghosts.

I imagine our car flipping sideways, the cold spill of water over my limbs.

My husband taps his fingers to the music, turns the radio up.

Samo mi pokashi chmi obichash, croons a young man. Just show me that you love me.

"She died too soon," Orpheus sang to Hades, strumming his lyre all those miles underground, his words echoing through the fleshless spirit world, the legions of the dead. "We had so little time together."

Bulgaria has its share of gifts. There are the savory delights of homemade *lyutenitsa,* the noisy neighborhood gatherings on warm afternoons, the layered history that places Thracian ruins next to Byzantine churches next to Ottoman mosques. But the country is also stymied by poverty, youth-drain, and the worst corruption in the EU. Recently, Bulgaria experienced a wave of self-immolations. Citizens burned themselves on the capitol's steps because there seemed no other way to protest. The gulf between communistic orderliness and the promise of capitalist salvation has stretched wide and grim and endless. My role, as an English teacher, is to help bridge that gulf—to distribute language like a currency—but my job often feels like thinly veiled imperialism. Really, I'm a cultural missionary, sponsored by the US government, stationed abroad in

a not-so-subtle bid to win the allegiance of young Bulgarians. "The West," they should learn to say, without rolling their R's or pronouncing their I's like E's, "has our best interests at heart."

Regardless, my teaching hasn't been especially successful. My students receive my lessons with jaded apathy, view me with suspicion. Some speculate that I'm an FBI agent. Maybe they aren't so far off. I tell them to call me "Mrs. McElroy," using my husband's surname. It feels like an alias. I don't use the name anywhere else. After school, I return to our apartment, take off my wedding ring. My husband does the same. Our rings don't feel natural. These cheap gold zeros we purchased at a pawnshop: we got them for our slapdash wedding, planned a day in advance, so that my husband—then boyfriend—could get his visa paperwork.

"You must be the first people in history," a friend said, "to get married for a visa to Bulgaria."

I look at my husband, driving the car with quiet concentration, his eyes fixed forward, his jawline scruffy with an encroaching beard. I wouldn't have gone abroad if he hadn't come with me. And if I hadn't gone abroad, we might not have signed those binding papers. The two things feel inextricable now—Bulgaria and our marriage—which in turn feels problematic. My husband has become part of the great gray weight of this country, the crush of its despair. He doesn't have the pressure of a government job, or even legal working privileges. Because of this, I often get resentful—even angry—especially as my inner film reel of calamities spins ever faster. But these emotions also make me feel ashamed. Perhaps Bulgaria, if anything, has kept us together: rendered us codependent in a city with no other native English speakers except a pair of skittish Mormons. Perhaps beyond Bulgaria we will disintegrate, dissolve.

Perhaps he has his own resentments.

My husband continues to drive, his lips sealed, his mind distant. I wonder if this is how marriages begin to end. Not so much in shouting as in silence.

"Please," sang Orpheus. "Give us another chance."

My husband pulls our car into a parking lot, empty. On one side a sheer cliff rises, a tiny doorway at its base like a mouse hole in a

Tom & Jerry cartoon. A man knocks on our car's windshield and tells us that tickets to enter cost five *leva* each. The tour starts in ten minutes.

We get out, stretch our legs. My husband produces a notebook and begins to scribble observations, glancing around at the jagged peaks, the arrow-straight pine trees, sniffing the sharp mountain air. Feeling the pang of exclusion, I take out my own notebook and make my own scribblings. We stay in physical proximity, but barricade our thoughts. This is a far cry from when we first started dating, both transplants to a new city, both unable to resist the contents of the other's mind. My future husband would invite himself over to my apartment to swim in an old overchlorined pool, and there we would bob in circles, talking and talking until our fingers pruned, doling out our lives to one another—so much at the beginning of something that every word felt like a new invention.

Now, though, it seems more like an incursion to share the thoughts inside me, to unravel my knotted anxiety, to expose the hot coals lining my mind.

"Another chance."

We pay for our tickets and walk into the mountain. Behind us comes the tour guide speaking with sardonic familiarity to several young Bulgarian couples who had arrived at the last minute. The men have a toughened demeanor, their heads shaven, their bodies lumpy and neckless beneath their tracksuits. The women wear shiny leather jackets and tight jeans, cigarettes balanced on their fingers, lips plumped, eyebrows plucked, hair pulled back tight enough to stretch skin.

We hurry on ahead of them. As we descend, the air turns stale. The tunnel walls press closer. I sink into subterranean unease, imagining earthquakes, the suffocating trap of a collapsed ceiling, a mountain river rising too fast to escape. My breath quickens. The tunnel worms deeper, well beyond the reach of natural light. Piss-colored lamps line the path, their glow throwing more shadows than illumination, dim phantasms cast here and there disguising the tunnel's turns until, finally, they reveal a huge cavern thundering with the muscular plunge of the river.

The Devil's Throat is ballroom big. Ceilings swell upward as if inflated by sound. On the floor, puddles gather and glint from

the waterfall's spray. Dark patches of bat colonies fleck the walls. There is a musty smell. I feel disoriented, both by the river's roar and the heady hugeness of the space. My husband disappears into a dim corner, scribbling in his notebook. The ache of exclusion becomes unbearable. I call to him but he does not hear me. I call again. I call and call and call.

At last he comes, putting his arm around me. We lean over a railing, marveling at the sheer force of the river. It feels good to look closely at the same thing. It feels important. I suggest that we should each send something into the river. We should send something to be taken into the earth and never returned. A feeling maybe. Or a fear. My husband likes this idea. With exaggerated decorum, we both make silent vows of absolution, then spit them into the river.

Resentment, I think. *Anger. Be gone.*

Then I hug my husband, fiercely, as if to rediscover the strength in my own body, my own solidity, my own living form.

Hades shed iron tears and they dropped to the ground with a plunk, plunk, plunk, his sympathy sounding through the underworld. "Go," he said to Orpheus, to Eurydice—called up from the depths—"go live long full lives and return when you are ready."

The tour guide and the Bulgarian couples are coming up into the cavern behind us. Their presence seems to push us forward, out, as if the men's wide-legged swagger, the women's eyerolling, might poison our moment of intimacy. We move through the cavern, across the slick ground, past a stone altar where pilgrims have placed glittering piles of copper *stotinki,* red and white bracelets called *martenitsi,* and little portraits of saints. Then we come to three hundred steps. DO NOT ATTEMPT TO CLIMB, reads a large sign, IF YOU HAVE A FEAR OF HEIGHTS, CLAUSTROPHOBIA, HIGH OR LOW BLOOD PRESSURE, DIABETES . . .

The list continues on, naming what seems like every conceivable ailment. My spirits falter. What if, I wonder, one's mind inevitably spins through deadly scenarios? What if one often loses hold of her real world?

"There's just one condition," said Hades to Orpheus, about to climb out of hell, to take Eurydice with him. "Listen closely . . ."

*

We begin climbing. My husband first and then me. The steps are narrow, puddled with mud and slippery with river spray, steep. If a person leans backwards, even slightly, she will plummet. She has to grip the railings tightly. She has to grip them even though they are made from iron rebar and are shockingly cold, almost too cold to touch. Even though she feels dizzy with the foreboding workings of her imagination.

". . . Until you have reached the living world, do not look at your wife. Do not look back."

Too cold to touch, and yet they must be touched. Must be squeezed and clung to. I long for gloves. I long to put my hands in my pockets or to warm them with my breath, and yet to do such a thing would mean giving in to gravity, grasping at air until I'm dashed on the rocks, flung into the churning river that would suck me into the earth and make me disappear.

Hades's instruction: at once simple and impossible, arbitrary and inevitable. Orpheus traveled up and out of the underworld, Eurydice close behind, when—and here different versions of the story provide different explanations, though the action remains the same—Orpheus could not resist glancing at his resurrected bride. He looked back. And when he did, death reclaimed Eurydice, drew her down into the underworld forever.

Ahead, on the stairs, my husband climbs steadily toward a crevice of light.

Orpheus was heartbroken, the stories tell us, bound for suffering and hardship and death by disembowelment, but I have always wondered about Eurydice. Was she also heartbroken? Or was the look, in a way, a thing of comfort? Orpheus had lost her, but she had gained him.

"What, then, could she complain of," writes Ovid, "except that she had been loved?"

My husband pauses climbing, turns to look back at me briefly. Then he continues. He has made sure that I'm okay, that I'm still

going. Perhaps this is marriage, I think. It's not the paperwork,
signed for one reason or another; it's two pairs of feet making the
same steady climb, the same bid for light. Two souls seeking
the same fate, doomed or otherwise.

I let my scared self fall backward, peel away, that ghost of me,
bottled up and angry. I grip the railings tighter. I scramble up-
ward after my husband, back into Bulgaria, our daily struggles, our
yearnings, the grayness and the poverty, and I hear the waterfall
roaring in the cavern behind me, the Devil's Throat loud with its
heady music, made from a river tonguing deep into a mountain,
carrying things in and bringing nothing out, like a lover's heart, a
promise, a tale told for the dead as much as for the bereaved.

RYAN KNIGHTON

Out of Sight

FROM *AFAR*

AS OUR LAND CRUISER nosed through the brush, cicadas buzzed above us like power lines. My wife and I had been in Zimbabwe only a few hours. So far, our guide on our first safari drive, Alan, had already spotted several species of antelope, and I was already concerned that for me—as a blind man—this was going to kind of suck. I might as well be at a drive-in movie.

Here, you try: Close your eyes. Over there is a kudu, whatever a kudu is.

Welcome to a blind safari.

Dharmesh, the driver, stopped the vehicle. Alan suggested in his lovely baritone voice that we step out and stretch our legs on the dusty path and have a drink, or "sundowner." Robert, the animal tracker, dismounted from his seat on the vehicle's grill to pass around beer and snacks. In the distance, apparently, a giraffe could be seen slipping into the trees. Tracy, my wife, watched quietly as Alan began his work, describing the animal and its behavior and its place in the ecosystem of the locale, the Malilangwe Wildlife Reserve.

My can of lager, because I could taste it, was more real to me than the giraffe.

How a blind man can be guided, how I might connect with unseen sights in an unseen place, would be Alan's challenge for the next seven days. A few years earlier, he had guided his first blind client through a game reserve on the western boundary of South Africa's Kruger National Park. The experience had radically enriched his approach.

"Whether you're sighted or not, the bush is overwhelming and confusing when you first arrive. It's an onslaught of stimuli," Alan told me. "But guiding a blind person helped me realize the significance, the depth, of our other senses. I could use them to enhance my voice as a guide. A taste, a sound, touching or holding something, these experiences slow everything down to a different focus."

A safari, by cliché and assumption, is overwhelmingly driven by photography. Tourists survey a living museum of wild animals and, as their primary experience, merely look through cameras and screens. But with Alan at the helm, here I was, ready not only to experience what a safari might reveal to the full spectrum of sensory input, but also to try to deepen my own understanding of what it means, or can mean, to be guided. Being blind, I'm a bit of a connoisseur. Daily, I'm dragged and steered and told where and how to move, perpetually hitched like a wagon to the elbows of strangers. You could say I live in a chronic state of guidance. But getting around without getting killed isn't anything like having a sense of place. Perhaps a professional guide could impart some of that. So far, I'd nursed a beer and heard rumors of a giraffe.

Suddenly Alan's hand clamped my shoulder, communicating everything in a grip. Do not speak. Do not move. Adrenaline shot through me. We were in a clearing surrounded by bush and shadow and, well, something else. Something not-giraffe.

Silence, for the blind, is often the most terrifying sound. Alan's grip firmed and pivoted me a few degrees to the right, aiming my attention like a satellite dish. At what?

"Elephant," he whispered. "Twenty-five meters."

I strained to hear it. To hear something. Was it moving? Had it seen us? Alan's hand gently squeezed my shoulder, then again, and again, as if counting the animal's steps.

"Fifteen meters," he whispered.

I couldn't hear my wife. I couldn't sense where our vehicle was, or how far we were from its safety. Alan's hand assured me we were fine for now, but it also implied, by its constant grip, everything could change in an instant.

"Ten meters."

Finally, a faint noise. The plodding of a six-ton bull. Something I've never heard. An elephant's loose-structured feet expand, landing with a small, dispirited squish, like the sound of spiking a semi-

deflated football. Now I could understand how something so large could glide so quietly through the bush. Squish, squish, it lumbered toward us, deciding whether it would charge, or not.

Alan's hand clenched harder. The animal had stopped. I could sense its stare, Alan angling my body toward its gaze. Neither I nor the bull knew what to make of the other.

Then, squish, squish, it stepped off into the bush and was gone. An odor followed. Wet earth, like parched land after a first rain. Later, Alan would explain that I had smelled the elephant's method of cooling and hygiene. Mud retains moisture, so elephants coat themselves in it to stay cool. When the mud dries, they'll scrape themselves against leadwood or baobab trees, the hardened earth taking parasites from their skin. An elephant waxing. I hadn't seen that, but I'd smelled my way into something.

Alan's grip on my shoulder finally loosened, and a quick pat of assurance told me everything was okay now. Nothing to see here. I was, in a word, awestruck.

"Well," he chirped, "that doesn't happen every day."

Singita's Pamushana Lodge is, by all sensory metrics, a stunning nest of luxurious thatched villas atop the sandstone cliffs of Malilangwe Lake. This game reserve, formerly a commercial cattle ranch, sprawls across roughly 130,000 acres and remains privately owned and operated by a nonprofit trust. The land itself has been rewilded, its natural flora and fauna allowed to return. It's thick with mopani and acacia groves, dry riverbeds, and rising stone bluffs. Caves and rock paintings can be found, too, evidence of the land's human occupants in centuries past. Revenues from safaris like ours fund the trust's conservation efforts. A sampling of notable resident species includes rhinos, both black and white, lions and leopards, African wild dogs and cape buffalo, cheetahs, baboons, wildebeests and hartebeests and, of course, elephants. Biologists and an on-site lab are part of the reserve, as is an anti-poaching force. Whenever we stepped from our Land Cruiser, Dharmesh would radio central command to record our location, as the security team would find and track any unreported human footprints.

Mornings at the lodge begin early. The aspiration was to be on safari by sunrise. Most large animals would be on the move by then, in search of water before the day's heat could stamp every living thing into lethargy.

"Today," Alan posited over breakfast, "perhaps we should try our luck at the blind."

Yes, the blind guy was going to—a blind. But this blind referred to a semi-underground hideout, like the ones used by hunters. Pamushana had constructed one next to a shallow seasonal pan where water, and animals, naturally collected. It would allow us to get close enough that I might smell and hear any number of thirsty species, from zebras to hippos to elephants, within a mere few feet.

Alan's style of guiding was to set a soft goal for the day—in this case, to check out the blind—but to take the long way, leaving our experience open to whatever caught his attention. We'd barely descended the sandstone heights of the lodge when Alan flagged Dharmesh to stop the Land Cruiser and strolled off into the bush. You know, like he was popping into a convenience store, not a forest that could conceal a lion's jaws.

"Here, take these," he said as he returned to the vehicle. He handed Tracy and me some leaves. "Crush one between your fingers and touch it to your tongue."

My reflex was to ask what we were about to taste, and why. Nobody wants to close their eyes and put an unnamed unknown in their mouth. But I didn't ask.

I shoved leafy bits into my mouth. Instantly my tongue went dry. Ridiculously dry.

"That's from all the tannins," Alan explained. "This is the leaf of a mopani tree. Now you know why most animals don't eat them. Except elephants." Given the tonnage of greenery they consume, it makes sense that elephants would possess the digestive capability to tolerate a nasty plant that attracts few competitors. "Now we also know what animal we're likely to find in a mopani grove and why."

He handed me another leaf, this one attached to a twig and nestled tightly among short, sharp barbs. Acacia. Whereas the mopani protects itself biochemically, by taste, the acacia deters predators with pain. Imagine, Alan noted, that you are a blunt-nosed browser, such as a rhino. To get between the barbs for the leaves would be nearly impossible. Giraffes, on the other hand, have long, narrow faces and long, narrow tongues that nimbly work between thorns. Where you find acacia, you find giraffes.

More than getting a botany lesson under the sun, I was learning about a way of guiding that begins with the animal's own sensory

experience. Leaves are food, so Alan had us approach them by taste and touch. Because most safaris work toward a photographic goal, the tendency is for guides to simply point to a distant scene and label it with names and facts like captions. Over there is acacia. Giraffes eat those. That's a mopani tree. Elephants like those. But Alan wanted us to experience the reality that everything around us is a living, working system of taste and tactile strategy for survival, not just a view.

Soon we stopped again. "Give me your hands," Alan said.

I couldn't help myself. "What is it?" I asked. Something in his tone made me wary, as if he knew better than to tell me what he'd found.

"Just feel this. Hold this," he insisted. "It's really something."

Please don't let it be a snake, I thought.

He dropped into my hands a rough and fibrous ball—dry, the size of a melon—of what felt like steel wool. I couldn't guess what it was as I rolled it around between my palms. Nothing snakey, that was for sure.

"Rhino poo," he said.

I swear I could hear him smiling. Then he laughed.

But you have to pause and appreciate such an act of bravery. Really. Imagine the potential offense of taking advantage of my blindness for a joke. So many people treat me like a child, or a fragile soul. Yet Alan had already figured me out. At least well enough to know I wouldn't get upset when handed a ball of rhino poo. In addition to interpreting nature, a good safari guide must also interpret the other people in the Land Cruiser.

Our destination that day, the blind, was nothing like the structure I'd imagined. In my mind's eye, we would crowd behind a lean-to, perhaps a wall of branches and logs among the trees, from which we'd spy on animals. Instead, we entered an entire room of comforts dug into the earth next to the water, its conical roof perfectly resembling a massive termite mound. A few steps down and through a door, we were shown into a lounge, complete with couches and a restroom and snacks, where we could wait for wildlife to arrive. Dharmesh and Robert opened the windows, two long slats that squinted from ground level, with no screens, no barricade from whatever might visit the watering hole just feet from us.

The potential dangers of this were real. Dharmesh told us they

once found a six-foot black mamba snake stretched out behind the couch cushions.

I had just started to doze a little in the dusky cool when Alan whispered, "Rhinos are coming. Two. A mother and calf."

I jumped to the open windows and listened. Soon I heard a snort and some stamping in the mud, all of it just a few feet away. But the water was also being upset somewhere to my right. A splashing, distant, then closer. "Uh-oh," Dharmesh whispered. "Hyenas."

I felt a familiar tickle in my spine. The tension that precedes violence.

Three hyenas approached as the rhinos continued to drink, unfazed. I feared that, at any moment, the three could attack, or chase, or scare the rhinos. If you can't see, your awareness hangs on the slightest changes in rhythms, maybe of the hyenas' feet, of their breathing, anything that might indicate where the situation is going. One hyena groaned, low and loud and clear, and then drank.

For now, little seemed to be happening in the peaceful distance between species, including us.

So many people go on safari with the desire, above all else, to see a lion. If you ask Alan, however, it is the least interesting purpose to have. Lions sleep most of the time. What is to be taken, to be remembered, from that? Here in the blind, the hyenas just feet from the rhinos, I stumbled on my own purpose, or a hope to guide me. I wanted to hear a hyena laugh. It would be a trophy of sound. My audio postcard, something rare and otherworldly and off camera.

But the hyenas wouldn't give a peep. Shortly after they arrived, they finished drinking and darted off into the hills, but not before the biggest one dropped the nastiest, most eye-burning carnivore fart ever blown into the face of a blind man. It was as if she knew I wanted to hear her laugh, and instead mocked me by obliterating my sense of smell. The stench was so foul and expansive in the blind that we were driven out and called it a day.

As we left, the rhinos continued to drink, as they will.

Our villa at the lodge, inspired by the mortarless stone walls of the royal palace of Great Zimbabwe—the now ruined eleventh-century capital one hundred miles north of Singita Pamushana —had few right angles. Pillars and rounded corners softened any

edge. I often pinballed off them and was sent randomly wander-
ing our cool, snaking rooms, lost and disoriented. At least I knew
that we faced the lake. When confused, I listened for the hippos
below our deck. Their old-man grunts and guffaws were my North
Star. Every morning I awoke to their sound, and to the birds. Four
percent of the world's bird species are represented on the reserve.
Imagine the variety and volume that creates. I would notice a spe-
cific call, and Alan would affix a name. Bulbul and oxpecker, que-
lea and ghost bird. My favorite quickly became the go-away bird,
whose cry literally mimics a plea to, yes, go away. On the thatched
roof above our breakfast table, we heard the foraging of hyraxes,
creatures something like a marmot or a prairie dog, their name
something from the pages of Dr. Seuss. I relished the pleasure of
so many new and strange names, their peculiar sound and shape
in my mouth. My own call. My own guffaws and song.

When you are a blind man strapped into the tracker's seat on
the grill of a Land Cruiser, you feel as if you are floating through
the air, because you are. And dangling out in front like that, you
are really just a hunk of bait. Or at least that's how I felt. I wasn't
forced to this perch, mind you. Alan was cool with me taking over
Robert's post, and was curious what would happen if the tracking
were turned over to my senses.

On the third day, we began motoring through mopani groves
and along riverbanks, and I became increasingly aware of myriad
odors, some bold, some subtle, but all of them coming at me with
Alan's descriptions of the quickly shifting landscape. Perhaps I
smelled dying yellow grasses, then suddenly the sour chemical of
umbrella trees, their canopy passing above, then just as suddenly
gone, all smells lifted, replaced by the breezy blank of an open,
sandy flatland. As I inhaled the air, suspended on the tracker's
perch, my mind's-eye image of where we were grew clearer and
clearer, and more alive, than ever before. Soon I could raise my
hand, flagging to Alan inside the Cruiser that something was dis-
rupting the smell of the land, something that might be of note.
A few times I noticed the same thin marbling in the air, a faintly
sour streak, sweaty like a horse. Moments later, off in the trees,
perhaps fifty yards away, Alan saw the giraffe. How rare it is that I
guide anybody. Not that I was very good at it. Mostly I flagged the

same pungent smell, only to be told I'd stopped us in the middle of another rhino latrine.

But I didn't catch a whiff of anything before Dharmesh slammed on the brakes. Alan immediately reached through the lowered windshield to where I sat on the tracker's seat, and clamped my shoulder. You know, the way he had done when we'd faced down an elephant. This time I was alone in front, and exposed.

"Black rhino," he whispered. "Just be calm."

We didn't want to startle it. Quick movements can alarm a rhino enough to charge. Black ones, in particular, are nervous and prone to acting out. So Alan began to whistle like a bird, letting it know we were here, small and unthreatening. It turns out rhinos are nearly blind. Wouldn't that be funny, I thought, the blind goring the blind?

I heard it take a step. A snort. It was coming closer, curious. And closer. A few more steps, then it rushed at us, but stopped short. Sweat slicked my back. The rhino was perhaps thirty feet in front of me, staring me down, with nothing between us. No smell helped me track its movement. No sound hinted at what it would do next. The rhino and I just hid in our blind silences.

Then it took off for the safety of the bush, exit stage left.

And I retired from my experiment as a tracker.

On one of our last days, the call I'd been hoping for came over the radio. Five hyenas had been spotted with a kill in the water near the blind. At that moment I was on my hands and knees tracing the shape of a fresh leopard track Robert had spotted in the sand. We were more than a half hour's drive from the blind. The hyenas could easily scatter before we got anywhere near. Then again, if they did run off, we could try our luck tracking them. It was a question of every safari's diminishing resource: time. Burn an afternoon chasing nothing, or run after a specific experience and forsake others along the way?

We loaded up and took off in pursuit of hyenas.

By the time we arrived at the blind, things had escalated. Yes, the hyenas were still in the water with what looked to Alan like the leg of an antelope, possibly a hartebeest. But a pack of African wild dogs had gathered at the water's edge. The species is nearly extinct. Only fifty dogs live in the entire reserve, and more than twenty of them were here, closing in on the hyenas to either

take their kill or pick a fight. The air smelled of blood. Hundreds of queleas, tiny birds, tornadoed above the dogs in a humming swarm. The wind from their wings blew in my face.

Soon there was a howl. Then a rumbling groan. And another. Warnings from the hyenas. Then I heard it. Their nervous laughter cut through the air. It was like a forced chuckle after a bad joke. Suddenly, an explosion of water and splashing as the wild dogs attacked. They rushed in on the hyenas, trying to disable them, mobbing, circling, confusing them from every side. The cries of wild dogs are the most alien noise I've encountered, like a chorus of twittering computers. Vicious, the dogs bit. The hyenas bit back and laughed, or, wounded, squealed like pigs in slaughter. The sound at times grew so intense that I wanted to turn away, as if I couldn't bear to look.

All of this went on, the dogs circling our Land Cruiser, the hyenas fighting, the chasing, the noise, for hours. It wasn't pretty. Or so I assume. But I can say I listened, as did Alan and Tracy, Dharmesh and Robert. We listened and we knew, given the dogs' near-extinct status, that we were experiencing one of the rarest sounds in the world. In fact, their fight may have been the only sound of its kind made on earth that day.

And I can still hear it.

RICHARD MANNING

Over the River

FROM *Harper's Magazine*

SELDOM CAN MAJOR NATIONAL NEWS be distilled to a single boneheaded decision, particularly one that poisoned a city. This circumstance alone could determine a narrative of the water crisis in Flint, Michigan. Yet when I arrived there on a Sunday afternoon last spring, I found myself driving the city's grid, trying to find a certain house that might reveal some historical explanation. This is the city where I was born, and I know of a larger story.

My destination was not much of a house, not even when it was new, just one cracker box among many in the old neighborhood of Mott Park. A few blocks northwest of downtown, Mott Park was designed in the 1920s as a workers' paradise: each street curbed and sidewalked, a bungalow in every lot, patches of lawn to mow, and trees that yielded leaves for raking. Returning after sixty-five years, I noticed first the empty spaces, like gaps in a hockey player's grin. Flint's main public-works project these days is razing a thousand houses a year, a number limited only by available funds. The supply of abandoned houses delivered by the collapse of the auto industry, the financial crisis, and now poisoned water has, at least, created work for bulldozers. Most of the houses not yet razed are falling in or filled with trash, or have been gutted by fire. Some have been boarded up against squatters, but hardly any people remain here, in this treacherous part of a city routinely ranked among the most dangerous in the country.

Against the odds, as I turned onto Raskob Street (named for John J. Raskob, a board member of General Motors) I found that the house I was seeking, number 2751, still stood. Barely. The roof

had sagged. The siding was painted yellow—in Flint, the color of dirty water and denial. Someone had fastened a thick steel hasp to the front door and padlocked it, but the back door's window was broken in a way that would allow an arm to reach the dead bolt inside. It seemed to suggest that I enter. As I approached the concrete stoop, shards of glass ground beneath my boots. But I couldn't go in. I couldn't find the will to ascend the steps that I had climbed as a toddler. This was my first home, but it had been many years, and it wouldn't be safe to trespass, I reasoned. So I backed off, snapped a photo, and drove away.

My reckoning of what happened in Flint really begins with another photo, taken on July 4, 1942. My grandparents are in standard *American Gothic* pose, flanked by a neat, stair-step line of four skinny young boys in fedoras and suspenders. The backdrop is their farmhouse, which stood and still stands a couple of hundred miles north of Flint, on Manning Hill. Within ten years, all four of those boys would be working in Flint, mostly in construction. The photo does not show my aunt, already in Flint by then, working at a defense plant. It does not show the tin shack a mile away, where my mother lived with no plumbing, nor her father and two brothers, who within a couple of years would be shop rats in Flint, and continue as auto workers their whole careers. Most critically, it does not show the four of my paternal grandmother's ten children who died as children.

The best explanation I have found for the connection between this photo and the one I shot on Raskob Street last spring appears in a recent book, Robert Gordon's *The Rise and Fall of American Growth*. Over some eight hundred pages of exhaustive fiscal and demographic analysis, Gordon, an economist at Northwestern, argues that the boom during the middle of the twentieth century, which created much of what we still think of as the American dream, was a one-shot deal, an unprecedented and since unequaled anomaly that spanned the dates on the picture at my grandfather's farm and my own high-school graduation photo, taken several miles away in 1969. These dates mark the period when innovation made the whole country thrive. Then the dream of shared prosperity died. It's over. If you think otherwise, ask Flint.

"Flint's pain is the result of so many different failures," Donald Trump said when he visited the city's Bethel United Methodist

Church in September. "The damage can be corrected and it can be corrected by people that know what they're doing. Unfortunately, the people that caused this tremendous problem had no clue." This reasoning—which was correct insofar as it was broad and empty—was largely overshadowed by Trump ridiculing the pastor who had invited him to speak. A deeper explanation of who gets the blame for poisoning Flint would mention the Republican governor, Rick Snyder, who placed the city under emergency management, a provision in Michigan law that allows governors to step over bankrupt local governments and impose state rule. In Michigan, bankrupt cities are mostly poor and black, as are a good number of the congregants at Bethel United. To save money, the city's emergency management decided to switch the drinking-water source from Lake Huron to the Flint River.

There is nothing especially wrong with the Flint River, which wends through the farmlands and suburbs of Lapeer and Genesee Counties, downtown Flint, and the Shiawassee National Wildlife Refuge before dribbling into Lake Huron's Saginaw Bay. Yes, the river did take more than its fair share of industrial pollutants when GM workers were busy building cars in Flint's factories. But the 1972 Clean Water Act was aimed at places like this, and it has remedied the worst of the Rust Belt's waste, leaving the Flint River relatively innocuous. The most troublesome pollutants today are pesticides and fertilizers from farms, suburban lawns, and golf courses, as is the case with most rivers across the nation. Kayakers celebrate the Flint River's cleanliness by paddling away from the edge of downtown, and bald eagles nest along its banks.

In a roundabout way, however, water from the Flint River is toxic because of our devotion to automobiles. My first car was a 1960 Corvair, which my maternal grandfather had a hand in building at the Fisher body plant. When it rolled off the line he tracked it to Applegate Chevrolet, a few blocks away, and bought it. The car was pretty well spent when I paid him a hundred dollars for it, six years later. Friends helped me break it in half within a few months, simply by piling in five or six passengers. By then the Corvair was so badly rusted that it folded under the load. All cars in Michigan rusted out within four or so years, a fact that we earnestly believed was traceable to obsolescence planned by the auto industry and executed by Governor George Romney, a former auto executive. The working hypothesis was that Romney per-

sonally ordered his highway guys to spread more salt so that the car guys could sell more cars. This conspiracy theory is not provable, but it deserves some credence, because the practice of salting roads to remove ice, now widespread in the northern states, began in Detroit in 1940.

Like everything automotive, chloride from road salt became layered in Michigan's geology. As salt runoff flowed from expressways to ditches to creeks over seven decades, finding its way to the Flint River, the water became corrosive—less so than Mountain Dew, but still corrosive. We call the corrosion of metal "rust," and any water-plant operator worth his paycheck understands how this works. Municipal water plants routinely neutralize the corrosion of pipes with high-school chemistry, usually by adding a bit of orthophosphate, which is cheap and harmless.

Underground water pipes form a narrative of a town's history, capturing in variously aged segments the patches and workarounds of infrastructure. Each part represents what was available, affordable, and considered a good idea at the time. City water systems—usually made from steel, zinc, copper, and lead—are all corruptible to some degree. But lead is our focus here, because it poisons people. Some of the earliest pipes are pure lead; others, mainly copper pipes, used lead as a part of the solder. In normal systems (to the extent that there is such a thing), most of the lead stays put, wrapped in a coat of oxidized metals that builds up between water and pipe, but corrosive water breaks down that coating, allowing the lead to make its way to taps.

When routine tests showed corrosion, plant operators in Flint did not treat the city's water. State regulators counseled that they should instead monitor the pipes for six months to see what could possibly go wrong. After GM noticed that water was corroding engine parts at one of its very few remaining plants in the city, and after the first case of household lead contamination was confirmed, in the home of LeeAnne Walters, whose children lost their hair and had persistent rashes, a year passed before Snyder's administration announced that something had indeed gone wrong.

It's easy to forget that Flint is not the outlier it seems to be. It is a basket case of a city, but basket-case cities are not so rare, especially in the Rust Belt. This catastrophe was set off by bankruptcy, but it was enabled by a normal river, an old infrastructure of pipes, and a government as creaky as its water system—each of which

appears in similar configurations in many places. A *USA Today* investigation found that there are at least 350 schools and day-care centers in America where the Environmental Protection Agency has, since 2012, identified unsafe levels of lead in the drinking water. The problem seems particularly prominent in Maine, which has corrosive water, and in Pennsylvania and New Jersey. Water contamination is going to happen in other towns too.

There was another house I went to see. My marker for finding it was a creek. I drove ten miles or so on an east-west artery south of Flint, Bristol Road, trying to make the scenery fit a five-year-old's version of the world. Oddly, it was a tree, not the house, that confirmed I was in the right place. I had not thought of the tree even once in all the time since I'd lived with it. Now it stood coppiced to a stub, a willow between the house and the creek, but it snapped into memory as a Leica-sharp image of what it was back then, in full histrionic weep. Its limbs were my mother's source of switches. She'd break one off and flail me for playing in the creek, which flowed to the Flint River. You should not read too much into this. I certainly don't. It's what people we knew did at the time.

Another memory probably has more to do with explaining why my family moved from that little house on Raskob Street to this one, at the edge of Burton. It was the mid-1950s, and my mother caught me mouthing a penny, as children do. "Don't put money in your mouth," she scolded. "You don't know whether a colored person has touched it." Actually, my memory has her using the more incendiary label for African Americans. Most of the people I grew up with did so casually.

Her racism reflected official policy in Flint. For instance, about ten years before, in the 1940s, black residents had pressured school and recreation officials into granting them access to a public pool. They were admitted only on designated days. Then the water would be drained before white swimmers came, since it was like the penny in my mother's mind, sullied by contact. She and some of the city officials were Baptists, and so had deep-seated faith in the ability of water to remove sin and wash it away. Maybe it suited them to imagine that having black skin was a sin that remained in the water.

The auto industry drew African Americans from the South to Flint almost from the beginning of the twentieth century, but after

World War II, GM began active recruitment and the trickle built to a wave, a volatile mix of hillbillies and black people. (US 23, "Hillbilly Highway," delivered Appalachians to Flint, Detroit, Ypsilanti, and Saginaw.) Between 1950 and 1960, Flint added about thirteen thousand white people, many of them Southerners, and the black population doubled. GM helped keep the groups apart by institutionalizing segregation, not just at swimming pools. Real estate transactions included specific language forbidding sales to African Americans in most neighborhoods. Banks redlined. Schools gerrymandered boundaries as rigidly as Jim Crow. Once, a mix-up somehow allowed a black student into an all-white classroom, and administrators dealt by placing his desk in a closet.

Yet racism in Flint was realized geographically in curious ways, largely owing to the difference between Ford and General Motors. Henry Ford wanted nothing to do with cities, consciously founding his empire in the suburbs. Today the metonym for the auto industry is Detroit, but the reality of it was not the city itself.

GM, on the other hand, which began in Billy Durant's carriage shop, where the river runs through downtown Flint, was from the start consciously urban. GM chose to try to keep all of its factories within the city, and, when forced to seek more land outside Flint, built close to the boundary, intending to be annexed.

The segregation of that boom period immediately after World War II was imposed in city neighborhoods, but the center could not hold. White people who could afford a Chevy moved outside the city limits, and commuted in. My parents joined the exodus in their new BelAir as soon as they were able. Certainly, there were forces in this beyond race: wide-open spaces, creeks, green grass, that sort of thing. But this system allowed white families to take advantage of the infrastructure, commerce, and employment afforded by the density of a city without paying city taxes.

The population shift pushed Flint in the direction of the Ford suburbanization model, which proved to be toxic. And, as had been the case with all things Ford during the latter half of the twentieth century, the pattern became codified in Michigan law: First was a rewrite of annexation legislation that largely prevented cities from capturing growth at their boundaries, meaning that cities lost their tax base. Second, the state decided to cap property taxes and instead share proceeds from a statewide sales tax with local governments. Over the years, the state legislature, increasingly

dominated by suburban lawmakers, tweaked that formula to favor the comparatively affluent suburbs. The result has been that the proceeds of the sales tax—a regressive form of taxation on its own —are disproportionately granted to the rich.

During the Sunday-morning breakfast rush at a Bob Evans where Flint ends and the suburb of Flushing begins, I met Dan Kildee, who represents this district in Congress. Kildee is a tall, balding guy with a guileless Midwestern demeanor. We realized that both of our great-grandfathers had come to Michigan in the middle of the nineteenth century as loggers. Mine was from England by way of Ontario, his from Ireland. Kildee's grandfather's generation, and my father's, came to Flint. Dan Kildee's seat in Congress is the same one that his uncle had held for eighteen terms.

Kildee learned to straddle the city-suburb line; he represents both sides, which was clear as he worked the room, recognizing constituents and greeting them warmly, mostly with double hand-clasps. But Kildee, who was born in Flint, is a city guy. He founded the Genesee County Land Bank, a nonprofit that collects money to raze abandoned houses, and later started the Center for Community Progress, which develops strategies to cope with sprawl and blight in cities nationwide.

We sat down at a table and ordered our strip-mall breakfast dreck. I asked him about Flint's changing demographics and the people who left. "They could stop cities from expanding to capture the true footprint of the community," he said. "Hopping the border to a less costly part of the geography, it's really grossly unfair. They are doing what they see as best for themselves, but in the aggregate it's not good for anybody. They starve the city."

In November, Kildee was voted into his third term. He carried 61 percent of the ballots, in a district that, like most predominantly urban areas, went blue in the presidential race. His constituents had listened to Trump's talk of "infrastructure first"—a policy that promises investment in clean water—but they couldn't decipher the plan in the blur of promises. "People who live in these cities don't see the Republican Party or Donald Trump as their path forward," Kildee said when I called him after the election. "We are turned off by his pretty obvious pandering when he talks about rebuilding and revitalizing inner cities."

The story of the water crisis has mostly been about the city of Flint, but it shouldn't be. Flint needs to be considered along with

places like Burton. My parents' Bristol Road house is best viewed
on a map that shows Burton and Flint sitting side by side, stitched
together like two squares of a quilt, and like a quilt, the image gets
its meaning from the clash of colors and patterns. Today, Burton
is 88 percent white, 7 percent black; Flint is 37 percent white, 57
percent black. Median household income in Burton is $42,002; in
Flint, $24,679. Burton ought to be part of Flint in any concept of
organic community growth, but it is a separate place, troubled by
the collapse of the auto industry while still enjoying new houses,
functioning schools, and drinkable water. Same deal in the clean-
water towns of Davison, Grand Blanc, Flushing, Fenton, Clio,
Montrose. All of these are in Genesee County, of which Flint is
the seat, yet since 1960 Flint has lost half its population, of nearly
two hundred thousand, while smaller towns in Genesee County
have grown. None of these places is bankrupt; Flint is bankrupt
only because of how we choose to draw the lines that define place.
Likewise for Detroit. This is the public-sector version of the asset-
stripping that drove a binge of corporate takeovers in the private
sector.

Flint is full of lead-poisoned children not because the Flint River
is bad or because inner cities are a "disaster," as Trump claims.
Flint is full of lead-poisoned children because social policy is cor-
rosive enough to deliberately engineer the bankruptcy of places
where poor black people live.

My fondest childhood memories are of days spent with my father
and his brothers. On weekends we would gather and build things.
Brotherly banter, then tools were unpacked from pickups, mud got
mixed, and a concrete wall rose—same thing they did all week in
their jobs putting up houses and laying roads. One of the boys in
that 1942 photo, Dale, the youngest, survives. When I visited him
a couple years back, he was pushing eighty and building his new
house, by which I mean swinging a hammer, not writing checks
to subcontractors. I can imagine what the people who raised me
would think about the city of Flint tearing down the houses they
constructed, by the thousands.

Douglas Weiland, who served as the director of the Genesee
County Land Bank started by Kildee, told me that occasionally
houses come along that can be rehabilitated, so their organization
sends in a crew, spiffs them up, and sells them as the market allows.

But most don't get offers. Perfectly good houses, tasteful old rambling Victorians, brick bungalows that would fetch half a million on either coast or even fifty miles away in Ann Arbor, won't sell for enough to cover the cost of rehabilitation. For example, Weiland said, a Cape Cod in Mott Park—my old neighborhood—that sold for $80,000 in 2000 and then for $15,000 a few years ago, showed up on the latest foreclosure list, abandoned as worthless. He noticed it on the list because it was once his house.

To economists, the empty homes awaiting bulldozers are more than just lost houses. Houses were part of the infrastructure supporting the economic boom of the middle of the previous century, as were highways, sewers, water pipes, and water-treatment plants. For decades, engineers have been harping on the nation's failure to care for this infrastructure, saying that our neglect places us in peril. Trump alluded to his vague ambition for an overhaul in his victory speech: "We're going to rebuild our infrastructure, which will become, by the way, second to none. And we will put millions of our people to work as we rebuild it." But tending to existing infrastructure is a lot cheaper than replacing it, and there is no better evidence than Flint's water system, where $50,000 worth of treatment could have saved more than a billion. Long-term economic analysis suggests the need for even greater attention to Flint's example: if Robert Gordon's meticulous research is right, and the midcentury boom was a one-off, then not only is it cheaper to maintain infrastructure, that is our only choice, because nothing on the horizon—certainly not tax breaks to private investors, as Trump has proposed—promises to generate enough money for a do-over.

Gordon establishes that the setup for the economic expansion of the midcentury began in the 1900s and 1910s—first in cities, and then in rural areas—with a decline in infant mortality and an increase in life expectancy. He argues that often-cited factors in the transition to the modern era, like improved medical knowledge and nutrition, were not the most transformative. Rather, he writes, babies stopped dying when sewers and contemporary public-water systems were introduced in US cities. Yet today in Flint, contaminated water has flowed to at least twenty-five thousand children, and nationally kids in four million households have been exposed to lead. A dozen people in Flint have died from Legionnaires' disease, believed to be the result of poison in their taps, and the ef-

fects of contamination on children there and across the country
will be harshly revealed as our pipes continue to break down.

On a crisp Saturday morning in Flint, the sky was blue, but frost
still hung in the air. I drove along Martin Luther King Avenue,
passing wasted, falling houses. Then I spotted a bigger, boarded-
up concrete building. The front door was propped open and a guy
was wheeling out stacked cases of bottled water on a hand truck
to a rusty, canary-yellow Chevy at the curbside. A family loaded the
water into the trunk.

This had been a school and was now a bottle warehouse, with a
hint of something on the nameplate still visible: BUNCHE COMMU-
NITY SCHOOL. The building was surrounded by a weedy expanse,
once a cultivated park, wooded with mature maples and oaks. A
year before I arrived, a collection of neighborhood groups had
bought the property, but there were no signs of rehabilitation—
the place looked overgrown and neglected.

Education, a commitment to the next generation, had been
essential in Flint when I was born, and this was because of the
auto industry. General Motors and the United Automobile Work-
ers, who gained recognition in 1937 through sit-down strikes, ac-
tively bargained and collaborated to run the city and the schools
and everything else—not textbook democracy, but it worked. If
a resident had a problem with, say, her drinking water, she took
it up with the union, and the union fixed it. This arrangement
spread across the state and established broad support for schools
and universities. There is no doubt in my mind that my path from
that shack on Raskob Street to the University of Michigan in Ann
Arbor was paved this way.

Bunche Community School bears the fingerprints of one origi-
nal GM principal in particular, Charles Stuart Mott, a Republican
three-time mayor of Flint and very generous philanthropist. (Mott
Park was named for him.) In the 1930s, Frank Manley, a local
teacher, sold him on the concept of community schools. Manley's
notion, picked up from Flint's Socialist Party, was to charge public
schools with a wide mission, including adult education and courses
in health and athletics, as well as enrichment classes for children.
Schools were set in sprawling parks with gyms, pools, and skating
rinks that were open day and night.

The Charles Stuart Mott Foundation remains Flint's major phil-

anthropic force. Neal Hegarty, who runs its programs, began working in the city sixteen years ago, and couldn't help but notice that whenever locals talked about their experiences at the community schools, they would wind up in tears and say something I'd heard too: "I didn't know I was poor." Hegarty told me, "This community had everything one could imagine." All the people I spoke with about community schools said that there was an underlying message in whatever they learned: the program was a conscious effort to teach the social contract. "It led me into a lifetime of community activism," David White, a Flint historian, said.

The community schools were segregated, however, and Andrew R. Highsmith, in his book about Flint, *Demolition Means Progress,* singles out the program as a Mott-funded effort to bolster racial division. Mott died in 1973, during the peak of white flight, and the foundation announced that it would quit paying for community schools in 1977.

When I met Inez Brown, Flint's city clerk, in a well-worn conference room adjacent to her office in City Hall, she expressed no interest in lamenting the discrimination she'd experienced. She was generally polite, slight, soft-spoken, and thoughtful. As a kid she had lived down the street from Berston Field House, a community school that provided extracurricular programs in the afternoon. Black children went there to swim, and though I didn't get this from her, Highsmith writes in his book that on days when white kids wanted to swim at Berston, the pool was among those drained and refilled. "At the time it was kind of segregated," Brown told me. "I hate to say it that way, but it was."

She wasn't there to swim. She was there for the books. The schools sponsored competitions for most books read. "I can remember as a child I was interested in everything," she said. "I wanted to be an anthropologist one time. Then I wanted to be a writer. Then I decided I wanted to be an actor." Before she became Flint's city clerk, Brown was an aide to Senator Don Riegle, specializing in urban policy, and then she worked in the Chicago office of the Small Business Administration during the Clinton years.

Brown could see that we were around the same age, and she said something that seemed to include us together in an important category: "You and I were both taught that every generation needs to be better than the next," she told me. "That's not happening anymore."

When we spoke again after the election, she said that Trump's form of bigotry had sounded similar to language she had heard all her life. "In every presidential election that I can recall in the past, racism has always been interjected," she explained. "But the way it was interjected this time was in a different manner, and it did cause more anger and consternation." Now, she told me, "We're at a crossroads."

Only once during my return to Flint did I allow myself to spiral into a towering rage. It didn't happen at either of my old houses—I have left those behind—but on hallowed ground, in an open field of grass in the inner city. This place, framed by a new parking lot and a paved trail along the Flint River, was known to generations as Chevy in the Hole. It was once a sprawl of eight plants on 130 acres, where nearly twenty thousand people built cars—the setting of the United Automobile Workers' strike—and has since been become part green park, part industrial wasteland.

My rage kicked in as I approached the chain-link fence that separated the field from the river. Beyond the fence was a tilted wall that stretched along each bank all the way downtown—a mile, give or take—forming a long concrete casket. The encasement of the river was a flood-control project by the Army Corps of Engineers, in the 1960s. The auto plants on the banks had been built in a floodplain ("the hole"), and this was their truly wretched way of preventing water from spilling. Concrete channels kill rivers, directly and indirectly—it's hard to care about a dead drainage ditch.

I suggested to people that what Flint really needed was to make the Army Corps come back and pull out the concrete. Everyone told me that this was a bad idea, even as they lined up for water bottles. Expensive. Besides, there are sites that once held factories —brownfields, now—all up and down the river, underlain by toxic waste and better left undisturbed. I still think that Flint needs to tear out this concrete, but maybe that's just me.

My anger here was personal and misplaced. It had to do with mobility. The river lost its mobility so that we could have ours, so that GM could make Chevys to carry people to the suburbs and be-yond. My father was infected with this mobile spirit, always moving, mostly because he could not keep a job. He had a pathological

streak of antiauthoritarianism, and if it is genetic, I thank him for it. By the time the 1960s came around, we had left Burton, lived in Tennessee and Ohio, and come back, two hundred miles north of Flint, to build a house on a corner of my grandfather's farm. My father's habit was to leave us there while he went away, traveling from job to job in construction, preferring his mobility over his children. In particular, he left me to fend for my six younger siblings in a house that was not equal to Michigan's winters. He could not abide staying put, and so he went to Flint, to work in concrete, on this very project, pouring the concrete walls along the river.

From Chevy in the Hole, one can walk straight north across the bridge that Flint cops crossed with tear gas, clubs, and guns in 1937 to try to end the auto workers' strike, and on the other side step into Einstein Bros. Bagels. At a table I found Jack Stock, director of external relations for Kettering University, and Dallas Gatlin, a longtime GM executive and former plant manager who now runs a homeless shelter.

The Einstein Bros. had been brought in by Kettering, a science and engineering school once run by GM—it was then called the General Motors Institute but known widely as the West Point of the auto industry. Now Kettering was a private nonprofit, just across the street. The site where we were eating had been a liquor store before, derelict and dangerous; Kettering works with the Land Bank to buy up such places and open mundane little amenities that elsewhere would be taken for granted. Gentrification? Maybe somewhere else, but on these streets the word gets no traction. Stock explained that the university was ultimately responsible for shielding students from crime in Flint, where the murder rate is about ten times the national average. (A shooting occurred a couple of blocks from where we sat two days later.) The university could either wall itself off or engage, Stock went on, and Kettering had chosen the latter. In March, the university began offering its employees loans of as much as $15,000 to buy houses in the neighborhood; the loans would be forgiven if the employee simply remained in the house for five years. There have been three takers.

Gatlin had joined us because his homeless shelter is part of the University Avenue Corridor Coalition, which includes Kettering, along with Hurley Medical Center, the city, GM, and some NGOs.

The idea is to use the river as an asset to promote development, and a homeless shelter counts, at least in Flint. The shelter, Carriage Town Ministries, is a new facility a few blocks east, which anchors a network with a clinic, gardens, and parks for the several hundred people it serves. Residents do chores for their keep, like picking up litter along University Avenue. In winter, the homeless had started shoveling sidewalks because the city couldn't afford to plow, and Kettering bought them snowblowers. The lessons about community responsibility once deliberately taught in Flint's public schools now occur in its homeless shelters.

We were in the emerging core of Flint, among the "eds and meds," as the locals say. It's a lash-up of necessity, to fill the void created by dysfunctional governance. When state regulators actively sought to cover up the water poisoning, and the EPA tied itself in useless knots for months, the scandal came to light only because outsiders, nongovernmentals, did the spadework. These were people like Marc Edwards, an independent researcher from Virginia Tech, and Mona Hanna-Attisha, a pediatrician at Hurley, one of the eds and meds from the neighborhood.

A year since the news broke, talk of Flint continues. Several state and local officials have been charged with misconduct, yet the government has not remedied the infrastructure that made public water unfit to drink. Faucet filters have been distributed, but people tend to feel safer buying water bottles. The EPA under the Obama administration, which has seen its budget slashed and is operating with the smallest staff that it's had since 1989, is at risk of being eliminated entirely by Trump. When asked by Fox News whether he would cut federal departments, he said, "Environmental Protection, what they do is a disgrace. Every week they come out with new regulations."

We speak of a postindustrial society, but ours is also postgovernmental. In the halcyon days of the industrial era, the period of our greatest collective prosperity, the Eisenhower years, there were 78 Americans for each employee of the federal government; today there are 150.

Before I left town, I went to see Heidi Phaneuf, a city planner by training, who was working to take the city apart. The Genesee County Land Bank had hired her to help manage their house-demolition project. She got her degree at the University of Michi-

gan campus a couple of blocks away from her office, which was downtown, by the river. When Phaneuf greeted me, her preternatural pleasantness and youthful laugh made her seem green. But she isn't, not after having been through all she has.

Phaneuf lives in the Grand Traverse neighborhood, a thin strip of resurrection and stately old wood-frame houses just south of the river. Hers is the same house that her grandparents lived in. When the roof and foundation caved, she and her husband tried to borrow enough money—some $20,000—to renovate. The banks refused, but cheerfully offered to loan them $100,000 to move to the suburbs. They stuck around, scratched together the money a bit at a time, and did the work themselves. "My car is worth more than my house," she said. The house is valued at $12,600.

Mostly, Phaneuf's work is to be an urban undertaker, and like an undertaker her greatest service is easing Flint residents through denial, and perhaps several other stages of grief, about the death of their neighborhoods. She showed me maps, as planners do. Hers depicted Flint over recent years, with each progressive year showing increasing concentrations of black dots that signified demolished houses. Many were north of the river, above the heart of Flint, and a few were south and along the city's commercial arteries. There were big blank spaces where factories once were. I asked her about where this was headed, insisting that she was a planner so what was the plan, and then I realized that this was irrelevant. What she understood and I had not was that she was not redrawing these maps herself.

Once, maps detailing Flint's future were drawn by the heavy hand of GM to create a habitat for its workers. GM is gone, and with it nearly one hundred thousand people. Still, as many remain, compelled by their commitment to the social contract. And there are newcomers, artsy urban pioneers drawn by $15,000 houses. Circumstances have presented Phaneuf and others with an opportunity to fill in the blanks with a city designed to meet the needs of those who live there now, the needs of people, not of a governing corporation. (Since we met, she has taken a new job, as a planner at the Michigan Department of Transportation.) Flint is feeling its way toward a postindustrial, postgovernmental future, and we all have a stake in the outcome.

I came away from Flint with a preoccupying question: whether the place where I grew up could still serve children the way it had

served me, by offering a pathway to a valuable life. No one I talked
to on my trip saw how it could. Like many in my generation, I
desperately want the path remade, and I have cast about for the
dimly recalled elements of prosperity and social commitment that
allowed it. None of my best-laid plans, or anyone else's, will pull
us from the ditch we are in. We can only watch as this city redraws
itself along its one meandering bold line: the river.

RACHEL MONROE

Outside the Manson Pinkberry

FROM *The Believer*

ON THE SECOND DAY I spent with the Manson Bloggers, we found a tongue hanging from a tree. This was in the northwestern fringes of Los Angeles County, the half-wild, half-suburban part of the city that the Manson Family once called home. These days, most of the land is owned by the state and nearby there is a church; on top of a hill, a ten-foot cross looms in right-angled judgment. The Manson Bloggers did not seem to notice the cross, because they had another mission in mind: finding the Manson Tree, a gnarled oak that's notable because Charles Manson used to perch in its crook and strum the guitar.

We had to scramble over a highway railing to reach the old oak. As we got close, I saw that some previous visitor had thrown a white rope over one of the tree's branches. Something was dangling from the rope—a sweet potato, I thought. Or some sort of lumpy, orangish doll. The Manson Bloggers knew better. "It's a cow's tongue," Deb said. She was right. Up close, it was unmistakable, a length of moist muscle, obscene and obscurely violent. The tongue was covered with rainbow sprinkles, the kind you'd put on a child's scoop of vanilla ice cream. One end of the white rope was tied around the tongue's root, where it had once been attached to the back of the cow's throat. The other end of the rope was tied around a bottle of fish-oil pills. There was one AA battery inside the fish-oil bottle. On the ground was a crumpled-up shopping bag from H&M.

The Manson Bloggers and I stared for a moment in mute wonder. The tongue, the rope, the sprinkles, the fish-oil bottle, the bat-

tery, the H&M bag: it all spoke to some inexplicable ritual, a dark magic that somehow brought together cult murder, fast fashion, and nutritional supplements. I'll be honest, I was spooked. The bloggers took it all in stride. Maybe their world accommodated more strangeness than mine. Or perhaps they were just used to finding messages of violence in unexpected places.

One year earlier, in the first throes of my renewed interest in the Manson Family, I had taken the Helter Skelter bus tour operated by Dearly Departed, an outfit specializing in Los Angeles death and murder sites. It sells out nearly every weekend, which is surprising given that there's actually not much to see anymore. Scott Michaels, Dearly Departed's founder and main guide, set the tone with a custom soundtrack of hits from 1969 ("In the Year 2525," "Hair"), cozy oldies made newly spooky by our proximity to death. He also included extensive multimedia add-ons, such as cleavage-heavy clips from Sharon Tate's early films and Jay Sebring's cameo on the old *bang-pow Batman* TV show. Going on the tour is a little like taking a road trip through the parking lots and strip malls of central Los Angeles, accompanied by a group of strangers wearing various skull accessories. Many of the sites aren't visible or no longer exist. The former Tate-Polanski house on Cielo Drive has been demolished; the site of Rosemary and Leno LaBianca's murders in Los Feliz is mostly hidden by a hedge.

In Los Feliz, Michaels slowed the bus and pointed across the street. That Pinkberry, he told our group—two Australian newlyweds in matching Museum of Death T-shirts, a mother and daughter both in light goth attire, an ominously normal-looking guy from Boston in a Red Sox shirt, and a man in a leather jacket who wouldn't stop grinning—once had a pay phone out front. And it was that very pay phone that Rosemary LaBianca's son used to call his sister the day he found his mother's and stepfather's bodies. I took a picture of the Pinkberry. We pulled into a parking lot. "This flower shop used to be a gas station. And that gas station may have been where Tex Watson refueled the yellow 1959 Ford the night he killed Sharon Tate," Michaels said. The parking lot felt surreal, eerily familiar. I shivered. "Also, it's the flower shop where Ruth worked in *Six Feet Under*," he added. I took another picture.

We drove by the house where, as Michaels told us, the murder-

ers had pulled over and used a garden hose to wash the blood from their hands. "Oh my god," leather jacket said. "There's a garden hose in the driveway." I took a picture of the hose. "The people who live here don't like us coming by," Michaels said. "But it's not like they own the street." Michaels and Red Sox shirt engaged in some idle shop talk about how difficult it had been to track down and purchase a carving fork exactly like the one that Tex had used to carve *WAR* into Leno LaBianca's stomach.

Halfway through, we stopped so Michaels could use the bathroom. I bought a coffee from a taco truck and stood near the smokers, half-hoping I'd make a friend. Our group was unselfconsciously chatty, in the way of fan conventions or trade shows. Red Sox was saying that he'd read *Helter Skelter* twice in preparation for this tour, bringing his grand total to twelve. He was also a fan of Michaels's celebrity death photos website. His favorite celebrity death photo was of either Chris Farley or Lisa "Left Eye" Lopes. I must have accidentally given him a weird look. "I mean, if you died, I would never look at pictures of you," he assured me.

"Thanks," I said, feeling unfamous.

As the van drove through Laurel Canyon, it began to rain — nothing dramatic, just the slow, gray spit of a failed Los Angeles day. Michaels passed around a binder stuffed with crime scene photos and autopsy reports. I flipped through it quickly; I'd seen it all before. Instead, stuck in traffic between sites, I stared out the window at nail salons and doughnut shops, places where no one — or at least no one I care about — had been killed.

My relationship with the Manson Family began in high school, when I read prosecutor Vincent Bugliosi's 1974 book *Helter Skelter,* the best seller that helped establish the contemporary true-crime genre. The book's cover, with its lurid red font and promise of never-before-seen photos, seemed to hint at violence and weird sex. It was much more alluring than anything else on my parents' library shelves. I wolfed it down and spent a week in a Manson Girl haze, imagining myself in the thrall of a googly-eyed guru, eager to do his murderous bidding.

Of course Charlie is popular with teens — all that misdirected fury, those pseudo-deep slogans. No sense makes sense. Pain's not bad; it's good — it teaches you things. As described by Bugliosi, the

Manson Family's aesthetic was like an adolescent imagining of the hippie era: the Beatles, the Beach Boys, cheesy 1960s satanism, motorcycles and long hair and trippy murals painted on vans.

This Manson phase was part of a broader crush that I, a late-'90s teen, had on the 1960s. I was unhappy, for reasons I didn't understand. My big, suburban high school was all clamor and boredom; I spent my evenings talking to my best internet friend, a twentysomething New Yorker I'd never met in real life, and half-heartedly embarking on an eating disorder. My romantic interpretation of my low-level malaise was that I just didn't belong to my own time. And so I wrote papers on Vietnam draft dodgers and rescued my dad's old Rolling Stones records from the attic.

In true crush fashion, I idealized and misunderstood my object of affection. In the apocryphal, utopian 1960s of my imagination, young people had power, and weirdness was socially sanctioned. Even better, people felt as though they were a part of something bigger, something that gave their lives urgency and meaning. Then was different from now in some crucial, ineffable way. Now was disappointing. Then was better.

The Manson Girl I most often fantasized about being friends with was Leslie Van Houten, the one with the pretty hair and the high IQ. In high school, everyone wanted to be Leslie's friend, too—at least at first. She was elected homecoming princess two years in a row. When she was thirteen, her parents split up, and she lost her social footing. She started hanging out with the other kids from divorced families, the bad kids. Drugs—first weed, then LSD and mescaline and DMT and mushrooms—helped. "It took me away from who I was at that moment," Van Houten said at her 2013 parole hearing. "And what was wrong with who you were?" a prison official asked. "I felt that I was out of place," Van Houten replied. At seventeen, Van Houten got pregnant; her mother convinced her to get an illegal abortion. The procedure took place in her childhood bedroom.

Van Houten tried out a few different lives before she took up with the Manson Family. She took steps to become a nun, then moved to an ashram for a while. In 1968, she met Charles Manson. She was nineteen years old.

In those early days, Charles Manson was a gentle man, with a vague, cultivated air of mysticism. His followers describe thinking of him as an elf, or an angel. It all fit in with the LSD fairyland

they imagined themselves living in. There was lots of barefoot ca-
pering and talk of magic. The growing Manson Family worked to
rid themselves of their pesky, greedy egos; the goal was to be like
a finger on a hand, an instrument designed for a higher purpose.

Over the course of a few months, the Manson Family's com-
munal fantasyland grew darker. Love and elves gave way to knives
and paranoia and stories about the coming race war. Maybe there
wasn't any less LSD, but there was certainly more speed. The night
of the Tate murders, Van Houten wasn't picked to go along. She
felt left out, and worried that she wasn't committed enough to
the cause. The next evening, the night of the LaBianca murders,
when Manson allowed her to get into the car with the others, she
was relieved. Whatever happened, at least she would be a part of it.

An interest in murders and cults and cult murders makes sense
in teenagers. Being sixteen feels chaotic and a little insane, even
under the best circumstances; the appeal of these stories is not so
different from the melodrama of many young-adult novels. Like
many teenage fans of the lurid and macabre, I had moved on to
more-complex icons of rebellion by the time I graduated from
high school. Charles Manson now seemed to me to have as much
depth as a T-shirt decal. Murder fandom felt like a relic of a more
turbulent time—something that could wash off, like unfortunate
eyeliner.

For some people, though, the obsession doesn't fade with time.

There are a dozen regularly updated Manson Family websites;
the most interesting was born as Evil Liz's Manson Cult, but is now
simply called the Manson Family Blog. The site hosts dozens of
contemporary photographs of former Manson Family members
and associates. Leslie Van Houten and most of the other famous
Manson Girls are all still in prison, of course; instead, the Man-
son Family Blog focuses its energy on more-peripheral members,
people who would qualify as celebrities only within this very small
subculture. Through various sneaky means, including, allegedly,
exploiting lax Facebook privacy controls, the Manson Bloggers
track down photographs of these people as they are now.

These photographs would look banal to the uninitiated: a
grandmotherly type on a bench, clutching a water bottle; a short
woman standing on the beach, flanked by three young men—
her sons? These people are infamous not because they've killed

anyone—they haven't—but because when they were fourteen or nineteen or twenty-three, they had the bad luck or bad taste to befriend some people who did.

In the intervening four decades, some of these ex–Manson Family members changed their names or became born-again—whatever it took to distance themselves from their turbulent, murder-adjacent youths. Sometimes these people write angry emails to the Manson Bloggers, asking for their photos to be taken down. It's easy to imagine them looking back at their former selves, shaking their heads, and thinking, That person isn't me anymore. But the Manson Family Blog is always there to remind them: yes, yes it is.

The Manson Bloggers spend hours hanging out with each other virtually, via emails and chat rooms, blog posts and blog comments. A few years ago, they decided to meet in person for the first time. It went so well that they now take an annual trip to Southern California to visit various Manson sites together.

I had returned from the Manson bus tour unfulfilled, convinced that there was something I still hadn't figured out. When the Manson Bloggers told me I could tag along on their next trip, I was thrilled. But whenever I told anyone what I was about to do, I got all tongue-tied and embarrassed. It seemed important to clarify that I wasn't myself fascinated by the Manson Family anymore, of course; instead, I was interested in people who were interested in Charles Manson precisely because I was no longer one of them.

Even though I would be staying with them in the four-bedroom house they'd rented for the occasion, in the weeks leading up to the trip the Manson Bloggers were still cagey about telling me anything about themselves. By the time I landed at LAX, the whole trip was starting to seem like an idea that was great in the abstract but terrible in practice. It was springtime, and the Southern California air felt soft and smelled like car exhaust and flowers. The radio played one '70s lite-rock hit after another, and I was grateful for the traffic, because it postponed the moment when I'd have to walk into a house full of strangers and try to make small talk about a forty-year-old cult murder.

But that turned out to be a silly thing to worry about, because when I walked in the door I found the Manson Bloggers so intent on each other that my arrival barely registered. They were talking shop with the eagerness of model-train enthusiasts. I grabbed a beer and tried to follow the rapid-fire discussion about unsolved

Northern California murders and Roman Polanski's sexual prefer-
ences. It was tricky—like all subcultures, when the Manson Bloggers
feel safe, they speak in a kind of in-group argot, full of nicknames,
acronyms, and arcane references. There were hardly any men-
tions of husbands, wives, children, jobs, any of the infrastructure
of daily life. Instead, they gossiped about minor Manson Family
characters as if they were mutual friends.

The next morning, we drove out to Chatsworth to meet Stoner.
Stoner spends his days in the Santa Susana Pass State Historic Park,
digging for relics. Over the years, Stoner has found bedsprings,
light-switch plates, charred wood, a spoon, a belt buckle. Most are
about forty years old, and closely resemble trash. Like most relics,
they are notable because of who touched them, what they were in
proximity to, what they may have witnessed. Stoner believes he's
found Spahn Ranch, the cowboy/porn movie set where the Man-
son Family lived for a little while, leading tourists on trail rides,
buying drugs from bikers, filming soft-core porn.

Stoner has a black goatee and is wearing a FREE LESLIE VAN
HOUTEN T-shirt. He told me that he'd been into the Manson Fam-
ily since he was a misfit among the misfits at Beverly Hills High
School in the 1980s, doodling Charles Manson's face in his note-
book instead of the Iron Maiden logo. The first time he went to
prison, he was sent to Corcoran, the same place Charles Man-
son himself has been incarcerated for years. During rec periods,
Stoner would sometimes sit in the yard and stare at the tall white
walls of the building that houses Charlie. "People'd be like, 'What
are you doing, man?'" he said. "And I'd just wanna say, *Just let me sit
here and look for a minute, OK? He's right over there, and this is as close
as I'm ever gonna get.*"

The Manson Bloggers and I dig around in the sandy dirt with
our hands. Someone unearths a curved ceramic shard, perhaps
part of a coffee cup. I discover a tarnished penny, dated 1968.
Stoner, who has lots of tattoos and a friendly, open face, insists
that I keep it.

Stoner is not homeless, exactly, but he's not particularly homed
at the moment. After showing us the dig site, he takes us to his
friend's apartment in Chatsworth, where he's currently crashing.
He keeps his relics on the narrow concrete patio. They are neatly
arranged on fattened cardboard—shards of pottery, bent nails,
rusty mattress springs. People who are in the market for objects

that Charlie may have touched know that Stoner is the person to call. He recently sold a similar Manson-era penny for twenty dollars. The nails are his most popular product. "Symbolism," he tells us, shrugging.

In a way, the Manson Girls have never been able to live beyond their adolescence. In 1977, Leslie Van Houten was granted a retrial for the murder of Rosemary and Leno LaBianca. After months of testimony and twenty-five days of deliberation, the jury declared itself deadlocked: five members voted for manslaughter, which would've meant she'd be free on the basis of time served; seven were set on first-degree murder. The prosecutor refused to negotiate a plea and insisted on yet another trial. In the time between the end of the second trial and the beginning of the third, Van Houten was released on a $200,000 bail. At that point, she had been locked up for eight years, much of that time in solitary confinement.

In the days after her release, Van Houten celebrated her freedom by going to the beach with her mother and attending a pizza-and-Scrabble party thrown by her lawyer. She was fragile, grateful, easily startled. She found grocery stores overwhelming. Some of the things she enjoyed about being free, she told a friend, were "ironing, the smell of fresh clothes, walks down a sidewalk." She worked as a legal secretary and didn't attempt to change her name. She understood that her period of freedom was something of a test—she had to prove that she was able to live in the world uneventfully. For six months, she did exactly that.

Then, in her third trial, Van Houten was convicted of two counts of felony robbery-murder, and sentenced to seven years to life. Her good behavior both in and out of prison made her cautiously hopeful when she first became eligible for parole, in 1980. At that point, she had been in prison longer than many murderers; many of the other women who had been on California's death row when she and the other Manson Girls were first locked up had since been released. But the parole board declined to release her. "[One of the board] insinuated to a reporter that he saw me as similar to 'that girl with eight personalities,'" Van Houten wrote to a friend afterward. "They don't understand how I can be normal now and have been part of the crime ten years ago."

For Van Houten, parole hearings soon came to feel like a cycle of anticipation and despair. (The victims' families, called on to

testify about their loss at every hearing, also find the repetition of the murder story exhausting and demoralizing; the LaBianca family was part of a group that lobbied for a California law that allows for parole denials of up to fifteen years at a time.) She'd spend the years after a parole denial following the parole board's recommendations to a T: more therapy, more volunteering, more education, more support groups. But at every hearing, she was denied again, for a shifting set of reasons—she was not remorseful enough, or she was too remorseful and therefore self-aggrandizing. She didn't apologize enough or in the correct words.

These hearings are on public record, and you can go online and read through the transcripts. It seems to me that although the parole board gives recommendations about what it thinks Van Houten should do to prepare herself for life in the outside world, what it's really struggling with is something deeper. A puzzle of self, an ontological knot: is Leslie Van Houten the same person at thirty (or forty or fifty or sixty-five) as she was at nineteen? If she's not, that seems to indicate a fundamental instability of some kind, a dangerously wobbly sense of identity. But if she is, then isn't she capable of killing again?

Tex Watson and Susan Atkins, two of the other Manson Family members convicted of murder, found Jesus in prison. They blame the devil for their sins. I can understand the appeal a murderer might find in being reborn. It's a neat solution, one that offers the possibility of a fresh self. A do-over. For whatever reason, Van Houten has refused the clarity of such a solution.

In 2013, Van Houten's parole was denied for the twentieth time:

> You have failed today to explain at this hearing as to why it is specifically —why it is and what it is about you that would cause you—you're a smart person. You were a smart teenager. You came from a good family. Why would you commit such horrific atrocities? . . . And the reasons for that, I still do not understand. You have failed to make the connection of how you went from Point A to Point B.

On one of my evenings with the Manson Bloggers, they sat around drinking beers and trying to explain how a murder that had nothing to do with them ended up being the defining interest of their lives.

Patty started out selling odds and ends on eBay. She wasn't re-
ally in it for the money; it was the social scene on the message
boards where you could chat with other sellers that drew her in.
At the same time, she was gobbling up true-crime books. One day
she went online to look up a detail from a book about Manson and
found the blogs. They were much more fun than eBay, basically.

Deb was adopted as a baby, felt misunderstood as a teenager.
As an adult, she taught herself how to navigate the bureaucracy of
municipal records so she could track down her birth mother. She
had these fantasies of a glorious reunion, maternal acceptance
and understanding, the broken world made whole again, etc. Her
birth mother turned out to be a drug-addicted prostitute; she
and Deb didn't have much to say to each other. The whole thing
dropped Deb into a depression for a while, though she shrugs it
off now. The Manson Family Blog allows Deb to put her crack re-
search skills to use; she can pretty much find anyone.

Max Frost is a stunt-car driver/Hollywood odd-job man in his
early thirties, a native Los Angeleno with nervous fingers that
don't look right without a cigarette. He is a representative of a
particular LA type: a guy subsisting on the margins of a rich sys-
tem, fueled by road rage, chain smoking, and black humor. You
look at him and think: Things didn't go the way he thought they
might. Max got really into Manson years ago, drawn in by the
Southern California specificity of the conspiracies, the drama
circling around places he had been, and also the way everything
knit together so neatly, the glorious improbability of all that co-
incidence. He got a little too far in, maybe; the Manson universe
started to take up too much space in his brain, which tends to-
ward obsessiveness anyway. He had to quit. For a little while, he
had a mental moratorium on all things Manson. But then a few
years ago, he started peeking at the websites. It didn't take long
before the interest rose up in him again. Or maybe it had been
dormant in there all along.

By the end of our five days together, the Manson Bloggers have
turned our shared rental house into something of a middle-aged
parody of the wild Spahn Ranch compound. The Manson Blog-
gers stay up late, talking and drinking beer. They seem to feel
freed from the constraints of their daily lives, and thus empowered
to break rules:

"I never eat pizza!" the very healthy Matt says, eating pizza.

I haven't yet been able to enter into the spirit of the house. The Manson Bloggers' fandom is exhausting to be around. It is confident and seemingly inexhaustible. I plead a headache and retreat to my assigned room. Lying in bed, I can hear the happy, muffled sound of their chatter.

It's not actually accurate to say that my interest in Manson Family obsessives is purely anthropological. The truth is that my Manson feelings came back in my late twenties, when I thought I was old enough to know better. What happened was, I got sad. So sad that I woke up one morning and my depression had given itself a name: the black rock. I found this name maudlin and embarrassing, even as it also felt true.

I was prepared for much of how depression felt—its smothering quality, the strange stuff it does to time—but this embarrassment took me by surprise. There was something unbearably adolescent about my unhappiness, the way it made me self-absorbed and attention-seeking. It felt so . . . unsubtle. When I could read again (for a while, even that part of me was defective), all I was interested in was Charles Manson. It wasn't comfort food, because it wasn't comfortable. Discomfort food, then, maybe—stories that embodied the kind of darkness I was holding close to my heart. My diet devolved until I was eating only Cheerios and Dove Bars; I listened to nothing but Cat Power. My face began to break out for the first time in years. It was like one of those terrible dreams where you find yourself back in high school, awkward and anxious and fully consumed with your own awkwardness and anxiety, all your grown-up perspective and wise patience having evaporated like the mirage they always were. Of course you're back there. You've always been there. The real delusion was when you thought you had left any of it behind.

The next night after dinner, Max showed me his clip reel on You-Tube. Back in the day, Max was a peripheral member of the Brat Pack. The two of us sat on the couch and watched young Max punch Charlie Sheen in the face. It looked fake, but fun. In the next clip, Max wore a leather jacket and drove too fast. He did a lot of sneering. It was a strange feeling, sitting there next to him, watching him watch himself. If you were in the mood to torture yourself with regret, watching your young self interacting with

movie stars would be a good way to do it. That vast distance from
there to here. The tragic, inevitable one-way procession of time.

But Max was smiling as he watched himself. Another clip:
a close-up of his face, which was smooth and tender, a young
man's face. He looked lovely even when he sneered. This time,
he was in a cafeteria that looked so platonically high-school that
I thought I recognized it from my own anxiety dreams, until I
realized it was from *90210*. Young Max got flung into a cafete-
ria table. Trays went flying. The clip cut off right before the in-
evitable food fight began. Grown-up Max watched himself and
laughed. Bemused by his youth and anger. By all the things that
had brought him here.

There's an old thought experiment that was first recorded by
Plutarch, though it may well date from before that. After killing
the Minotaur, Theseus sailed from Crete back to Athens, where
the Athenians preserved his ship as a memorial to his triumph.
For years—centuries, even—they diligently cared for the ship,
making necessary repairs and replacing rotten boards. Eventu-
ally, long after Theseus's death, not even a single wooden board
from the original ship remained. Everyone still called it "the
ship of Theseus," even though it no longer had physical parts
that had ever been touched by Theseus. John Locke tells a more
humble version of the same puzzle involving a favorite sock that
gets patched up over and over again until none of the original
material remains.

This paradox used to depress me in both its sock and warship
forms. Here's what I thought the moral was: despite the most
dramatic internal (or even external) renovations, you are always
stuck being you. Because of course the one thing you can't es-
cape is your own shape. Your cells die and regenerate through-
out your lifetime. Can't they come up with anything imaginative
or new to create? But no, they keep on making you. Thinking
about it like that is a good way to make life sound like a trap, or
a prison cell.

Lately, I've been wondering if I have it all wrong. In these past
couple of years, my friends have started having babies, and this
completely normal but also miraculous thing keeps happening
where I can see my friend's face in her baby. And now that I've
known some babies since birth, I get to watch them grow up and

see how they have the same face the whole time. "Miracle" doesn't feel like an overblown word for that: for the fact that something stays the same even as it is transformed.

On the day the Manson Bloggers and I found the cow tongue covered in sprinkles, I followed Matt and Stoner down a steep hillside near Spahn Ranch. They had something they wanted to show me. It turned out to be less a walk than a scramble, made more arduous by the full afternoon heat of summer. Desert plants scratched at my ankles. Finally, the ground leveled out and we saw what we had come to see: a rusty car squatting in the sunbaked dirt. As local legend has it, Manson Girl Mary Brunner went to test-drive a new Volkswagen, somehow convinced the poor salesman to step out of the car, and then drove off without him. The Manson Family stripped the car for its parts and then pushed it off the cliff above us.

It must've been fantastic to watch it fall. And now it lives here, this remnant of her adventure, or mistake, or whatever you want to call it. Matt and Stoner touched the chassis with a kind of joyful reverence. After a moment, I did, too. I thought about the Manson shards still lodged in me, leftover bits of something adolescent and melodramatic and disturbing. And how they are maybe not a ruin but a relic. Something precious from a long time ago.

EILEEN POLLACK

Righteous Gentile

FROM *Harvard Review*

WHEN I TOLD my mother I was dating a Polish Catholic, the abyss that opened in our conversation was so deep and dark I could see three generations of our family tumble in. Hadn't my grandparents fled Poland to escape the brutish peasants who got drunk and murdered Jews? Didn't all Poles rat out their Jewish neighbors, or nod approvingly as the Nazis led them to waiting vans?

My boyfriend fit none of my mother's stereotypes. The director of an economic development institute at the university where we both worked, Marian was far better read than most writers I knew. When the High Holidays rolled around, he donned his *kippah* and accompanied me to services, then suggested we walk to the river and toss in our sin-laden crumbs for *tashlich*. The local Hadassah awarded him the designation "Righteous Gentile" for organizing the yearly Holocaust symposium and editing a magazine in which he took his fellow Poles to task for their anti-Semitism. In one of our first email exchanges, I admitted I couldn't help but be turned on by the idea of kissing a Righteous Gentile.

And yet, I shared my mother's fears. Marian had been raised by parents who viewed the Jews as conniving financiers and Communists. His parents had been imprisoned in Nazi jails, yet his father sat in the basement listening to an anti-Semitic Polish radio station and was anything but pleased to see his son dating a Jewish divorcee. When Marian took me to a Polish fair in suburban Detroit, the sight of the towering steel crucifix, the sour smell of kielbasas and Okocim beer, and the oompah-pah of the accordion to which the fairgoers were dancing a polka induced a panic.

Even so, I was determined to prove my mother wrong. As Marian and I spent more time together, I saw a side of Polish culture few Jews encounter. Whenever a Polish writer or musician visited Ann Arbor, the auditorium filled up with the local intelligentsia. I learned to pronounce Polish names, and even to spell them. (Once, when Marian and I showed up at a resort in northern Michigan, he fumed at the way he was registered at the desk, until I confessed that I had been the one to misspell his last name.) On Wigilia, I stood with head bowed while Marian's mother recited the Lord's Prayer in Polish. Then I took one of the Styrofoam-light *Oplatki* crackers embossed with the Holy Family and shared pieces with Marian's brother and father.

Finally, he asked me to travel with him to Poland. He had been born in a displaced persons camp in Munich, Germany, after the war and brought to America by his parents in 1951, when he was three. But he traveled to Poland often. During the Communist years, he smuggled assistance to Solidarity. (We joked that he single-handedly brought down the Iron Curtain.) Now, he spent several weeks a year visiting his relatives, keeping up his fluency in the language, and immersing himself in Polish culture. I had no desire to visit Poland. But I knew if I wanted to remain his partner, I would need to accompany him on future trips. What I was less sure of was whether I could directly confront the reality that the man I loved was a Catholic Pole.

The journey started well. Marian's friends picked us up at the airport and drove us past the dismal Soviet-era apartment blocks that surround Warsaw to a house so modern and luxurious my friends in Ann Arbor, or even New York, would have coveted it. Walking the cobbled streets, I felt that pressure behind my eyes that nothing but a quaint, graceful European city seems able to evoke—an effect intensified by the knowledge that 80 percent of the buildings I saw were replicas of the originals, Warsaw having been dynamited by the retreating Germans.

I was surprised how many Polish words I understood, the equivalent of their Yiddish counterparts. Ditto the tastes and smells of the heavy, fatty, fried, dill-and-garlic-seasoned foods, which, with the exception of the kielbasa, could have been found in the dining room of my grandparents' Catskills hotel. In fact, my inability to stop shoveling in all that familiar and enticing Polish food almost spelled my doom. I previously had undergone three abdominal

surgeries, and my intestines were knotted by scar tissue. Often, when I travel, my digestive system shuts down and I become what my father would have called *ongeshtopt*, which in Yiddish means "all dammed up."

The condition is made worse by stress. Marian had already visited Auschwitz six times—his family had lost many relatives at Auschwitz, while as far as I know, my family lost none—and we agreed it wouldn't do our relationship any good to turn our trip into the death-camp march most American Jews follow. But how could I not see the Warsaw Ghetto—or rather, the residential neighborhood where the ghetto once stood? The Poles weren't the ones to create that ghetto. But they didn't come to the aid of their starving, disease-ridden fellow citizens, not even when the Jews staged a suicidal uprising against their common enemy.

As if my intestines weren't knotted enough, I kept noticing the Jewish stars embedded in the town's graffiti. When I asked Marian to translate a slogan etched on a bus, he admitted that a citizen was venting his frustration with the prime minister, Donald Tusk, by labeling Tusk's economic policies "Jewish chicanery," a telling gripe considering that Tusk is not a Jew. On our drive to Krakow, we saw spray-painted slurs accusing the players on rival soccer teams of being dirty Yids—an odd complaint given that virtually no Jews remain in Poland. It was as if enemies of the Detroit Tigers had defaced the team's posters by spray-painting an *N* over the *T* and adding a second *g*, even though no black people played for the team, or remained anywhere in the United States.

In Krakow, Marian and I checked into the quaint apartment he had rented. Guilty about having bypassed Auschwitz, I requested we spend the few hours before dinner touring the Jewish quarter. The Kazimierz was even eerier than the Warsaw Ghetto; here, the shops, apartment buildings, and synagogues still stand, though creepily devoid of Jews. In recent years, Judaism has become trendy. Poles who once would have cursed you for intimating they had a drop of Jewish blood now go to great lengths to claim their Jewish ancestry. The busloads of American Jews who visit Auschwitz stop in Krakow, so a bustling business in Jewish kitsch has grown up in the Kazimierz. Tourists can dine at Jewish-style restaurants owned by non-Jewish Poles. They can attend Jewish cultural festivals, study Yiddish, and listen to Klezmer music played by non-

Jewish musicians. They even can buy hand-carved wooden dolls in the shape of *davening* rabbis and pious old *balebustas*.

I told myself we Americans had done much the same thing to Native Americans—tried to wipe them out, then turned them into objects of fascination. And yet, the kitschy Jew-dolls pissed me off. For one thing, I had seen exactly such a doll in Marian's bedroom back home. Bought on a previous trip, it had been carved by a craftsman with higher artistic standards than most of his fellow hucksters. Also, Marian knew a graduate student who was writing her dissertation on these figurines, which have a long history in Polish folk art. (Apparently, a big-nosed rabbi holding a sack of money might bring the owner his own good fortune.)

And yet, here in a Jewish Quarter devoid of Jews, the sight of these dolls, combined with the memory of having seen one on Marian's shelf back home, made me feel like a doll myself, something to be fetishized and collected. How could Marian not have noticed the graffiti on Poland's walls? How could his father still believe the Jews caused Poland's downfall? And, the question I couldn't stop asking: if we had lived in this country three quarters of a century earlier, would Marian have saved me from the Nazis? Would I have saved him? Would I have risked my life to protect a Pole, even if he had been my lover? It wasn't as if I expected the Nazis to rise again. But I needed to know the person I loved wouldn't have blindly gone along with the crowd. Easy enough to earn the designation "Righteous Gentile" in Ann Arbor, Michigan. I needed to be sure Marian would have been one of the very few Poles who disobeyed the Nazis to save the Jews.

I refused to eat at the fake Jewish restaurants, and I was afraid another bite of Polish food would kill me, so Marian treated me to an Italian bistro. We strolled back to our apartment. Exhausted from our long day, Marian conked out. I tried to sleep, but the cramps I had been ignoring all week grew so excruciating I hurried to the bathroom, only to pass out on the floor. Near dawn, Marian came in and found me barely able to breathe. He ran to the street to call an ambulance, then came running back and led me from our apartment down the narrow alley past three locked gates to wait. Crippled by pain and convulsed by the most intense nausea I ever experienced, I slumped to the cobblestones and lay curled on my side until the ambulance came.

Deducing I was an American, the driver promised he would take me to "best hospital in Krakow." I was grateful for this consideration, but I couldn't help but be dismayed when the facilities turned out to be as primitive as something out of *Doctor Zhivago*. The emergency room was so crowded that even though I was screaming in pain, the admissions clerk told Marian I would need to wait. "Scream louder," Marian whispered, and, finally, the orderlies rolled me into a vast room filled with cots occupied by heavyset older men, many with their privates hanging out. The doctors spoke very little English. If not for Marian, I wouldn't have been able to make myself understood. I begged for drugs, but I was informed no medications could be administered until the cause of my pain had been determined. A nurse wheeled me through a maze of primeval corridors to a cavernous exam room, where an alarmingly somber gynecologist jammed her ultrasound probe up my vagina and studied the images it produced on a computer that resembled my ancient Apple IIe. A boy who looked young enough to be in elementary school translated her instructions.

"Has anyone ever say you have very advance cancer of uterus?" the boy inquired. When he saw my expression, he added cheerfully: "Not to worry! Very, very serious cancer, but we surgery you tomorrow and you maybe live many month!" I tried to convince the gynecologist she was seeing a benign fibroid my OB in Ann Arbor had been ignoring for years, but she pooh-poohed my diagnosis. "She know is difficult to believe," her sidekick said, "but very sad is true."

When I promised I would have my uterus examined the moment I got back to the United States, the surgeon said she couldn't allow me to leave the hospital. She would "surgery me tomorrow," she repeated. Then she pointed me in the direction of the ER and instructed me to walk back to wait.

Bent ninety degrees and shivering, I wandered the desolate corridors until I found my way back to the emergency room, where I slipped into the crowded waiting room and begged Marian to swear he wouldn't allow the doctors to operate on me for cancer.

"Cancer?" he said. "You have cancer?"

"No, no," I said, "I *don't* have cancer. They only *think* I have cancer. Swear to me you won't let them operate!" I could see he wasn't sure. How many of us would believe a layperson, even a layperson we love, rather than believe her doctors? Only when I

had extracted his promise that he would, under no circumstances, allow the doctors here to "surgery me" for cancer did I head back to the hellish ER.

Hours later, Marian convinced the doctors to move me to a ward for patients with gastrointestinal disorders rather than the ward for patients dying of uterine cancer. My room housed five other women, each of us assigned to a primitive metal cot against a wall. Whoever had occupied my cot before had tacked above it two images of the Black Madonna, an icon that graced the nearby monastery at Czestochowa. An object of veneration for Poles, the six-hundred-year-old painting reportedly had saved the country from invading Swedes. Another legend had it that she rescued the church from a catastrophic fire, which is how she and Jesus had ended up with black skin. Marian asked if I wanted him to take down the cards. But with my five Catholic roommates watching, I told him no. I didn't really think they would turn me over to the Gestapo. But I decided not to tempt fate by removing the images of a woman everyone believed to be the mother of God and the most powerful healer in the universe. Besides, she and her son were the only two Jews in the room but me.

At last, the nurses hooked me to a morphine drip. The drugs allowed me to sleep. But in the middle of the night, the laxatives in my IV started to work. The nurse on call unhooked me from my tubes, but she indicated it was up to me to make my way to the bathroom. Barefoot, half blind without my glasses, I wobbled down the infinitely long corridor, only to reach a communal bathroom so filthy I could barely withstand the stench. Despite my lack of slippers, I made my way across a floor puddled with urine and feces and sank to the toilet, where I remained for hours, convulsed with diarrhea. When I discovered the bathroom had no toilet paper, I sat weeping until dawn, when a kindly older woman came in and took pity on me by sharing hers. As I later found out, the hospital couldn't afford luxuries such as toilet paper, soap, or paper towels. Patients were expected to bring their own.

You can imagine how overjoyed I was to see Marian, who ran out to purchase my supplies. He helped me wash my face and brush my teeth. Then, as I lay recovering from this ordeal, he chatted to my roommates in Polish, explaining who I was and how I had come to be in such a sorry state. Goodness! they said. Wasn't I lucky to have been admitted to one of Poland's finest hospitals!

Most of them had made their appointments months in advance
and were looking forward to a vacation from all the cooking and
cleaning for which they normally were responsible. Several of the
women patted their heads and motioned in my direction, and
Marian said they envied my curly hair.

"You mean my Jew hair?" I whispered.

Yes, well, he said, these women had never seen a Jew. But they
wished they could get their boringly straight Polish hair to look
like mine.

The weather grew unseasonably hot, and the nurses opened the
windows. Not only did the flies buzz in, anyone could have climbed
in from the street. Without curtains, the cots were exposed to view;
when a doctor conducted an exam, the rest of us could hear and
see whatever there was to hear and see. After visiting hours, when
everyone's boyfriends, husbands, sisters, mothers, and children
left, my roommates passed the time comparing maladies in Polish,
watching Polish soap operas, and reading Polish magazines. The
reservation on our apartment had run out, and Marian needed to
hurry around Krakow to find another place to stay; reluctant to
ask him to run more errands, I made do with the glossy English-
language edition of a fan magazine about Michael Jackson one of
the women had found for me to read.

After three or four days, I managed to choke down a few bites
of bread and drink a few sips of water. The doctors interpreted
this as a sign I was strong enough for the surgery to remove my
uterus, while I tried to use my newfound ability to eat and drink as
evidence that I was healthy enough to check out of Hospital Dos-
toevsky. After heated negotiations, Marian persuaded the doctors
I could leave, but only if I agreed to undergo an endoscopy. Sadly,
the hospital could afford to provide the services of an anesthesi-
ologist only on Thursdays, and today was Monday.

I have a terrible gag reflex. The thought of a doctor jamming a
length of metal tubing down my throat all the way to my intestines
made me shake. But I was even more frightened of staying in a
hospital where toilet paper and soap were considered luxuries and
everyone seemed determined to "surgery me" for a cancer I didn't
have. I don't mean to imply the Polish doctors and nurses were
sadistic or incompetent. I was getting far better care than most
Poles. And I had suffered equally appalling misdiagnoses at the
hands of American doctors. Yet lying helpless in a city that once

had been home to sixty thousand Jews, of whom only two thousand survived the war, I couldn't help but grow more paranoid.

Marian supported me through the corridors to the wing where I would undergo my endoscopy. We took our place at the end of a very long line of patients, many of whom were elderly or frail, or both. At last, it was my turn to enter the tiny room where the doctor and his assistant waited. I tried to relax, but as they lowered me to the table and inserted the thick metal snake in my mouth and began unwinding it down my throat, I panicked. The doctor and his assistant pinned me down and kept jamming in the tube. I flailed my arms, attempting to throw them off, but Marian joined in and held me.

That's when I lost all self-control. He was no better than the rest! If his fellow countrymen wanted to torture me, he would take their side and hold me down! I tried to struggle harder. Finally, Marian saw the terror in my eyes and ordered the doctor to stop. When he didn't, Marian pulled the two men off me, lifted me in his arms, and carried me from the room. It was his fault I had come to Poland. But it wasn't his fault I had gotten sick, or that the best hospital in Krakow was so poorly equipped. For a while, he had taken his countrymen's orders. But in the end, he had thrown them aside and saved me.

As we passed the line of feeble old people waiting their turn, I could see how frightened they were. If the healthy young American needed to be carried from the room in the arms of her strong Polish-American husband, how would they, so much older and frailer, be able to endure what was in store for them?

I doubt the endoscope descended low enough to allow the doctors to make out anything in my intestines. But they told me I could check out—so long as I paid my bill. By American standards, the amount I owed was laughably small. (If I had been a Pole, I wouldn't have owed anything.) And my insurance back home would reimburse me. (A week later, my gastroenterologist confirmed that I had been suffering from an intestinal blockage, while my gynecologist looked at the grainy ultrasound and said there could have been an old shoe in my uterus and the doctors wouldn't have been able to determine what it was.) But the hospital demanded we pay in cash, and so, on a sweltering afternoon, Marian ran from one ATM to the next to extract enough zlotys to pay my ransom.

At last, the time came to pack my few belongings. I surprised myself by taking down one of the cards of the Black Madonna. When Marian asked why, I couldn't say. I didn't want a reminder of my ordeal. But the Madonna had endured ordeals of her own, and seeing her above my bed had brought me comfort. In the old days, I might even have credited her for my miraculous cure from what the doctors had assured me was a fatal case of uterine cancer. But mostly I took the card because it would offer me a false identity in a world in which it is still sometimes dangerous to be a Jew.

Marian carried my bag and held my arm as we proceeded step by tiny shuffling step down a long street to a corner where we could find a taxi. He helped me up the stairs to our new apartment, then sat beside my bed while I took a nap. When I awoke, I was ravenous. The doctors had warned that trying to consume anything fatty or spicy or fried would land me right back in the hospital. Boiled chicken, they advised, along with the broth in which the chicken had been boiled. I laughed. Chicken soup! Exactly what my much-loved and long-deceased Polish grandmother would have prescribed. But where in Krakow would we find boiled chicken? As we hobbled past the cafés lining the main square, we saw nothing but couples dining on French, Italian, Indian, and Chinese food. At the more traditional Polish restaurants, the menus listed the usual sausages, fried cabbage, potato pancakes, and pierogies.

In an alley off the main square, I stopped, so exhausted I needed to slump against the wall. I was about to tell Marian that he should go on without me when he noticed a plaque on the wall. There, in the basement of the building against which I leaned, a division of the Polish underground called the Zegota had schemed to provide Polish Jews with false documents and hiding places. Because of the Zegota, some four thousand Polish Jews had survived the war.

"Look," Marian said. "There's a restaurant around the back. This building used to be good to the Jews. Do you want to go in and try it?"

The shabby café looked as if it hadn't changed since the 1930s. The waitresses were cleaning up from the evening meal. But Marian said a few words in Polish, and the hostess nodded and held up a finger. They did indeed have boiled chicken on the menu. But there was only a single serving left. Did we want the cook to save it?

"*Tak!*" Marian told her. Yes! Thank you! "*Dziękuję!*"

The waitress ushered us to a seat, then brought out a cup of

chicken soup so comforting it brought tears to my eyes. When the soup was gone, she returned with a domed silver plate such as the ones we used to use in the dining room at my family's Catskills hotel. When I lifted the lid, I saw exactly what I would have seen when I ate there as a child—the same breast of boiled chicken, the same boiled potato, the same waxy white beans. It was the blandest, whitest, most delicious meal I had ever eaten.

"So," Marian said, "was I right? Is this building good for the Jews?"

"Yes," I said. "This building is good for the Jews." I took another bite. "And so are you."

ALBERT SAMAHA

Looking for Right and Wrong in the Philippines

FROM *BuzzFeed*

I

MY UNCLE PEPO didn't want to take us to the farm. It was too dangerous, he said, and he didn't want me kidnapped on my first trip back to the Philippines in twenty-two years.

Our family had owned the farm since the end of World War II, when the US government granted the land to my great-grandfather for his service as a guerrilla fighter resisting the Japanese occupation. Uncle Pepo, my mother's cousin, a dentist of modest means, was the farm's de facto manager because he lived closer to it than anyone else in the family. From his home in Iligan City, a bustling industrial town on the northern tip of Mindanao, the southernmost island of the Philippines, the farm was less than an hour's drive up the mountains and into the jungle. Yet even Uncle Pepo hadn't been there in years.

With eight major languages spoken across its seven-thousand-plus islands, the Philippines is a fragmented place, and even the dangers vary by region. On the northern island of Luzon, communist insurgents attack from base camps hidden in the mountains. In the Visayas, a cluster of touristic islands in the center of the country, military forces recently warded off an attempted terrorist attack by Abu Sayyaf, a jihadist group pledging allegiance to ISIS. In Mindanao, the threat comes from the Islamist rebel groups determined to form an independent state for the country's Muslim minorities.

These rebels carry on a war that their ancestors had waged for

centuries, resisting the Spanish colonizers who arrived in 1521 and the American occupiers of the early twentieth century. In 1989, the Philippine government granted the rebels partial autonomy over a crescent of land along the eastern coast of Mindanao. Today, the region is a hub of militant activity. Communist guerrillas, Muslim separatist rebels, and jihadist terrorist groups have all made base in the area. The fighting got so bad this May that President Rodrigo Duterte declared martial law over the entire island of Mindanao.

My Uncle Pepo and other locals consider the rebel-controlled land off-limits, and the area just outside its border a danger zone. Our farm sits five miles from that border.

In this danger zone, and even further into the island, the rebels sometimes ambush military forces on patrol and bomb electricity towers and churches. To raise funds, they kidnap—and my American-looking ass dripped with dollar signs.

"What they do is they kill the Filipinos to show they're serious and hold the Westerners for ransom," Uncle Pepo said to my mom and me, after we arrived in Iligan City in mid-April.

But my mom, stubborn as cement, thought her cousin had inflated the risk in his mind. She had visited the farm often when she was young; her mother managed it back then. My mom didn't believe the tensions could have gotten so much worse in the years since. And, she asserted, this was our family's land! Were we simply to abandon it now, because of political tensions that had existed for hundreds of years and would maybe exist for hundreds more? She was persuasive. This might be our last chance to see the farm, she told Uncle Pepo.

Our family was trying to sell it. The land yielded few crops, was barely profitable, and had become a burden. All but one of my mom's seven siblings had moved to the United States, and they had little interest in dealing with the responsibilities of a struggling farm an ocean away. Her cousins who remained in the Philippines, all busy with professional careers, wanted the farm off their hands too. It was only a matter of time before Uncle Pepo found a buyer.

"I should check on the farm anyway," he conceded.

And so, on the tenth day of our two-week journey through the Philippines, we boarded a gray van with tinted windows and headed up the mountain.

"At least it's safer now that Duterte is president," Uncle Pepo said.

My mom nodded knowingly.

Uncle Pepo supports Rodrigo Duterte, of course. Most Filipinos do.

A year into his presidency, with nearly eight thousand extrajudicial killings linked to his war on drugs, polls showed that around 80 percent of Filipinos approved of Duterte—this authoritarian strongman executing criminals, cleaning out corruption, cursing like an uncle, joking about rape, reviled by the West yet beloved by his countrymen.

Over my two weeks in the Philippines in April, hitting more than a dozen big and small cities from the northern tip to the southern edge, I spoke to scores of people—vendors, farmers, professors, drivers, politicians, cops, writers, business owners, lawyers, dentists—and nearly all of them, even those who voted against him, said they believe that their president is making the country better.

I struggled to understand his popularity. From the start, I thought Duterte was a madman. Under his rule, the Philippines would revert to a police state, I feared, a return to curfews and crackdowns on all who opposed. Murder as official state policy. Hadn't the country moved past this? It was only a generation ago that its people toppled a dictator, and now this new president would burn to ash the democratic freedoms established in the three decades since.

I assumed my family agreed with me. Our kin were on the front lines of the 1986 revolution, when the streets of Manila filled with protesters and dictator Ferdinand Marcos fled into exile, his twenty-year rule ending without a shot fired. "People Power," we called it, as homemaker-turned-heroine Cory Aquino stepped into the presidency, restoring order to the nation that had been the birthplace of modern democracy in Asia.

My mother raised me to despise Marcos. She and her seven siblings had grown up during his martial law years. Her uncle, Tomas Concepcion, was an activist and congressman who spoke out against the killings and torture committed by the Marcos regime. Her cousin, Joe Tale, worked as a legal aide for Cory's cabinet as they worked to repair the economic devastation wrought by Marcos's crony capitalism. Her aunt, Mary Concepcion, was an inau-

gural member of the committee assigned to track down the billions of dollars pilfered by the Marcos family. Her mother's best friend was the sister of Senator Ramon Mitra, a political opponent of Marcos's jailed on phony charges. Her father, Manuel Concepcion, was a lawyer and entrepreneur whose career was stifled by his refusal to pay kickbacks to the Marcos government.

Our blood had been on the right side of history.

But somewhere over those three decades, we had drifted. I realized that one afternoon last June, eating *chicharon* and drinking San Miguel beer with four of my uncles on a patio in Vallejo, California. I was in town for a nephew's baptism. The talk turned to Duterte, who had been elected president of the Philippines a month earlier; over that first month, already more than a thousand people had been killed in his drug war. Most of them were poor. Many were merely addicts. Some were innocent of even that.

All four of these uncles loved Duterte. My mother and two of my aunties, in the living room a few steps away, loved Duterte too. I couldn't believe it. I decided, in that moment, that it was my responsibility to shift our family back toward righteousness. I dropped statistics on the rising death count and news reports on the human rights groups calling the president a mass murderer. I cited the commandment about not killing, the parents and children of the victims, the role our bloodline had played in defending the rule of law against authoritarian excess. I raised my voice, flailed my arms, stood from my chair. My uncles met my indignation with restraint and calm.

"Albert, you make good points," one uncle said, "but you don't understand."

"What's there to understand about extrajudicial killing?" I said. "The courts should determine guilt and punishment."

"The courts are corrupt," said another uncle. "The judges cannot be trusted."

"Then the answer is to fix the courts," I said. "To reform the system, not to go around it."

"Albert," said a third uncle, still calm, still sitting, still swirling the beer in his bottle like he had all the time in the world to hear me out. "You're from America. It's different here."

"You don't understand what it's like in the Philippines," said the fourth uncle.

They were right. I hadn't been there since I was six. My mom

and I had lived in a condominium in Manila while she awaited her green card. My memories of the country were distant and random. I remembered a litter of kittens in a box in a yard; a Lego city sprawled across my bedroom's hardwood floor; a birthday party at Jollibee's. And I remembered my family's farm—banana trees, chickens, bamboo huts with no electricity or hot water. My mom and I spent two weeks there after my kindergarten school year in Manila ended.

Sitting with my uncles that June afternoon, I couldn't have told you what city the farm was in, or even which island it was on. But that farm was the setting for my most vivid memories of the Philippines. In most of those memories, I was playing with a boy named Sargento. He was a few years older than me, and he climbed the tall, thin trunks of coconut trees, chopping down the fruit with a machete. He taught me to not touch my face after touching a butterfly. He laughed when I ran screaming from a spider. He rode with me on a *carabao*—and the photo of us small boys together on that big animal still hung on the wall of my mom's house in San Francisco.

That summer, after those two weeks on the farm, my mom and I moved to the States. Over the years I often wondered what Sargento's life was like—whether he was still on the farm, whether he had moved to the city, whether he had left the country, whether anything horrible had happened to him. On that afternoon in Vallejo last June, Sargento again popped into my mind: I wondered what he thought of Duterte.

Several beers down and I was back in my chair, voice calm, unsure about positions I had been certain of hours earlier. The rise of Duterte had caught me off guard, exposed my distance from a culture I claimed to have pride for.

"Duterte is just what the Philippines needs," said my Uncle Joey, the oldest of my mom's brothers. He went on about the president and the renewed hope he felt for the country, and he had so much faith in this tyrant that soon his eyes welled with tears.

It was then that I decided to go back to the Philippines. Nine months later, I landed in Manila.

On the third day of the trip, my mother and I sat in traffic on a bright day thick with smog and heat. I had invited her as translator and cultural guide. While I understood Tagalog fluently, I did

not speak it. My mom never taught me, and I sometimes gave her a hard time about this. She reasoned that the language had no practical value in the Western world.

This was true. Even in the Philippines, everybody spoke English. Teachers lectured schoolchildren in English. Street signs and food menus were in English. Language options at ATMs were limited to "English" and "Taglish."

But Tagalog was still the language of the people, the language Filipinos had preserved through four hundred years of colonial rule. It was the language my mom and our taxi driver, Danilo, were speaking to each other while I was looking out the window at the traffic, and past the traffic, at the slums. These unpainted, precariously built, two-story cinderblock shacks sat just feet from the main road, a dense row of teetering shanties that seemed to go on for miles. Slums like this were all over the country, which is geographically smaller than California yet has a population that exceeds one hundred million. In front of one roadside shack, a small child bathed in a plastic bucket. In front of another, a man killed a rat with a broomstick.

These were not merely homes. Many residents had converted their bottom floors into stores, with snacks and cheap umbrellas hanging from their windows. Hustle is woven into the fabric of the Philippines, an intersection of developing-world desperation and American-inspired commerce. Vendors in slippers shuffled through the crawling traffic, carrying bags of straw hats and bottled water. Massive billboards, maybe thirty feet tall, looked down on us. Motorbikes with side carriages zipped paying riders through gaps in the traffic, their engines squealing. Fruit sellers waved down drivers, hawking mango and durian and papaya. Skyscrapers, many of them housing call centers that employ thousands of English-speaking Filipinos, loomed in the distance.

This hustle has its dark side. What is corruption but a bastard brother of the free market—a drive to get all you can get from all you have to offer? I overheard Danilo tell my mom that earlier that day a police officer had pulled him over for making an illegal turn. The officer told him the ticket would cost 2,000 pesos, which is about forty dollars. But the cop offered an out: Danilo could simply hand over the payment and avoid the inconvenience of dealing with a ticket. Danilo told the cop he didn't have that

much cash on him. They negotiated until the officer agreed to
450 pesos. "It was all I had," Danilo said, throwing his hands up in
exasperation.

"That criminal cop!" Danilo exclaimed. He was worked up now.
"I'm sorry, I keep thinking about it. If I had a camera I would have
filmed him and sent it to President Duterte! He'd have that cop
fired."

My mom sucked her teeth and shook her head. "So corrupt!"
she said to Danilo. Then she turned to me and whispered in Eng-
lish, "See, that's why I left."

My mother left the Philippines in 1983. She had been a flight
attendant for Philippine Airlines, learned she could make more
money with Saudia airlines, and moved to Riyadh.

During those years, many Filipinos were leaving for work in
Saudi Arabia, Australia, Hong Kong, the US, and elsewhere. With
the economy in decline and the job market shrinking in the
1970s, Marcos had signed agreements with other countries that
opened opportunities for overseas work. This became a pillar of
the Philippine economy, and by 2015 nearly two million Filipinos
were working in other countries, sending back close to $30 billion
in annual remittances, 10 percent of the gross domestic product.

On one of her flights in 1984, my mother met a Lebanese busi-
nessman: my father. They married in Las Vegas a year later and
traveled the world together. After she got pregnant with me, she
quit her job and went to Vallejo, where her sister lived, and in
1989 I was born. For the first few years of my life, my mom and I
spent equal time at her condominium in Manila, her sister's house
in Vallejo, and my dad's apartment in Paris, where his energy com-
pany was based.

My mom expected that we would build our lives in Paris, but
that never happened. My dad's family didn't approve of her, and
he never told his parents about their marriage—or me. So in
1995, she and I settled in San Francisco.

I'd see my dad about once a year, when business took him to
California. My mom made efforts to keep me in touch with my
Lebanese side; she learned to make *labneh* and *manakish* and in-
sisted that I study French. But I always felt fully Filipino. I knew
only my Filipino family, the cousins and uncles and aunties in
the Bay Area with whom I spent holidays, played basketball, and
watched cartoons and Super Bowls.

We bounced around Northern California, following the trail of affordable housing east to Sacramento, where I went to middle school and high school. Most of my friends were white, black, or Mexican, but inevitably there'd be a few Filipinos in my circle. We were drawn together by the magnet of shared culture, as if by better understanding one another we could forge a clear vision of our Filipino identity from the disjointed remnants our parents had left us, which we had cobbled into a genuine but superficial pride. We bragged about Filipino food. We dropped stray bits of Tagalog into our conversations. We convinced our white friends that we personally knew the Jabbawockeez. When Manny Pacquiao began his rise to stardom, we gathered at bars to wave Filipino flags and taunted our Mexican friends about our hero knocking out their heroes.

But we were a generation bred to assimilate, just as our parents had. They had not fled their homeland out of desperation, nor had they been brought here in chains. Our parents had left middle-class lives for the glittering promises of America, to become Americans—or rather their perception of what Americans were supposed to be.

Filipinos are the fourth-biggest immigrant group in the US, but you'd hardly notice. All across the country there are Chinatowns, Koreatowns, Japantowns, visible enclaves of Jamaicans, Indians, Dominicans, Mexicans, Ethiopians, Egyptians, Puerto Ricans, Persians, Haitians, Russians, Vietnamese. Not us, though. This became a running joke in my circle of Filipino friends. We concluded that there were three kinds of Filipino Americans—a theory I had learned at age eleven from a movie called *The Debut,* an indie flick starring Dante Basco that was my first experience of seeing multiple Filipinos on a screen. One of the film's teenage characters, who listened to rock music and was embarrassed by the Filipino artifacts his parents displayed in their house, was teased for being a "coconut" (brown on the outside, white on the inside). Another character, a new immigrant who missed basic pop culture references and dropped his F's and Z's because of his thick accent, was dubbed a "fob" (fresh off the boat). A third character, who wore puffy jackets and used to have cornrows, was criticized for acting black. Where did I fall on the spectrum? Closest to the third one, I guess. I sometimes wore a du-rag in eighth grade, and my college dorm room was decorated with posters of Tupac, Ken

Griffey Jr., and Muhammad Ali (though, to be fair, the latter was an image of Ali fighting in Manila).

One of the dominant genes of Filipino national identity, I have come to believe, is the ability to blend in. It's a trait that I imagine developed out of necessity over centuries of imperial rule, and one that became especially valuable for the Filipino workers navigating distant lands and unfamiliar cultures. The cost was a diminished reverence for the homeland. As far back as the late nineteenth century, José Rizal, the national hero whose writings helped inspire the revolution against Spain, had called for a stronger sense of national unity. Without that collective pride, he argued, a people would struggle to break the colonial yoke and build their own nation. Yet even he recognized the irony of his message: he wrote mostly in Spanish, the language of the elites, which the majority of Filipinos could not read.

But what can be done about it now? We embraced our colonizers, shaped our culture and our government in their image, landed on their soil so babies like me could be gifted this promised land as birthright.

Well, not all embraced the colonizers. In Mindanao, the resistance continued. The night before we went to the farm, a bomb exploded at an electricity tower a hundred miles away, killing three police officers.

2

The morning we left for the farm, the island was on red alert and traffic clogged the mountain road. Ahead of us, a long line of vehicles snaked toward the military checkpoint, where guards with machine guns peeked into windows and trunks.

Tensions had been thick all over the Philippines in recent days. Government agencies reported terrorism threats. Security guards checked underneath cars at parking garages in Manila. Masked police forces patrolled mall parking lots. The US issued a travel advisory discouraging people from visiting the country. At a hotel in Cebu City, the biggest city in the Visayas, staff called the police to report that ten men from Mindanao were checking in. A SWAT team arrived, only to discover that the men were actually just government workers in town for business.

Worry was running especially high in Iligan City. A local water-fall, normally a big tourist attraction, was closed to the public be-cause it powers the hydroelectric plant that keeps the lights on for much of Mindanao—making it a conspicuous target for potential rebel attacks. SORRY WE ARE ON RED ALERT STATUS, read a big sign at the gate.

We rolled slowly to the checkpoint. Because we were headed south, out of the city and toward rebel-controlled land, the guards on the road took only a passing glance before waving us through. Across the road, the northbound lanes were at a standstill.

The barricades behind us, traffic cleared and our bulky van chugged up the mountain past thickets of coconut trees and ba-nana groves and wooden shacks. Pepo and our driver, his friend Clelan, seemed on edge, sitting stiffly and silently in their seats at the front. My mom's mood was lighter.

"Will I look like too much of a tourist if I wear this hat?" she asked Uncle Pepo in Tagalog, trying on a straw hat she'd bought at a market.

"No, you'll be fine," Uncle Pepo said. "There won't be many people around once we're on the farm."

"OK, good," my mom said, before adding with a chuckle, "I don't want it to get us kidnapped."

Nobody else laughed.

Fifteen minutes after we left the checkpoint, Uncle Pepo told Clelan to pull over.

"This is where our land begins," he said.

There was no marker indicating that this portion of land was any different from all the other land we had driven past. Just an-other thicket of coconut palms and banana groves along the high-way. A wooden shack sat under the shade of fat leaves. In front, almost acting like a makeshift fence, damp clothes hung from a rope tied between two trees.

I felt a rush of excitement, but by the sullen look on Uncle Pepo's face, I could tell he felt differently. I'd barely cracked open the door when Uncle Pepo said, "Stay inside the van." This was not yet the farm, he said. That was still further up the mountain. This was just the edge of our land. He pointed to the shack, where an old woman sat on the porch and a teenage boy stood beside her, and said, "They're not supposed to be here."

I felt for those squatters. In a country with astounding economic

inequality, and with very limited resources for the have-nots, you scratch for everything in reach. And if you find a patch of unoccupied roadside land, with trees bearing fruit you can sell, you jump on it and build a home.

Several of my relatives in the Philippines told me that this mindset is more like a guiding principle—an ethos of taking all you can get away with. People might complain about squatter camps popping up near their neighborhood and politicians skimming off the top, but they have little faith that the rules of engagement will ever change—so what else can you do but play along?

The way I began to understand it, these were not acts of deception, but of tacit understanding, an ongoing state of negotiation beneath the surface of Filipino society. I saw it most clearly every time we drove through chaotic streets crowded with buses and cars and motorcycles. Lanes were meaningless, every inch of space an opportunity for advancement. Drivers zigged and zagged, hustling, but when you cut somebody off, you warned them with a quick *honk-honk* and they acknowledged you with a *honk-honk* reply that seemed to recognize that it's all part of the game. There was none of the shouting and steering-wheel slamming so common in America. There was no pretense of courtesy on these roads, no expectation that everybody else would follow the official rules.

It is not so much a selfish mindset as a team-first mindset. People look out for themselves and take care of their own. More than anything else, the Philippines is a collection of family units jockeying for power and wealth at every level of the class hierarchy, from the impoverished strivers to the oligarchs. At the top, you see the same last names running for office now that your grandparents saw decades ago. The three top vote-getters of the 2016 presidential election each had politician fathers.

At a dinner at his home, Felipe Antonio Remollo, the mayor of Dumaguete City in the Visayas, whose father and grandfather were also mayors, told me that politics is the "national sport." Indeed, Filipinos follow the game as they would basketball, well-versed in the names of the players, loyal to the dynasties of their region, antagonistic to their rivals. The biggest rivalry is still Aquino versus Marcos. It persists to this day: Cory's son, Noynoy, was president before Duterte, and last year Ferdinand's son, Bong Bong, was runner-up for vice president (which Filipinos vote on separately from president).

My family is an Aquino family. Ninoy Aquino is our hero. The leader of the resistance against Marcos, he was imprisoned for eight years and then exiled to Boston. He returned in 1983 and was shot dead seconds after stepping off the plane. The images of his body lying on the tarmac shocked the world and pushed the revolution into a higher gear. His widow Cory's ascension to Malacañang Palace—the White House of the Philippines—three years later was etched into my mind in stark moral terms: good had finally defeated evil.

So, shortly after we'd arrived in the country, when a relative heard that my mom and I were planning to visit Marcos's home-town on the fourth day of our trip, he was sure to remind us: "Don't say anything bad about Marcos when you're in Ilocos."

In Ilocos Norte, an isolated region at the northern tip of the country, boxed in between a wall of mountains and open ocean, they love Marcos as much as we hate him. My hate is rooted in historical knowledge, based on stories I've heard and books I've read. My mom's is personal. To this day she blames Marcos for our family's inability to climb the country's ladder of power.

I worried she'd let her tongue slip and talk some shit. She often spoke of the Marcos years with disgust—the abuses of power, the cold indifference to the plight of Filipinos, the immorality of it all. A church-every-morning Catholic, she sees the world in black and white, and the expression on her face often speaks for her.

But in Ilocos, she kept her wits. We hired a local guide we met at the airport, Ray, to take us around the region. His thoughts mirrored that of every Ilocano we spoke to that day: Marcos was a great leader who was ultimately betrayed by his generals. When we approached Laoag City, the capital of the region, Ray pointed out that we were crossing the bridge that Marcos had built in 1969. "He took care of us," Ray said. The Marcos name remains pristine in Ilocos Norte, and the family still runs these streets. The infa-mously extravagant former first lady Imelda Marcos—whom Ray referred to as "Madame Imelda"—is a member of Congress. Their son, the aforementioned Bong Bong, was a senator and will likely run for president once Duterte's six-year term is up. Their daugh-ter, Imee, is governor of the region.

So highly revered is Ferdinand that the region boasts three mu-seums dedicated to his life, which we visited under a spell of gro-tesque curiosity. His mother's old home, where he was born, is a

shrine to the humble countryside beginnings of the first Ilocano president. His father's old home, where he grew up, honors his meteoric rise from the top of his law school class to the halls of government, where he became the youngest member of Congress in Philippine history. The lakeside mansion constructed during the height of his power, nicknamed "Malacañang of the North," showcases the highlights of his reign: modernizing infrastructure, luring international investors, and bringing the Philippines to the world stage with his savvy diplomacy. On a wall, in big letters, is a quote from his first inaugural address in 1965: WE SHALL MAKE THIS NATION GREAT AGAIN.

Marcos understood the West well and saw opportunity in the American disaster unfolding in Vietnam. He positioned the Philippines as a bulwark of democracy in the East, a defender of American interests, home to three major American military bases. He used the threat of communism to justify ordering martial law a year before his final term as president was set to end. Four US presidents pumped billions of dollars in economic and military aid into the Philippines during the fourteen years of martial law. Much of that money went to Marcos's family and allies, and over the course of his twenty-year rule the Philippines tumbled from the second-strongest economy in Asia to one of the poorest.

The museums mostly displayed a collection of carefully selected truths. As we wandered through the exhibits, my mom playfully questioned the museum tour guides, feigning ignorance, shooting me wry smiles when they answered with canned lines of propaganda. "How can they believe all this?" she whispered to me.

It was all laughs until we got to the exhibit about Marcos's war medals. The placard on the wall, and the tour guide before us, said that Marcos had been the most decorated soldier in the nation's history, with more than two dozen World War II medals to his name. This lie had been a staple of the Marcos biography until journalists checked the records in the 1980s and discovered that he had actually been awarded zero medals during the war. And yet there they were, lined up on a wall behind glass casing. My mom was incensed.

She furiously took photos, determined to capture evidence of this injustice. She began interrogating the guide, attempting to hide her anger beneath a fake sheen of awe.

He really won all these medals? Where did these medals come from? How do you know he won all these medals? Did they tell you he won these medals?

Her cover was slipping. The museum guide, a skinny college kid working this part-time job for some side money, stuttered something about how there was "controversy" over the medals, and before the exchange could spin out of control I jumped in with a softball question to change the subject.

My mom was still fuming after we left the museum.

"That is not right!" she said. "How can they spread these lies? Why doesn't anybody correct this? How can they do this? These Marcoses are so shameless!"

And suddenly she was back in 1972 and the years that followed. When police officers cut the hair of men who'd illegally grown it to their shoulders. When you had to be home before midnight— or at least at a party you could stay at until sunrise. When journalists and activists vanished, rumors of torture and death whispered in their wake. When newspapers and television stations were shut down, and nothing was reported that the state didn't want seen. In those years, fear soaked through the country like rising floodwater, carrying with it a choice that floated at the knees of every Filipino: to submit or to suffer.

In 1972, my mother's family lived in a big house on Scout Reyes Street in Quezon City, a booming suburb of Manila. They'd bought the home, the first one built in a sprawling subdivision, a few years earlier. Raised and educated in Mindanao, my mother's parents were of the postwar generation of new money flowing into the fast-growing, increasingly cosmopolitan metro area—from 1940 to 1960, Manila's population nearly doubled to 1.1 million.

My grandfather traced his family's lineage to a sultan who ruled the land around the city of Marawi in northern Mindanao. During the 1800s, the island's inhabitants were nearly all Muslim, fighting off Spanish armies and friars who had brought Christianity to the rest of the country.

The sultan had a daughter, Princess Bato Bato, my great-great-grandmother. One day in the late 1800s, a Spanish soldier named Juan Fernandez arrived in the city and married Princess Bato Bato. She converted to Catholicism. By the time my grandfather was born, the Americans had taken over. He grew up on an Army base in Marawi, where his father was postal commissioner.

He met my grandmother, Rizalina, in school there. Her fa-
ther had come to Marawi for a job as a police officer for the US
forces overseeing the island, battling the Muslim rebels. His fam-
ily line had originated in southern Luzon. His grandfather was a
brother-in-law of Andrés Bonifacio, leader of the rebellion against
the Spanish. The revolution was ultimately successful—the Philip-
pines became the first Asian country to topple its colonial rulers,
declaring independence in 1898, a short-lived freedom that did
not survive the American conquest. But Bonifacio did not live to
see even that freedom. He was killed in 1897 by a rival revolution-
ary faction. His death sent his family, all allies in his cause, on the
run. They changed their names and dispersed across the country.
His brother-in-law—my great-great-grandfather—ended up in the
Visayas, which is where my grandmother's father lived before com-
ing to Marawi.

As history would have it, the descendants of the sultan and the
revolutionary went to a school with an American flag fluttering
out front. The curriculum cultivated a deep interest in the West.
While the Spanish had sought to control the colony with force
and religion, the Americans preferred indoctrination through
education, culture, and the allure of capitalism—seeds that would
bloom years later in households where parents raised my mother's
generation to see the United States as the finish line.

After the war, my grandparents, college-educated and taught
to aspire to leather-shoe careers, left for Manila. My grandfather
specialized in civil law, and my grandmother was an accountant,
hired to work at the country's Central Bank, which was headed by
the father of her best friend, Baby. My grandparents made good
money and had eight children. The big house on Scout Reyes was
a social center, buzzing with everybody's friends, several maids on
hand to feed them.

My mom was twelve when Marcos declared martial law in 1972.
She saw over the next few years that the lives of her parents were
changing. After the Marcos government replaced Baby's father at
the Central Bank with an ally and then arrested Baby's brother, a
senator, for his political opposition, she and Baby quit their jobs in
protest. They opened a clothing store that limped along through
the increasingly monopolized economy.

My grandfather's law practice ran into a blockade of corrup-
tion. Money did not always guarantee that a judge would rule in

your favor, but the court filings submitted with an envelope of cash were slid to the top of the docket, ensuring indefinite gridlock for the rest. Having mostly represented poor clients, my grandfather made his living through commission from monetary verdicts, which slowed to a trickle. He refused to pay the bribes.

He tried to start various business, but a business permit also required a bribe. So he turned to ship salvaging, investing his savings in boats and equipment he needed to prowl for sunken vessels to sell. The family's money dwindled. My grandparents had sent their older children to the most expensive, elite private schools in Manila. But there was not enough to fund the same education for their younger kids.

They transferred my mother midway through high school. Later, she dropped out of dental college because her parents could no longer afford the tuition. They sent her three younger brothers to live with an aunt and uncle in Dumaguete City, where education was cheaper and they wouldn't be exposed to the stress and bitterness that now filled the big house on Scout Reyes.

At least one of my uncles resented his father for his stubborn righteousness: he had put principle before family and they all suffered for it. When I brought this up with my mother, she turned angry and adamant. "Your grandfather was a man of integrity," she said. "I'm so proud that he never gave in."

The knockout blow came not from Marcos, but from the only force more powerful than him in the Philippines. During an expedition at sea, my grandfather pulled in a massive sunken ship, a huge score. On the way back to land, a storm hit and wiped him out. As if by act of God, he lost everything. Shortly after that, sheriff's deputies evicted our family from the big house on Scout Reyes, repossessing it and everything inside.

My grandfather moved back to Mindanao, to the northern city of Cagayan de Oro, where he focused his energies on hunting for the hidden treasures rumored to have been buried by Japanese generals fleeing the country at the end of the war. He paid the bills, barely, by representing poor farmers in land dispute cases. My grandmother began spending more time in San Francisco, where my grandfather's sister lived.

The 1986 revolution came and went, and the struggles persisted. The courts remained corrupt, and my grandfather's cases stalled. Most of his clients were tenant farmers who had been

granted land through an agrarian reform program intended to redistribute the country's stratified wealth, one of Cory Aquino's first big policy initiatives in 1987. But the law was filled with loopholes and weakly enforced. Many landowners refused to abide not just out of greed but principle: after all, Cory's family, old-money oligarchs who owned a massive sugar plantation in central Luzon, had been able to keep their holdings intact.

My grandparents died with barely a peso to pass down. The only meaningful possession to their names was the farm.

As my grandparents clawed through the final years of martial law in the '80s, their children began their exodus. My Uncle Joey went to Australia. Six of his siblings ended up in California. The only one who stayed was my Uncle Paul, whom we visited on the eighth day of our trip.

Paul had been the brightest among his siblings, they all said, the one with the best grades and the sharpest wit. As a kid, I often overheard my mom and aunts talking about him. They recalled how he got perfect scores on tests he never studied for. They discussed how to bring him to America. They debated how much money to send him. In their voices, I sensed guilt: they had left him behind.

As a young man, Paul had become addicted to *shabu*—Filipino meth—and ruined his life. The drug ravaged communities across the country after arriving from mainland Asia in the 1980s. Filipinos talk about the drug's impact the way Americans talk about the crack epidemic; every one of my uncles had stories of friends lost to *shabu*. Most Filipinos blame widespread use for the high crime rate—the addicts who robbed, the meth-fueled aggression that sparked murders and rapes, the politicians who protected the powerful drug lords funding their campaigns.

Uncle Paul is clean now. He lives in a small nipa hut in a remote bed-and-breakfast my mom's cousin, Earl, owns in the dense jungle outside Dumaguete City. My mom and her siblings pool money to cover his living expenses and medication.

Uncle Paul was standing on the side of the dirt road, waiting for us, when we pulled in. He held a mug of black coffee and was dressed in a crisp blue button-up shirt and pressed black slacks. He wore nonprescription glasses with a Batman logo on the side. We hadn't seen him in more than twenty years.

· My mom greeted him with a long, loud, warm "Hiii Paaauuul!"

but Uncle Paul could muster only a soft "Hi." From the decades of *shabu* and the pills he now took to keep his mind calm, he was a faint echo of whatever he had once been. Sitting in his small hut, beneath a thatched roof covered in spiderwebs, I asked him many questions, just small talk and family gossip, and he answered them with short, simple sentences. It was like talking to a well-behaved but bashful child. Yet below his numb demeanor I sensed a warmth stirring, bits of his old humanity piercing the surface. He asked me only one question that afternoon: he asked me how my father was doing.

My mom brought up some of their old neighbors on Scout Reyes. She grasped for their names, which Paul recited quickly and surely, as if they were lyrics to a favorite song. Many of those old friends had also fallen into addiction. Nearly all of them were now dead.

"How lucky we are to still be alive," my mom said, and Paul smiled slightly and nodded.

We took him to Jollibee's, where we ate fried chicken and spaghetti. Afterward, we went to a mall and my mom bought him a T-shirt. He picked one that said BROOKLYN across the front. When I asked him why, he said he liked the design.

Then we dropped him off, said goodbye, and drove away. The next morning, we flew to Iligan City to visit the farm. When we came to the squatters' shack, I thought about something my mom had said after we left Uncle Paul. "Thank God he has a place to stay," she said. "At least he has a home."

There wasn't much Pepo could do about the squatters. He told them they had to leave and offered advice on where they could move to, but he knew they were unlikely to give in. They had a far greater stake in the land than our family did.

We continued up the mountain until we reached another wooden shack, this one bigger than the last. It was a small general store whose tin roof connected to a small cinderblock house in the back. A family of tenant farmers who worked on our land lived here, Pepo said. The plan was to wait for the head tenant farmer, from another family, who would lead us to the heart of the farmland, which was still further up the mountain, through dirt roads that cut deeper into the jungle, across land that didn't belong to us—land where a local face was necessary for safe passage.

When we got out of the car, we were greeted by three barefoot

women in headscarves. One offered us a tray of Coca-Colas and chips from the store. Another brought us plastic chairs, which she placed in a narrow dirt alley between the store and the house. The third woman was much older, their mother, and she sat, hands folded in her lap, beside the doorway of the home. The day was sunny with a cool breeze to take the edge off the heat, and from the shade of the alley I could see inside the house, which was dark and sparsely furnished.

The women said they had known our family for many years. When their family first began working on the land, they were the only Muslims for miles. Now, perhaps more than half of the families living on this part of the mountain were Muslim. Most, if not all, had sought to escape the tensions roiling further south, where jobs were limited and young men were joining the rebels not for ideology but for stable employment.

The head tenant farmer, Felix, arrived a few minutes later. A short fiftysomething man with a weathered face and a firm handshake, he teased us that of all the days to visit, we had visited on a red alert day. We thanked the three women and turned back to the van, where Clelan had waited with the engine running.

A few feet behind the van, two hard-faced young men sat on a motorcycle, watching us. I did a double take and when I looked again, I saw that the young man in the front of the motorcycle was watching not *us*, but me specifically. He wore a white shirt, black shorts, a black hat, and when he turned on his engine, he pulled a black scarf over the bottom half of his face. I quickly looked away and got into the van. Felix hopped in next to me.

Uncle Pepo waved to the young men. He said they were there to escort us to the farm. The motorcycle took off and we followed.

The young men made me nervous. I kept thinking about that guy in the white shirt and his intense, deliberate stare. I wondered if it was a look of resentment—at this young American in his bright green polo shirt, eager for a taste of the *authentic* Filipino jungle experience, fancy phone filled with photos of slums and banana trees, stories of adventure to share with his affluent friends over forty-dollar bottomless mimosa brunches in New York City, *so brave* to have ventured through exotic dangers, *so cultured* to have spent such time in the far reaches of an underdeveloped nation.

Insecurity and self-consciousness do a lot to the brain, and that's the excuse I'm using to explain why, as we drove farther up the mountain, I wondered, fleetingly, if these young men on the motorcycle planned to kidnap me. They were strangers to me, after all, leading us through remote roads that twisted deeper into the jungle. This was their land and I was at their mercy and people are capable of wild things when they're desperate.

There was poverty all around us. There had been poverty all around us every day of our trip, juxtaposed against the gleaming skyscrapers and crowded malls and pristine beaches and wondrous mountain vistas and unending natural beauties that dominate every square mile of the Philippines. Over the course of those two weeks on the island, I drew closer and closer to the realization that the 1986 revolution had been a failure. It had not been a revolution to upend the social order, but a revolution to return the gears of power to the oligarchs who had felt cheated and helpless during the Marcos dictatorship.

Even my relatives who had fought for the revolution and worked in the administration that followed acknowledged this. "Everybody was euphoric," said my Uncle Joe Tale, who worked as an attorney for Cory's cabinet. Once they had finally defeated Marcos, they seemed to assume that progress was inevitable. But they had no vision for the country beyond ending the dictatorship. "We weren't thinking about the business of government."

This failure explained why, even outside of Ilocos, Marcos was not the universally despised figure I had assumed he would be. The dictator's remains were recently moved to the Heroes' Cemetery, to lie alongside the bodies of soldiers and dignitaries—a decision approved by the country's Supreme Court, despite protests. It was in this climate that Bong Bong, Ferdinand's son, ran for vice president, falling less than three hundred thousand votes short of victory. He filed papers for a recount. There was a real chance that he might win the appeal and become second-in-command to a seventy-one-year-old president with questionable health and threats of assassination against him. At dinner with Dumaguete City's Mayor Remollo, I had asked, "So we could be pretty close to another Marcos presidency?"

And the mayor replied, "I don't think that would be such a bad thing."

He added, to my surprise, that he still believed Marcos was the nation's greatest president.

"Sure, he had twenty years to do it, but he accomplished far more than anyone else," he said. "In the Philippines, we need a benevolent dictator."

Thirty years of liberal democracy, he pointed out, had not fixed the country's deep-rooted problems. And while I disagreed with his assessment of Marcos, I had seen no reason to think that the progress since 1986 had been anything more than incremental.

Of the four presidents between Cory Aquino and Rodrigo Duterte, two have been prosecuted on charges of corruption; one of them was impeached. Over those years, there have been promises of spreading resources outside of Manila and the handful of other urban centers, bolstering the agricultural sector, developing the strained farmland that covers much of the country. Instead, the farmland has continued to deteriorate, lacking irrigation systems and paved roads—which all helps explain why a country with so many farmers remains the world's biggest importer of rice.

Uncle Pepo understood this reality well. The conditions of our family farm made it unappealing to potential buyers. There was its proximity to conflict, of course, but perhaps just as troubling, there was no way to get to the crops by car. A narrow dirt path, accessible on foot or motorcycle, was the sole artery to the main road two miles away—an imposing obstacle to anyone hoping to boost the farm's profitability with modern equipment. Building a road was a nonstarter without government support: the path crossed land that did not belong to us. So our farm remained in the past, tilled and picked by hand.

The young man in the white shirt driving the motorcycle turned up the dirt path and stopped at the top of a hill. He hopped off, and his partner accelerated ahead toward the farm. Clelan parked our van on the shoulder and we stepped out, onto the dirt path. The young man walked down the hill. I saw that he was still eyeing me. He walked toward my mother, glancing at me every few steps.

"Is that Albert?" he said to her.

"Yes," she replied.

"I'm Sargento."

3

Sargento had worked on the farm all his life. By the time he was ten, he had mastered the harrowing craft of shimmying up coconut trees, machete in one hand, bare feet gripping the rough trunk, twenty or thirty feet high in the air, knowing just how to drop the fruit so it did not crack and splatter all over the grass.

He was born into a family of tenant farmers who lived on our land, but our farm didn't make them much money. They worked the field hard, the three oldest brothers plowing and harvesting, their sister tending to the chickens, goats, pigs, and *carabao*.

His father, Felix, was well-respected in the area and my grandmother's most trusted worker. She gave the family extra pay when tough times came and taught Sargento how to read. When he was nine, she encouraged his parents to send him to school. Soon Sargento dreamed of leaving the farm, and my grandmother promised him that if he graduated high school, she would pay for the vocational school he hoped to attend. Sargento wanted to become a mechanic and travel the world, working in the US or Hong Kong or Saudi Arabia, sending back money to his family.

Then, in 2010, when Sargento was twenty-four and two years away from getting his high school diploma, my grandmother died. He left school. He found a second job, enlisting with a private army tasked with guarding the electricity towers from rebel and terrorist attacks. They trained for forty-five days before going into combat. Firefights broke out every few weeks. In 2016, seventeen towers in Mindanao were bombed. Sargento would work fifteen days on duty, then get fifteen days off. He made 4,500 pesos, about ninety dollars, each month-long cycle.

By now he had a wife and two kids, a ten-year-old and a toddler. The army salary was barely enough to provide for them, and certainly not enough to support his parents and siblings. On his fifteen days off, he worked on the farm, and during one of those mornings, his father told him that my grandmother's daughter Lucy—my mother—was visiting. He remembered my mother, and when he saw the young man next to her, he wondered if this was the same boy he had ridden *carabaos* with twenty-two years ago. He stared hard, trying to match the face before him with the murky

image in his memory. He made eye contact, looking for any sign of recognition.

"Is that Albert?"

"Yes."

"I'm Sargento."

My heart damn near burst through my ribcage. My eyes bugged out and my mouth opened wide. Sargento, sensing that I indeed remembered him, smiled. We hugged. Even as we began walking up the trail, we kept patting each other on the back.

On either side of us, fields of forty-foot coconut trees seemed to stretch into eternity; it felt like we were ants crawling through tall grass. Sargento and I caught up as we walked far ahead of the rest of the group. After maybe forty minutes we came to a barren dirt patch. This, Sargento said, was where my grandmother's farm started.

We cut through a thick grove of banana trees, past the pigs feeding in a tub of slop, and came to a wooden shack with an aluminum roof. It was Sargento's family's house. Out front, in a dirt yard encircled by a rickety fence, chickens bumbled around and roosters crowed, their legs leashed to fence posts so they didn't fight each other.

The vast expanse of the farm surrounded us—the banana grove on the left, the durian trees beyond it, the empty corn fields across the center, the giant coconut trees to the right in the grassy fields where the livestock grazed. Sargento pointed to a patch of yellow grass near where the corn grew.

"You used to run around there," he said.

As he showed me around the farm, he recalled the same stories I remembered. He asked me if I still liked coconuts, and when I said I did, he climbed the tree just as he had for me long ago. He climbed to the top easily, casually, within seconds, then twisted the coconut off the branch with one hand while his other wrapped around the trunk. I ate at least eight or nine coconuts that afternoon, drinking the juice from the hole he sliced into the top with his machete, scooping the meat with a chunk of husk he'd carved off.

I asked him about Duterte, and he said he liked him, but we didn't talk politics beyond that. There was too much else to discuss. He still hoped to leave the farm. The money was much better overseas.

"I don't want to be a farmer forever," he said, as we trudged

through the soft dirt along the cornfield. "I want to make my family comfortable."

He planned to go back and finish high school, he said, but he worried about taking time away from working the farm, which would put more strain on his parents and siblings. And anyway, he didn't make enough money to save for vocational school, which he believed he needed in order to get a job overseas. He felt stuck. He had been stuck for years.

After a few hours, it was time to leave. We walked back down the trail slowly, savoring the moment. As we neared the road, he mentioned that he'd felt a heightened responsibility to take care of his family after what happened to his older brother.

Two years ago, his older brother was killed by thieves who stole his motorcycle. There was no use going to the police, he said. Nobody trusted the police. This part of Mindanao adhered to old traditions of justice. His father, Felix, went around the area, talking to people until he learned the names of the three men involved in the murder. He went to the families of the men. Two of the families apologized and offered cash in compensation. A local politician oversaw the settlement. The third suspect, the one whose family did not join the negotiation, was soon found dead, fatally shot. The identity of the gunman is no secret around the area, but I won't be the one to say it out loud.

Sacrifice, I think, is the virtue most respected in the Philippines. In the years leading up to the revolution against Spain in the 1890s, José Rizal believed so deeply in the power of sacrifice that when he returned to the country after years living in Europe, certain he would face execution, he wrote a letter to a friend, with orders that it be opened only after his death. The letter explained that his death was necessary to spark the uprising, which it did, just as Ninoy Aquino's did for the revolution that came in 1986. These days, overseas workers are extolled for their willingness to provide for families they almost never see. And Duterte supporters sometimes note that even if they don't condone the drug killings, they see the rising death toll as a necessary antidote to poison that has long corrupted the nation, calcifying in its bones.

I can only assume that the Filipino reverence for sacrifice is rooted in the Catholicism so many of us were raised with, faith

that carried the country's people through centuries of oppression and poverty. *Blessed are those who suffer.*

The Spanish left a deep mark on our people. By the time they relinquished their colony, more than 85 percent of Filipinos were Catholic. Good Friday was the most sacred day in my home growing up. From noon to three, the hours Jesus hung on the cross, my mom didn't let me watch TV or read anything other than the Bible. Even now, with me off in my adult life, my mom is sure to text at noon every Good Friday to check that I am properly honoring the moment.

Yet over their three centuries in power, the Spanish colonial masters barely made a dent into Mindanao. The farther south they went, the more resistance they found. It was not until 1848, more than three hundred years after Magellan landed on the islands, that the Spanish finally conquered the Davao region on the southern tip of the country. The people of Davao take great pride in this fact—so much so that in the 1960s, officials of the region's biggest city, Davao City, named its highest civic honor after Datu Bato, the Muslim warrior who led the fight against the Spanish.

Rodrigo Duterte, a Davao native, the first president from Mindanao, seemed to embody this spirit of resistance. Unlike the populism sweeping through the West, his truly seemed a populism of the oppressed, a rejection of ancient hierarchies rather than a return to them. In a country whose rulers have, without exception, aimed to appease and impress the US, Duterte has detached from the West. In a country so devoutly Catholic, Duterte, himself a Catholic, has accused the church of being "full of shit." In a country where the rules of political engagement encourage corruption, Duterte has threatened to kill crooked officials.

Less than a year into the president's term, several business owners told me they were no longer paying the bribes that were once customary. One frequent traveler said he stopped worrying about extortion by customs agents, who have long held a reputation as the most reliably corrupt slice of government. I lost count of all the Filipinos who told me that they saw fewer drug dealers in the streets and felt safer walking outside at night.

It is change built on fear—and powered by force of will rather than reform of laws. But in a country where people don't trust their institutions, where the law's grip is loose and shaky, where the legal system has been used to hide corruption, justify authoritarianism,

silence the press, and jail dissidents—in a place like that, who better to turn to than a man who goes out and says what so many have been thinking for years: Fuck your laws. Trust me, Duterte tells his people, and hold on for the ride. And so the people have placed their faith in a demagogue.

They trust him not because he is righteous, but because he resists the old order. Perhaps they are wrong to do so. Already, Duterte has admitted that his drug war spiraled out of control, giving cover to rogue cops, vigilantes, and drug lords who kill to further not public safety but their own interests, targeting rivals and enemies. Already, the president has announced that he is considering expanding martial law from Mindanao to the whole country—but who even needs nationwide martial law when you have the mandate of overwhelming public support? This is the most troubling aspect of Duterte's rise, the way he has reached this popularity even while openly undermining democratic principles. But the more desperate a people, the more they are willing to sacrifice. What Filipinos crave is not an executive but a savior.

That reverence for sacrifice and saviors is what brings thousands of Filipinos to the provinces to watch the literal crucifixions of men reenacting the anguish of Christ on Good Friday every year. On Good Friday of this year, the fifth day of our trip, my mother and I traveled to the Pampanga region north of Manila to watch one of these ceremonies. Hundreds of us stood in an open field beneath the harsh afternoon sun, packed against a railing along the dusty path on which a man dressed as Jesus would carry a wooden cross up a hill.

Behind the crowd stood dozens of tents, bearing the logos of Gatorade and Smart Communications, a local wireless provider. Vendors sold food, drink, religious memorabilia, and umbrellas for shade. As we waited, a group of men passed through the grounds, lashing their raw, skinned backs with whips embedded with razors. Their blood splattered onto the cars inching through the narrow road toward the parking lot.

Early that morning, two other men had gone up on the hill. Their hands and feet were nailed, and the crosses were raised as their faces twisted in pain. Our crucifixion, though, was the 3:00 p.m. showing, which felt especially meaningful because it was the hour of Jesus's death. A few minutes before the hour hit, there was our Jesus carrying the cross up the hill, his legs wobbly, his chest

heaving. An entourage of worshippers followed behind him. We all took photos.

As our Jesus dragged the cross slowly up the dusty incline, I felt a rush of anticipation. What was going through this man's head? Was he dreading the moment to come? Or was he embracing it, cherishing the purpose it instilled in him as hundreds of us watched under the hot sun?

Many of these Jesuses were repeat performers. I'd heard the story of one of them, who after surviving a thirty-foot fall in the 1980s, after having accepted his imminent death in the long seconds before hitting the ground, decided that the only way to properly thank God was to feel nails pierce his hands and feet on every Good Friday that followed. My mother saw this as an extreme act of faith, a recognition of the immense debt of gratitude we all owe. But I saw something else. I saw a man who had run out of options, a man searching for greater meaning in the new life God had gifted him, a poor man with nothing to give but his pain. Only desperation, I concluded, could drive a person so far.

I thought a lot about what happened on that hill over our final two days in the Philippines. My mind was on sacrifice and belief and the ways our beliefs dictate what we are willing to sacrifice and where we draw the line. I was thinking about all this after my mom and I got into our most intense argument of the trip.

After leaving the farm, we spent a day in Davao. The city, as Duterte supporters eagerly note, is indeed cleaner and more orderly than any other city in the Philippines I've been to. Duterte's daughter is the mayor. His name and image are all over: life-size cardboard cutouts in stores, stickers on cars, placards by roads, posters on walls. His home, a green two-story house in a middle-class subdivision, is something of a pilgrimage site; visitors leave their IDs at a military checkpoint and walk to the end of the block, where a life-size cutout of the president stands at the house's front door. Nearby, I saw a vendor selling shirts that riffed off of Nike catchphrases, perhaps unintentionally morphing them into somewhat dark, cryptic allusions: DUTERTE KNOWS, read one. DUTERTE NEVER SLEEPS, read another. Taking it all in like a fangirl, my mom had me snap photos of her next to Duterte cutouts on two occasions, her hand proudly held out in a closed fist, the president's campaign emblem.

Davao's city museum honors Duterte no less than the museums in Ilocos honor Marcos. A bust of Duterte's father, the former governor, stands prominently at a second-floor exhibit. There, our tour guide mentioned that the father had stepped down from his seat to accept a cabinet position for the Marcos administration. My mom hadn't known this. She looked bewildered.

She was aware that Duterte was friendly with the Marcos family. He supported Bong Bong's recount attempt and deemed the dictator's son a worthy successor. But my mom had chalked this up to political expediency. Ilocos and the regions around it voted as a unit—the "Solid North," people call it—and a Marcos endorsement guaranteed this valuable bloc. She hadn't considered that the ties might run deeper. Was there loyalty there? Reverence, even? A history? Suddenly, my mom was pondering the possibility that the Duterte clan was, in fact, an adversary.

"I thought he was a man of integrity," she said in the museum. "But what about this?"

I replied that much of Philippine politics seemed to exist within a vast gray area between right and wrong, and nobody's heart was pure, and there were no saviors—only people navigating an entrenched system. While Duterte might be willing to kill in an effort to upend that system, he had still come up through the same old passages to power. "If I grew up here and became a politician, I'd probably be a little bit corrupt," I said, in a tone that suggested I was kidding.

But my mom must have sensed a thread of truth, because her face froze into a mask of shock and disgust. Before she could find the words, I preemptively laid out my defense. "I'd do all I could to help the poor, of course, and make the country better," I said. "But I'd also make sure our family was comfortable and I was comfortable. I wouldn't do that in America, but here it's part of the game, right?"

She shook her head feverishly, and when she finally found the words, she delivered them sternly. "I'm so disappointed you would say that," she said. "I'd be so ashamed if that were the case! I wouldn't want any of that money."

This argument carried on the rest of the day and into the next, when we were back in Manila, on our last afternoon in the country. We rode through the city in the open side-carriage of a motorbike,

flying through the seams in traffic, exhaust blasting our faces, veering recklessly close to the buses and semis jockeying for position. Over the din of the engine, my mom and I went back and forth.

"What use is righteousness if it adds nothing to the greater good?"

"There is nothing more important than morals. If everybody stood up for their morals, the Philippines wouldn't have these problems."

"But what if some of those problems could be solved by good-willed people who do what they have to do to get things done?"

"God will always know that you sacrifice your morals. You will always have to answer to God."

As the sun dipped, the sky turned pink over the shacks and skyscrapers. The air smelled of fish and fumes. We passed some small boys playing basketball with a rusty hoop perched on a wooden beam fastened with electrical tape to a cinderblock wall. Seeing this, my mom brought up that her father had been very good at basketball and even in middle age had played with men much younger.

"You know, he could have been rich, but he refused to sacrifice his morals," she said. "We could have been millionaires."

I lingered on this alternate reality for a moment, imagining how the world would have unfolded for us, for me. Perhaps my mom and her siblings would have stayed in the Philippines. Perhaps the Concepcion family would have risen to one day compete with the Aquinos and the Marcoses. Perhaps we would have developed the farm into a lucrative enterprise, built a big house for Sargento and his family, and paid for all of their schooling. Perhaps Sargento and I would have grown up as friends.

When Sargento and I parted ways at the farm, we vowed to keep in touch, even though he had no email or Facebook and his early 2000s-model Nokia phone didn't always get reception. I felt guilty as our van rolled down the mountain. The questions I had pondered during my trip—about Duterte, about corruption, about sacrifice—had little bearing on my own life.

The farm, whether or not my family sells it, served its purpose for me—as a memory to keep, a reminder of what I left long ago. For Sargento, it is his family's livelihood. A month after my visit, Mindanao again went into red alert. In Marawi, the city of my grandparents, police forces fought militants linked to ISIS. Over

the first week of shootouts, at least 129 people were killed. Sargento would be called into battle. His family would live under martial law, though nobody was quite sure what that would look like under Duterte.

"It would not be any different from what President Marcos did," Duterte said in a late May speech explaining his decree. "I'd be harsh." I wondered what my grandfather would have thought—if he would have seen Duterte as an indulgent despot charging toward his aims no matter the cost, or as an uncompromising force against corruption and disorder. In other words, if he would have seen in Duterte a reflection of Marcos, or of himself.

He could have been rich, my mom said to me in the motorbike carriage, *but he refused to sacrifice his morals.*

"Don't you kinda wish he had?" I said.

"Of course not!" she said. "All the riches of the Philippines would not have been worth it."

Days earlier, in that grassy field in Pampanga, we had watched our Jesus reach the top of the hill.

He placed the cross on the ground and laid himself on it, arms extended. His entourage formed a circle around him. We craned our necks to see our Jesus amid the crowd of bodies. He was still. His head tilted back against the wood. His chest rose and fell slowly, as if he were breathing himself into serenity.

Several men stood right beside the cross. Their task, I assumed, was to hold our Jesus down in case the pain caused his body to flail. The others in the entourage got down flat on their stomachs. A man went around the circle and whipped them on their backs and on the bottoms of their bare feet. Another man went to the head of the cross and knelt down. I took it that he was in charge of putting the nails in. My heart raced. We waited.

A hush fell over the grounds. Every eye was on the hill. Some in the crowd stood on their toes. Small children sat on shoulders. Birds chirped in the distance. A gust of wind rustled the tents. A few people peeked at their watches—about five minutes to three. We waited some more.

Eventually, the man in charge of the nailing stood and walked to the edge of the hill and looked over the crowd, into the parking lot, gesturing with his hands. A staticky message came over the radio of a security guard standing next to me: they had forgotten to bring the hammer.

The hour of Christ's death was nearing, two minutes and count-
ing, and a hammer still hadn't come. The entourage gave up and
raised the cross, no nails or blood or anguish, just a tired man, his
wrists tied to the bars, his feet on a ledge. We took more photos,
but it felt like a letdown. Jesus hopped off a few minutes later. The
crowd began to disperse. Some went up the hill to take photos.
One teenager got up on the cross and posed as Christ.

As the man who played Jesus in the ceremony walked down the
hill on the dusty path, a group of onlookers argued about what
they had just seen.

"He didn't do the nails!" one man said.

"No, no, he did! They hammered it! You just didn't see it," said
another. He pointed at the Jesus, about twenty yards away. "Look,
on his hands, there's blood!"

But there was no blood.

GARY SHTEYNGART

Thinking Outside the Bots

FROM *Smithsonian*

THE BEST PART of a fourteen-hour flight from New York to
Seoul is the chance to catch up on South Korea's over-the-top
and utterly addictive television shows. *Hair Transplant Day* is about
a young man who believes he can't get a job because he's going
slightly bald and has to resort to criminal measures such as extor-
tion to raise funds for a hair transplant. "It's a matter of survival
for me," the hero cries after a friend tells him that his baldness is
"blinding." "Why should I live like this, being less than perfect?"

Striving for perfection in mind, body, and spirit is a Korean way
of life, and the cult of endless self-improvement begins as early
as the *hagwons,* the cram schools that keep the nation's children
miserable and sleep-deprived, and sends a sizable portion of the
population under the plastic surgeon's knife. If *The Great Gatsby*
were written today, the hero's last name would be Kim or Park.
And as though human competition isn't enough, when I land
in Seoul I learn that Korea's top Go champion—Go is a mind-
bendingly complex strategic board game played in East Asia—has
been roundly beaten by a computer program called AlphaGo, de-
signed by Google DeepMind, based in London, one of the world's
leading developers of artificial intelligence.

The country I encounter is in a mild state of shock. The tour-
nament is shown endlessly on monitors in the Seoul subway. Few
had expected the software to win, but what surprised people most
was the program's bold originality and unpredictable, unorthodox
play. AlphaGo wasn't just mining the play of past Go masters—it
was inventing a strategy of its own. This was not your grandfather's

artificial intelligence. The Korean newspapers were alarmed in the way only Korean newspapers can be. As the *Korea Herald* blared: "Reality Check: Korea Cannot Afford to Fall Behind Competitors in AI." The *Korea Times* took a slightly more philosophical tone, asking, "Can AlphaGo Cry?"

Probably not. But I have come to South Korea to find out just how close humanity is to transforming everyday life by relying on artificial intelligence and the robots that increasingly possess it, and by insinuating smart technology into every aspect of life, bit by bit. Fifty years ago, the country was among the poorest on earth, devastated after a war with North Korea. Today South Korea feels like an outpost from the future, while its conjoined twin remains trapped inside a funhouse mirror, unable to function as a modern society, pouring everything it has into missile tests and bellicose foreign policy. Just thirty-five miles south of the fragile DMZ, you'll find bins that ask you (very politely) to fill them with trash, and automated smart apartments that anticipate your every need. I have come to meet Hubo, a charming humanoid robot that blew away international competition at the last Robotics Challenge hosted by the Defense Advanced Research Project Agency, or Darpa, the high-tech US military research agency, and along the way visit a cutting-edge research institute designing robotic exoskeletons that wouldn't seem out of place in a Michael Bay movie and hint at the strange next steps humans might take on our evolutionary journey: the convergence of humanity and technology.

Seoul is a place that veers between utopia and dystopia with alarming speed. The city sleeps less than even New York, and its permanent wakefulness leaves it haggard, in desperate need of a hair transplant. Driving in from the airport, you get the feeling that Seoul never really ends. The sprawling metropolitan area tentacles in every direction, with a population of twenty-five million residents, which means that one out of every two South Korean citizens lives somewhere in greater Seoul.

And yet to get around the city is a dream, as long as you avoid taking a taxi during rush hour from the historic northern neighborhoods over the Han River to wealthy Gangnam (popularized by Psy and his horsey dance-music video), as the cabbie invariably blasts Roy Orbison on the stereo, an obsession I never quite figure out. I dare you to find a better subway system in the known uni-

verse: spotless, efficient, ubiquitous, with WiFi so strong my fingers can't keep up with my thoughts. At all times of the day, bleary-eyed commuters candy-crush it to work, school, hagwon private schools. Over the course of an entire week, I witness only three people reading a print-and-paper book on the subway, and one of those is a guide to winning violin competitions.

Above us, high-resolution monitors show mournful subway evacuation instructions: people rush out of a stranded subway car as smoke approaches; a tragically beautiful woman in a wheelchair can't escape onto the tracks and presumably dies. But no one watches the carnage. The woman next to me, her face shrouded by magenta-dyed hair, shoots out an endless stream of emojis and selfies as we approach Gangnam Station. I expect her to be a teenager, but when she gets up to exit, I realize she must be well into her fifties.

Full disclosure: I am myself not immune to the pleasures of advanced technology. At home, in New York, my toilet is a Japanese Toto Washlet with heating and bidet functions. But the Smartlet from Korea's Daelim puts my potty to shame. It has a control panel with close to twenty buttons, the function of some of which—a tongue depressor beneath three diamonds?—I can't even guess.

I encounter the new Smartlet while touring the latest in Seoul's smart-living apartments with a real estate broker who introduces herself as Lauren, and whose superb English was honed at the University of Texas at Austin. Some of the most advanced apartments have been developed by a company called Raemian, the property division of the mighty Samsung. Koreans sometimes refer to their country as the Republic of Samsung, which seems ironically fitting now that a scandal involving the conglomerate brought down the country's president.

The Raemian buildings are buffed, gleaming examples of what Lauren continually refers to as the "internet of things." When your car pulls into the building's garage, a sensor reads your license plate and lets your host know that you have arrived. Another feature monitors the weather forecasts and warns you to take your umbrella. An Internet-connected kitchen monitor can call up your favorite cookbook to remind you how to make the world's best piping bowl of kimchi jigae. If you're a resident or a trusted guest, facial recognition software will scan your visage and let you in. And, of course, the Smartlet toilet is fully Bluetooth accessible,

so if you need to wirelessly open the door, summon your car, order an elevator, and scan a visitor's face, all from the comfort of your bathroom stall, you can. If there's a better example of the "internet of things," I have yet to see it.

Across the river in Gangnam, I visit Raemian's showroom, where I am told that each available apartment has a waiting list of fourteen people, with the stratospheric prices rivaling those in New York or San Francisco. The newest apartment owners wear wristbands that allow them to open doors and access services in the building. The technology works both ways: in the apartments themselves, you can check in on all your family members through GPS tracking. (Less sinisterly, the control panel will also flash red when you use too much hot water.) I ask my chaperone Sunny Park, a reporter for *Chosun Ilbo,* a major national newspaper, whether there is any resistance to the continued diminution of privacy. "They don't mind Big Brother," she tells me of South Korea's plugged-in citizens. Sunny, of a slightly older generation, admits that she can sometimes run into trouble navigating the brave new world of Korean real estate. "I once stayed in an apartment that was too smart for me," she says. "I couldn't figure out how to get water out of the tap."

Remember the hero of *Hair Transplant Day* who cries out, "Why should I live like this, being less than perfect?" The automation of society seems to feed directly into the longing for perfection; a machine will simply do things better and more efficiently, whether scanning your license plate or annihilating you at a Go tournament. Walking around a pristine tower complex in Gangnam, I see perfect men toting golf bags and perfect women toting children to their evening cram sessions to bolster their chances of outcompeting their peers for spots in the country's prestigious universities. I see faces out of science fiction, with double-eyelid surgery (adding a crease is supposed to make the eyes look larger) and the newly popular chin-shaving surgery; one well-earned nickname for Seoul, after all, is the Plastic Surgery Capital of the World. I see Ferrari'd parking lots and immaculately appointed schoolgirls nearly buckling under the weight of giant school bags in one hand and giant shopping bags in the other. I see a restaurant named, without any apparent irony, You.

Despite all that perfection, though, the mood is not one of luxury and happy success but of exhaustion and insecurity. The

gadget-festooned apartments are spare and tasteful to within an inch of their life. They may come prestocked with Pink Floyd boxed sets, guides to Bordeaux wineries, a lone piece of Christie's-bought art—a style of home décor that might be called "Characterville," which is in fact the name of one Raemian building I come across. Of course, it betrays no character.

Back in the Raemian showroom, I see a building monitor showing a pair of elderly parents. When the system recognizes your parents' arrival in the building, their photo will flash on your screen. The "parents" in this particular video are smiling, gregarious, perfectly coiffed, and impervious to history. One gets the sense they never existed, that they too are just a figment in the imagination of some especially clever new Samsung machine.

One morning I take a gleaming high-speed train an hour south of the city to meet Hubo the Robot, which lives at the Korea Advanced Institute of Science and Technology, or KAIST, inevitably known as the MIT of Korea. Hubo is descended from a family of robots that his dad, a roboticist named Oh Jun-ho, has been working on for fifteen years. Hubo's the fifth generation of his kind—a five-foot-seven, two-hundred-pound silver humanoid made of lightweight aircraft aluminum. He has two arms and two legs, and in place of a head he has a camera and lidar, a laser-light surveying technology that allows him to model the 3-D topography of his environment in real time. But part of the genius of Hubo's design is that while he can walk like a biped when he needs to, he can also get down on his knees, which are equipped with wheels, and essentially transform himself into a slow-rolling vehicle—a much simpler and quicker way for a lumbering automaton to get around.

Winning the 2015 Darpa challenge and its $2 million top prize was no small feat, and it made the genial Professor Oh a rock star at the university. Twenty-five teams from the likes of Carnegie Mellon, MIT, and NASA's Jet Propulsion Laboratory entered the competition, which was designed to simulate a disaster scenario like the meltdown at Japan's Fukushima nuclear power plant in 2011. At Fukushima, the engineers had to flee before they could completely shut down the plant, and it was a month before a pair of remote-controlled robots could enter the plant and begin to assess radiation levels.

Darpa hoped to drive innovation to improve robot capabilities in that kind of scenario, and operated on the premise that robots with some measure of human-like facility for movement and autonomous problem-solving would best be able to do work that humans couldn't, saving lives. "We believe that the humanoid robot is the best option to work in the human's living environment," Oh says. Although specific tasks may well call for specialized robots—self-driving Ubers, Amazon delivery-drones, nuclear plant disaster valve-turners—a humanoid robot, Oh says, is "the only robot that can solve all the general problems" that people may need to solve, from navigating changing terrain to manipulating small objects.

Oh, a dapper man with round spectacles, a high forehead, and as friendly a grin as you are likely to come across, explains that at the Darpa challenge, each robot had to complete a set of tasks that real disaster-response bots might face, like climbing stairs, turning a valve, opening a door, negotiating an obstacle course laden with debris, and driving a vehicle. Hubo drives much the way a self-driving car does, according to Oh: he scans the road around him, looking out for obstacles and guiding himself toward a destination programmed by his human masters, who, as a part of the competition's design, were stationed more than five hundred yards away, and had deliberately unreliable wireless access to their avatars, as they might during a real disaster. Although he can execute a given task autonomously, Hubo still needs to be told which task to execute, and when.

One such task at Darpa required robots to exit the vehicle after finishing their drive. It may sound simple, but we humans are quite used to jumping out of a cab; a robot needs to break the task down into many component parts, and Hubo does that, as he does all the tasks asked of him, by following a script—a basic set of commands—painstakingly written and programmed by Oh and his colleagues. To climb out of a car, he first lifts his arms to find the car's frame, then grabs hold of it and discerns the right amount of pressure to apply before maneuvering the rest of his bulk out of the vehicle without falling. I've watched several of the larger characters on *The Sopranos* get out of their Cadillacs in the exact same way.

But Oh explains it's especially tricky, and Hubo's success sets him apart: most humanoid robots would rely too much on their arms, which are often made to be rigid for durability and strength,

and in the process risk breaking something off—a finger, a hand, sometimes even the whole metal limb. Or they might overcompensate by using the strength of their legs to get out and then never quite catch their balance once they're outside, and tip over.

Hubo has what Oh describes as a reactive or "passive" arm—in this case, it's really there for nothing more than light stability. Part of Hubo's special intuition is to recognize how to use his component parts differently based on the specific task in front of him. So when he has to execute a vehicle exit, and reaches up to grab the frame of the car, he's simply bracing himself before, as Oh puts it, "jumping" out of the car. "It's the same for a person, actually," Oh says. "If you try to get out from the vehicle using your arm, it's very hard. You're better to relax your arm and just jump out." It's clearly a feature Oh is proud of, beaming like a happy grandfather watching a year-old grandchild teach himself to push himself upright and stand on his own two legs. "It looks very simple, but it's very difficult to achieve," he observes.

This past January, KAIST inaugurated a new, state-funded Humanoid Robot Research Center, with Oh at the helm, and Oh's lab is now developing two new versions of Hubo: one is much like the Darpa winner but more "robust and user-friendly," Oh says. The lab's immediate goal is to bestow this new Hubo with total autonomy—within the constraints of set tasks, of course, like the Darpa challenge, so basically a Hubo with an intelligence upgrade that gets rid of the need for operators. The other prototype might lack those smarts, says Oh, but he will be designed for physical agility and speed, like the impressive Atlas robot in development by the American company Boston Dynamics. "We are dreaming of designing this kind of robot," says Oh.

I ask Oh why South Korea, of all countries, got so good at technological innovation. His answer is quite unexpected. "We do not have a long history of technological involvement, like Western countries, where science has generated bad things, like mass homicide," he says. "For us, science is all good things. It creates jobs, it creates convenience." Oh explains that although Korea was industrialized only in the 1980s, very late by comparison with the West and Japan, the government has made huge investments in scientific research and has been funding key growth areas like flat-screen displays, and with enormous success: there's a good chance your flat screen is made by Samsung or LG, the world's two top

sellers, which together account for nearly a third of all TVs sold. Around the year 2000, the government decided that robotics was a key future industry, and began to fund serious research.

We talk about the rumored possibility of using robots in a war setting, perhaps in the demilitarized zone between South and North Korea. "It's too dangerous," Oh says, which is another answer I was not expecting. He tells me that he believes robots should be programmed with intelligence levels in inverse proportion to their physical strength, as a check on the damage they might do if something goes wrong. "If you have a strong and fast robot with a high level of intelligence, he may kill you," Oh says. "On the other hand, if he moves only as programmed, then there's no autonomy," shrinking his usefulness and creativity. So one compromise is a robot like Hubo: strong but not too strong, smart but not too smart.

Oh offers me the opportunity to spend some quality time with Hubo. A group of graduate students wearing matching Adidas HUBO LABS jackets unhook the silver robot from the meat-hook-like device on which he spends his off-hours, and I watch them power him up, their monitor reading out two conditions for Hubo: "Robot safe" and "Robot unsafe."

Proudly stenciled with the words TEAM KAIST on his torso and the South Korean flag on his back, Hubo gamely faces up to the challenge of the day, climbing over a pile of bricks sticking out at all angles. Like a toddler just finding his legs, Hubo takes his time, his camera scanning each difficult step, his torso swiveling and legs moving accordingly. (Like a character out of a horror movie, Hubo can swivel his torso a full 180 degrees—scary, but possibly useful.) Hubo is the ultimate risk assessor, which explains how he could climb a set of stairs backward at Darpa and emerge from the competition without falling a single time. (Robots falling down tragicomically at the competition became a minor internet meme during the event.) After finishing his tasks, Hubo struck something of a yoga pose and did a brief victory two-step.

It's hard to mistake Hubo for a humanoid along the lines of the "replicants" from Ridley Scott's *Blade Runner* (despite his good looks, he's no Rutger Hauer), and, as I've mentioned before, his head is basically a camera. But it's still hard not to find him endearing, which may be true of our interactions with robots in general. When the non-Hubo robots at the Darpa competition fell

over, the audience cried out as if the machines were human be-
ings. As technology advances, a social role for robots, such as pro-
viding services for the elderly (perhaps especially in rapidly aging
societies like Korea and Japan), may well mean not just offering
basic care but also simulating true companionship. And that may
be just the beginning of the emotional relationships we'll build
with them. Will robots ever feel the same sympathy for us when
we stumble and fall? Indeed, can AlphaGo cry? These questions
may seem premature today, but I doubt they will be so in a decade.
When I ask Oh about the future, he does not hesitate: "Everything
will be roboticized," he says.

Another immaculate high-speed train whisks me across Korea to
the industrial seaside town of Pohang, home to the Korea Institute
of Robot and Convergence. The word "convergence" is especially
loaded, with its suggestion that humankind and Hubokind are des-
tined someday to become one. The institute is a friendly place
gleaming with optimism. As I await a pair of researchers, I notice a
magazine called the *Journal of Happy Scientists & Engineers,* and true
to its promise, it is filled with page after page of grinning scientists.
I'm reminded of what Oh says: "For us, science is all good things."

Schoolboys in owlish glasses run around the airy first-floor mu-
seum, with features such as a quartet of tiny robots dancing to
Psy's "Gangnam Style" with the precision of a top K-pop girl band.
But the really interesting stuff lies ahead in the exhibits that show
the full range of the institute's robot imagination. There's Piro, an
underwater robot that can clean river basins and coastal areas, a
necessity for newly industrializing parts of Asia. There's Windoro,
a window-cleaning robot already in use in Europe, which attaches
to skyscraper windows using magnetic force and safely does the job
still relegated elsewhere to very brave humans. There is a pet dog
robot named Jenibo and a quadruped robot that might serve in
some guard-dog-like capacity. There's a kind of horse robot, which
simulates the movements of an actual horse for its human rider.
And, just when it can't get any stranger or more amazing, there's a
kind of bull robot, still in development, which can perform eight
actions a bullfighter would encounter, including head-hitting,
shoving, horn-hitting, neck-hitting, side-hitting, and lifting. An en-
tity called the Cheongdo Bullfighting Theme Park already seems
to have dibs on this particular mechanized wonder.

I ask Hyun-joon Chung, a young University of Iowa–educated researcher at the institute, why he thinks Korea excels at technology. "We have no natural resources," he tells me, "so we have to do these things for ourselves." Still, there's one resource that has long dominated the area around Pohang, which is steel. The city is home to Posco, one of the world's largest steelmakers. And this has given birth to one of the institute's most interesting and promising inventions, a blue exoskeleton that fits around a steelworker's body and acts as a kind of power-assist to help the worker perform labor-intensive tasks. This quasi-robot is already in use in Posco's steel mills and is the kind of human-machine convergence that actually makes sense to me.

As Posco's workers age, it allows them in their fifties, sixties, and beyond to continue performing tasks that require great physical strength. Instead of robots providing mindless company to seniors —think of Paro, Japan's famous therapeutic seal robot for the elderly, already a punch line on *The Simpsons*—the institute's exoskeleton allows seniors to stay in the workforce longer, presuming they want to. This may be the one case of robots helping to keep manufacturing plant workers employed, instead of seeing them packed off to a lifetime of hugging artificial seals.

After my visit, at a little stand near the space-age train station, an older woman beneath a profound perm dishes out the most delicious bibimbap I've ever had, a riot of flavor and texture whose chunks of fresh crab remind me that industrial Pohang is actually somewhere near the sea. I watch an older woman outside the station who is dressed in a black jumpsuit with a matching black cap power-walking through a vast stretch of desolate scrubland, like a scene out of a Fellini movie. Above her are rows of newly constructed utilitarian apartment blocks the Koreans call "matchboxes." Suddenly, I am reminded of the famous quote by the science fiction novelist William Gibson: "The future is already here. It's just not very evenly distributed."

When I was a kid addicted to stories about spaceships and aliens, one of my favorite magazines was called *Analog Science Fiction and Fact*. Today, Science Fiction and Fact could be the motto for South Korea, a place where the future rushes into the present completely heedless of the past. So taking this phantasmagoric

wonderland as an example, what will our world look like a generation or two from now? For one thing, we will look great. Forget that hair transplant. The cult of perfection will extend to every part of us, and the cosmetic-surgery bots will chisel us and suck out our fat and give us as many eyelids as we desire. Our grandchildren will be born perfect; all the criteria for their genetic makeup will be determined in utero. We will look perfect, but inside we will be completely stressed out and worried about our place (and our children's place) in the pecking order, because even our belt buckles will come equipped with the kind of AI that could beat us at three-dimensional chess while reciting Shakespeare's sonnets and singing the blues in perfect pitch. And so our beautiful selves will be constantly worried about what contributions we will make to society, given that all cognitive tasks will already be distributed to devices small enough to perch at the edge of our fingernails.

As the great rush of technology envelops us and makes us feel as small as the stars used to make us feel when we looked up at the primitive sky, we will be using our Samsung NewBrainStem 2.0 to send out streams of emojis to our aging friends, hoping to connect to someone analog who won't beat us at Go in the blink of an eye, a fellow traveler in the mundane world of flesh and cartilage. Others of us, less fortunate, will be worried about our very existence, as armies of Hubos, built without the safeguards developed by kindly scientists like Professor Oh, rampage across the earth. And of course the balance of power will look nothing like today; truly, the future will belong to societies — often small societies like South Korea and Taiwan — that invest in innovation to make their wildest techno-dreams a reality. Can you picture the rise of the Empire of Estonia, ruled by a pensive but decisive talking toilet? I can.

Spending a week in Seoul easily brings to mind some of the great science fiction movies — *Blade Runner, Code 46, Gattaca, The Matrix*. But the movie I kept thinking about most of all was *Close Encounters of the Third Kind*. It's not that aliens are about to descend on Gangnam, demanding that Psy perform his patented horsey dance for them. It's that successive generations of post-humans, all-knowing, all-seeing, fully-hair-transplanted cyborgs will make us feel like we've encountered a new superior, if highly depressed, civilization, creatures whose benevolence or lack thereof may well

determine the future of our race in the flash of an algorithm, if not the blast of an atom. Or maybe they'll be us.

One day, I take the train out to Inwangsan Mountain, which rises to the west of Seoul and offers spectacular if smoggy views of the metropolis. On the mountain you can visit with an eclectic group of free-range shamans, known as *mudangs,* who predate Buddhism and Christianity and act as intermediaries between humans and the spirit world and for steep prices will invoke spirits who may foretell the future, cure disease, and increase prosperity. On this particular day the mudangs are women dressed in puffy jackets against the early March cold, tearing strips of colored sheets that are associated with particular spirits. White is connected to the all-important heaven spirit, red the mountain spirit; yellow represents ancestors, and green represents the anxious spirits. (If I could afford the shamans' fees, I would definitely go with green.) Korea may be a society where nearly every aspect of human interaction is now mediated by technology, and yet turning to the spirits of the heavens, mountains, and honored ancestors in this environment makes a kind of sense. Technology bestows efficiency and connectivity but rarely contentment, self-knowledge, or that rare elusive quality, happiness. The GPS on the newest smartphone tells us where we are, but not who we are.

The Seonbawi, or "Zen rock," is a spectacular weather-eroded rock formation that looks like two robed monks, who are said to guard the city. Seonbawi is also where women come to pray for fertility, often laden with food offerings for the spirits. (Sun Chips seem to be in abundance on the day I visit.) The women bow and pray intently, and one young worshiper, in a thick puffy jacket and a woolen cap, seems especially focused upon her task. I notice that squarely in the center of her prayer mat she has propped up an iPhone.

Later I ask some friends why this particular ritual was accompanied by this ubiquitous piece of technology. One tells me that the young woman was probably recording her prayer, to prove to her mother-in-law, who is presumably angry that she hasn't produced any children, that she actually went to the fertility rock and prayed for hours on end. Another companion suggests that the phone belonged to a friend who is having trouble conceiving, and that by bringing it along, the woman is creating a connection between the

timeless and immortal spirits and her childless friend. This is the explanation I like the most. The young lady journeys out from her city of twenty-five million plugged-in residents to spend hours on a mountaintop in the cold, promoting her friend's dreams, hands clasped tightly in the act of prayer. In front of her, a giant and time-less weather-beaten rock and a small electronic device perched on a prayer mat steer her gently into the imperfect world to come.

CHRISTOPHER SOLOMON

In the Home of the Bear

FROM *High Country News*

BEHOLD THE GREAT OUTDOORSMAN, bravely stalking the north bush for his quarry. He has come to observe, up-close and in the unmitigated wild, the ferocious Alaskan brown bear. See him push from his mind the niggling fact that in his fraught quest he carries neither rifle nor shotgun nor bear spray—indeed, is armed with nothing more protective than a spray-can of mosquito repellent—and that his most technical piece of bear-stalking apparel is a pair of caution-light-yellow clamming boots, which at this moment are being sucked from his feet by a vengeful tidal goop. Before him, Alaska is a broad baize beneath weeping clouds. He lifts his powerful and overpriced binoculars to his eyes and scans the horizon.

There, in the distance! A brown hulk squats, unmoving, on the tidal flat. Even from here he can see its dark ursine mass rippling with potential energy, waiting for the moment to burst toward his group with merciless velocity.

"Mud bear," dismisses his guide, walking onward.

Ah.

Truth to tell, the Great Outdoorsman is a bit jumpy, and also is growing near-sighted. He is not feeling altogether great at the moment. He has come to the McNeil River State Game Sanctuary to see why, each summer, this place claims the crown as the beariest place on earth. But the rain has made him shivery, and he thinks he has forgotten his pocketknife at home.

For twenty years he has lived in Seattle, which not long ago felt like a big mountain town, but now is the fastest-growing metropolis in the nation. His life mirrors that of his city, further removed

from nature by the day. The three-hour rush hours that lead out of town discourage him. So do the two hundred cars he sometimes finds at the trailhead. He feels stuck in the traffic jam of the Anthropocene. Instead, he spends long hours at his desk, and on the telephone, trying to do big things, and to be big.

Sometimes the Great Outdoorsman—my better, former self—stops striving long enough to wonder, *Is this all there is? Must we spend our days trying to control the world around us, even as things spin out of control?* When those questions become too much, he knows it's time to escape from behind the bars of his cellphone and get beyond the reach of other humans. Way out here, in places like this, he likes to think, a person can better see how the world fits together, and perhaps see where he, too, fits in.

You have seen the poster hanging in the harshly lit purgatory of a dentist's office or strip-mall DMV: a bear standing at the top of a foamy cataract about to devour a leaping salmon. Beneath the bear, a single sentiment: PERSISTENCE. These photographs are mostly taken at Brooks Camp of southwest Alaska's Katmai National Park where, on a busy day, a squadron of floatplanes shuttle hundreds of tourists to gawk at a handful of bears on the river. It's impressive, and also crowded.

Northeast of Katmai at McNeil River, by contrast, seventy-five bears have shared the falls of the river. On the same day. At once. "That's more bears than there are in France!" Larry Aumiller, a former manager of the sanctuary, said upon witnessing the scene in 2011. When the salmon are running thickest in the McNeil River in mid-July, it's normal to watch forty bears fish together.

The numbers are all the more remarkable when one considers that perhaps only eighteen hundred grizzly bears roam the Lower 48 today. They occupy about 2 percent of their historic range. In the Greater Yellowstone Area, lawyers sue over whether one grizzly per fifty-eight or so square miles is enough to consider the bears recovered. Alaska, on the other hand, has thirty-two thousand brown bears, which are basically grizzlies that enjoy coastal living. Their numbers may be most dense of all on the Alaska Peninsula of southwest Alaska. Here, on average, there's roughly one brown bear every square mile.

While nearby Kodiak Island likes to brag that it's home to the biggest browns on earth, the Alaska Peninsula grows 'em just as

big—up to fifteen hundred pounds for the truly colossal males. To conjure the falls at McNeil in midsummer, imagine forty bears standing in a space a bit larger than half the size of a football field, with each bear weighing as much as two NFL defensive tackles. It's the largest seasonal gathering of the biggest brown bears on earth.

These bears don't live behind a zoo's high walls. They are free-range, completely wild, and they largely go where they want. Here, a bear will catch a salmon, step out of the river and eat its dinner, just a fish-stick toss away from the unfenced, ground-level pad where stunned humans sit and watch. A few years ago, an IMAX cameraman found himself frustrated: the bears were too close for his lens to focus on.

"This place is not a park," Tom Griffin, who has worked at the sanctuary for more than eighteen years and managed it since 2010, says. "With the exception of human safety, that world out there belongs to the bears. When we leave camp every day, we have to control our behavior."

Unlike Brooks Camp, access to the McNeil Sanctuary is strictly limited, to only ten visitors at once, four days at a time, two hundred visitors a season. To come here, you must win the lottery, literally: there's a drawing each spring for spots, with preference given to Alaskan residents. Finally—a good reason to persist for hours at the Nome DMV.

In June, having won a coveted out-of-state lottery spot, I stand on a dock in Homer as a young pilot named Jimmy stows my duffel in his ancient, reliable de Havilland Otter. Two couples arrive to share the ride. Soon we're up and arrowing west toward the Alaska Peninsula, leaving behind house and highway and the halibut charters that split the waters of Cook Inlet. Clouds smudge the horizon like a finger run across a chalk line. The clouds push the plane low. None of this seems to faze Jimmy, who navigates by iPad, texting as he flies. Having stowed my technology for the next several days, I look out the porthole, though, and feel a geographic vertigo set in. Past and future erased, all that remains is a not-unpleasant feeling of going—that, and the sea below, the color of flea-market jade.

In time, a rocky island appears, then another, followed by steep headlands and small bays that reach back into a delirium of grass and alder, a world painted in approximately twenty-six shades of

green. Like eyes adjusting to the dark, it takes a few seconds to see what's not there, which is nearly anything that says humankind. I do spy a brown dot among the green. Then a second one. Jimmy sets the floatplane down on the high tide and cuts the engine. "I saw ten," he says, unbuckling, with the matter-of-factness that steered us here.

The human footprint at McNeil consists of a clutch of old cabins and tent pads huddled at one end of a parenthesis of sand and driftwood. On one side of the sand is a tidal cove. On the other, beyond Kamishak Bay and Cook Inlet, lies the North Pacific. Encircling camp is a low hedge of Sitka alder. This hedge isn't so high that I can't look across it and watch bears munching grass. As barricades go, the hedge is risible. Except that it works, mostly. This small patch belongs to humans. The rest of the two-hundred-square-mile sanctuary is for the bears.

We unload the floatplanes and haul gear down the beach, led by Beth Rosenberg, the sanctuary's assistant manager. Rosenberg is a friendly, caffeinated presence with dark hair and cheeks ripened by the brisk Alaskan summer. Before she's friendly, though, she's a martinet. She orders our group of ten to purge gear immediately of anything that has an odor. Food, toothpaste, mouthwash, deodorant: all marched into the cook shack instead of the tents.

Rosenberg chases this order with more camp rules, simple and inviolable: *When you walk to the outhouse, which sits among tall grass some distance away—clap. Do not walk alone outside the hedge. Do not leave the hedge without permission.* She doesn't have to ask twice. Bears are everywhere. Bears clamming on the mudflats. Bear cubs rough-housing on the beach. A mother bear eating sea pea, two feet from the hedge. Where there are no bears, there are signs of them: inside the cook shack is a cast of a paw print. It is the size of a garden rake. Chew marks scar the door of the wood-fired sauna down the path from my tent.

After we pitch camp, Rosenberg guides several of us outside the perimeter to a creek to fill jerry cans of water. Heavy whorls depress the tall grass around us, as if an engine block had recently arisen from a nap. I've never been so attuned to every sough of wind, every rustle of leaf. I take stock of my situation: four hours earlier I was a white, middle-aged, white-collar American male. Statistically speaking, I straddled the world. Now, I'm on the menu —in theory, anyway. The skin prickles as if in the moment before

the lightning strikes. Nothing focuses the mind like the realization that you no longer stand atop the food chain. It is exhausting, and exhilarating. Back at camp I unzip my tent flap and send a bank vole skittering for cover. "I feel you," I say. At bedtime I give myself a standing O on the walk to the privy, then lie awake and listen to a golden-crowned sparrow sing its three-note song: *Oh poor me, oh poor me.*

Sleep that night takes the long road around the mountain.

"It's a Kamishak-y day—fifty shades of gray," Rosenberg greets us the next morning in the cook shack. The one-room shack serves as our kitchen and living room. It holds a few tables, a crackling woodstove, and shelves that sag with field guides, all of it secured behind a heavy door. On another shelf sit a dozen air horns, and a note: *Toot twice if a bear in camp.*

We bundle up and walk outside, single-file, into perfect brown bear country. Low tidal flats yield to sedge prairie, which gives way to low, humping hills bearded with low alder. On the horizon stands a single poplar tree. The air smells of grass and mud and bear shit—a green, horsey smell of ripe decay and the beginnings of the world. Rosenberg leads the way. She walks with the deliberation of someone entering the house of a neighbor who she's not sure is home. "Hey, bear," she says, in a tone that's almost conversational. "Hey, bear." Slung over her shoulder, and also over the shoulder of state research biologist Dave Saalfeld, at the rear of the group, is a Remington Model 870 shotgun filled with slugs.

The guns remind me of the letter that arrived in the mail with notice of my lottery win. The letter encouraged visitors to bring neither pepper spray nor weapons to the sanctuary, invoking its excellent safety record. No one has been injured or killed by a bear in more than four decades since the permit system began, and no bears killed by visitors. The implication is clear: Who are you to disturb the universe by being the first?

We splash across Mikfik Creek, a salmon stream that by late June is a trickle. Rosenberg halts midstream. On a small rise about sixty yards away, half-hidden among the tall grass, is a brown hump to loosen a hiker's bowels. The sanctuary's managers know more than a hundred bears by sight that return here year after year. But Rosenberg doesn't recognize this one. Ankle-deep in the water, we pause and watch the stranger.

"Let's just walk like this—in a blob is great," she says after a few moments.

We splash forward.

The bear comes more into view. He's an adult male, his great head resting on his great paws. He raises his head. Considers the air. Yawns.

Boredom! I think. *This seems propitious.*

It isn't propitious. "Animal signals are not the same as human signals," Rosenberg says. "A yawn usually signals mild concern."

Our blob pauses again. The bear lowers his head. We splash forward, slowly. He raises his head. We stop. So it goes, with permission, until we have passed him, a humbling Simon Says with North America's apex predator.

Rosenberg walks us farther upstream on what appear to be hiking trails. They're not hiking trails. Look closer. "These are all bear trails," she says. "We just happen to use 'em." Sometimes, the roads are so worn into the earth from decades of use we walk nearly knee-deep to the surrounding land. Turf runs down the middle of the paths where the gap-legged bruins saunter: bear highways complete with bear medians. Bald eagles lift, pterodactyl-like, from a cliff above our heads.

In time, Mikfik Creek enters the hills. There we sit on a grassy knoll above the trickle. It is the waning days of salmon-fishing for the year on Mikfik. An aging bear named Rocky with a necklace of scars lies on a patch of grass beside the creek. He watches a female named Queen Bee fish at a small spillover where the red salmon bunch as they try to make it upstream to spawn and perish.

Adult females like Queen Bee may become receptive to a male's advances for only a short period in the late spring. Rocky is biding his time. (Managers use names here for bears instead of numbers because it makes easier to remember the scores that return annually, not because they consider them pets. When an animal has a bite-force greater than an African lion, "Hot Lips" isn't an endearment.)

Another big male enters, stage right. He's the color of a four-dollar chocolate bar. Rocky stands and walks almost wearily toward Queen Bee, to show his ownership. The newcomer cuts high on the slope above the creek to approach Queen Bee from another direction. Rocky checks him coming around a willow. It's the age-

old drama in a different playhouse—love and war and what's for dinner.

A brown bear will never earn the word "graceful." Consider Rocky: His gait is pigeon-toed. His back is hunched with muscles for grubbing roots and grabbing rodents from their dens. From a distance his face seems as wide and flat as a hubcap. When he walks, his rear legs saw, arthritically, resisting forward motion and one another—one-two, one-two. Watching Rocky lumber toward his rival, my abiding impression is of an articulated bus coming into service.

This is deceptive. The final regret to pass through a human brain is having misjudged the speed and agility of a brown bear. At track distances, an adult brown bear can run down Secretariat.

While I'm mulling the velocity of large carnivores, Queen Bee suddenly appears on the hill just forty yards away from where we sit. The dark suitor follows immediately behind her. She lets him draw close. He stands and mounts her, biting her behind the right ear and holding tight. For forty-five minutes. We make embarrassed jokes, but still take snapshots. Rocky, outflanked, lies down beside the stream, his head on his folded paws.

He may yet get his shot at immortality. A female normally mates with a few males in June and then, in a practice called delayed implantation, holds the blastocysts for several months in her uterine horn. If she's sufficiently fed in summer, the pregnancies take hold in the fall. In January, she will give birth in the den to possibly several cubs—pink, hairless, one pound, premature—who will suckle for months in hibernation. They may all have different fathers.

One day as we walk to McNeil Falls with Griffin, the sanctuary's manager, we meet a nougat-colored bear named Quinoa and her yearling. We pause at a respectful distance for a few minutes, then Quinoa lets us pass within about twenty-five feet of the two—close enough to hear her tear sedge from the earth. Afterward, Griffin turns to us. "What we just did," he says, "you would not do almost anywhere else on earth."

At McNeil, though, humans have found a way to abide with the bears. It's been a crooked journey. The territorial government of Alaska first recognized the unique congregations of bears here and closed off the McNeil drainage to hunting in 1955. A dozen years later, the state legislature created the sanctuary, with a farsighted mandate to place the welfare of the bears first and hu-

man appreciation and research second. As word got out, flocks of people showed up to see the bears, until the falls were overrun with people, Jeff Fair writes in *In Wild Trust,* his excellent 2017 book about the sanctuary.

Confrontations sometimes led to the killing of bears, until area biologist Jim Faro, in 1973, successfully lobbied for a permit program to limit the number of visitors.

The longtime sanctuary manager under Faro, Larry Aumiller, spent three decades studying how humans could live in harmony with *Ursus arctos* on the landscape. Perhaps no one in modern history had ever done anything quite like it. Aumiller made rookie mistakes—walking heedlessly through thick brush, staying all night at the falls, alone ("Bears own the night," he told Fair)—but over time, he learned how humans and bears could reside together.

And what works? First of all, restraint—not bulling into the landscape. Bears don't like surprises. Moving slow and being predictable are good starts. That's why humans walk the same trails, about the same times every day, and in the same group size. Over decades of such long and careful practice, the bears here have learned to see humans as another presence on the landscape—neither the source of a meal, nor the cause of pain or fear. They are "neutrally habituated," in the argot of this place.

Watching Quinoa and her offspring, it occurs to this still-fidgety Outdoorsman that, should mama grow angry, she would cover the ground that separates us before Griffin could unshoulder his Remington. But Quinoa never looks up, and never stops eating. She's aware of us. But as long as we remain predictable, and respectful, she remains comfortable.

And if the managers do need to alter a bear's behavior—to keep a bear outside of that hedge, say—they rarely need anything as persuasive as that shotgun, or even a firecracker. As little as a sharply spoken word, or a shake of a saucepan filled with rocks, is almost always enough to dissuade a neutrally habituated bear.

All this helps create a memorable human experience. "When bears are comfortable, they stick around and we can watch them," Aumiller told author Fair. "And when they are comfortable, unstressed, they are safer in general to be around. So, it turns out, safety leads also to proximity."

Unfortunately, McNeil remains the exception. "Don't try this at home," Griffin reminds us one day after another close encounter.

When he's not at McNeil—for a hike near Anchorage, say—and he thinks a bear is near, even Griffin heads in the other direction. Almost everywhere else, the ability for humans and bears to move easily among each other has been lost. What is different at McNeil is that humans don't try to dominate. We listen. We adjust. We find out how it all fits together, and where we fit in. "Here we learn that we can live among the great bears," Fair writes. "Here we learn the human behaviors that allow this." In more than seventy thousand encounters with bears over thirty years at McNeil, Aumiller was charged just fourteen times—one-fiftieth of 1 percent of meetings—and not one of them resulted in injury. All those bears, it turns out, were newcomers to McNeil.

There's one more reason McNeil works: there's still enough elbow room here, and food, for a bear to be a bear. We haven't diced up the land, dammed the river, paved the mudflat, or shot the residents. At McNeil there are clams and young sedges in spring, when other food is scarce. The reds run up Mikfik in early June, followed by the main course, the chum salmon, in late June and July. The feast concludes with crowberries, low-bush cranberries, and blueberries for dessert in late summer and fall. The McNeil Sanctuary remains an intact, groaning buffet table. And it brings in the crowds. As if to underscore that point, one morning even before we head out, we can count twelve bears from the door of the cook shack—bears clamming, bears scanning the tide for fish, bears gorging on sedge. "It's habitat, with a capital *H*," says Rosenberg.

Something good is happening to me. My once-fearful "Hey, bear!" has turned interrogative. I pull on the fleece and slickers, anxious to get out among them.

The first bloom of the wild iris coincides each year with the arrival of McNeil River's chum salmon run. Whether the brown bears of the Alaska Peninsula are observant botanists remains an open question, but somehow they know to come. On our second morning we follow Griffin past bouquets of iris and head into the spitting rain. Walking at the speed of a funeral cortege, we cross the wide sedge flats, pass beneath bluffs and their hanging gardens of Kamchatka rhododendron, then angle across tundra sprinkled with heather flowers.

We hear the McNeil River before we see it. The falls consist of

about a hundred yards of sluice-y whitewater located about one mile upstream of where the river spills into the ocean. The falls are neither wide nor steep. They are obstacle enough, though, to give pause to tens of thousands of chum salmon that each year try to return to the hills, and the waters of their birth. Chum salmon are poor jumpers, so the fish gather themselves at the base of the rapids to think things over before tossing themselves into the rapids. The bears are waiting.

It's quite a thing to breast a green rise to the sound of smashing water and come upon a dozen bears, or three dozen, standing in a cataract, fishing. Some point downstream. Some point upstream. Some stare into the cappuccino foam of eddies as if all the answers are held there. Still others "snorkel," shoving their snouts into deep pools and then diving, rumps skyward, like fat children diving for pennies. Sated bears catnap on rocks in the river. Every few minutes a new bear materializes from the alder and descends to join the group.

At two gravel pads—room-sized, unfenced, just a few feet above the river—Griffin hands out more rules: *Do not leave the pads. Do not stand quickly. Do not move between the pads without permission.* We settle in on folding chairs to watch a show with more players than a soap opera. A bear named Aardvark charges Hot Lips over his prime fishing spot. They rise and slam into one another. They bite each other on the neck, hard. The fight is over quickly. Hot Lips reluctantly backs away. Aardvark takes the spot and soon has a fish.

Early in the salmon run on the big river is the time for sorting out of the pecking order. In nature, though, fighting is expensive. Bears avoid it if they can. Instead, they try to intimidate. They swagger. They huff and salivate. On bowed legs, they walk slowly, stiffly toward an adversary—cowboy in the front, sumo in the rear—to see who veers first. Bears that don't want any trouble move crab-wise around one another with the no-sudden-movements of gunslingers who just rode in for a sarsaparilla. Ironically, says Griffin, by the time forty or more bears fish together later in July, there will be fewer scuffles.

At high season, with enough fish running for everyone, the bears will gorge and grow fat. During the peak of such salmon runs a coastal brown bear may eat ninety pounds of salmon per day and pack on three to six pounds of fat. An adult male like Rocky might pack on 25 to 30 percent of his body weight and

waddle away to a winter's den weighing thirteen hundred pounds. When fish are most plentiful, bears will "high-grade"—eating only fatty skin or brains. Some McNeil bears get so full and so selective, they've been known to hold a salmon in their mouths and gum it for eggs, or drop a male fish without taking a bite, writes biologist Thomas Bledsoe in his book about McNeil, *Brown Bear Summer.*

As we sit and watch, a big male comes up the bank with a wriggling hunk of sashimi and settles into the tall grass within twenty-five feet of the pad. His muzzle is smeared with blood. We stare at each other. I feel an almost overpowering urge to reach out and touch him. I want to connect with something so wild, of such terrible power and beauty. I have felt that feeling once before, exiting a helicopter, when I felt an overwhelming desire to put my hand to the spinning rotor blades.

The result would be roughly the same.

I don't reach for the bear.

This is another of McNeil's lessons. Let nature draw near, if it wants to. Close your eyes and let the moment burn behind your eyelids. Do not, however, mistake proximity for mystical connection. Do that, and you'll end up the subject of a Werner Herzog film. People will remember you, but only as a cautionary tale.

The barometer plunges. Thirty-mile-an-hour winds sweep the peninsula, driving the kind of rain that finds the weak spots in your waders. Each morning we leave the camaraderie of the woodstove and venture into the gale, past a yellowing note tacked to the shack's door: *Bad weather always looks worse through the window.*

The note knows. We sit at the falls in our lawn chairs for hours, soaked but transfixed. More bears arrive by the day. In the air is an odor that recalls an old bathmat—eau de wet fur. How many bears have I seen? Counting seems irrelevant now. Counting is what the old me thought was important. Instead, I try to pay attention, reminded of Simone Weil. "Attention, taken to its highest degree, is the same thing as prayer," Weil said. "It presupposes faith and love."

I watch a bear called Revlon install himself in a Class III rapid. His legs could be the pilings of the Triborough Bridge. He stares at the water with mineral patience. Finally he lunges, pins a twenty-inch chum to the bottom. He eats it where he stands. A female named Ivory Girl with gorgeous, bone-colored meathooks works her way among the males, begging for food. I watch a lone

wolf—soaked, yellow-eyed—appear on the far shore, slinking among the bears and sneaking scraps.

One afternoon as we sit at the falls with Rosenberg while the day's variety show plays out and the wind howls its approval, one bear begins to chase another over some beary slight. The first bear races out of the water, headed for the near shore. In about two seconds, he's up on the bank, the other bear in fevered pursuit—right toward us.

My amygdala is throwing off sparks. Immediately I'm on my feet, breaking the rule. If there were time, I would break more of the rules. But there's not time. The lead bear is now twenty feet away. The electric prickle returns and races up the spine and across the scalp, the feel of lightning about to strike. Everything slows. The world shrinks until it is seen through a pinhole camera. Einstein needn't have looked to the heavens to contemplate space-time collapse. He could have stood before a charging bear.

Rosenberg stands slowly. The lead bear is close enough now for us to see pearls of slobber arc from his mouth. Rosenberg doesn't retreat. Instead, she steps toward the advancing bears. "Hey," she says. The word is as short and sharp as two stones clacked together.

The lead bear lifts his head and looks directly at Rosenberg. The look isn't angry. Instead, it's one of surprise, and recognition. *Oh,* the look says. *Yeah.* Then, without breaking stride, the bear pivots left, toward the tall grass.

Exit, pursued by a bear.

Weeks later, back in Seattle, the Great Outdoorsman tells himself that, in the moment when the bears charged, he felt privileged to witness such a thing. This, of course, is revisionist hooey. When a Hyundai's worth of meat is bearing down, "privileged" doesn't make the emotional Top Ten.

Only upon reflecting in Wordsworthian tranquility does he think, Yes, precisely, that's exactly what I needed: not any great lessons, but simply to brush against nature, where it still exists in all its humming electric-dynamo bigness. And to be reminded of my smallness, and how good it feels to revel in this smallness, and find again where I fit. And then to come home, thinking small again.

Thus re-baptized, the Great Outdoorsman resolves to get outside again soon, traffic or not. Next time, he swears he will remember his pocketknife.

BARRETT SWANSON

Notes from a Last Man

FROM *New England Review*

IT WAS A BELATED wedding present. Early last January my wife and I were offered the chance to spend three months in Fort Lauderdale, a touristic city on Florida's southeastern edge, one that in the 1950s served as the nativity scene for the American Spring Break. Around that time, her grandfather bought an apartment four blocks from the ocean, and her family has been vacationing there ever since. The building is a squat midcentury complex with a stucco-white exterior, and in the shared courtyard out back there is a kidney-shaped pool cordoned off from onlookers with a hem of clacking palm trees. Most of the amenities inside the apartment haven't been updated since the Kennedy administration. There are turquoise couches and sun-faded curtains, terrazzo floors and senile kitchen appliances.

My wife's grandfather would let us stay there in balmy reprieve from the bleak winter months of Wisconsin, where we'd been living for the past five years. Since both of us were teaching online that semester and thus had no fixed geographical commitments, we decided the trip might have a salutary effect and embarked on the cross-country trek at dawn on New Year's Day. I suppose the date carried some symbolic importance, a version of that old chestnut: *a new year, a new you.* Perhaps the tropical climate would render us porous to sunny influences and slacken our sense of self. Over the next forty-eight hours, we watched the tundra of the Midwest gradually defrost into the profligate greenery of Kentucky, noting the steady accretion of drawl among gas station attendants anytime we stopped to fuel up. Doing our best to scrimp, we spent

our nights in budget motels with glowing marquees that whirred electrically near the roadside, advertising their amenities with an oddly poetic phrase:

KING BEDS OPEN
VACANT HBO

After two days, we finally crossed the Florida state line, entering a corridor of sugarcane and everglades where we were made to endure an endless parade of weather-battered billboards, signs that spoke of surf shops and alligator wrestling, but the promises seemed dubious with their bubbled fluorescent fonts. Somewhere south of Gainesville, we came across a billboard that offered a mortal riddle: TEXTING WHILE DRIVING KILLS. FOR MORE DRIVING TIPS TEXT "SAFETY" TO 79171.

We reached the ocean by nightfall. The sky was rinsed with sherbet colors, the edges of distant clouds rimmed with a vulgar pink. I suppose I thought I'd feel relieved, that confronting the edge of the country might offer a bolt of fresh enlightenment, some timely mitigation of mood. But I was worried because we had just crossed the entire continent and I didn't feel a thing. We parked along the boardwalk and piled out of the car, with chip wrappers and empty soda cans spilling from the open doors, to which we pretended to give chase. The shoreline was dimpled and forlorn, and as we watched the silver mulch of crashing waves, the moment soon acquired the breathy impressionism of a Terrence Malick film. For a few minutes, I gazed contemplatively at the horizon and felt my wife turn to me, her expression bright with anticipation. "How do you feel?" she said. "Good," I said. She raised an eyebrow, unconvinced. "Really good."

We needed a break from the Midwest. That was our public reason. Whenever friends or family members asked about our abrupt change of plans, we responded with stock answers, a litany of complaints—Wisconsin was too cold; we felt too isolated in our insular college town; plus, we hadn't taken a vacation in years. You have to understand that this kind of preemptive apology is necessary in the Midwest, where the dominant aesthetic is utilitarian, where suffering often takes on a Schopenhauerian inevitability. There, even the slightest indulgence will be interrogated if it's left unexplained.

We were, in fact, due for a holiday. For the last five years I had been teaching English at a small Midwestern college, grading stacks of student papers riddled with bad logic and woeful syntax. On campus, I taught five sections of freshman composition, and while I was only an adjunct instructor, I let my students call me "professor," even though it was precisely this misnomer that obscured the gross pay differentials that existed between my colleagues and me. Still, by dint of coupons and self-restraint, my wife and I managed to evade the coercions of debt collectors, and my measly income made us eligible for food stamps and Medicaid. Our apartment was a thrifty university recommendation, in a complex of brick buildings with a scrubby garden and a windswept piazza, where in late summer grad students would smoke clove cigarettes while frowning at Camus novels. Each year, by October, there was snow on the ground, and the confected hills of our courtyard made the walk to the mailbox seem like a chore of Benny-Hill pratfalls, a lethal prank. But for a few years there, I managed to keep up appearances to the best of my abilities. I woke at dawn to tinker with a novel. I held office hours. I wore tortoiseshell glasses and kept my beard at an urban length. Cigarettes were permitted on special occasions, and I eschewed one classic novel after another, spending my nights, instead, in front of the latest HBO series, which was better at depicting structural injustice anyway. As the months flickered past, I snuggled with my wife on a comfy IKEA couch, in a rent-controlled building, in the middle of the country, in one of the safest cities in the world. And this was enough, if only for a little while, to make me feel as though I had somehow managed to escape that unnamable turbulence of mind that seemed always to be nipping at my heels.

Apart from my online teaching, I was supposed to be finishing a novel, but for various reasons, I no longer had a mind for narrative, neither fictional nor memoiristic, and could not seem to plot the events of my life on some sturdy narrative trajectory. Every Freytag Triangle seemed to swell into a circle where the climax was the beginning and the beginning was the denouement. Perhaps it could be attributed to living in the Midwest, yet through the scrim of our bunkered isolation it was hard not to think that greater forces were at play, that the stitching had unraveled, that what had appeared to be the grand sweep of history was actually a patchwork job in which answers were furnished in loose, ad hoc

fashion. Meaning was historical, I had been told, but we were said to be living at the end of history. A few years earlier, when I'd been in grad school, amid the sweetly fragranced wood of the lecture hall, I could dispassionately accept the way in which the Omega circled back toward the Alpha, which is why those acts of critical deconstruction had felt so rejuvenating and alive, why it was with no small amount of relish that I proceeded to unpack and dismantle every last story I'd ever told myself, armored with the theories of trendy midcentury thinkers, toting dog-eared copies of *Signature Event Context* and the work of Paul de Man. Nothing was sacred. No one was spared. One weekend, my wife and I were invited to a service at a local Unitarian church, which we attended with the heartless curiosity of anthropologists, and on the ride home, we mauled its á la carte theology for sport, lampooning the handholding of the parishioners as they swayed to effulgent major-chord hymns. Within the gates of the university, among like-minded colleagues, this had felt purposeful and important, as if we could peel back the hard rind of the Edenic apple to reveal its hollow core.

I could spout French names at you, could speak knowledgeably about Lyotard, Derrida, or even Gilles Deleuze. But a survey of postmodern thinking wouldn't go very far in expressing the sadness I felt during those years, that eerie twilight hour of history. That I bumbled through each day, attendant to its requirements, ever mindful of its issues, but that I did so passively, without an inkling as to its real meaning, was an agitation from which I could no longer find a viable distraction. To admit these feelings at dinner parties or departmental mixers was to be met with baffled incomprehension. It seemed never to have occurred to my colleagues that the hermeneutics of suspicion which they so reliably brought to bear on literary texts could be just as easily applied to the events of their own lives. Somehow they seemed able to maintain an impervious distance between ideas and affect, between ideology and state of mind. Theirs was a happy nihilism, and whatever spiritual desolation they felt could be readily assuaged with a menu of epicurean comforts. Of course, I too tried to laugh off the world's disappointments. I too devoted myself to "the myriad small needs of the body." I too wrote for the little magazines and invented droll theories about what Trump's ascendancy might mean for America. But such conjectures necessitated a belief in the old stories, a quix-

otic faith in the system itself, and the truth was that I no longer had the heart to keep the game going. When it came to the Mayberry fantasies of the Right or the technocratic utopia of the Left, I could no longer suspend my disbelief.

When you are trained in this manner of thinking, long periods of isolation are to be avoided. And yet the previous fall, as these preoccupations seemed to gain new urgency, I began turning down invitations and failing to return calls. Everything began to seem beside the point, untethered from telos or impact. There were no more faces in the clouds, no more symbols to chart and decode, no more sermons to be found in the debacle, as Joan Didion once put it. Occasionally, my wife and I would take weekends away, and we would traipse along the shoreline of Lake Michigan, watching ducks paddle through kelpy surf, but the water did not promise the absolution of Noah's flood nor evoke Hegel's grand historical flux. Educated to possess a literary worldview, to believe reality was endowed with meaning, I finally reached a point in my life where the skin of allusion had been peeled away from everything, where the world was nothing more than a brittle husk. It was during those long autumnal months that the water was only water and the world was always the case. As the days wore on, I grew quiet and abstracted. I was losing weight. And in the glacial blue twilight of those late November evenings, it became difficult to ignore the concern in my wife's face.

So it was in this spirit of recuperation that we headed south that New Year's Day. Maybe the coastal air would alleviate the lethargies of winter and offer us a galvanic dose of Vitamin D. Perhaps we'd channel our best selves by lying sun-struck on the beach, basking alongside the college students with their beery pledges and the millionaires with their cut-loose, notional workdays. In some sense, we were partaking in that age-old American custom first started by the colonial elite. In the early nineteenth century they would escape the brutal winters of the North and sojourn to mineral springs and watering holes for several months at a time. Of course, these aristocrats were merely imitating the gentry of the Old World, who'd been marinating in spas since the Middle Ages, even sipping from the briny pool in which they soaked as if to confirm their faith in that old Latin maxim, *Sanitas Per Aquam*—or "health through water." Still, it seemed strange

to head to the sea when I was feeling rudderless and unmoored, but we decided that a few months in the tropics might lend us some perspective.

Four blocks from our apartment, along the strip of oceanfront hotels, there is a hollow building stretching twenty-four stories into the sky. The construction signage identifies the development as the Conrad Hotel, but it is more widely known by the unofficial designation the locals have given it: Trump Tower. In a disastrous licensing scheme a few years ago, Trump lent his brand to the venture, which motivated buyers to shell out a half-million dollars per condo. But when wind of bad prospects eventually ruffled the elaborate comb-over of the real estate mogul, he quickly dropped his name from the project, and almost immediately the hotel tanked. Now, the Tower looms on the horizon like a totem, begging to be read as a portent of something, an emblem of the culture itself. Not only is the edifice wholly untenanted, it's also unfinished, its interior carpeted with the sawdust of renovation. We've only been here two days, but already my wife and I have taken turns coming up with inane interpretations.

"It's a symbol of ineffectual patriarchy—empty but erect," I say. "A symbol of the Viagra generation."

"No, no," my wife says. "It's aesthetics over essence. Name recognition trumps—ahem—everything."

As we meander down the boardwalk, we do our best to make each other laugh, but in truth I can't help but feel a needling unease every time we come upon the specter of the empty building. It is a terrain without telos. It could mean anything.

"But you're right," she says, "it really does look like an erection."

My wife has been coming here with her family since she was a girl and reinhabits this space seamlessly. When we return to the apartment, she changes into a flowing daisy-print muumuu and a pair of jelly sandals that are the color of vodka-cream sauce. Fleetwood Mac booms through the stereo, and she twirls around the kitchen, drinking diet root beers and seeming visibly unclenched from the doldrums of regular life. There is a strange House-of-the-Rising-Sun quality to her dancing—languid gestures, lots of swaying.

"Shall I throw a chiffon over the lamp?" I say.

"This is my homage to Stevie Nicks," she says.

She continues to boogie, unfazed.

I myself am having a harder go of it.

Our apartment complex is a corridor of gossip. Voices ricochet up the concrete patio steps, and owing to the tropical climate, the walls of the building are uninsulated, providing a barrier that is merely ornamental. Our neighbors' daily habits resound with alarming clarity, making us inadvertent eavesdroppers of their private dramas. Through the bubble-thin walls we discern belches and bowel movements, tiffs and endearments, confronting, in other words, alternative ways of life.

Next door is an octogenarian married couple from Kentucky, and all morning long we can hear their preferred daytime talk shows blaring in the living room—the pep-squad ebullience of Kathy Lee Gifford, the nasally homiletics of Dr. Phil. Our apartment has a view of the pool in the courtyard, and in the afternoon I sometimes watch the two of them lounging on deck chairs in distressing casket-ready postures. Most of the other residents here are retired senior citizens, affluent snowbirds from New York and southern Québec, many of whom congregate in the open-air atrium around 4:30 p.m. for group trips to Cracker Barrel. My wife and I are in our early thirties, and our relative youth makes us a magnet for their attention. One morning, after returning from a jog, I amble out to the courtyard for a brisk round of pushups, and when I flip over for crunches, bronzed and shellacked in sweat, I notice several gray-haired ladies watching me from their apartment windows, like a panopticon run by AARP. Without quite noticing it, we have gradually become the apartment building's de facto form of tech support. Last week, I created a Facebook account for an unregenerate codger named Harold, whose profile picture I snapped by the swimming pool, for which he posed in a crimson leisure suit whose stench of mothballs was vainly undercut by a cloud of Brut cologne. My wife and I muse about a potential racket, a Geek Squad for geriatrics.

There's one younger permanent resident in the complex, a lanky English guy in his late forties who's rumored to be the scion of a London-based department store. He spends most of his days sunning by the pool and reading dog-eared paperbacks by Alain de Botton. Currently, he's ripping through *Religion for Atheists*.

Though twice I've told him my name, he persists in calling me "chap," which feels somehow both credibly British and deliberately impersonal. Still, his charm seems battery-powered, and because he's the youngest permanent resident in the complex, he is the source of fervent gossip among the old ladies. Apparently, he spends the entire winter down here, summoning a revolving door of women from Canada, Europe, and other parts of the US, some of whom tote children who are, presumably, his. Whenever we hang around the pool, the old biddies report his dalliances in scandalized tones, grasping our forearms and confiding their theories. "My theory is that he's got a whole harem of these broads," one says. "My theory is that he's trying to make it work with the one from Bulgaria." One Sunday evening a few weeks ago, one of the residents found him "porking" a brunette in the laundry hutch, his trousers puddled around his ankles. "They even had the dryer going!" I suspect their intrigue stems from the fact that the man lives in a blatant state of flux, trading old lovers for new ones, eschewing the standard midlife trajectory of settling down.

But sooner or later the ladies chide themselves for talking out of school, for spreading unwholesome impressions. Gossip, they tell us, is not a Christian habit of mind. Almost every week one of them will invite us to their church, and though we smile and make idle promises, my wife and I have no intention of joining them. Wasteful, we think, to have a sermon fall on deaf ears. But sometimes in the morning I watch these women assemble near the pool for prayer and morning devotions, their leather-bound Bibles thrown open to Leviticus or Ephesians or John 3:16, and I'm struck by the rigor they bring to these studies, the neatly inscribed jottings they make in small Mead notebooks. Much has been said about the erosion of literacy in this country, our customs of skim and glance, but one need only look at a Bible study conducted by Midwestern ladies to find a paragon of close-reading. Perhaps I shouldn't be shocked, exactly, especially when this particular act of interpretation can mean the difference between providence and perdition, when the arc of that story imbues every moment of their lives with the glimmer of cosmic meaning. Occasionally, when the wind isn't too rough and stray bits of their conversation float up to our apartment unimpeded, I am struck by the elegance of the scripture they recite, the lilt and rhythm of delivered praise. "In a moment, in the twinkling of an eye, at the last trumpet," they

say, in doddering unison. "For the trumpet shall sound, and the dead will be raised incorruptible." I watch them from the window, a circle of tinsel-haired women sitting at a patio table made of frosted glass, their heads bowed in the auspicious Florida sun, the pool flickering chimerically beside them, a loop of blue and gold. Max Weber once called himself "religiously unmusical," and while I can appreciate the kernel of his sentiment, I fall into a different strain of unbeliever, for I can still hear the melody in the parable, can still feel my neck kindle at the timbre of grace, even though it's a song I cannot bring myself to sing. "In a moment," the ladies say. "In the twinkling of an eye. We shall be changed."

Our rebirth, however, is of a more intemperate sort. We fall prey to other stories, place our faith in different beliefs. During the first couple weeks of our stay, my wife and I eschew work and become dedicated practitioners of sloth, letting emails and texts go unanswered, watching as every day stretches out before us like an open pasture, rambling with possibility. We buy cheap sunglasses with fluorescent rims and stroll aimlessly down the boardwalk, sipping beverages of deliquesced fruit from a calligraphy of neon straws. On mornings like this, with a boulevard of sunlight coruscating on the Atlantic, it's difficult to summon those old political enthusiasms, to pretend that this climate hasn't loosened the stiff joint of our convictions.

Something inside of us is becoming unhinged. Or rather I feel as though the whole notion of selfhood is becoming unhinged. In the words of our Midwestern grandmothers, we start "acting out of character." At night, we skinny-dip in the courtyard pool, our voices echoey and resonant, the underwater halogens turning the water the rinsed blue of Barbicide. And even though we've been vegetarians for years, we soon find ourselves ordering quarter-pounders with cheese, our napkins blotted translucently with the grease of contradiction. Even our professions are open to reform. One night, we watch a documentary about heroin addicts, one of whom admits to her substance-abuse counselor that she's been turning tricks, allegedly earning three hundred dollars per john.

"That's what I should do," my wife says.

My eyebrows shoot up. "Go on dates?" I ask.

"Become an addiction counselor," she says.

One could argue we've been penned in for too long, that we're

simply recuperating from a long cabin fever. But it becomes hard not to sense a certain questing spirit in our activities, as if the happiness we were chasing were an American rite of passage, a national pastime.

There's a television ad here on heavy rotation. Since our arrival, scarcely a day has passed that it hasn't aired at least a dozen times. The commercial opens with a montage of tropical motifs—sweeping aerial shots of wan coastlines and schooners marring cobalt horizons. The screen flashes with a row of deck chairs occupied by comely blondes in bikinis who toast one another with mimosas. The theme music is clubby and has a vaguely sexual backbeat, and after a short instrumental prelude, we are soon addressed by the lecherous voice of Pitbull—patron saint of Miami pop—who admonishes us in a series of gravel-voiced blandishments: "Feel free / to do whatever you want / whenever you want / with whoever you want." As the song rollicks on, the images of lotus eating come to us in torrents. Butter-glazed lobsters on silver trays. Rowdy men playing pickup basketball. A gang of half-nude twenty-somethings jumping exuberantly from a littoral cliff. But halfway through the ad something strange happens: the vocals cut out, and short gnomic messages colonize the screen, which somehow gives the impression that the viewer is supposed to sing along, like a congregant during the praise chorus at church.

> Rules are for land.
> Out here you're free.
> Free to indulge.
> Free to explore.
> Free to laugh.
> Free to love.
> Free to feast.
> Free to dance.
> Free to relax.
> Free to enjoy life's best moments.
> See a horizon.
> Change your view.

The captions here give prestige to an older American ethos, the freedom-lust of the frontier cowboy and the backwoods pioneer, both of whom roamed and rutted as they pleased. Like these national icons, the cruiser—it is an ad for Norwegian Cruise Lines—

should not feel beholden to any ideological commitments. In-
stead, unfettered from the strictures of the continent, he can
change course at the slightest whim and set out for new horizons,
all while engaging in a derby of carnal pursuits.

In light of the last couple weeks the commercial serves as a
cruel looking glass for our behavior, and I throw a sheepish glance
in my wife's direction only to find that she's fallen asleep, head
tipped back in a flutey snore, which means I have no one to chide
me for this halfhearted anthropology. Instead, I'm left alone to
contemplate a Nietzsche reference.

> And this is a universal law: a living thing can be healthy, strong and
> fruitful only when bounded by a horizon; if it is incapable of drawing a
> horizon around itself, and at the same time too self-centered to enclose
> its own view within that of another, it will pine away slowly or hasten to
> its timely end.

Nietzsche was responding to a cast of mind that had become
prevalent in Germany after the Franco-Prussian War, which sug-
gested that history was nothing more than a welter of pointless
battles waged over grim, untenable ideologies. That morality was
relative to the tenor of a given historical moment. The result of
such a worldview, Nietzsche believed, was that individuals would
commit their lives to petty agendas: the crass gratification of bodily
urges, the bloodless quest of idle pastimes. There'd be no more
grand causes, no more systems of belief. "We [would] desire the
happiness of animals," he wrote. "But not on their terms." Instead,
we'd float through life with the mutability of grocery bags drifting
insouciantly in the wind, seeking only lavish foods, luminous vistas,
and titillating incidents. Nietzsche had several terms for these in-
dividuals. He called them "men without chests" or "beasts with red
cheeks." He called them "last men."

I can't explain it, but the commercial makes me sad. It makes
me sad in the way certain dusking hours on a Sunday afternoon
often can—a despondency immune to consolation. I suppose you
could say that over the past few years I'd been approaching the
end of something, that I was running up against the frontier of
a certain manner of thinking. For so long, I had fallen under the
misapprehension that the point of life was to chase down a suc-
cession of exotic experiences, to accumulate anecdotes, to con-

struct a lurid diary, to toggle indiscriminately between the apparel of possible selves. Rather like Nietzsche's gutless milquetoast, my chest had grown hollow, and I had come begrudgingly to believe that no cause was better than any other, that I could place my faith in the indeterminacy of meaning and thus feel free to believe in anything at all. If all ways of living were considered equal and no true consequences stemmed from my ideological decisions, what difference did it make if I became a banker, a lawyer, a ballroom dancer? A Buddhist, an atheist, a Jew?

Of course, we forgot about the children. They start appearing in trickles and drips toward the end of February, but by the first week of March, scads of college students pour into the city, their rusted low-slung cars clogging every inlet and roadway. One morning, I go for a jog along the boardwalk only to discover that they've colonized the beach. Shirtless boys in straight-brimmed ballcaps migrate down the shoreline in groups as large as ten, jostling one another and razzing other beachgoers like some great cloud of hubris. Leggy females in fluorescent bikinis quaff openly from Solo cups, shouting vulgarities that would make their parents blanch.

In the middle of this bedlam, I pull out my phone and text my wife— *Noooooooo,* I type. *They're here*—and after a volley of commiserative messages, we agree to meet near Trump Tower, where she arrives a few minutes later in what has become her standard outfit of muumuu, shades, and sunhat.

I flourish my arms like a game show assistant, as if showcasing the beach.

"Oh, God," she says. "It's an infestation."

Whiffs of coconut sun-oil and Axe body spray, of watery pilsners and dried vomit assault us as we veer toward the encampment. Thousands of collegians are here, loitering under wind-tossed flags that bear their school's name: OHIO STATE, one says. INDIANA UNIVERSITY, says another.

As my wife escapes to a more serene vector of the coastline on the thin premise of getting some midday exercise, I turn around and begin swerving through the mayhem. The beach teems with incident, and the reigning mood is comparable to *The Garden of Earthly Delights.* There are beer bongs and quarters and rounds of beachside shots. Dozens of students are cavorting through the turquoise surf in a way that reminds me of a T-Mobile commercial.

I walk so far. When I finally turn around to measure the distance I've traveled, Trump Tower is merely a smudge on the horizon, and the Boschian chaos of spring break stretches into the distance as far as the eye can see—a blur of flesh and indulgence.

Heading back toward the boardwalk, I somehow find myself dragooned into a conversation with a quartet of bros from Indiana University, all of whom have corn-blond hair, impeccable orthodontia, and apostolic names: Matthew, Paul, Luke, and John. The boys are all wearing FitBits, and when I inquire about their devices, they become ecstatically animated, maundering on and on about their features and apps. To ask about this technology is to send them into reveries of self-improvement. They tell me about optimizing their workouts. They tell me about saving time. They tell me about sleep schedules and REM cycles and the Superman diet. For a minute, I toy with the idea of bringing up the idioms of Zarathustra, of mentioning offhandedly something about the perils of the Übermensch, but the fervor with which they speak about these self-bettering regimes makes it seem like they'd be impregnable to my concerns. They've fallen hard for the gospel of self-determination, of Dataism and enhancement, and I know better than to contend with hardcore zealots and challenge foundational beliefs.

Scarcely are the boys alone in their fervor. It seems to infect every last visitor to this cloudless swath of South Florida. It hovers over the poses of the sunrise yoga club, a group of hotel guests who contort themselves on the beach every morning, and pervades the temple of the South Florida Dharma Punx, a posse of young people with mohawks and narrative tattoos who aim for mindfulness without dulling their countercultural edge. More often than not, these promises depend upon a faith in materialism. Exercise becomes a conduit for self-invention, which suggests that a sculpted torso can be an emblem for a sturdy identity.

In hindsight, the injunction to optimize our selves has been hounding us since we arrived. Earlier this month, while spending a day in Miami, my wife and I came across something called "The Self-Mastery Gym," where a horde of true believers inside a banquet hall clutched flutes of prosecco and watched a bald man in Jeff Goldblum glasses stand behind a lectern and wax capably about Eckhart Tolle. And in the cereal aisle of a Whole Foods last week, a redheaded woman in a leotard and show-horse braids

handed my wife a flyer for something called "The Real You" re-
treat. The glossy brochure boasted "four days of fun & fitness," in-
cluding workouts with celebrity instructors, makeovers and fashion
shows, and an "All White Beach Party," which sounded like a soiree
hosted by the KKK.

My wife responded with a polite half-smile, equal parts derision
and amusement. "I'm not sure I'm ready, spiritually, for this kind
of commitment."

"I get that," the woman said, "but sometimes we have to go be-
yond our abilities." Our willowy spirit guide then flashed a runic
smile and retreated down the aisle in soundless ballet flats, which
were coated in ruby-colored glitter.

Not since the Sophists have there been so many spiritual con-
sultants—chakra experts, biorhythm specialists, and Vision Quest
advocates—all of whom are willing to sell you a certain version
of your life. We used to have counternarratives to defend against
these chimeras, to curb the tendency to see ourselves as omnipo-
tent—as gods. But today, tech prophets in headsets forecast the ar-
rival of our digital bodies, which in due time will no longer suffer
from canker and decay. Instead, we will "hack" our lives, program-
ming new efficiencies, our defects coded away. In a moment. In
the twinkling of an eye. We shall be changed.

The boys invite me to join them for a "boot-camp workout" on
the beach tomorrow morning, and I feign interest and give them
my number. "It was a pleasure to meet you," Luke says. "Yeah, drop
us a line," says Paul, "and hopefully we'll touch base tomorrow."

Dusk settles over the shoreline, a hallucinogenic wash of infant
blue and lewd pink, and the students gyrate to a song that blares
from someone's speaker. Darkness is upon them, but the students
are a thousand strong. They lift their hands exuberantly, a roil
of limbs and exaltation, and they bellow a faithful mimesis of the
lyrics, a great communal roar that sounds somehow both jubilant
and desperately pained. "And we can't stop," they cry. "And we
won't stop."

Of course, there is a point at which self-determination veers un-
avoidably into self-delusion. In March, the news breaks about an
eighteen-year-old boy named Malachi Love-Robinson who appar-
ently has been posing as a doctor at an outpatient clinic in West
Palm Beach. For nearly a year now, the boy has been running

something called the "New Birth New Life Medical Center," which offers a gamut of dubious services, including air and water treatments, phototherapy, and many other "natural remedies." On the walls of his New Life office, Dr. Love exhibits a fraudulent diploma from Arizona State, along with a doctorate of theology that is, apparently, authentic. While still in high school, the boy completed a PhD from the Universal Life Church Seminary, an online degree that can be purchased for $29.99.

One evening the pool in the courtyard is humming with gossip. The old ladies play judge and jury while fanning themselves with sunhats, wearing long sheer robes over one-piece swimsuits.

"Did you hear he's a Christian?" one says.

"It says here," says another, her face tented by the *Sun Sentinel*, "that he treated an elderly woman for severe stomach pain and charged nearly $3,500. Imagine if that had been one of us!"

Later that night we gather in a neighbor's apartment to watch an interview with Dr. Love on the nightly news, and I'm struck by the manner in which he conducts himself, a veritable theme park of bluster and prevarication. "The situation I face now is accusations . . . I'm not portraying as an MD. I've never said that I've gone to school to be an MD Accusations are merely accusations."

"Don't you just think that's awful?" one of the ladies asks. "Him pretending like that?"

Except I don't. The air down here is too polluted with mythologies, too humid with tales about freedom and reinvention.

It is difficult to say precisely when things begin to worsen for me. One morning in the atrium, I run into the debonair Englishman, who proceeds to say one of the most thoroughly British things I've ever heard: "Dreadfully sorry to interrupt you, friend, but I wonder if you're sharing my same trouble this morning. Though I can't say for sure, there appears to be, in my bathtub here, the presence of human waste." Dutifully I follow him into his apartment, where the stench of excrement hangs roguishly in the stagnant air. His bathroom has Kohler fixtures and monogrammed towels, but these luxuries do little to offset the scene of horror inside his bathtub. In it, there is a stew of shit, an ankle-deep gumbo of fecal matter that appears to burble nightmarishly near the drain. A plumber arrives a few hours later and tells us that the septic tank has ruptured beneath the complex. "You overburdened the

system," he says. "So now you've got shit coming up through the pipes." It's difficult not to read his statement as metaphorical, as though the stern expression he gives us were inflected with darker meaning.

Eventually, my anxieties become Victorian—gothic, even. All morning long I sit at the jalousie windows, lost in doleful contemplation, and from this elevated vantage everything takes on a mortal tinge. The octogenarian man who wakes at dawn to sit by himself near the pool, accompanied only by the jargon of morning birds, now possesses a drastic sadness, his torpor bewildering to me. I wonder how he can manage to sit there blinking at the blue nothing, as one hour slips irrevocably into the next. Soon, it occurs to me that our respective postures are shared, that I'm wasting just as much time as he is.

We make a point to get out more. At night, my wife and I walk along the boardwalk in the accretive dark, watching the spangled hulls of cruise ships retreat into the distance—tiered illuminated edifices that, to my wife's estimation, look like wedding cakes. The black water is varnished with the boat's emerald lights, and I think of Gatsby, think of Fitzgerald, think of Zelda going bats. My wife and I sit near the surf, debating the merits of antidepressants and professional therapy. Coins of moonlight flicker on the dark waves, and I tell her that coming down here hasn't helped. She knows, she says, and points out that I've been running twice a day. Reaching over to bracelet the girth of my wrist with her index finger and thumb, she says, you're getting twiggy. Marriage, Samuel Johnson once said, is "a continuity of being," and never before have I felt that sentiment with such ardor as when we sat along the lunar shoreline. It occurs to me that the vows we swapped three years ago in that little church in Michigan functioned as the lone instance in my life when I traded the freedom of choice for the burdens of commitment. So I tell her not to worry, that everything will be okay, but there's something in her expression that makes it easy to see she's not entirely convinced.

Near the beginning of March, my wife's sisters visit us from Michigan. We pick them up at the airport, and they come stumbling out of the terminal doors with an air of pallid exhaustion, a sluggish Midwestern ennui. Pushing flight-addled toddlers in strollers, they tote diaper bags and Samsonite luggage, which I race out of

the car to relieve them of. Our greetings are bright and lilting,
everything in falsetto, and on our way to the coast, they bring tid-
ings from back home. They tell us about an acquaintance who has
died, a friend who's getting married, and as these facts of life be-
gin to sink in, the illusions of our life here in Florida begin to
scatter and dissolve. Such is the way of family. Their mere presence
calls into question your entire manner of being and points out the
extent to which you'd been living under a mistake. I glance in the
rearview mirror, and my sister-in-law puts her arm up to my wife's
shoulder, comparing pigments, and the gesture almost seems like
an accusation.

My three-year-old niece is strapped into a car seat. Around her
mouth is a continent of juice-stain. She keeps saying, "This doesn't
feel like Florida, Mom."

They ask us how we've been. My wife mentions nothing of my
insomnia or my two-a-day jogs in the deadening heat. We don't tell
them that I've stopped writing, that we've paged through the Yel-
low Pages in search of out-patient clinics, that on certain mornings
I lock myself in the bathroom, sequestered with dire urges.

Over the next couple days, my wife's sisters fall under the spell
of the tropics. They unwind with pineapple daiquiris and spend
whole days beside the pool, abjuring sunscreen because, of course,
the scarlet burn will give way to a handsome sienna tan. Absent
other guardians, the children fall under our care, and my wife and
I ply them with colossal stuffed animals and gadgets that we think
are age-inappropriate.

One day, I spend a listless afternoon reading to my nieces by
the pool—illustrated books with spare plotlines that are told in
faithful terza rima. A young black bear with anthropomorphic eyes
hunts for salmon in an overfished river before eventually losing
track of his den. It's a smart book, I think, about greed and the
perils of a debt economy. We lie on a deck chair, and the girls,
who are two and three, have cuddled their heads into my armpits
while I hold the book over my chest. It is an old volume, a battered
hardcover with a torn dust jacket, its edges curling like birch skin.
My wife sits along the lip of the pool with her feet in the deep end,
making little dawdles and splashes, the water cerulean and twin-
kling behind her. Chewing the limb of her sunglasses, she watches
me read to the girls with an attitude of evaluation, as if, despite

her aversion to having children, she were measuring my fitness as a father.

Somehow, despite my best efforts, I have returned to the realm of stories, have settled unwittingly into the arcs of conflict, climax, and denouement. As I'm reading about the bear's tribulations, some dormant critical reflex is activated in me, and I'm soon interpreting his adventure not merely as a lesson about the virtues of communal life but also as an Iliad of self-delusion, knowing full well that the beasts who haunt our hero are not real threats but figments of his own making. Tragedy, Adam Phillips writes, doesn't show us "the horror of life" as we know it. Instead, the genre aims to dramatize "the horror of life under the aegis of a certain kind of conscience."

But when I turn the page to bring the story to a close, we find ourselves up against the inside back cover, a hard blank surface— empty, inscrutable, showing nothing—at which point I realize the last couple pages have been torn out—it's an ancient and poorly kept storybook, after all, its original owner probably my wife's grandmother. So the story will end here, cantilevered over empty space, uncertain the outcome awaiting our skittish woodland hero. When I try to explain the missing pages to my nieces, they are not simply flummoxed, they are tearfully indignant. They want to know—what's the story? How does it end? Their expressions are wounded with earnestness, their eyes tear-glinted and full of anticipation. I glance at my wife, who can sense my distress, and who tries to assuage the girls with palliative phrases, with the promise of TV and ice cream, but their unhappiness cannot be contained. I am thirty-one years old, a husband with a lettered disposition, someone who attended grad school to learn the art of telling stories, who knows all about the conventions of storybook endings, a person who can chart character development the way doctors read EKGs. But for some reason, I cannot lend this story an ending, cannot give it some final meaning.

Without explanation, I get up and run. Because I am stuck in this lousy failing body, I run. Much to the confusion of our nieces, I dash up to our apartment, change into my sneakers, and I'm out of the door within minutes, bolting down the side streets, flying past the condos, the resorts, the garish retail developments. The

sky above the shoreline looks hazy and provisional, something that
will surely darken before it comes to an end. Pageants of tourists
maneuver down the boardwalk, families and couples and loutish
spring breakers, everyone fleeing the approaching storm, and I
am the lone person running among them, my breath audible and
gruff. I've grown so tired of stitching this into some orderly nar-
ration, when the truth is that I have no more stories to relate, no
more anecdotes to decode. The only thing left is the dumb lurch
of my body and the vans of this buffeting wind.

I make it as far as Trump Tower, where I stop, hunched over
and gasping for breath. The sky over the ocean is forked with
lightning and the sidewalk is pocked with rain, and I veer under
the hotel's porte cochère where there are, inexplicably, squadrons
of men—workers, presumably—who are barking orders through
static-glitzed walkie-talkies, running pallets of boxes into the fren-
zied atrium. From outside the glass of the doors reflects the drab,
rain-muddled street, but when I cup my hands around my eyes,
I'm astonished to find the hotel's interior humming with life.
Inside there are sweeping marble floors and trios of low-backed
chairs, accented with autumn-colored pillows. It looks nearly fin-
ished. How long have they been at work, invisibly but diligently,
without ever once drawing notice? Months later, in the middle
of that fateful November, it would become impossible not to see
this moment as a harbinger of how wrong we had been. Down
here, in these balmy climates, one can easily come to think that
the world boils down to the whims of the body, that ideology is
nothing more than a thing of the past. But these men had been
summoned to another calling, driven by some unseen master, and
together in these months of vague disquiet, they had erected this
formidable structure. We had presumed it was empty, but their
work was nearly done.

ANYA VON BREMZEN

Counter Revolution

FROM *AFAR*

"STAND STILL. GLASSES OFF!" barks the blonde at passport control in Moscow's Domodedovo Airport. She fingers my visa, peers at my face, then scowls back at my visa for a long, long minute, clearly relishing my mounting anxiety. "Anything wrong?" I squeak in a small voice, fighting a Soviet instinct to address her as "Comrade." "Nah," she finally sneers. "Just wondering why you look even worse in person than you do on your visa."

I snatch my stamped papers and tramp off toward the airport train past gaggles of guys flogging overpriced taxi rides into Moscow. "Come with me," one of them tugs at my sleeve. "Why ruin your not-so-young health, lady, with your not-so-beautiful luggage?"

Home. Or, more grandly, *Rodina*, Russian for homeland. An ideologically loaded and often overbearingly patriotic noun back in the Soviet days. With this Rodina my relationship has been extremely complicated, ever since the rainy day in September of 1974 when my mother and my ten-year-old self stood at Moscow's Sheremetyevo Airport, stateless refugees stripped of our citizenship and the right of return after my mother decided to flee the despotic Soviet regime. We bade our existential farewells to the family we never expected to see again. But in the late '80s, after Gorbachev opened the border, we did return, a miraculous rising from the dead. I remember our relatives' tearful eyes as we reentered the same Sheremetyevo Airport; how they kept touching our American coats to assure themselves we weren't a mirage.

I was in the Soviet Union again on December 26, 1991, when its scarlet empire ceased to exist and the entire nation became ef-

fectively sundered from its own "glorious socialist past." I've since returned to Moscow many times—during Yeltsin's lawless "crapoc-racy" and then Putin's kleptocracy—but these homecomings never quite feel normal. I fret over the draconian visa application. I worry about the loss of identity, Moscow's and mine, as the city changes so dramatically. In 2011 I spent a month in Moscow fin-ishing my memoir, *Mastering the Art of Soviet Cooking*. And I got so fed up—with the bling, the inequality, the mistreatment of Central Asian migrants, the twelve-dollar espressos, that imperious Mos-cow Gaze, to say nothing of Putin's authoritarianism—that I made no further plans to return.

Much has transpired in Russia since then, most of it politically awful, from the war with Ukraine to the spectacular collapse of the ruble. Yet along with the usual intimations of doom, I was also hearing positive stories. That Moscow was becoming, at long last, a livable city. Cheaper. Friendlier. Normal! With five-dollar Uber rides and affordable Airbnbs, bike paths on the streets and Wi-Fi in the metro. Where the oligarchs once guzzled Château Pétrus, woolly hipsters were now apparently lolling over craft beers in the dim glow of Edison lightbulbs.

Finally, what drew me back were reports of Moscow's incredible and improbable restaurant renaissance.

I'd always been fascinated with the flamboyance and the sheer theme-parkish strangeness of Moscow's twenty-first-century dining scene, but it also seemed bafflingly inauthentic. Sushi had long replaced *selyodka* (herring) as Russia's national dish. The onions at supermarkets were Dutch, the tomatoes from Turkey. On previous visits I kept puzzling why here, in one of the world's richest agri-cultural countries, more than 40 percent of food was imported. Then in 2014 Putin, in retaliation against Western economic sanc-tions following the Ukraine-Russia crisis, issued a ban on most foreign foodstuffs. The embargo launched with all the drama of Stalin's political show trials: truckloads of Polish apples crushed live on TV; wheels of Italian Parmesan tossed into vast public bon-fires. Citizens were urged to inform on the comrades who secretly noshed on Camembert and Ibérico ham.

And amidst this surreal political carnival, something exciting had happened: twenty-five years after the collapse of the USSR, Muscovites had finally begun rediscovering Mother Russia's own cuisine and ingredients. This new food patriotism—stoked by

Putin himself—had sparked Moscow's current restaurant boom-
let. And so, hungry for *stroganina* (Siberian shaved frozen fish),
piroghi (Russian savory pies), grass-fed beef from the Volga re-
gion, and giant snow crabs from Vladivostok, I bought a ticket for
Moscow. A deeper reason? Between meals, I was hoping to squeeze
in nostalgic visits to familiar places in the hope of finding resonant
fragments of my past and myself—of Home—amidst the espresso
bars and locavore hangouts. And so my boyfriend, Barry, and I
alighted at Domodedovo Airport to that achingly Russian welcome
of insults. (Who said Moscow got friendlier?) My eighty-two-year-
old mom, a fierce Putin-basher, had already arrived from New York
and was staying with relatives.

After checking into the Metropol, a fragrantly historic hotel near
the Kremlin, I leave Barry to admire its art nouveau murals and
stroll over to Bogoyavlensky Lane nearby. On this street I was born
in a Brezhnevian communal apartment where eighteen families
shared one bare-bones kitchen, where alcoholics slumped in the
cavernous hallway, and a larcenous little babushka would burgle
soup meat from neighbors' pots. I come to this street not expect-
ing any Proustian savor, though. This corner of Moscow, a few
yards from the Kremlin, has become real estate so exclusive my
former building now stands half gutted and clumsily padlocked—
no more than a forlorn shell of a facade, awaiting its upscaled fate.
 "I used to live here," I confess to a passerby, overcome with sud-
den emotion.
 "*Nobody* lived that close to the Kremlin," she snaps and walks off.
 I console myself nearby at Alyonka, a new sweets emporium,
named for the iconic Soviet brand of chocolate with a mirthful ker-
chiefed girl on the wrapper. Alyonka sits on handsome Nikolskaya
Street, which I barely recognize; it's been pedestrianized and out-
fitted with benches and flowerpots as part of Mayor Sergei Sobya-
nin's ambitious Moscow beautification program. Alyonka itself
beautifies—and commodifies—our Soviet past with its cheerful
bounty of retro confections. Proustian-enough moment achieved:
I feel a childish thrill now, sifting through bins of these socialist
madeleines in bright wrappers designed by the Red October choc-
olate factory. Here are Crayfish Tails, caramels that tormented the
dental fillings of the proletariat; here are the prestigious Mishka
the Clumsy Bear chocolates with brown Mishkas climbing trees on

icy-blue wrappers. I load up my shopping cart and stand in a line so long it nearly catapults me back to the USSR. "You gonna eat *all that?*" demands a woman behind me. "No, they're presents," I assure her. "Phew," she exhales, "'cause you sure don't look like you need any more calories."

Nobody insults me that evening at Grand Café Dr. Zhivago. This new venture from Moscow's current restaurant czar, Alexander Rappoport, sits inside the landmark Hotel National across the way from Red Square. As a nine-year-old obsessed with the mythical and unattainable West, I would loiter by the National's door in the hope that some friendly foreigner might toss me a ballpoint pen or a packet of capitalist chewing gum. Now I feel secret triumph marching past the young maître d', myself a foreigner. Zhivago is yet another vessel riding the wave of Soviet nostalgia that keeps washing over Moscow and now, to my utter surprise, seems to be cresting. The striking room is all neoclassical whiteness framing scarlet accents a sexy shade pinker than the orangy red of the USSR. Snow-white statues of Young Pioneers stand impishly blind-folded with crimson kerchiefs—as if they'd lost their path to the Radiant Future and were abducted into a decadently capitalist neo-Soviet pastiche. "Foo, *yuk,*" my mother grumbles about the de-cor. "They are literally *whitewashing* the Soviet past." She also *foo*'s at the restaurant's blithe appropriation of the title of the epic dissi-dent 1957 novel by Boris Pasternak. "*Zhivago* changed my life," she declares solemnly. "I read it in manuscript fresh from Pasternak's typewriter."

Our dining companions are Bo Bech, a celebrity chef from Copenhagen who is guest-stinting in Moscow, and Brian McGinn, producer of the Netflix series *Chef's Table,* in town filming an epi-sode—all meeting here in Russia by a happy coincidence. They nod politely and slather their blini with caviar. "Russians went from shit to bullshit," says Bo, agreeing with Mom. Our host, Gen-nady Jozefavichus, bon vivant, travel writer, and uber-hipster, snaps imperious fingers at waitresses dressed in retro chambermaid out-fits. Out come frosty carafes of interesting vodkas, along with the wildest of wild pickled mushrooms and herring more buttery than Japanese toro. *Pelmeni,* the iconic Siberian dumplings, here sport a filling of Kamchatka crab; the Salat Olivier, a mayonnaise-laden USSR New Year staple, is returned to its original nineteenth-century version, with crayfish tails. This is food from Soviet com-

munal apartments—glamorized and locavorized with Siberian fish, artisanal lardo, and heirloom millet and buckwheat. "*True* Soviet food was never meant to taste this delicious," my mother protests before surrendering to the inauthentic deliciousness of the *solyanka* soup loaded with smoked meats and sausages. "The hookers aren't here tonight," whispers Gennady. "Aren't hookers so '90s?" asks Barry. "Moscow hookers," declares Gennady philosophically, "are eternal."

The next evening, we're perched at the dining counter of the WR Lab, a small slate-clad space where thirty-four-year-old wunderkind chef Vladimir Mukhin, the culinary force behind an eighteen-restaurant empire, previews the tasting menus for his flagship White Rabbit restaurant. An unstoppably creative fifth-generation chef born in a provincial town in the northern Caucasus, Mukhin is applying futuristic techniques to old Russian dishes, decoding food clues from Slavic folk tales, searching in remote villages for forgotten traditions. His latest obsession is *Domostroi*, a sixteenth-century bible of Slavic domestic advice and recipes.

Mom, a passionate amateur food historian, bounces up in excitement at the opening dish. Called Scarlet Flower after an old Russian fairy tale, it's a tart juicy begonia blazing red on a picturesque nest of twigs, its petals filled with May honey fermented inside a hollowed-out radish. Folklore imbued flowers with magic, Mukhin explains, because they could heal: begonia, it was believed, would treat stuttering and allergies. From here we're off deeper into archaic Russia, with birch bread made from the tree's ground inner core. The flavor invokes morning walks in some primordial forest. "Ecologically pure and gluten free," notes Mukhin, grinning, "this bread is our past and our future." We also taste *ryazhenka* (a kind of baked yogurt) concealing a mousse of swan liver (Slavic foie gras of yore); white caviar of an albino sturgeon; and *kundyumi*, centuries-old dumplings black from the flour of dried bird-cherry buds. Mukhin spins his ingredients into a narrative that in the course of the meal helps explain our cultural DNA. At the end of the evening, Mom poses for selfies with Mukhin and demands that I post them on Facebook *immediately*.

Over the next few days my plans for nostalgic strolls down memory lanes along Moscow's winding streets and flowering boulevards keep crashing against Mayor Sobyanin's pharaonic $2 billion

"My Street" program. Under Sobyanin, each summer the historic center turns into a muddy construction zone as facades are overhauled, sidewalks widened, and streets often pedestrianized. Mom complains that not since the Stalinist '30s, when vast swaths of the city were bulldozed and churches destroyed, has Moscow seen anything like this. "Frigging pedestrians, they'll own the city now," Uber drivers lament, before launching into their usual tirades against America's hand in everything from common colds to bad weather.

To escape Sobyanin's apocalyptic beautification-in-progress, Barry and I take the metro out to VDNKh in northeastern Moscow. Inaugurated in 1939, this six-hundred-acre Stalinist theme park glorified Soviet industry and the agricultural might of the Soviet republics (never mind that by the start of that tragic decade millions of peasants had perished from famine). On my last visit, the park's propaganda-kitsch sprawl resembled a morose ruin of a fallen civilization. Its decrepit ornate pavilions, which Federico Fellini once called the "hallucination of a drunken pastry chef," advertised shabby fur coat fairs and cat exhibits. Now, with Putin's personal blessing, VDNKh is getting a makeover by the same savvy team that turned the derelict Gorky Park, another Stalinist relic, into a multimillion-dollar hipster arcadia featuring the Rem Koolhaas–designed Garage Museum of Contemporary Art.

Strolling up the wide central avenue of VDNKh, I once again recognize things, yet don't. Gone are the tacky kebab stalls. The towering eighty-two-foot-tall *Worker and Collective Woman* statue has been moved to its own chichi museum. The Stalinist Empire–style colonnades of restored pavilions gleam in the June sun under a fresh coat of that New Moscow whiteness. Spruced-up hammers, sickles, stars, and socialist realist murals and statuary, so familiar to me from my childhood, now resemble some gigantic fantastical restaurant decor. The park offers yoga classes, edgy art shows, food trucks, even a farmers market. "Hipster Stalinism" is what some commentators call this repurposing of totalitarian public spaces into playgrounds for the iPhone generation.

As a Moscow kid I was mesmerized by VDNKh's "People's Friendship" fountain: a gilded 1950s extravaganza of sixteen monumental maidens in the national garbs of the Soviet republics encircling a vast sheaf of wheat. When I was a girl, most republics had representative restaurants in Moscow, the empire's capital.

The oldest and most famous of these was Aragvi, a Georgian land-mark on Gorky Street. Opened in 1938, Aragvi offered an oasis of hedonism in that terror-filled era of purges and gulags. Here my father blew an inheritance left by his grandmother (who perished in the gulag) on sizzling lamb riblets and chicken in walnut sauce. Here Lavrenty Beria, Stalin's bloodstained chief of secret police, had his own dining room, with a small balcony from which he spied on the customers. In Aragvi's private rooms the lyrics of the Soviet anthem—celebrating "the Unbreakable Union of freeborn Republics"—were penned; airplane designs were sketched; and visiting celebs such as Yves Montand and John Steinbeck smacked their lips over spicy Georgian specialties.

Privatized during the Wild East Yeltsin years, Aragvi by the end of the '90s had become a notorious *mafiya* hangout, and it was finally shuttered in 2003 after the attempted murder of one of its owners. Now, like many Soviet icons, it has made a *kambek* (that's Russian for comeback) after a $20 million makeover.

My heart races as Mom, Barry, and I trudge through the puddles (it's been raining relentlessly) and the construction scaffolding on Tverskaya (formerly Gorky) Street toward Aragvi. The restaurant is Moscow's history—my own family's history! Yet another sudden downpour sends us ducking into a huge bookstore, where I gasp and feel simultaneously proud and utterly mortified to see my So-viet memoir, recently translated into Russian, featured in a cheesy crimson display of USSR-kitsch memorabilia. Once inside Aragvi, we're offered a tour that includes Beria's dining room, now all blinding white (that whitewashing again) brightened with murals of happy collective farm workers. For me, the reconstruction lacks coherence, but the Georgian food truly shines, from the cheesy *khachapuri* pies crowned with a sunny baked egg to the fist-size *khin-kali* (meat dumplings). I understand now why six generations of Muscovites raved about Aragvi's signature chicken *tabaka* (crisp-fried under a press) and those succulent lamb riblets. A huge hall-way mirror is about the only artifact left from the restaurant's orig-inal decor. "Beria," my mother whispers, with a shudder. "I swear I can see that monster's bald head and his pince-nez in this mirror."

The Kremlin's recent truce with the Republic of Georgia as-sured the return of sun-kissed Georgian food imports to Moscow. Ukraine? A different story entirely, given the ongoing *krizis*. In this heated political context, the extravagant 1950s mosaics at Ki-

evskaya station of the Moscow metro glorifying the indomitable Russo-Ukrainian friendship seem like a particularly cruel political joke. Emerging from the station the next evening, Barry and I pass under the Stalinist hulk of the former Hotel Ukraine—loudly rebranded as the Radisson Royal—then parse the ironies over contraband fish smuggled from Ukraine itself at the restaurant Barkas, a new riverside hot spot dedicated to the garlicky Jewish cuisine of Odessa, Ukraine's buoyant port city. Sharing the ironies—and the potent horseradish vodka—is our New York friend Masha Gessen, who's in town researching a book on historical memory. Masha, a writer and a courageous critic of Putin, emigrated, as I did, as a kid, then moved back to Moscow in the '90s, then recently reemigrated. Mouth full of crisp latke and fluffy chopped herring, I talk about the de-ideologizing and aestheticizing of the Stalinist past at the city's reclaimed public spaces. "Not just *aestheticizing*," snaps Masha. "They [the Putin regime] are resurrecting it wholesale: restoring the Soviet imperialist values."

Masha, my mom . . . I envy their political clarity. Myself, I'm caught in a perpetual moral bind of falling—hard!—for the scarlet "Planet USSR" with its rebranded Soviet theme parks and chocolates, then feeling pangs of guilt for my glee. During my week in Moscow, the Metropol Hotel becomes my refuge from the construction, insistent rains, and conflicting emotions. With its iconic art nouveau look, the Metropol served as a hostel for the new Bolshevik government members after the 1917 Revolution. I love the view of the Bolshoi Theater from our old-fashioned suite, love the harpist tinkling under a stained glass dome in the breakfast hall where Lenin and Trotsky orated and schemed. Love the inspired New Russian cooking—that borscht!—at the Metropol's Savva restaurant. One day, the hotel's resident historian gives us a tour of the three-room suite where Nikolai Bukharin, Lenin's favorite Bolshevik, lived with a menagerie that included an eagle, a bear cub, and a monkey. In 1938 Bukharin was executed after one of Stalin's notorious show trials.

On our last day in Moscow, Barry and I share enameled metal bowls of pelmeni, Siberian dumplings, around the wooden communal table of a "dumpling boutique" called Lepim i Varim, or Shape and Boil. This sweet *lokavorosky* (locavore) spot run by three young dudes, two of whom are hosts at Moscow's Comedy Radio, aims to hook Muscovites on Russian fast food. Outside, the peep-

ing Moscow sun glints on the pedestrianized Stoleshnikov Lane (Moscow's "it" shopping street), where nineteenth-century facades preen in new coats of buttercream and pistachio. The gazelles strutting out of Chanel and Louis Vuitton stores most likely have no idea that the journalist Vladimir Gilyarovsky, a legendary chronicler of Moscow's late-nineteenth-century restaurant scene, lived on this street. Suddenly I recall the days of Brezhnev-era stagnation when my parents were still together and Mom, Dad, and I ate frugal borscht and stale sausage while reading Gilyarovsky's orgiastic descriptions of suckling pigs and tall sturgeon pies at Moscow's fin de siècle taverns. How preposterous, it dawns on me now, how completely improbable it would have seemed to us then, the idea of me flying in from New York to report on Moscow's 2016 revolution in dining. I call up my mom to share these thoughts with her. She's having lunch with her now octogenarian school friends.

"*Da, da,* isn't life strange?" she chuckles. And then demands: "Did you post my photos with chef Mukhin on Facebook? How many likes did it get?"

Vacances

FROM *Esquire*

The Dinner Party

ONE OF THE SELLING POINTS my wife, Anaïs, pitched me before bundling me off to France to live the rest of my days was that we'd have six weeks of vacation a year. I grew up in Georgetown and came from a family who didn't vacation well at all. I thought everyone flipped their outboard skiffs or had their luggage stolen in Budapest or unwittingly brought poison ivy into China. My first grand tour of Europe was a ten-day Griswold-esque blitz through Paris, Amsterdam, Rome, and Venice. At the time, I thought it was normal to hit the Louvre drive-by style, then dash through the Tuileries Garden to grab a seat on a Bateaux-Mouches boat that sped past the Eiffel Tower while you wolfed down your dinner so you could catch an overnight train to Marseille.

The first hint that there might be a better way came at the other end of that train ride, at a topless beach. Even though I was nine, I still remember it vividly—yes, because of the breasts, but also because everyone seemed so perfectly at ease, like they were in a Seurat painting. Charming white-and-turquoise boats rocked in the harbor. Older men played leisurely games of *pétanque*. Pastis flowed like a ruptured water main. Even as a nine-year-old, I had the impression that these people not only knew how to live, they knew how to take time off. It was equally clear that my parents, on the other hand, who exited the changing booths bitching that we'd better hustle up if we wanted to see where Gene Hackman filmed *The French Connection,* did not.

Anaïs and I had met in a French café in Brooklyn called Le Gamin, which just happened to be on the ground floor of my building. She had one of those bobs with concave bangs that made her look like an adorable KGB agent from the 1960s. Anaïs wasn't the first Frenchwoman I'd dated. In fact, ever since that topless beach, I'd been mythologizing France and Frenchwomen to the point of fetish. Forget Farrah Fawcett or Michelle Pfeiffer, I dreamt about French actresses like Anne Parillaud, aka *La Femme Nikita,* and Béatrice Dalle from *Betty Blue.*

And now, two and a half years after we met, Anaïs and I were married with a child and living in Paris. I had a beautiful French wife and new *bébé,* and I had ditched America's lame, puritanical, two-week-if-that vacation for the six, seven, even eight weeks' holiday that is the birthright of the French—enough time for a man to really hone his vacationing skills. I pictured us jaunting off to Normandy in October to watch the colors change while we made vats of cider. During Christmas, we'd drink mulled wine with our extended family while the kids fawned over the Galeries Lafayette department-store windows. In February, we'd ski in the Alps and eat fondue, and at Easter we'd be somewhere warm like Antibes or Marrakesh, working on that base tan for the fat three-weeker coming up in late summer. All this was not only legal, it was encouraged!

My rookie error came my first year in France. Of course, I'd always heard that the French abandon Paris in August. Naively, though, I thought I'd beat the French at their own game. While everyone else was gone, I told myself, we'd have Paris to ourselves! I didn't realize that after July 15, the Left Bank becomes an annexed protectorate of Wichita, Kansas, overrun with Reebok-wearing Midwesterners. And in the places tourists don't venture, like my neighborhood in the Tenth Arrondissement, you could possibly starve to death, because everything is closed.

Unlike me, Anaïs didn't care that we seemed to be the only people not vacationing. While she's politely listening to someone recount their trip to the Dordogne region, I'm asking exactly where the Dordogne is and what they packed and how they looked for houses, trying to find patterns and links that would help me master this high French art and live the *Moveable Feast / Year in Provence / Under the Tuscan Sun* fantasy. And I learned that one reason the French can afford so many weeks of holiday—skiing, swimming, etc.—is that unlike Americans, they do so *en groupe.*

So one January, after dinner at the home of our friends Stan and Elisabeth, the conversation naturally turned toward the August holiday. The talk became more serious once we retired to the salon for a digestif. A laptop was moved to the coffee table and we all snuggled around the couch, looking like an impromptu key party, searching for houses to rent. Greece was in play early, then Spain made a run, but as choices were vetoed and prices compared, we coalesced around Italy, and the long shot of Umbria. It wasn't as touristy as Tuscany, and it was cheaper. The house was bigger, and it had one of those infinity pools overlooking the hills.

What I didn't know then was that by merely looking at the photos and parroting phrases like *"pourquoi pas!"* and *"super cool!"* I was signing a moral lease that bound us all together eight months down the road.

Rule No. 1 of French vacation: Never toss out the idea of vacationing with people unless you really intend to vacation with those people.

Eight months later, Anaïs, Bibi, and I were driving through the Umbrian countryside ogling the lush chestnut groves and elm forests, the sweet wafts of lavender streaming through the sunroof. The yellow-ocher hills pitched and rolled as far as the eye could see, while the cypress trees that lined our road stood green and upright like soldiers saluting our arrival.

But I probably should have been flooring it, because of

Rule No. 2: Your bedroom is decided not by who draws the short straw or who pays the most but by the time-honored French gentleman's agreement of first come, first served

—which in this case was Stan and Elisabeth's friend Bashir, despite the fact that he was single. We, alas, were the last to arrive.

On our way to the only remaining room, we passed the airy and cool suites on the first floor with big windows overlooking the pool and the vista behind it. Laptops were open, and clothes were strewn everywhere, as if to say, "Look, I can't just pick up and switch rooms now." I even saw a photo that had been hurriedly tacked to a wall.

The room we'd be staying in for the next two weeks was up a long flight of stairs at the end of a hall. Its one window was choked off by thick ivy, so no breeze could penetrate. "You have great shade! I'm jealous," Elisabeth said, entirely unconvincingly, as she left us to gripe.

Rule No. 3: Remember that you not only vacation with friends, you vacation with their friends as well, people you've never met until you actually arrive.

Sometimes they are cooler than your actual friends, which gives you the option of upgrading. Other times they're so awful it makes you question not only your friends' taste in people but also whether you're the exception or the norm.

And then there are surprise guests. In the car, driving to the destination, you'll receive a text explaining that someone's seventy-year-old mother is set to "pass through" for ten of the fourteen days.

Elisabeth and Stan, our friends from that initial dinner, both worked corporate jobs. There was one artist, Bashir, the Lebanese muscle-bound sculptor whom I called "the sculpted sculptor." Then there were the divorcees, François and Simone. The soft-spoken and genial François would be staying with us for two weeks and then continuing on to meet his adolescent daughter in Sicily for some father-daughter time, just to give her a glimpse of what life would be like now that she had a sad dad. Simone, meanwhile, was constantly monitoring her phone in case her lonely father called. "He really wanted to come with us this year!" she told us. (Bullet dodged.)

By the way—and this cannot be underlined enough—we were the only ones with a child. Bibi, now four, was embarking on her first real French vacation, too, and it turns out she'd end up being the only friend I could count on during our stay.

A Taste of What's to Come

The French are naturally good cooks; I'll give them that. They're like friends who grew up with gearhead dads and can fix a lawn

mower as easily as I can post something on Twitter. Vacations for them are a chance to get behind the apron and show their skills.

Rule No. 4: The first twenty-four hours of a French vacation must be reserved for "the food shop."

First, you're huddled in long debates about who wants what on the menu that week. Some will come with recipes they've ripped out of *Elle* magazine. Others will want to get the lay of the land first.

Once the food was gathered (from three different places), the mission was to drive together to another village to find the right wine, and since the market that sold the fish was closed, it was decided we'd come back the next day.

Over limoncello and candlelight that first night, it was announced with fanfare that there would be activities—but not the kind you find listed in a pile of brochures. No, each of these *ateliers* ("workshops") would be headed by, yes, one of us, depending on each of our respective talents and passions. Let me repeat this: on the first night of my French vacation, I was told I'd be working.

Rule No. 5: For the French, vacation is a job.

A list was thumbtacked to a corkboard in the entryway, with the programs written down next to the name of each "professor." There was an *atelier abdo-fessier* (a snobby word for crunches) manned by Elisabeth, plus an *atelier peinture* guided by Simone, an *atelier philosophie* ("Spinoza?") was Stan's gig, and an *atelier théâtre* would be led by Anaïs. Aside from the fear of having to act in a play directed by my wife, what stressed me the most was that it wasn't apparent to me what my talent was. Eventually, I proposed an *atelier stand-up*, mainly so I could heckle my housemates with impunity. (I'd learn later on from other French people that these *ateliers* are not at all typical, though they seemed intrigued by the idea, so I may have inadvertently helped to spread it.)

A heat wave was sweeping Europe that summer. Unable to sleep, I moved onto one of the couches downstairs. "What, can't John live without his AC?" Bashir needled Anaïs the next day.

Ironically, I *did* dream about AC that night. As I slumbered in

this picture-perfect villa, I dreamt I was in a blinds-drawn hotel room in an anonymous Charlotte Radisson, soulless and freezing — a place I'd always imagined to be the nadir of American travel but that now I might have traded for.

The Bathing-Suit-Mozzarella Incident

On French vacation, there's no chance of sleeping in, especially when you're sprawled on a living-room couch. I'd awake around eight to commotion in the kitchen made by early risers already fixing a giant tray the French call a *plateau,* which holds tea, coffee, bread, butter, cheese, and jam for everyone. The *plateau* is a sort of dinner bell for French breakfasts, and its preparation is the signal that everyone is expected, once again, to eat and be together.

I don't do chitchat precoffee, so for the next few mornings I scurried up to my room after folding up the couch, telling our housemates that "I need to help Bibi put together that Lego horse stable she's been wanting to build."

Bibi, I learned, hated *plateau* as much as I did. She was used to our laid-back style in Paris: cereals and croissants and baby bottles and coffee in our bed each morning, which she called *le camping.*

"Pourquoi no camping?" she asked, on the verge of tears.

"Because," I said, flashing an unsettling smile like the one Jack Nicholson perfected in *The Shining,* "we're on *vacation,* that's why."

"Well, I hate vacation, then," she pouted.

"Me too, dear. Me too."

My absence, however, did not go unnoticed. "Where is the American?" they'd ask my wife, loud enough for me to hear them through the ivy.

The Breakfast Club would then all wash dishes together and hit the pool. A net was brought over from the garage and a volleyball game would start up. I tried to sleep, but the *bink! bink!* of the ball, followed by a splash, then an *"ohh — trois zéro!!"* made it too hard to ignore. And amidst the splashes and the yells, all of this at 9:00 a.m., there was the announcement "One more game, and then we're off to food-shop!" which was met with a sort of childish group response of *"Ouiiii!!!"*

The lure of the cool water proved too strong, and I soon found

myself joining them. But what started as simple back-and-forth lobs of the volleyball morphed into a game, and although I was a novice, my unorthodox serve turned out to be effective. Before I knew it, the game had become serious, and Bashir suddenly flashed in anger, which I found flattering, only because it meant my serve was baffling him.

Now I was flopping around the shallow end, trying to save the ball at all costs, spiking on a frail Simone, taunting the other team with wide eyes, all with the goal of beating Bashir's ass. Not because he'd taken the best room and brought his own stress into my vacation, but because I wanted so badly to be able to ask him at tomorrow's *plateau* if he planned on hosting his annual "How to lose gracefully in volleyball" *atelier.*

The excitement in the pool made me hungry, and while the others were resting on their chairs following the game, I darted into the kitchen on wet feet and a dripping bathing suit to raid the fridge, breaking

Rule No. 6: There will be no snacking.

I was pawing some mozzarella and cutting wedges of tomatoes when I heard footsteps, which forced me to shove the tomatoes in my mouth and—sadly—the mozzarella down my bathing suit.

It was Elisabeth, and I could tell she sensed something was up. "We'll be leaving for the village in a couple of minutes if you want to get ready," she said. I nodded and smiled with a closed mouth. Since bathing-suit mozzarella should never be put on bread, I inhaled it like a Jell-O shot, then changed clothes for another two-hour food shop.

I'm not sure if the French obsession with being together on vacation has to do with the ingrained notion of *République* they learn at school or whether it comes from the *colonies de vacances* (summer camps) they attend in July. But the more my housemates wanted to be together, the more I wanted to be alone, and by the second week, the impromptu *atelier* I'd created could have been called Find the Hiding John.

"Où est John?" became a group rallying cry, because John, it seemed, was always needed for some pool game, some *bocce* contest right before dinner, or some karaoke sing-along of bad French '70s music. I can't tell you how many times I'd be relaxing by the

pool only to hear, "Where's John? He's supposed to beat those egg whites for me!" or "Did John get the charcoal ready?" And the more they looked, the better I hid. There were "jogs" in the morning. There were fake long calls from the US just so I could play games on my phone, and long stints with Bibi either playing "hide from the evil adults" or in the pool fake-teaching her how to swim just so I didn't have to hear the minstrel Italian being spoken on the terrace.

But the only time I could really avoid them was when I grabbed Anaïs and we stowed away to our room, me screaming into my pillow like a grounded teen. "John's fucking here, YOU ASSHOLES! Fuck off!!!! YOUR FUCKING FRIENDS SUCK, Anaïs!!"

"Oh, stop exaggerating," she would say. Anaïs had been oblivious to much of the horror, perhaps because as a French person, she found most of it quite normal. For her, anybody after two weeks could come off as *pénible* (annoying). "Friends are like fish," her father likes to say. "After three days, they start to stink." He usually invokes this famous proverb on his fifth day at our apartment.

That night at the yoga *atelier*, as *Easy Yoga for Dummies* played on the same laptop we'd huddled around at that fateful dinner party in January, I exchanged wearied glances with Bibi. I realized, sweating in full crow pose, that I had finally lost my illusions about the perfect French vacation I had spent so many years building up.

The Rentrée

It was decided our last night together would be "American night," which meant we'd speak English all day and eat American for dinner, and John, of course, was named cook. I accepted the nomination, only because I didn't want to confirm everyone's assumption that Americans suck at cooking. Plus, by choosing to do smoked barbecue, I'd be able to avoid all the group activities planned that day with the excuse that someone had to keep an eye on the ribs. Under a tree in the shade, with a bag of chips and a couple of beers, which Bibi had smuggled to me, I "tested" the ribs every hour, and a soothing calm drifted over me as the sauce ran down my stomach.

By the time we said our goodbyes, I wasn't even angry anymore

at my friends for having hoodwinked me into vacationing with them.

Rule No. 7: Accept your French friends for who they are — people you'll gladly hang out with . . . in Paris.

We returned a day before the *rentrée,* the ceremonial French back-to-school period. In front of the school, while Bibi hugged her friends, the parents hung back and caught up on, of course, what else?

"Alors? Vous êtes partis où?" (So? Where did you take off to?), one parent asked. As I began describing my first real French vacation, the photoshopped version, with great friends and food and "lots of stories to tell," I could see the gears of her mind were already turning.

"Well, you sound like just the kind of people we should go on vacation with!"

And while she told me about the dinner she was organizing that weekend to plan for next year's trip, extending an informal invite to you know who, I found myself backing away, ever so slowly, subtly looking over my shoulder for the one lifeboat I could count on to save me from my next French vacation.

"Bibi . . . Bibi? . . . BIBI!!!!"

Contributors' Notes
Notable Travel Writing of 2017

Contributors' Notes

Elliot Ackerman is the author of several books, including the novel *Dark at the Crossing*, which was a finalist for the National Book Award, and *Waiting for Eden*. His writings have appeared in *Esquire, The New Yorker, The Atlantic*, and the *New York Times Magazine*, among other publications, and his stories have also been included in *The Best American Short Stories*. He is both a former White House Fellow and Marine, and served five tours of duty in Iraq and Afghanistan, where he received the Silver Star, the Bronze Star for Valor, and the Purple Heart.

Rabih Alameddine is the author of the novels *Koolaids*, and *I, the Divine; The Hakawati; An Unnecessary Woman;* the story collection *The Perv;* and most recently *The Angel of History*.

Sam Anderson is a staff writer for the *New York Times Magazine*, where he has written essays and profiles on such subjects as the Fountain of Youth, Haruki Murakami, Russell Westbrook, Anne Carson, and the perilously cracked ankles of Michelangelo's *David*. His writing has won a National Magazine Award as well as the National Book Critics Circle's Balakian Citation for Excellence in Reviewing. He recently published his first book, *Boom Town*—a portrait of Oklahoma City, America's most secretly interesting place. He lives in Beacon, New York.

Bianca Bosker is an award-winning journalist and the author of *Cork Dork*, a *New York Times* best seller about wine, obsession, and the science of taste. Bosker, a contributing editor at *The Atlantic*, has written about food, wine, architecture, and technology for *The New Yorker, The Atlantic*, the *New York Times*, the *Wall Street Journal*, and *Food & Wine*, among other publications. The former executive tech editor of the *Huffington Post*, she is the author

of the critically acclaimed book *Original Copies: Architectural Mimicry in Contemporary China* (2013). She lives in New York City.

Brin-Jonathan Butler has written for *Esquire, Bloomberg, ESPN Magazine, Al Jazeera, Harper's Magazine, Paris Review, Salon,* and *Vice.* His first book, *The Domino Diaries,* was shortlisted for the PEN/ESPN Award for literary sportswriting and a Boston Globe Best Book of 2015. His work has also been a notable selection in both *The Best American Sports Writing* and *The Best American Travel Writing* multiple times, and his book on chess, *The Grandmaster,* will be published in November 2018.

Jennifer Hope Choi is the recipient of the Carson McCullers Center's Marguerite and Lamar Smith Fellowship, the BuzzFeed Emerging Writer Fellowship, and the B. Frank Vogel Scholarship at Bread Loaf Writers' Conference. Her writing has appeared in *Virginia Quarterly Review, The American Scholar, Lucky Peach, Guernica, BuzzFeed Reader, Catapult, The Atlantic,* and elsewhere. She is currently working on a memoir.

J. D. Daniels is the winner of a 2016 Whiting Award and *The Paris Review*'s 2013 Terry Southern Prize. His collection *The Correspondence* was a *New Yorker* "Books We Loved in 2017." His "Letter from Majorca" appeared in *The Best American Essays 2013.*

Camille T. Dungy is the author of *Guidebook to Relative Strangers: Journeys into Race, Motherhood, and History* (2017) and four collections of poetry, most recently *Trophic Cascade* (2017). A professor in the English Department at Colorado State University, her honors include National Endowment for the Arts fellowships in both poetry and prose, an American Book Award, and nominations for the National Book Critics Circle Award and the NAACP Image Award.

Matthew Ferrence is the author of the upcoming memoir *Appalachia North* (February 2019), as well as a book of cultural criticism, *All-American Redneck.* He teaches creative writing at Allegheny College and divides his time between northwestern Pennsylvania and Prince Edward Island.

Ian Frazier is a longtime staff writer for *The New Yorker* and author of twelve books, including *Travels in Siberia* and *On the Rez.* He was the guest editor of *The Best American Travel Writing 2003.*

Rahawa Haile is an Eritrean American writer. Her work has appeared in the *New York Times Magazine, The Atlantic, The New Yorker, Outside,* and *Pacific Standard. In Open Country,* her forthcoming memoir about through-hiking

the Appalachian Trail, explores what it means to move through America and the world as a black woman.

Nathan Heller is a staff writer at *The New Yorker* and a contributing editor at *Vogue*. Previously, he wrote for the *New York Times Magazine, Slate, New York, The New Republic,* and other publications, and he's appeared as an essayist on the *PBS NewsHour*. He grew up in San Francisco and lives mostly in New York.

Pam Houston is the author of *Cowboys Are My Weakness,* and five other books of fiction and nonfiction. She directs the literary nonprofit Writing by Writers and teaches creative writing at the University of California, Davis, and the Institute of American Indian Arts. She lives on a ranch at nine thousand feet near the headwaters of the Rio Grande, and her book about that, *Deep Creek: Finding Hope in the High Country,* will be out in January 2019.

Allegra Hyde's short fiction and essays have appeared in *Tin House, Kenyon Review, American Short Fiction,* and elsewhere. Her debut collection, *Of This New World,* received two Pushcart Prizes, as well as the John Simmons Short Fiction Award. She is currently based in Houston, Texas.

Ryan Knighton is an author, screenwriter, professor, and performer who lives in Vancouver. His memoirs, *Cockeyed* and *C'mon Papa,* both received many award nominations, including the Stephen Leacock Medal for Humour. He has been a frequent contributor to *This American Life* and *The Moth* and has written for the *New York Times, Esquire, Vice, Outside, AFAR,* and *The Believer,* earning a Lowell Thomas Award for his travel writing. A Sundance Lab screenwriting fellow, Knighton mostly writes for film and television despite the fact that he is blind.

Richard Manning is the author of ten books, including *Go Wild: Free Your Body and Mind from the Afflictions of Civilization; It Runs in the Family;* and *Rewilding the West: Restoration in a Prairie Landscape.* His work has appeared in *The Best American Science and Nature Writing 2010.* He lives in Montana.

Rachel Monroe is the author of *A Life in Crimes: Women, Murder, and Obsession,* which will be published in 2019. Her reporting and essays have been published in *The New Yorker, The Atlantic, Texas Monthly, Oxford American,* and elsewhere. She lives in Marfa, Texas.

Eileen Pollack is the author, most recently, of the novels *The Bible of Dirty Jokes* (2018) and *A Perfect Life* (2016). Pollack's work of creative nonfiction

Woman Walking Ahead is the basis for a recently released movie starring Jessica Chastain. Her investigative memoir *The Only Woman in the Room: Why Science Is Still a Boys' Club* was published in 2015. Pollack's novella "The Bris" appeared in *The Best American Short Stories 2007;* her essay "Pigeons" was selected for the 2013 edition of *The Best American Essays.* She divides her time between Manhattan and Ann Arbor, where she is a professor on the faculty of the Helen Zell MFA Program in Creative Writing at the University of Michigan.

Albert Samaha is a criminal justice reporter at *BuzzFeed News* and author of *Never Ran, Never Will.* His work freed a man from prison and got a police chief fired. Previously, he wrote for the *Village Voice, San Francisco Weekly,* and the *Riverfront Times.* He lives in New York City.

Gary Shteyngart was born in Leningrad in 1972 and came to the United States seven years later. His most recent book was the memoir *Little Failure,* a national best-seller, a finalist for the National Book Critics Circle Award, and chosen by the *New York Times* as a Notable Book of the Year. His novels include *Super Sad True Love Story, Absurdistan, The Russian Debutante's Handbook,* and the forthcoming *Lake Success* (September 2018). His books have been translated into twenty-nine languages. Shteyngart lives in New York City.

Christopher Solomon (@chrisasolomon) is a contributing editor at *Outside.* He also writes on the environment and the outdoors for the *New York Times Magazine, National Geographic,* and other publications. This is his sixth appearance in the Best American series. He lives in north-central Washington State. His work also can be found at chrissolomon.net.

Barrett Swanson was the 2016–17 Halls Emerging Artist Fellow at the Wisconsin Institute for Creative Writing, and was the recipient of a 2015 Pushcart Prize. His short fiction and essays have been distinguished as "notable" in *The Best American Nonrequired Reading* (2014), *The Best American Sports Writing* (2017), and *The Best American Essays* (2014, 2015, and 2017). His work has appeared most recently in the *New York Times Magazine, The Believer, The New Republic,* the *Guardian, Pacific Standard, Orion, New England Review, The Point, Boston Review, American Short Fiction, Southern Review,* and *Guernica.*

Moscow-born **Anya von Bremzen** is a writer based in New York and Istanbul. She is the recipient of three James Beard Awards, and the author of six acclaimed cookbooks, as well as a memoir, *Mastering the Art of Soviet Cooking,* which has been translated into fourteen languages.

John von Sothen is an American columnist living in Paris, where he covers entertainment and society issues for *French Vanity Fair.* He has written for both the American and French *GQ, Esquire, Bon Appétit, Slate, Technikart, Libération,* and the *New York Observer,* and has interviewed among others Robert De Niro, Zach Galifianakis, Vincent Cassel, Stella McCartney, and Bernie Sanders. von Sothen has also written for TV both at Canal+ and MTV, and is now penning a column for the humor site Mediapart. He is currently writing a memoir about life in modern France.

Notable Travel Writing of 2017

THE BEST AMERICAN SERIES®

FIRST, BEST, AND BEST-SELLING

The Best American Comics

The Best American Essays

The Best American Food Writing

The Best American Mystery Stories

The Best American Nonrequired Reading

The Best American Science and Nature Writing

The Best American Science Fiction and Fantasy

The Best American Short Stories

The Best American Sports Writing

The Best American Travel Writing

Available in print and e-book wherever books are sold.

hmhco.com/bestamerican